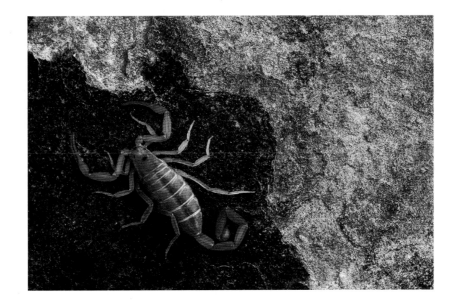

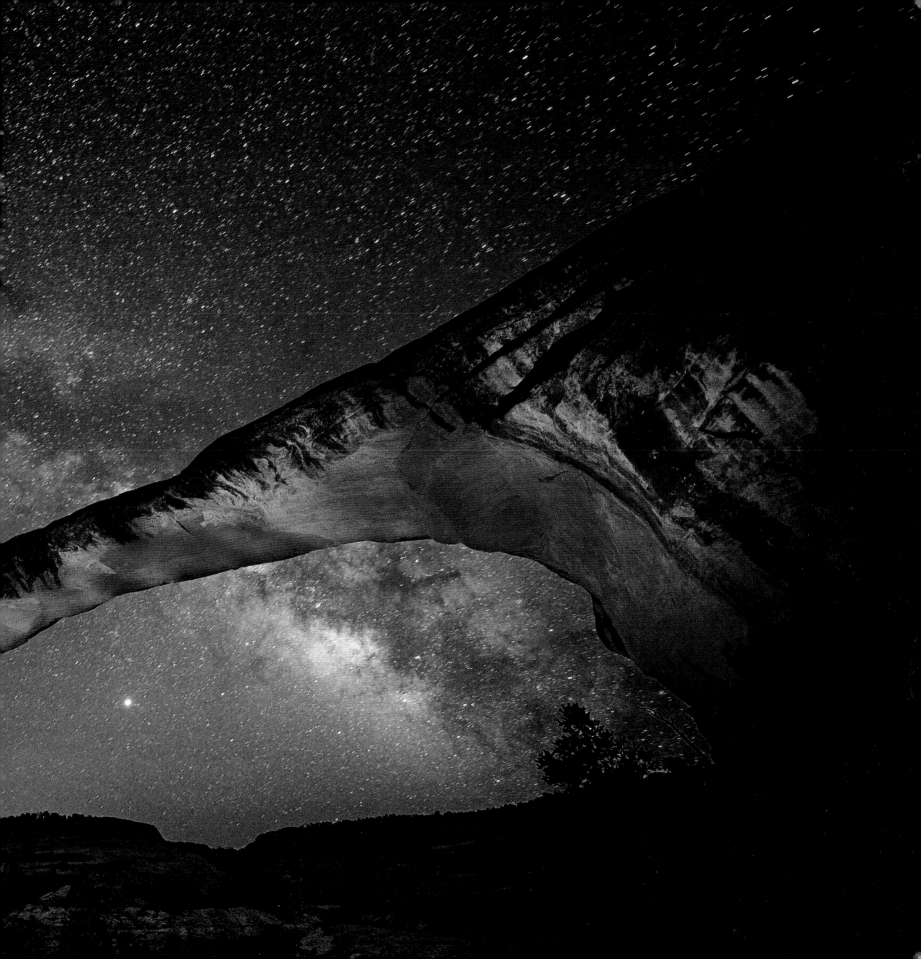

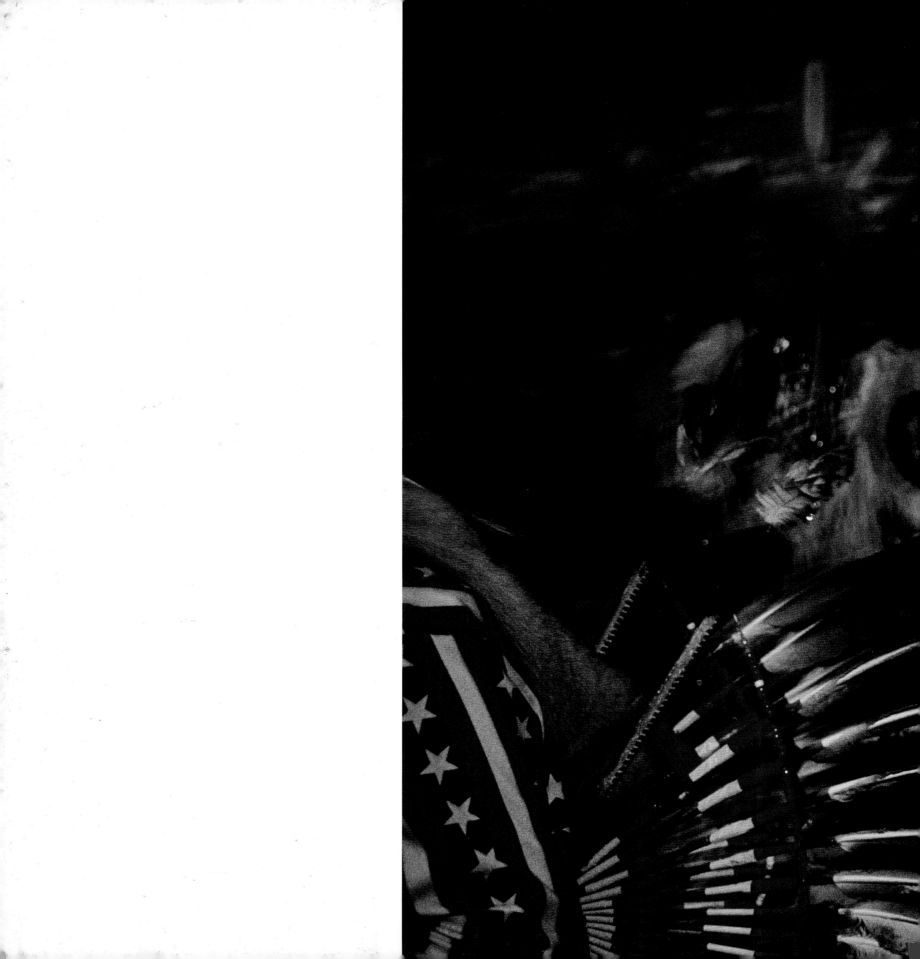

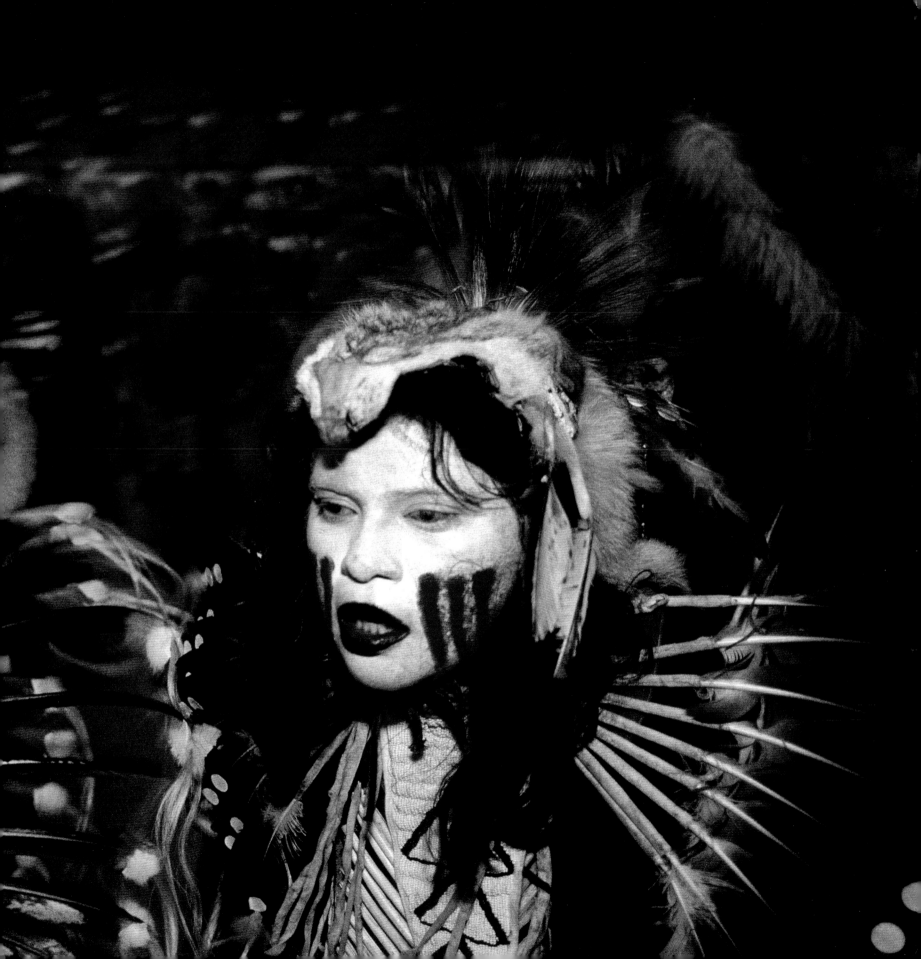

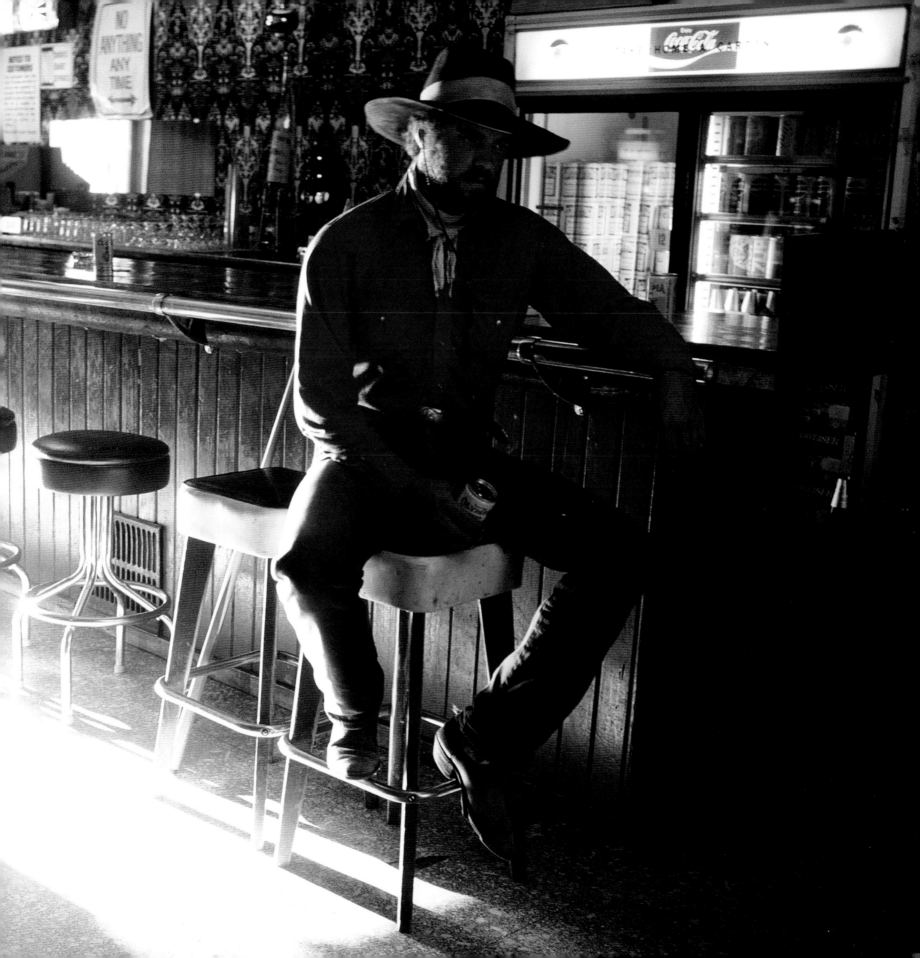

GREATEST PHOTOGRAPHS OF THE AMERICAN WEST
book and exhibit have been generously funded by

The Mays Family Foundation

The project was a partnership between the National Museum of
Wildlife Art, National Geographic Society, and Museums West

Exhibition opens simultaneously
October 27, 2012, at the following institutions

Booth Western Art Museum Cartersville, GA

Buffalo Bill Historical Center Cody, WY

C.M. Russell Museum Great Falls, MT

Eiteljorg Museum of American Indians and Western Art Indianapolis, IN

Gilcrease Museum Tulsa, OK

National Cowboy & Western Heritage Museum Oklahoma City, OK

National Geographic Washington, DC

National Museum of Wildlife Art Jackson Hole, WY

Rockwell Museum of Western Art Corning, NY

Stark Museum of Art Orange, TX

previous pages

page 1 **MICHAEL NICHOLS**
Orange scorpion in the Grand Canyon, Arizona.

page 2/3 **JIM RICHARDSON**
Milky Way behind Owachomo Bridge, Utah.

page 4/5 **DAVID ALAN HARVEY**
"Comanche John" at Red Earth Festival, Oklahoma.

page 6/7 **WILLIAM ALBERT ALLARD**
Buckaroo Stan Kendall in Mountain City, Nevada.

opposite page **ANSEL ADAMS**
"Clearing Winter Storm," Yosemite Valley, California.

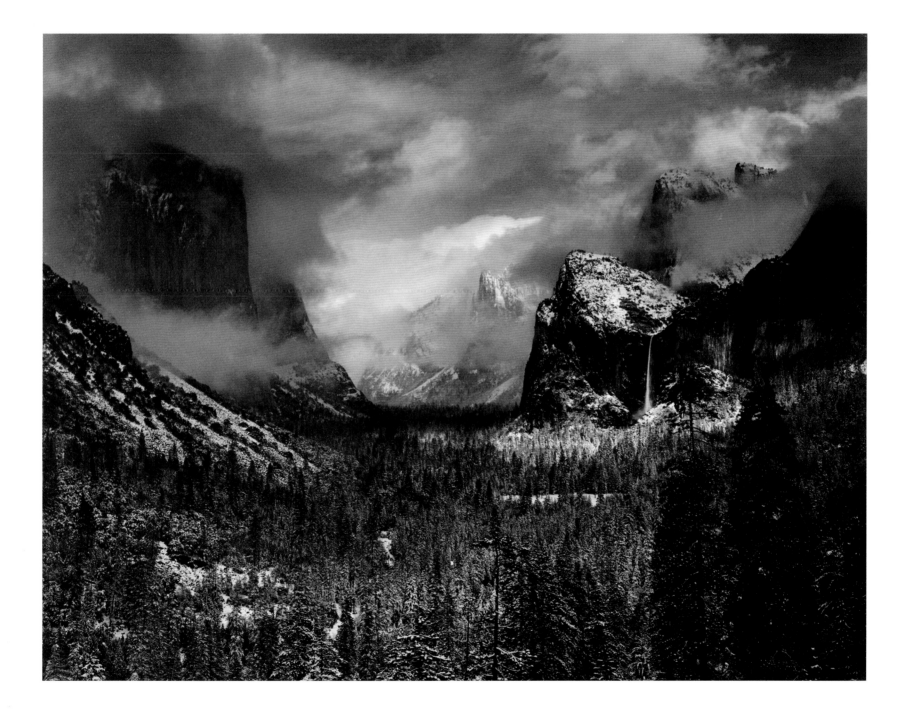

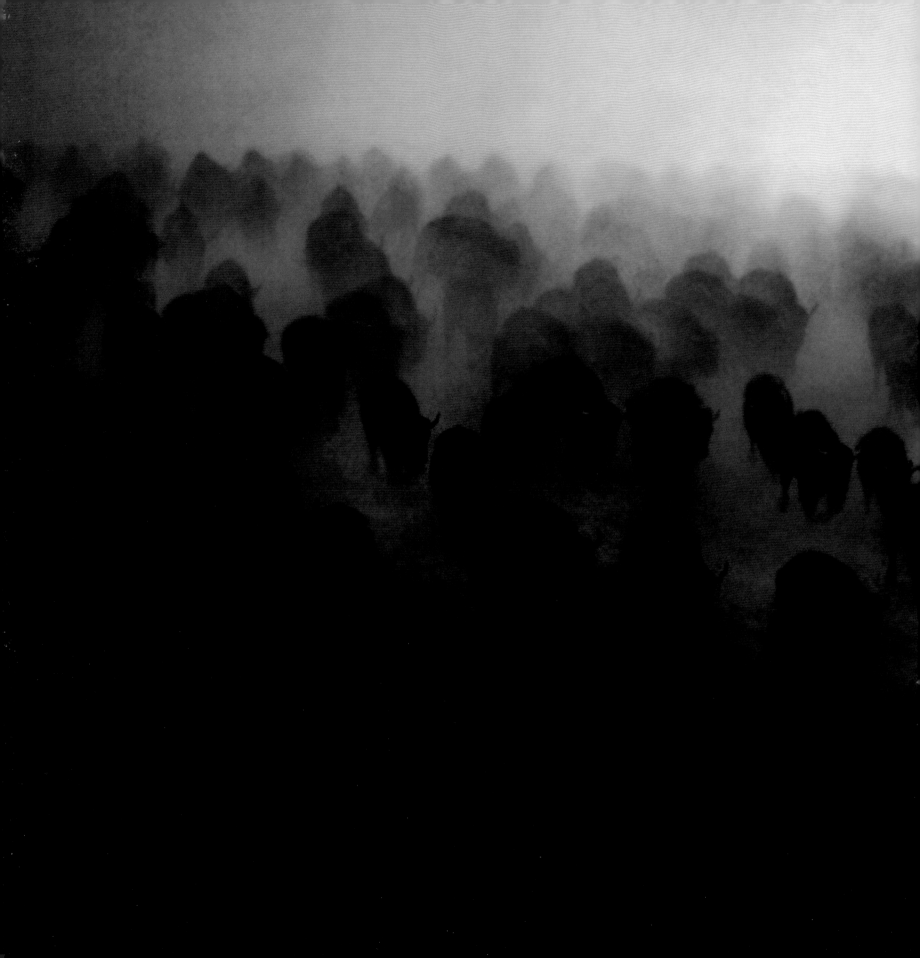

NATIONAL GEOGRAPHIC

GREATEST PHOTOGRAPHS OF THE
AMERICAN WEST

CAPTURING 125 YEARS OF MAJESTY, SPIRIT AND ADVENTURE

CONTENTS

previous pages (10-11)
JIM BRANDENBURG
Bison stampede on the open prairie, South Dakota.
opposite page
MICHAEL NICHOLS
Lightning bolts plunge into the Grand Canyon near Sublime Point, Arizona.

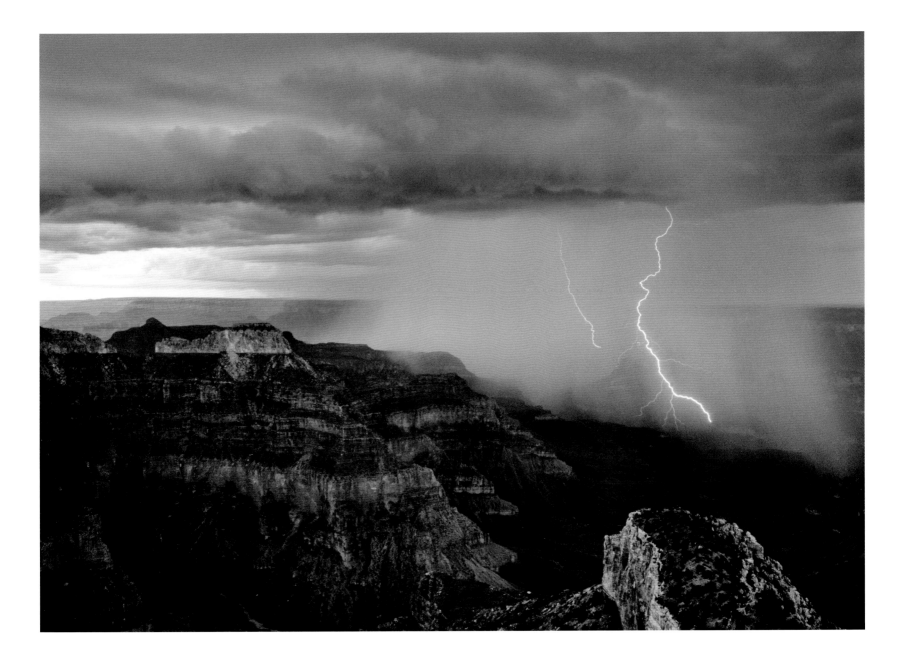

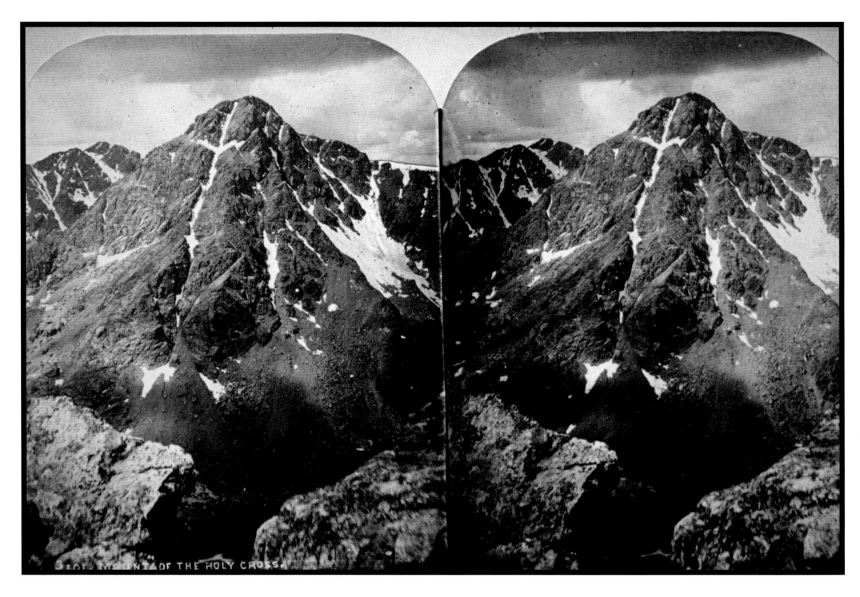

WILLIAM HENRY JACKSON | Colorado, 1873

This stereograph of the Mountain of the Holy Cross symbolized to many the union of America, Nature, and God that fulfilled a romantic destiny.

[INTRODUCTION]

PROVING LEGENDS AND SEEKING THE FUTURE

JAMES C. McNUTT

ON AUGUST 23, 1873, PHOTOGRAPHER WILLIAM HENRY JACKSON AND HIS TEAM OF assistants—16 people and a greater number of mules—labored up a valley strewn with fallen timber, slick rocks, and bogs west of the Eagle River in Colorado, seeking a route to a view of the legendary Mountain of the Holy Cross. Leaving the valley, Jackson took two members of the team and ascended a ridge to a vantage point on Notch Mountain. Hauling hundreds of pounds of photographic equipment up the last 1,500-foot climb, they spent a day above the clouds that obscured the main subject but that compensated by producing a nearly circular rainbow.

After a restless night at tree line, they arose to a clear, cold morning and a sunrise view of the snow crossed mountain. Jackson had to wait for snowmelt to produce the water needed to wash his glass plates, then he made eight images, the first ever, of the Mountain of the Holy Cross. His stereographs and prints, slightly altered to extend one arm of the cross, became one of the most popular photographs of the American West in the 19th century, symbolizing to many the union of America, Nature, and God that fulfilled a romantic destiny.

Proving a legend, Jackson's photography helped bequeath to future generations a sense of the American West as an enormous natural territory in which to explore national and human possibilities. In the words of one writer, "the photographs became as legendary as the mountain itself."

Jackson's photograph served his sometime collaborator, the painter Thomas Moran, as a spur to action and a confirmation. Just as their joint works imaging the Grand Canyon of the Yellowstone had prompted congressional action to establish the first national park, the photographer and painter again created paired images that would convince their audiences of the significance of the West. Moran deposited a copy of the photograph of the Mountain of the Holy Cross with the U.S. Copyright Office in 1874 so that he could lay claim to its use for a painting, and then he made the difficult trip himself to obtain sketches. Jackson's photograph and Moran's painting both appeared in Philadelphia's Centennial Exhibition in 1876, where the photograph won seven medals. Upon seeing the image, Henry Wadsworth Longfellow composed a sonnet to memorialize his deceased wife, "The Cross of Snow" (1879, published posthumously), with the lines:

There is a mountain in the distant West
That, sun-defying, in its deep ravines
Displays a cross of snow upon its side.

In 1989, *National Geographic* magazine published both images in a retrospective of William Henry Jackson's career. By that time, the pages of the magazine had been carrying stories of Western adventure and expansion for over a century. The legends of lost cities of gold, endless deserts, rivers flowing to the Pacific, and enormous herds of wildlife followed by nomadic peoples belonged to the history of the frontier.

But in 1889, when *National Geographic* first published photographs, the magazine was the organ of a young, consciously scientific organization. The figures of John Wesley Powell, John Muir, and Theodore Roosevelt promoted a vision of the West as something more than legend, a place that could test the potential of people to respond to the demands of the earth. Powell, a founding member of the National Geographic Society, was himself a legend-maker, leader, and protagonist of Western surveys—he was the first to descend the Colorado River through the Grand Canyon, the second director of the U.S. Geological Survey, and the founding director of the Bureau of American Ethnology. He was also the principal proponent of the idea that the West itself was not an unoccupied, limitless resource but a complex ecology that required careful management. Standing beside Tau-gu, a Paiute, on the banks of the Colorado, the one-armed Powell points down the canyon with his good arm and the photographer captures a moment's worth of the human response.

On a chilly morning in November, 1903, Theodore Roosevelt and John Muir awoke near the top of Glacier Point, high above the Yosemite Valley, shook the snow from their blankets, and embarked on an 11-mile hike that Roosevelt was soon describing as "the most wonderful day of my life." The two men posed for a photograph that eventually reached millions of people through the distribution of stereographs by the hugely successful company of Underwood and Underwood and in many later publications, including *National Geographic*. The image, with Yosemite Falls prominently in the background, shows Roosevelt dressed for hunting, Muir for the classroom, gazing at the camera as if to prove the existence of the spectacle behind them.

Muir had deliberately postponed, at the last minute, a planned journey to Asia to accompany Roosevelt on a three-day camping trip and sought the President's support for the preservation of the stands of gigantic redwoods around Yosemite. Around the campfire, he did not hesitate to ask Roosevelt why he continued to hunt animals, a childlike pursuit in Muir's eyes. Nor did Roosevelt shrink from pointing out that Muir knew plenty about trees and mountains but did not recognize the songs of birds in the area that he himself knew intimately. The two men became strong allies in the conservation of wilderness areas as national parks, forests, and monuments: Muir's preservation efforts, legendary in themselves, perfectly matched Roosevelt's desire to promote his own sense of the West, imbued with glories of the hunt and exploits of explorers and cowboys.

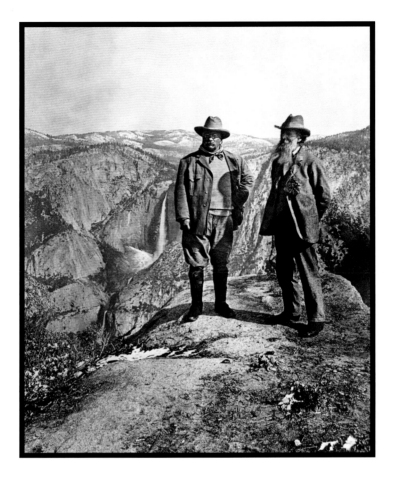

UNDERWOOD & UNDERWOOD | California, 1903

Three icons of the West—Theodore Roosevelt, John Muir, and Yosemite Falls—stand together for conservation on a camping trip.

The popular reception of these early photographs by the public was in part due to the daring nature of the photographers themselves. The development of photography could not have had a more dynamic subject than the settlement of the American West by Easterners rushing for gold and seeking renewal after the losses of the Civil War. The people who understood the power of photography quickly grasped the significance of easily reproduced images. As the *Philadelphia Independent* newspaper reported in 1904 about Theodore Roosevelt: "While talking, the camera of his mind is busy taking photographs" (Edmund Morris, *The Rise of Theodore Roosevelt*, 1979). The statement says much about Roosevelt's tireless engine of self-promotion but also about the acceptance of photography as a medium in his time. In a little more than 50 years, photography had become so pervasive that it served not only as a documentary method but also as a metaphor for human memory. The American West had already become a standard by which to measure human endeavors—and the public has remained hungry for images of the West to this day.

This book gathers the best images of the West published by *National Geographic* over its 125-year history, and also reveals some surprises from the National Geographic Image Collection. Many of the images will be instantly recognizable for their subjects; others less so. Arrayed together, they tell a story about imagination, spectacle, adventure, and surpassing beauty, together with startling views into the daily struggles of people and animals in a vast and often intimidating territory.

The romantic impact of popular fiction and Hollywood movies crowds our view of the West with raging gunfights, barroom brawls, cattle stampedes, Indian fights, and the lone cowboy riding away into the sunset. These motifs derived first from historical narratives, paintings, and photography—when they were not created whole-cloth by imaginative hack writers. But even the most iconic locations of the West that appear in movies, such as the Monument Valley backdrops in John Ford's films, do not convey the sense of being able to travel to the location itself. The movie *West* is a place in past time.

National Geographic photographs, in contrast, appear in real time, hot off the press, showing places, events, people, and wildlife that are within driving distance for many of us. Old Faithful Geyser towers over a few scattered onlookers in 1916, more people gather beneath it in 1936,

and by the 1970s, hundreds crowd on boardwalks made to keep tourists from wandering too close to the heat. The distant, legendary mystery, confirmed by the photograph, becomes a common, accessible experience that every visitor owns. The photographs themselves, framed in the familiar magazine cover, become part of common memory.

Images repeated over a long period of time in a magazine disseminated to millions acquire familiarity. Ask anyone on the street about the name "Old Faithful," and they will more likely know the answer than they will be able to recall the name of the vice president of the United States.

No single institution, even one with the reach of the National Geographic Society, can bear credit for the diverse and complex associations that attach to the simple phrase "the West." Nevertheless, *National Geographic* has steadily reported on the West and, more particularly, has consistently published images that form a sort of cultural commons for popular understanding of the region. Neither rigid in its editorial form nor comprehensive in its coverage, the magazine has reminded us consistently about the significance of the region, its lands, creatures, and people, to human imagination.

Sifting through thousands of images and working back and forth through the pages of *National Geographic* magazine, it is easy to wander and burrow down into a particular photograph. How fascinating

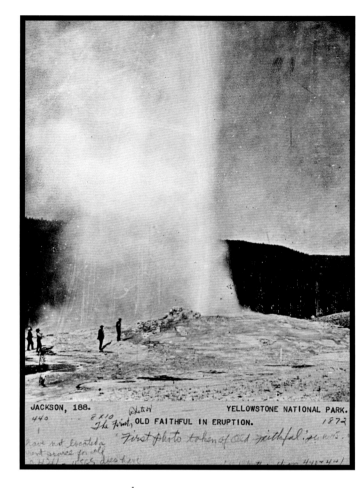

WILLIAM HENRY JACKSON | Wyoming, 1872

The familiar plumes of Old Faithful Geyser soar above onlookers in the geothermal wonderland of Yellowstone National Park.

to see the first published halftones of American wilderness or to wonder how a photographer managed to capture the golden curve of a grainfield harvest or the brilliant eye of an eagle.

Hundreds of publications and exhibitions characterize the American West and reveal the passions of its history. The effort here is to show, rather than tell, how images characterize the region, to let the human eye synthesize a sort of "facial recognition" program for the region. Out of a collection of spectacular photographs of a broad area, taken over more than a century, what visual outlines emerge that have guided public recognition of land, people, animals, and events?

This presentation settles into four sets of images. The first explores legends of the West and captures the early and late renditions of places and people that are the basis of stories that are only partly believable, but have some basis in fact. Next are the visual outcomes of contact: discoveries and encounters between peoples, struggles and triumphs of people and the land, predation and preservation of wildlife. Then, the very vision of Western geography appears in photographs striving to capture space and distance in a

limited, but far-seeing, frame. The final set pushes forward to images of the West that create visions of the future. These restore viewers' status to that of those who first heard rumors about vast mountains, endless plains, and thundering hooves and then stared breathless as the new scientifically and athletically captured images appeared in print.

For thousands of years, people traveled and explored the West seeking economic opportunity, religious freedom, political autonomy, and national dominion. The things they discovered and the people they encountered, their struggles for survival, and their triumphs became the basis for stories that still condition practice and policy about the stewardship of natural resources and the relations of diverse cultural groups. The heritage of the romantic horizon led travelers to expect that they would discover dramatic wilderness landforms and tribal cultural traditions firsthand. *National Geographic* photographs make it clear that the unknown and the unexpected still go with the territory.

What follows discovery? Native American historians, responding to the quincentennial celebrations of Columbus' arrival and the discovery of America, have convincingly argued that what constituted "discoveries" for the likes of Columbus, Lewis and Clark, Kit Carson, and westward-pushing pioneers ought to be regarded, less positively, as "encounters," or even genocide where native tribes were concerned.

Discoveries bring elation, excitement, and wonder; encounters bring caution, doubt, and dubious outcomes. Between the two extremes fall most of the real-life experiences of everyday people, but photographs allow viewers to approach the wonder and feel the doubt. They also provide perspective. Conditioned to seeing spectacular mountains towering over river gorges from an eagle's-eye view, viewers of a photograph get a new perspective when the camera is pointed over the heads of tourists pointing at the same peaks and valleys. Roadside mechanics struggling to start a stalled car are reminiscent of stranded pioneers next to an overland stagecoach. The photographer's story illuminates the actuality, noting that young boys who volunteered their mules to get stranded travelers across the river then imposed a fee in order to take them back across.

Direct images of conflict are few in *National Geographic* magazine. One way to resolve and understand human encounters in the West is to study photographs depicting festive performance. Tribal dances before tourists, powwows, parades, rodeos, races, and football games appear insistently as each group stakes its claim to a part of the West. *National Geographic* photographs capture the diversity of the West on display in revealing detail.

Fifty years after the Battle of the Little Bighorn, several thousand people gathered at the site to commemorate the event, including participants from both sides of the fight. *National Geographic* published a photograph of White Man Runs Him, a Crow scout who served under Custer, and General E. S. Godfrey, who served under Custer as a lieutenant. Contemporary accounts describe a solemn procession of hundreds of Sioux and Cheyenne, among them nearly 80 who participated in the battle itself, convening at Last Stand Hill. A caption for a photograph of Crow warriors in the same story in 1927 remarked: "Approximately 12,000 Indians took up arms for the Great White Father in the World War." Much later, in the 1980s, images appear of reunions of Navajo Code Talkers who served in World War II. Then, more dramatically, a young fancy dancer in a blur of color whirls at a powwow, and an

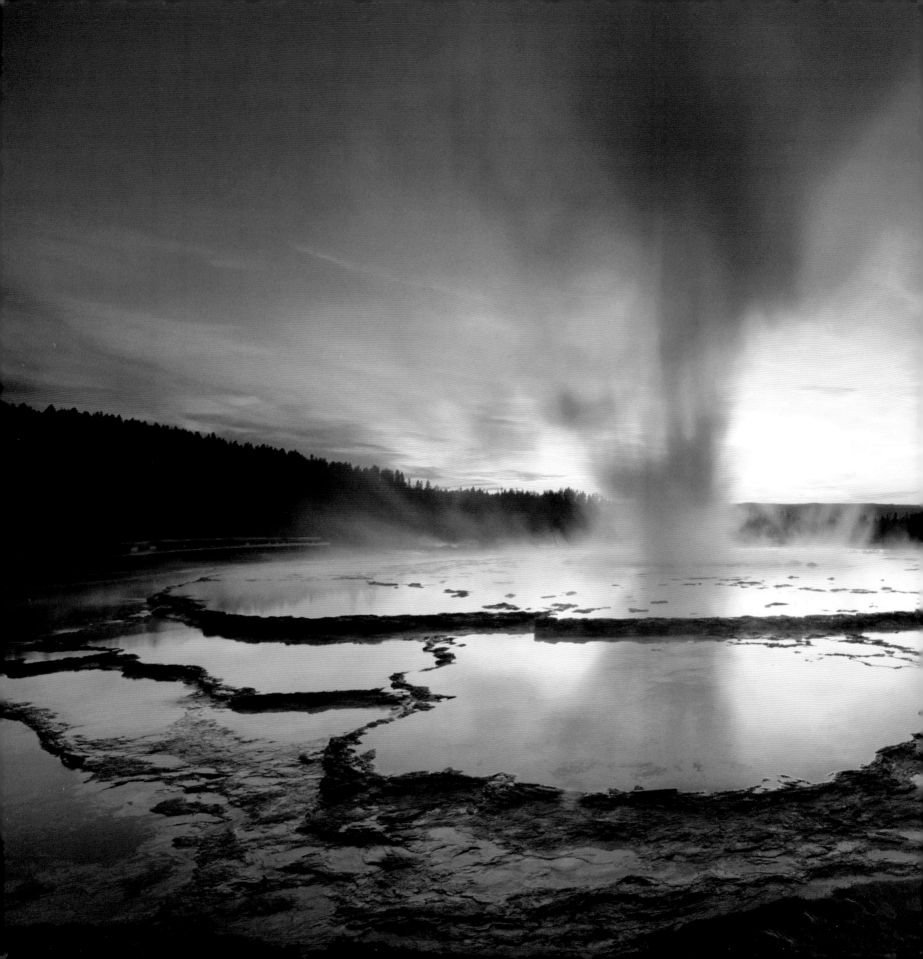

adult pins a feather to his ear, cigarette dangling from his lips as he stands in front of a tent with aluminum poles. Teenage girls in jeans and T-shirts walk together through the tall prairie grass, one turning back to look over her shoulder at the SUVs and campers circled around the powwow. The images arrayed together signify the ardor and passion of journeys taken by people since the time of the legendary West.

It is easy to find photographs of Native Americans, resplendent in long, Plains-style feather headdresses that conform to popular conceptions. Likewise, we see a cowboy dramatically posed in woolly chaps, bandana, and hat, aiming a pistol at some unseen antagonist. But moving beyond the posed and even humorous depictions—a cowgirl leading a horse and putting a nickel in a city parking meter—the dress of people in the West is a performance of identity: an Anglo seated in a portrait with his three Apache wives; Mennonite women in long dresses helping to stack hay; a Navajo policeman sitting at a lunch counter in a crowded diner; African-American women in ball gowns on a river float in a parade; a Native American family, neatly dressed as if for Sunday school, standing in front of a marquee sign welcoming people to the Cactus Café.

Discoveries and encounters involving humans often dominate stories of the West. Nevertheless, the natural world has always provided fascination and motivation for humans who go there. Consider bison. Neither photographs nor even film ever quite captures the rustling thunder of hundreds of thousands of shaggy creatures moving across rolling prairie, or the smell of the earth kicked up in their wake. But people believe that such a phenomenon occurred because it recurs in woodcuts, lithographs, photography, and film, in painting and in sculpture. Awkward, imaginary buffalo images began to appear in the 15th century, but more accurate sketches and paintings proliferated with the settlement of the West. No other animal suffuses our sense of the West and the changes that have occurred there more than bison.

Photography showed the reality of bison slaughter: thousands of skins and skulls piled at railheads on the prairie, images that confirmed a deliberate pursuit of a policy to starve Indians into submission. Later, photography documented the existence of scattered, remnant herds, kept together by independent ranchers like Charles Goodnight or herded by government agencies to provide food for reservation tribes. Pictures appeared repeatedly, too, of mounted bison heads on the walls of homes, offices, and barrooms. Now, bison-lovers exult in brilliant images of restored herds galloping across the prairie, or the head-on shots of massive bulls charging toward us through the snow as if emerging from the misty past.

We are prone to focus on the glory shots of these creatures, isolated from the herd, mysteriously staring back at us as if to say, "We are timeless." But no such image works for us independently of all those predecessors, just as no one conceives of the West without bison. These things are associations that we cannot sunder. It is well that we cannot, because we need the West.

The history of bison slaughter and restoration speaks for all the creatures that encounter humans. But the striking contrast between a grizzly strung up in front of a storefront after a hunt and a humorous scene of people feeding his cousins in a park warns against the too-easy assumption that people and wildlife have found a comfortable coexistence.

A recent story about the experience of some National Park Service rangers with a grizzly bear illustrates human-bear relations in a practical way. The bear was heading for hibernation, so it was looking for food. Finding two trash bins next to a closed lodge, it made such a racket that it drew the attention

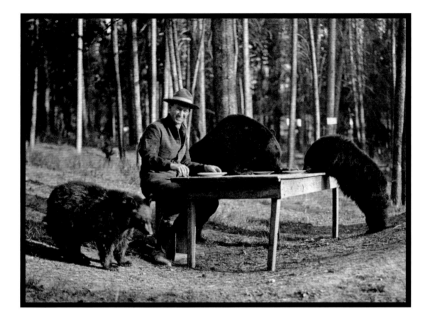

U.S. NATIONAL PARK SERVICE | Wyoming, 1922

Despite rules against feeding them, even Yellowstone Superintendent Horace Albright nourished the myth of friendly, fed bears.

of nearby park rangers, who opened a locked gate to investigate. The trash bins, massive steel boxes with heavy hinged doors on top and a locked, sliding door on one end, sat side by side in the parking lot. The grizzly had already made his way through the first one. He had simply ripped the heavy sliding door off.

He apparently had less immediate success with the second bin, where the sliding door proved less fragile. Being an inventive bear, and a big one, he resorted to pushing the entire box—about the size of an SUV—over on its side. When the first ranger arrived, she found him busy inside the trash bin, and bleeped her siren to scare him off. This caused the grizzly to quickly decamp, but not to leave his newfound meal entirely. He lingered at the edge of the nearby woods and continued to eye the scene.

When ranger backup arrived, armed with plastic bags and rubber gloves to recover the trash, one ranger stood by with a shotgun while the other did garbage duty, his bear spray ready. Mission accomplished, they posted warning signs while workers removed the trash bins and replaced them with a newer type with stronger doors. The grizzly, meanwhile, circled the area and moved toward a third bin in a nearby housing area. Rangers hazed him along with horns and noise and had that trash bin also replaced. When last seen, the bear was headed away, toward his presumed denning site.

Photographs of tourists happily shutterbugging bears on national park roadsides clash with this story of cautious rangers. Images from earlier days—predating the National Park Service decision in 1970 to treat wildlife as wild—depict rangers actually sitting at picnic tables feeding the bears, or tourists sitting on bleachers watching bears feed at garbage dumps.

We tend to focus on the amazing aspects of discovery and encounter—people in close proximity to bears—but often forget to think about the outcomes. Bears symbolically straddle the divide between wild and tame, preservation and extinction. For this is actually the point of the rangers' concern. As the saying in the parks goes, "A fed bear is a dead bear." As preservation succeeds and the threat of extinction possibly diminishes, human-bear encounters will increase. What does this prospect say about our plans?

Once plentiful and wild across North American, bears now reside and resist extinction in limited islands of national parks and wilderness areas. Grizzly bears in particular no longer reside in 99 percent of the lower 48 states and Mexico where they once roamed. Continued loss of habitat and food sources threatens a population now geographically isolated around Yellowstone National Park.

The story of the grizzly and the rangers represents one outcome of a discovery and encounter experience of the West. The recognition of new people, places, and things that we characterize as discovery converts to encounter whenever the object becomes animated or chooses to speak. Encounters may produce both good and bad results. Animals go extinct. Tribal peoples speak out against the presumption that they have "disappeared." Dams impound water and shortstop salmon returning to their spawning grounds, but dams also provide drinking water to people hundreds of miles away.

National Geographic photography captures the great range of the results.

The first sensation is one of awe and bewilderment; a shock, a sense of oppression, perhaps of horror, overpowers you. There is nothing you have seen before that has given you even a hint of what this is; nothing you can compare it to. It is an innovation in nature which it takes time to comprehend—to appreciate; then as you gaze grows on you a realization of the enormousness, the gorgeousness, the weirdness, the grandeur, majesty, and sublimity of the scene. Speechless you gaze on the vast sea of ghostly, giant shapes, and are overcome by the feeling of your own insignificance as in the presence of infinity. Only gradually are you made fully conscious that you behold the most sublime of all earthly spectacles. No picture has ever conveyed an idea, language there is none that can ever give an adequate conception of the ensemble of this great chasm.

The images of the Grand Canyon that accompanied this dramatic statement, made in an 1897 article by Bernhard E. Fernow, chief of Division of Forestry, U.S. Department of Agriculture, were some of the earliest to appear in *National Geographic*. Eventually the photography and the printing would improve so much that the words seemed less necessary. The practice and the constant return to the Canyon, harking back to John Wesley Powell's descent down the Colorado River, made it, like only a few other Western places, the living room of the Americas.

Photography came to grips with the boundlessness of Western space, marked in the recognition by pioneers such as William Henry Jackson that lens and focal length could compensate for the lack of panoramic vision wide enough to convey the feeling of a few men and mules in tents on a vast sea of sagebrush. Carlton Watkins, Ansel Adams, and other photographers made specialties of particular Western locations.

Just as surely as space signifies openness, freedom, and opportunity, topography and people create boundaries and divisions. Mountain ranges rear up and river canyons dive away to pose barriers to travel; deserts carry warnings against crossings. Where boundaries may appear not to exist in a wide-open plain, people create them: political, economic, physical, and even spiritual. The range and fencing wars and the painful settlement of Native American reservations in the 19th century became the fights over water reclamation, mineral rights, immigration, and endangered species in the 20th century, wars all waged in the tacit recognition that wide-open spaces do not imply unlimited resources.

Nineteenth-century boosters of Western settlement promoted the West with slogans that often eluded the facts—"rain follows the plough"—but their promises led generations to migrate to become farmers, ranchers, miners, oilfield workers, and builders, and they moved the world to regard the Western Plains as

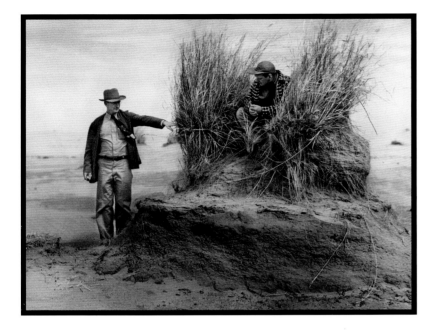

the world's breadbasket and the desert West as a fount of energy. The stories of these people, told and retold through the generations, lie behind the momentary snap of the camera shutter.

Mody Boatright, the Texas folklorist and collector of oil field tales, grew up working on his family farm near the prairie town of Sweetwater. Of his father's ways, he recalled the habitual westward gaze in the evening, keeping an eye out for clouds on the horizon. "I had seen my father sit on the front porch at night watching a cloud in the northwest—to [sic] tense to sleep or read until he was convinced that it would rain or that it would not rain" (private letter, Boatright Papers, 1935). In the days before artesian wells began to answer the thirst of dryland farmers and their crops, that evening gaze was a constant.

The lasting struggle about the West is between the desire to manage natural resources to produce things that are useful or necessary and the perception that management will ultimately fail to preserve either the resources or the stunning landscapes that harbor them. Advocates for farming, mining, hunting, fishing, dams, and timber all claim that they protect the land and the flora and fauna that they disrupt. They can demonstrate the good effects, in many cases, of their efforts to replace forests, restore streams, and improve lives. What they cannot demonstrate, however, is the future continuity of ecosystems that sustain the life-forms that depend upon these natural resources.

As one drives across West Texas, through New Mexico and Colorado on the way back to Jackson Hole, the wonder of traveling across great spaces never fails to take hold of the imagination. Wintertime heightens the starkness of mesquite and greasewood flats as they give way to prairie and sagebrush. The Rockies rise beyond the desert and lead north. At any time, the horizon may recede 50 miles or more in the distance.

When cruising across these forbidding spaces, with no worries about the next water hole or shelter for the night, it is easy to stop and spend some time watching pronghorn graze. Their migrations take them northwest to southeast, from summer grazing to winter and back again the following season. Transportation and technology have reduced the traveling time for humans on these routes to practically nothing, but our speedy travel and fenced ranges disrupt and fragment the pronghorn's paths. Pronghorn made a significant recovery as a species in the 20th century—but have never returned to their teeming population of the early 1800s.

Regardless of every sort of boundary, the limits to population in arid climates, and the clamor for the capture or preservation of natural resources, the visual power of open space persists to jolt the

BRUCE DALE | Arizona, 1997

Reflecting the immense scale of the Western tableau, a dust cloud hundreds of feet tall rolls past the monoliths of Monument Valley.

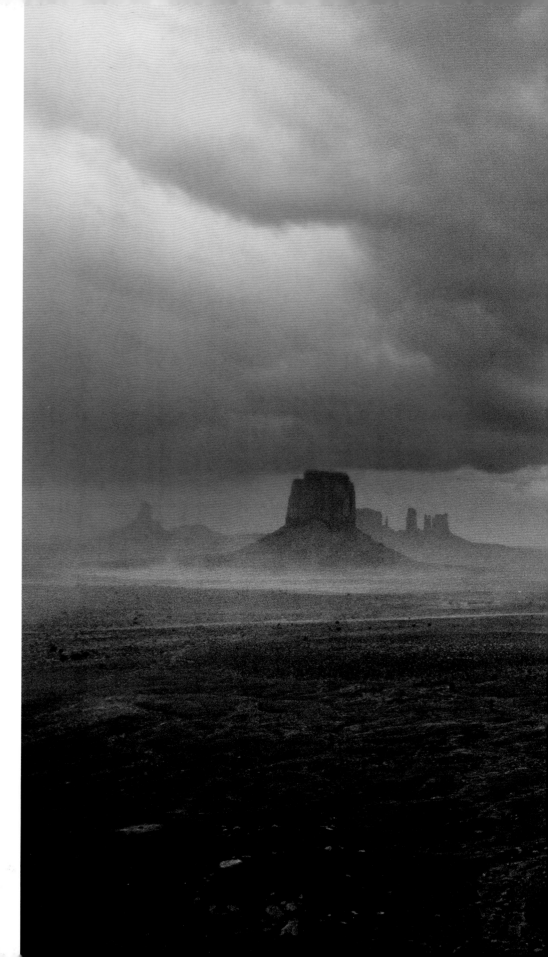

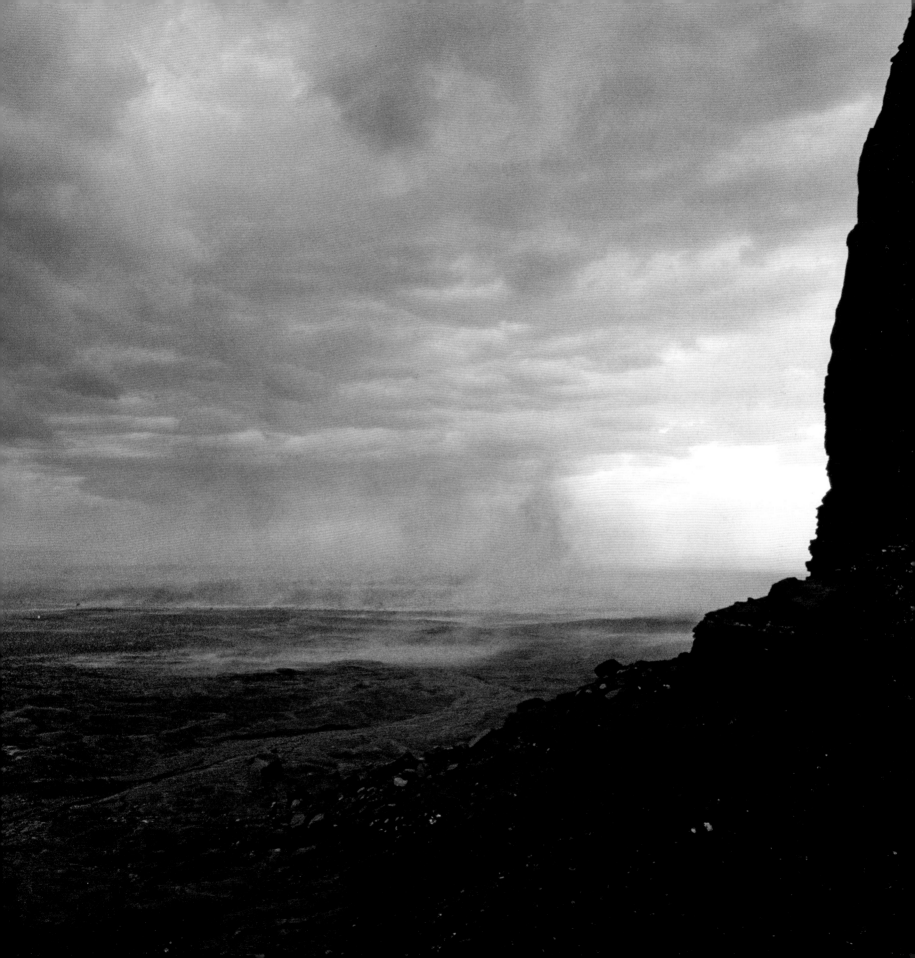

imagination, and now reaches beyond. Cameras, planes, and satellites provide photographic perspectives that unframe everyday vision and stagger imaginations of people today the way those early images of Mountain of the Holy Cross and the giant redwoods and towering peaks amazed our predecessors. From the earliest aerial views of the grassy plains around San Antonio, made only a few years after the Wright brothers' flight, to our everyday manipulations of Google Earth and resplendent satellite images, people in the 20th century have grown accustomed to images of vast distance compressed on the printed page.

Evolving photographic treatments show that present-day issues surrounding water, land, wildlife, and people magnify and multiply the sketchy and mystical memories that persist about a place in the past. A geyser surrounded by tourists recalls tales of trappers and explorers. A moonlit stone bridge arches beneath the starry sky, leaving us to wonder at the carvings of wind and water. Bison charge across the plains, a spectacle still imaginary in its drama. Redwoods stretch upward to the haze and dwarf the people posed at their feet. Stacks of timber recede to the horizon alongside railroad tracks. Chinese laborers pose on the cowcatcher of a locomotive. A miner squats beside a stream, staring at the grains in the bottom of his pan. Diminutive figures appear on the adobe walls of Mesa Verde. A Navajo woman cavorts with her granddaughter. A scruffy cowboy stares into the lens.

National Geographic photographs cover all these and more, and tell us that despite the dominance of cowboy images, the West is as complex an environment as any on Earth.

Out of legends, discoveries and encounters, across spaces and boundaries, the West still lures those who risk change. With a tradition of restless migration to reach new places, the West retains an appeal to individuals who attempt to climb the highest, go the fastest, and push performance for its own sake, frequently risking all for a mere notation in the record books. This competitive bent furnishes much of the romantic history of the West. Many of its latter-day detractors focus on conflicts between people and nature, or between people and other people.

But the persistent strength derives from people who challenge themselves rather than each other. The challenge may come in the form of personal risk-taking, but more frequently it appears in the attempt to preserve space for communities and ecosystems. The daily lives of people in communities in the West emerge as the most telling measure of the impact of the land on people, and the impact of people on the land. Sometimes the guiding principles are scientific or political or economic, but frequently they are also spiritual.

So among the photographs that attempt to capture the future of the West frequently appear children: a young Western gentleman dressed for church, a baby swaddled on a cradleboard, a whirling fancy dancer, a boy standing with his hands in his pockets, girls high and horizontal on a wooden swing.

So much of the West and the stories of the West partake of the land that people have become accustomed to aerial views giving perspective across vast distances. The power of the enormous sky is the only thing that can diminish the vastness of Western topography. What photography shows about the Western sky could fill a book by itself. The all-night visions of stars circling overhead, captured by an open shutter, now make a striking contrast with satellite images of the pattern of city lights across the country. A time-lapse of giant windmills shown against a brilliant starry sky exposes the limitations of human attempts to generate power in the face of energy moving across space for eons. Laser beams shooting into the night render an observatory as some kind of enormous cannon.

The visions of the West that appear in *National Geographic* photography jar the imagination. The legendary places and figures of earlier years reappear in brilliant color, juxtaposed with contemporary technology. The intrusion of technology into the landscape and the resources of the West demands attention as much as the mysteries of geology and weather. Historian Walter Prescott Webb's focus on the transformative power of frontier technologies—six-shooters, windmills, and barbed wire—pales beside the massive structure of the Hoover Dam, strip mines, and railroads, not to mention the terrific and terrifying juggernaut of nuclear power.

If the early photographs of the West are about proving the legend, the late ones are about revisiting the legend in a changed world. Overcoming boundaries is a more likely activity in the future West than overcoming spaces. A woman stares out a window, directly at the camera, from a building adorned with stickers opposing a tallgrass park. Young Mexican-American men gather in front of a Los Angeles storefront on Whittier Boulevard. Young people inspect petroglyphs while an adult nearby reads a newspaper. A Montana ranch hand turns from the carcass of a wolf-killed calf in Montana.

The iconic images of the West have staying power, and a rainbow over the Grand Canyon or a geyser spouting against a beautiful sunset may have the magic of protecting those places. Yet again, a bison herd pounds through the grass. More poignant, perhaps, are those young girls working their way uphill through the grass, looking back at the circled wagons of the powwow and the clouded mountains beyond. The photograph positions the viewer above it all, gazing at people and distance, waiting for the next move. Like so many great American images, small people figure in an enormous landscape, and we want to know their story.

In this manner, the hero of N. Scott Momaday's *House Made of Dawn* (1968), Abel, becomes the Everyman of the Western experience. Looking wistfully over his shoulder at traditions and places that he will never engage in with the same fullness that his grandfather's generation did, he wrestles with the dangers and frustrations of modernity:

The road curved out and lay into the bank of rain beyond, and Abel was running. Against the winter sky and the long, light landscape of the valley at dawn, he seemed almost to be standing still, very little and alone . . . He was running, and under his breath he began to sing. There was no sound, and he had no voice; he had only the words of a song. And he went running on the rise of the song. House made of pollen, house made of dawn. Qtsedaba.

The role of photography in creating and perpetuating beliefs and understandings about the West has been continuous and evolving. Beginning with adventurous pioneers in the field and never ceasing to the present day, when it has become a common and instantaneous convenience for people to copy and share what they see, photography accumulated an enormous record of change beyond the 100th meridian. This volume and the exhibit that it accompanies give a small hint of the scope and significance of the *National Geographic* holdings. From that it is only possible to guess at the impact of millions of such images disseminated through *National Geographic* magazine and other media. What happens to the West in the future may not result directly from *National Geographic* photographs—but then again, it may. ■

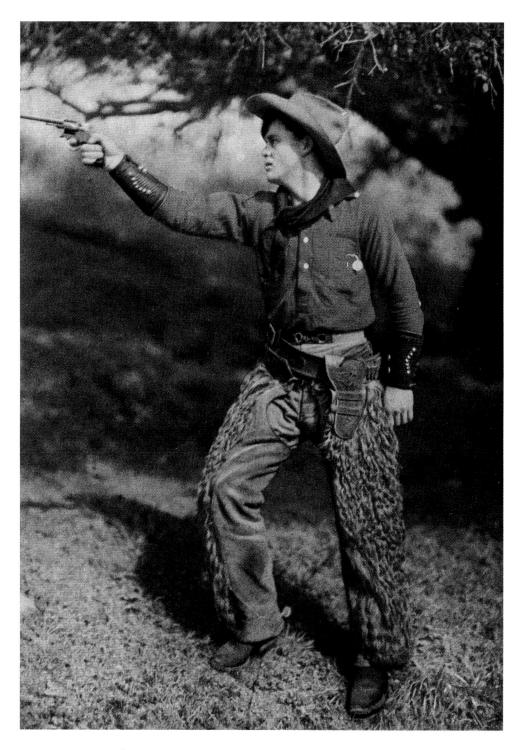

FRANKLIN PRICE KNOTT | California, 1916

A vintage Autochrome romanticizes what the magazine called the "fast-disappearing type" of cowboy whom encroaching settlement would soon relegate "to the Wild West Show."

THE LEGENDS OF THE WEST ARE MANY AND HARD-DYING.
The cowhand that is rode hard and hung up wet. The gunslinging hero who saves the town and rides off into the sunset. A painted raiding party under a Comanche moon. These and other legendary figures have paraded across the framed landscape, creating enduring myths of the American West. And beyond the human legends lie the most legendary of all Western icons—the eagle, the grizzly, the buffalo, and the land itself, grassy and rumpled, torn and red-arched, severe and snow-peaked, and, above all, breathtakingly, gloriously vast. *National Geographic* has recorded Western scenes by the thousands, sometimes perpetuating the myths, sometimes dispelling them, but always reflecting the evolving American consciousness of what lies in the West.

When the National Geographic Society began photographing the West in the 1890s, a mere 90 years had elapsed since Lewis and Clark penetrated the unexplored lands of the continent. Yet in that time, a parade of trappers and explorers, miners and ranchers, settlers and soldiers had tramped westward, changing the region forever. By the 1900s, railroads belted the land,

LEGENDS

the great free-roaming herds of buffalo were gone, and the Indians had been corralled onto reservations. Still, the West that *National Geographic* came to shoot remained wild in many places; moreover, it was relatively unknown to readers back East. Armchair travelers and late-coming adventurers were eager to know what was out there.

In early stories about the Hopi and Escalante and the Santa Fe Trail, *National Geographic* sought to preserve what was left of an original, authentic West while also documenting an evolving landscape and mentality. The West of outlaw legends like Billy the Kid and Butch Cassidy had long since given way to peaceful towns and ranches, where cowboys were no longer dry-gulched, nor sheriffs bushwhacked. Though increasingly popular, *National Geographic* was never interested in purveying the stuff of contemporary dime novels and stock Western films—legend-slingers which in many cases imprinted a perception of the West that never was.

On the other hand, there *were* (and are) real live cowboys and Indians. And the magazine was there photographing them in their real-life circumstances—roping cattle, or participating in ritual dances, or simply parodying stock characters out of Hollywood. Consider the title of a 1956 article: "Back to the Historic Black Hills: The Old West Rubs Elbows with the New in a Frontier Vacationland Rich with Memories of Indians, Covered Wagons, and Gold Fever." Two years later, the magazine ran an article called "Better Days for the Navajos: The Largest U.S. Indian Tribe Shapes a New Life with Schools and Hospitals, Irrigated Farms, Steady Jobs, Oil, and Uranium." The Society recognized that the Vacationland was a fantasy, and the struggling Navajo were occupying the living West.

"A person puts on a cowboy hat anywhere in the world," observes Western author Timothy Egan, "even if alone in a room, and starts acting differently." The old myths are hard to shake because they have the power of simplicity, and we share them in our collective consciousness.

Writer William Kittredge remarks on "the difficulty of working when expected to write from inside myth." Yet, gradually, the Western mythology has shifted. By the 1990s, gritty, myth-busting films like *Unforgiven* and *Dances with Wolves* were offering new archetypes to replace those of *Shane* and *High Noon*. Likewise, new Western images began running across the pages of *National Geographic:* artfully composed portraits of wildlife, pictures illustrating stories on water and land use issues, and Indians as more than symbols of history.

Where are the heroes and the legends for our time? Are they the cowboy poets, who have forsaken the myth of the six-shooter and taken up the pen in defense of the homeland? Are they the knightly tycoons who have swooped in, visions of the Old West cantering in their heads, and bought up mega-ranches, wild fiefdoms where nature can have its way in perpetuity? Are they the hobos, the politicians, the migrants, the young people with nothing but packs on their backs and visions only of sheer cliffs to scale and frothy rapids to run?

Though the first national park, Yellowstone, was set aside in 1872, it would be another century, with the growing environmental movement, before mass audiences were ready to consider the West a place that needed to be protected more than it needed to be won. Thanks to the evenhanded reputation *National Geographic* had carefully established over the decades, the magazine was well positioned to help lead the change in attitude. *National Geographic*'s thorough coverage of Western places, people, and issues has allowed readers to decide for themselves which legends are worth preserving.

"Above the treeline in the stony highlands it is possible to imagine the absolute clarity of crystalline light over the glacial cirques is a moral imperative," writes Kittredge. The best photos of the West deliver powerful, iconic scenes, provoking us toward both awe and duty. In this chapter, we tip our hat to the cowboy and the Indian, and we bow to the legends of nature.

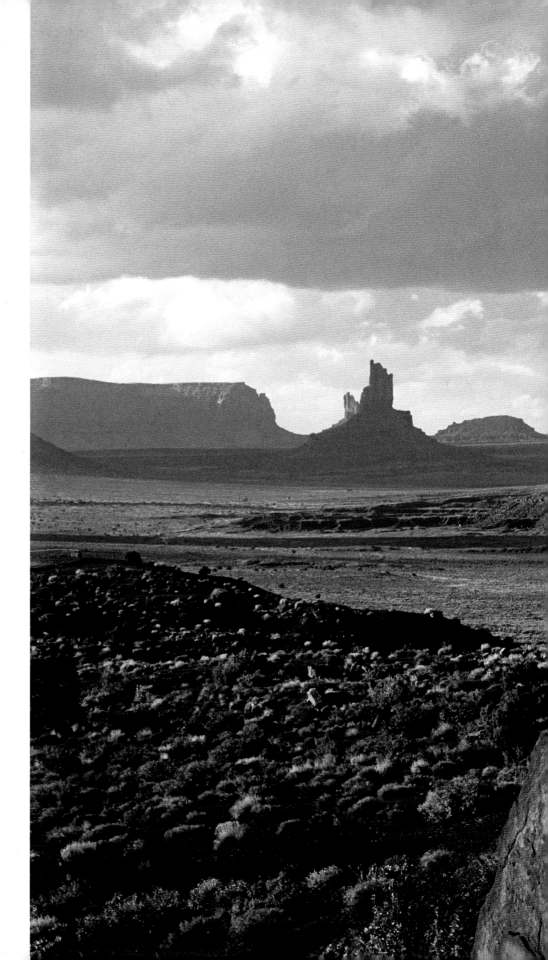

BRUCE DALE | Utah, 2001

Eons of sandstone erosion open a two-foot-high window onto such Monument Valley monoliths as Stagecoach, Bear, Rabbit, Castle Rock, Mitten, and Merrick.

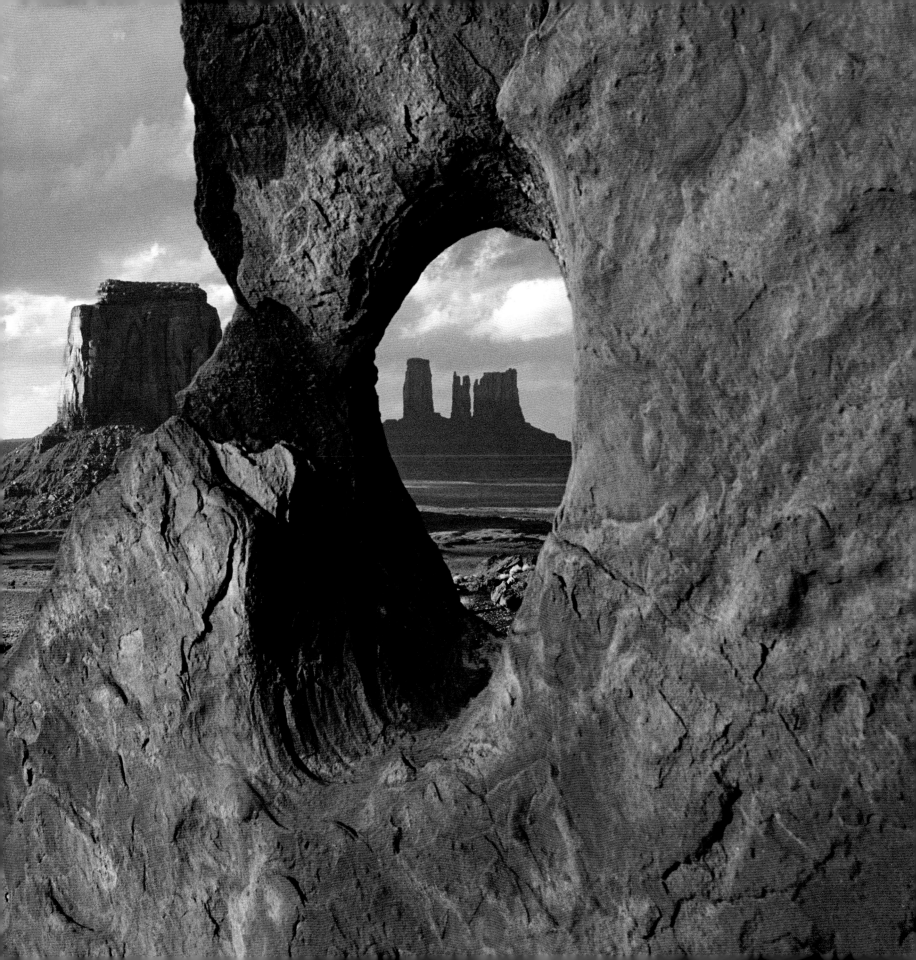

A hand-tinted infrared image illuminates an echt Sonoran landscape of organ pipe and saguaro cacti, blooming yellow brittlebush and other wildflowers.

"WILDERNESS IS NOT A LUXURY BUT A NECESSITY OF THE HUMAN SPIRIT, AND AS VITAL TO OUR LIVES AS WATER AND GOOD BREAD."

—EDWARD ABBEY, 1968

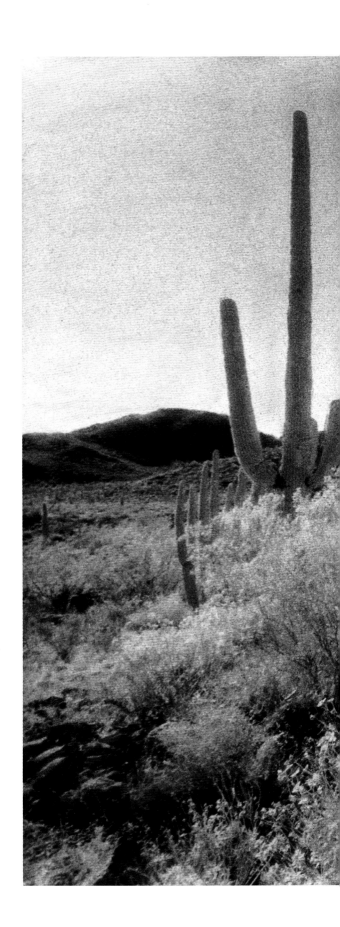

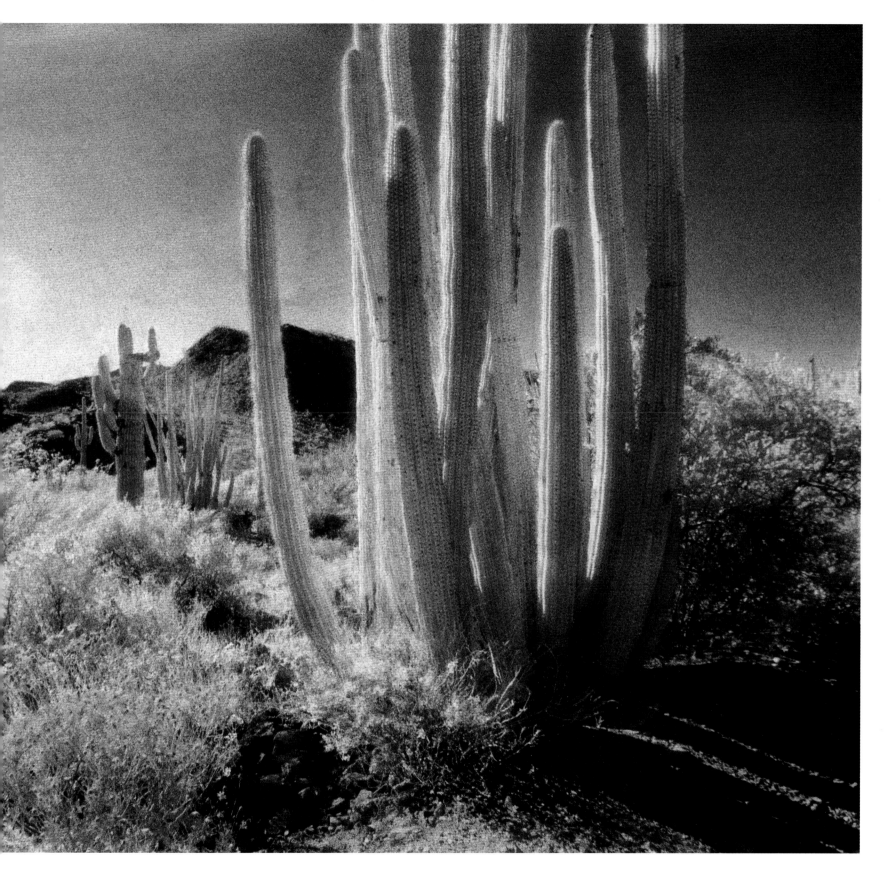

EDWARD S. CURTIS | Montana, 1910

Tearing Lodge, an elder of the Piegan Black-feet, poses in a buffalo skin cap made and worn at the command of a spirit in a vision.

FREDERICK I. MONSEN | New Mexico, 1921

An old war captain of the Laguna Pueblo proudly displays weapons from the tribal battles that predated the arrival of white settlers.

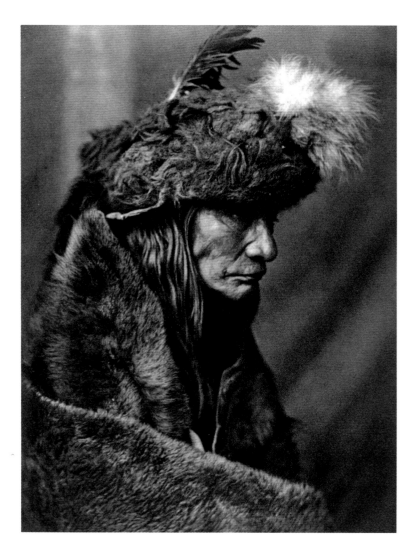

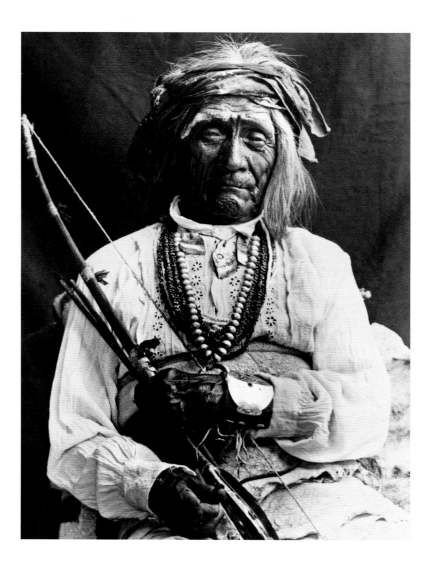

P. G. GATES | California, circa 1911

A Hopi snake priest dons the traditional vestments worn during the Arizona tribe's annual 16-day ceremonial prayer for rain.

EDWARD S. CURTIS | Idaho, 1905

Black Eagle, the nephew of legendary Nez Perce Chief Joseph, presents the twice-parted hairstyle identified with his tribe.

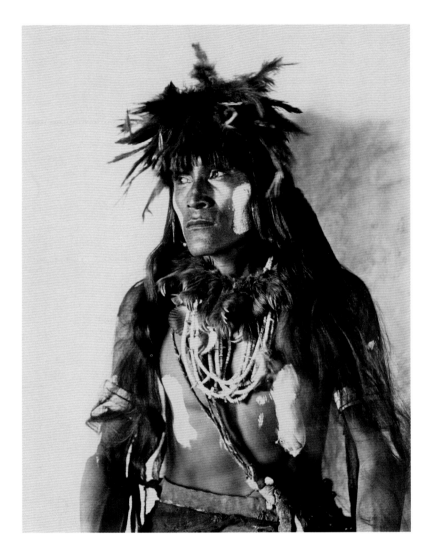

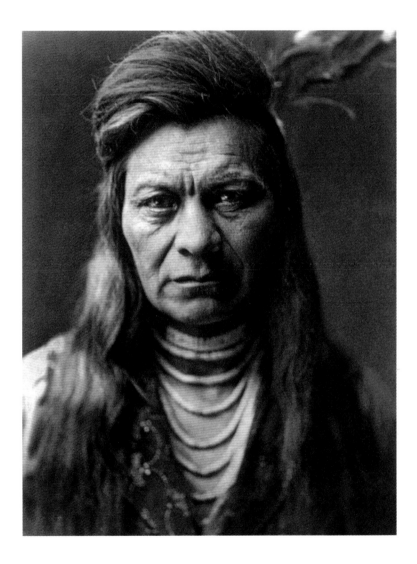

DAVID ALAN HARVEY | Oklahoma, 1994

A ceremonially clad boy dancing at Oklahoma City's annual multi-tribal Red Earth festival suggests the enduring drumbeat of North America's indigenous cultures.

following pages (42-43)
DAVID ALAN HARVEY | Utah, 1979

Carved by wind, water, and ice, and bathed in afternoon sun, the totemic hoodoos of Bryce Canyon National Park radiate nature's timeless rhythms.

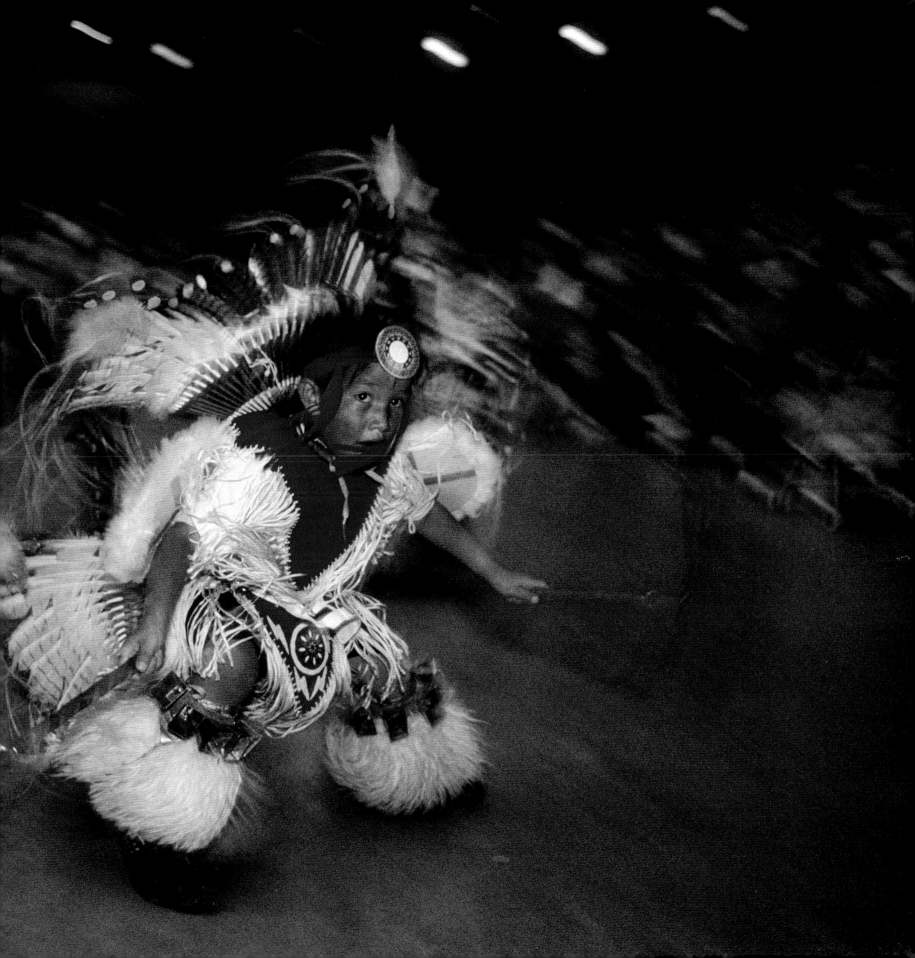

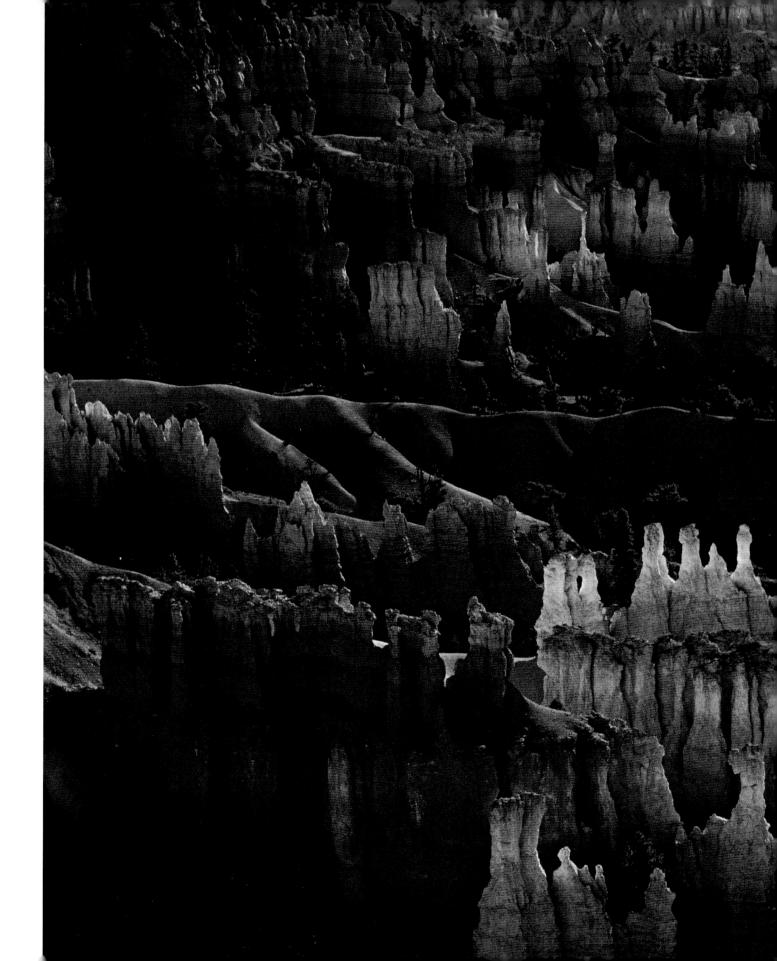

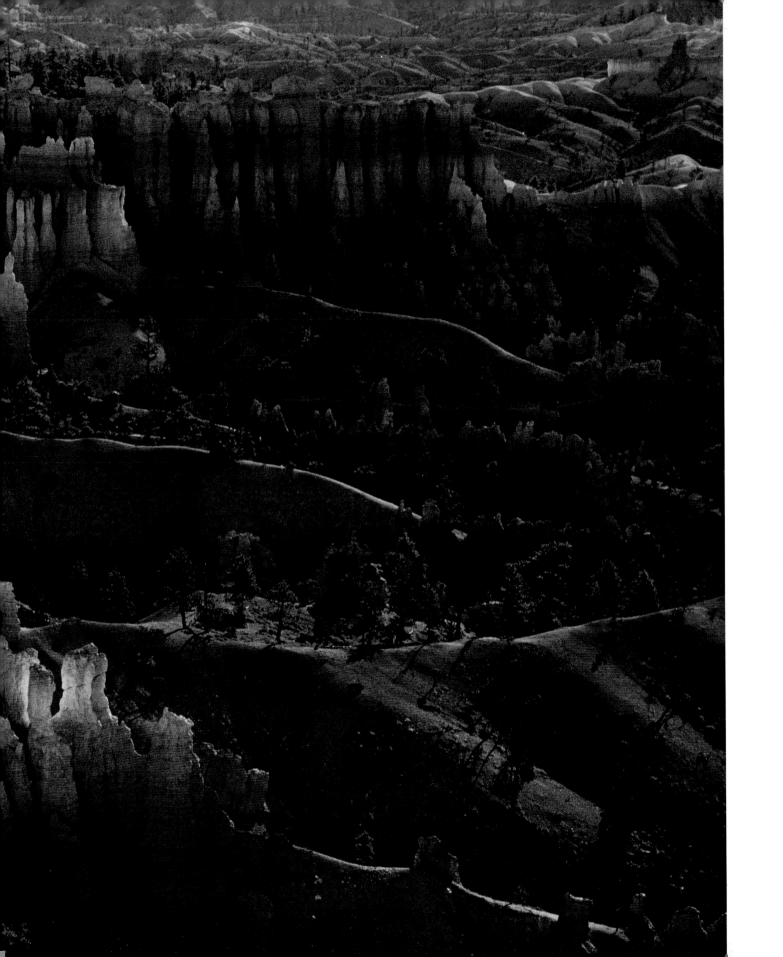

Dramatic Navajo cliff dwellings and petroglyphs speak to nearly 4,000 years of inhabitation in the Canyon de Chelly.

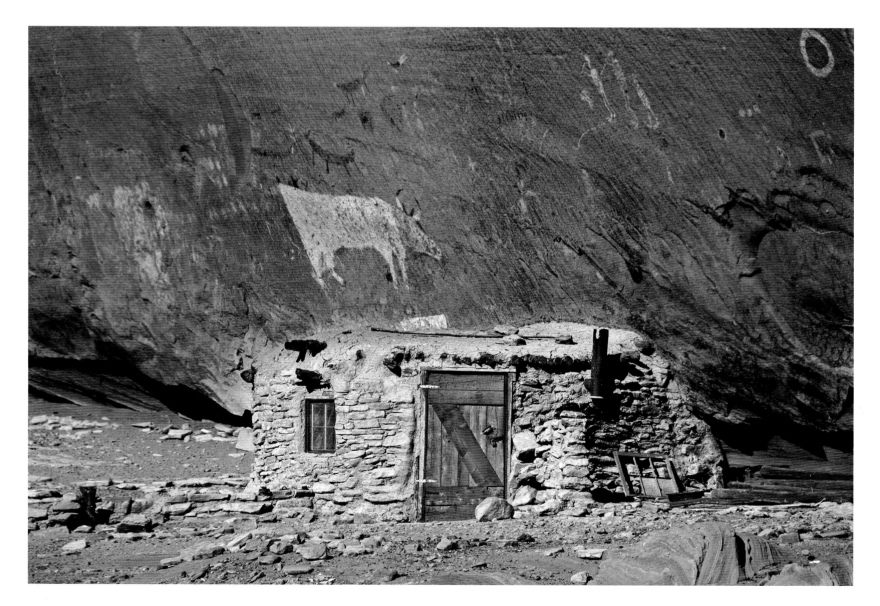

Pictographs and petroglyphs evincing ancient life constitute Horseshoe Canyon's Great Gallery in Canyonlands National Park.

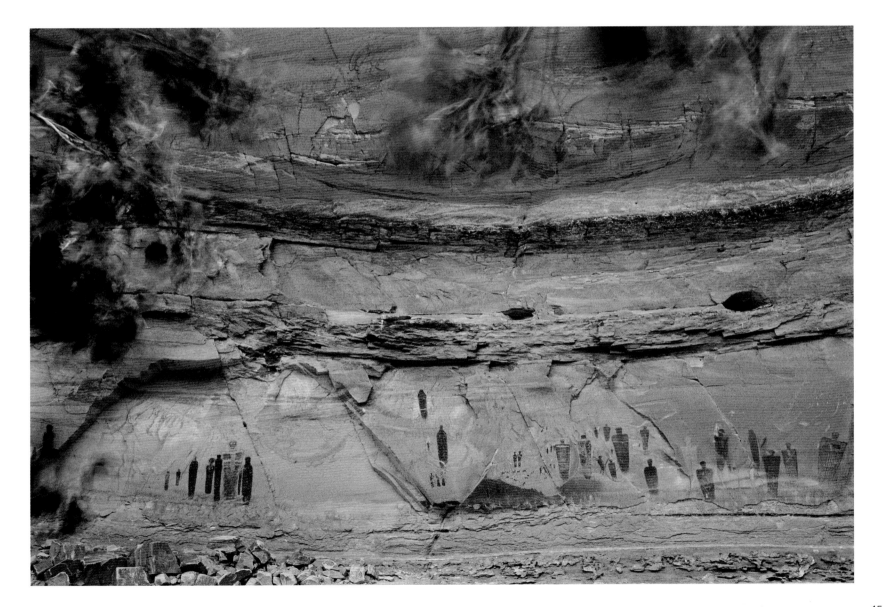

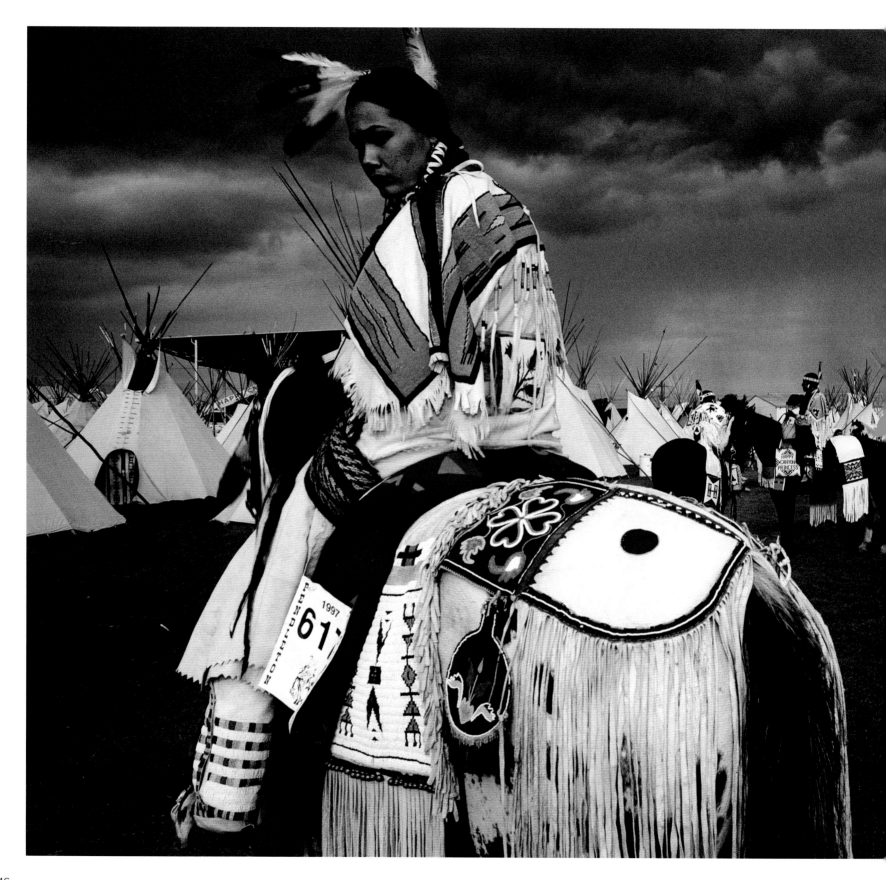

American Indian Beauty Pageant winner Acosia Red Elk waits for a parade at the teepee village, a part of the Pendleton Round-Up rodeo since its 1910 inception.

"IF WE'RE LUCKY, WE FIND A PLACE SPECIAL TO US. EVEN THOUGH IT MAY CHANGE, IF WE LOVE IT DEEPLY ENOUGH, PART OF IT IS WITHIN US TO THE END. THAT'S HOW I FEEL ABOUT THE WEST."

—WILLIAM ALBERT ALLARD, 2010

JAMES L. AMOS | Colorado, 1989

Iconic Chimney Rock, also known as Jackson Butte after pioneering photographer William Henry Jackson, stands alone as a horizontal lightning flash splits the threatening sky.

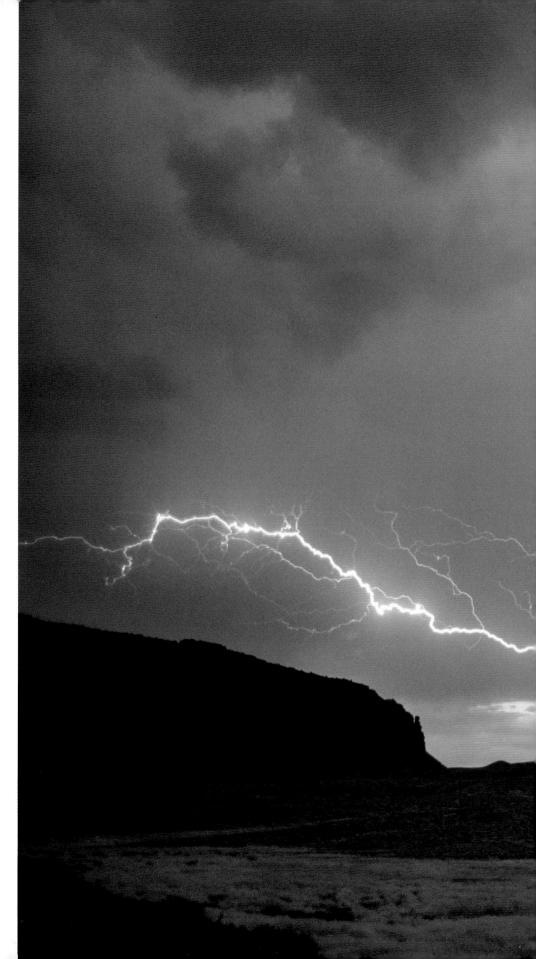

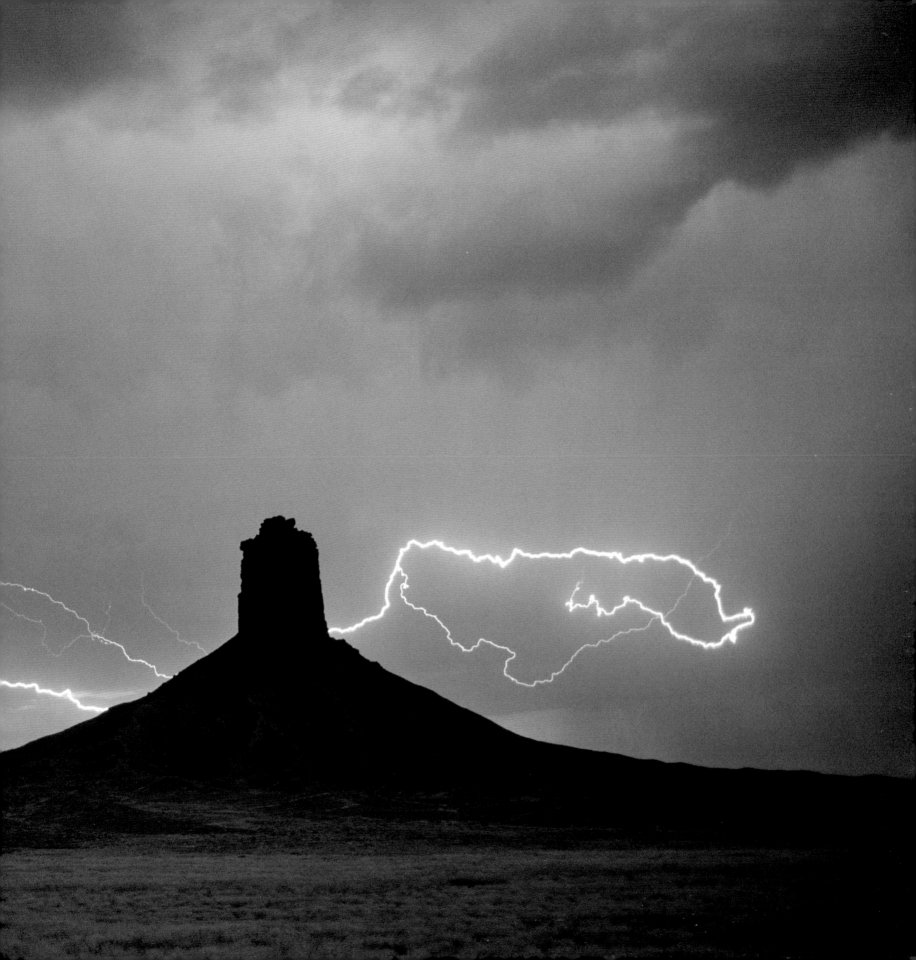

FRANS LANTING | Utah, 2007

With the Uinta Mountains in the distance, the vastness of the West manifests itself as heavy rains sweep across the Colorado Plateau in Arches National Park.

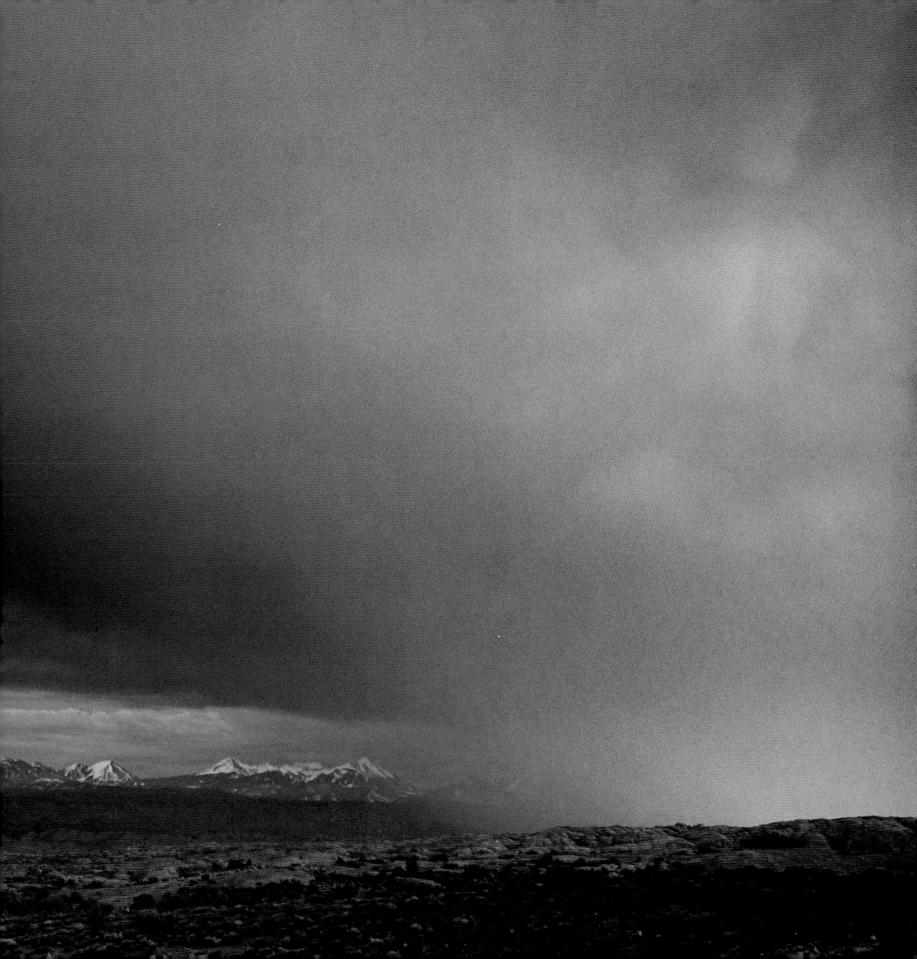

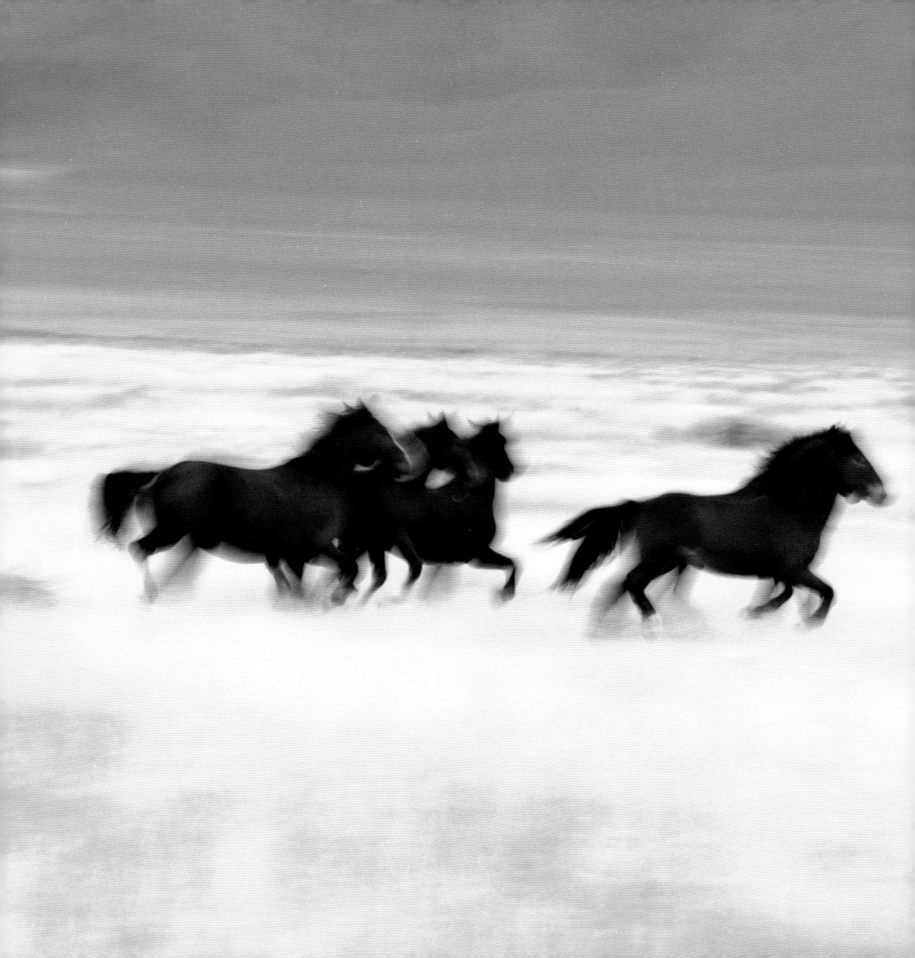

J. BRUCE BAUMANN | Nevada, 1974

Wild mustangs, largely descended from horses ridden by Spanish conquistadors, thunder across the endless plains near Reno.

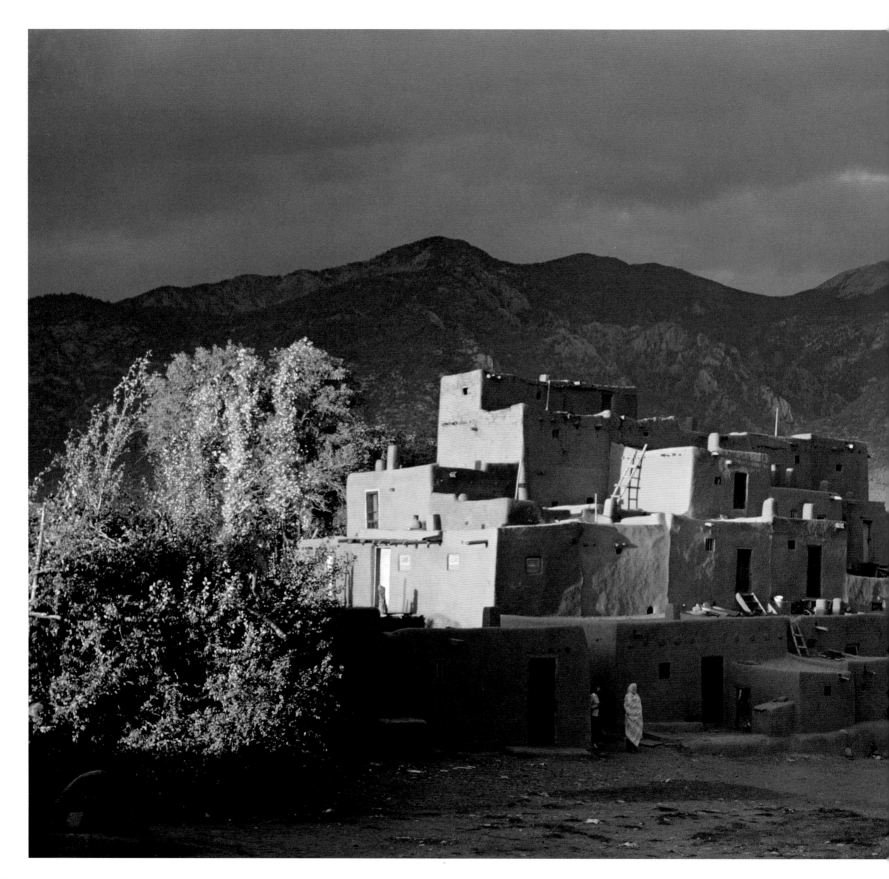

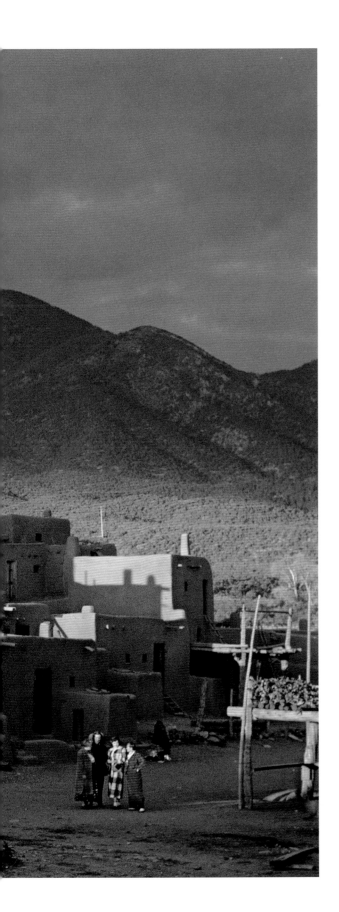

JUSTIN LOCKE | New Mexico, 1949
Sunset's gleam limns one of the many adobe buildings in the Taos Pueblo in bright light and shadows.

"WE HAVE INHERITED AND KEPT PURE FROM MANY AGES AGO A RELIGION WHICH, WE ARE TOLD, IS FULL OF BEAUTY EVEN TO WHITE PERSONS. TO OURSELVES AT LEAST, OUR RELIGION IS MORE PRECIOUS THAN EVEN OUR LIVES."

—COUNCIL OF ALL THE NEW MEXICO PUEBLOS, 1924

EDWARD S. CURTIS | New Mexico, 1903

Shown here carrying water from the river, Zuni daughters, the photographer recounted, "are the preferred heirs of family land. Houses are the absolute property of women."

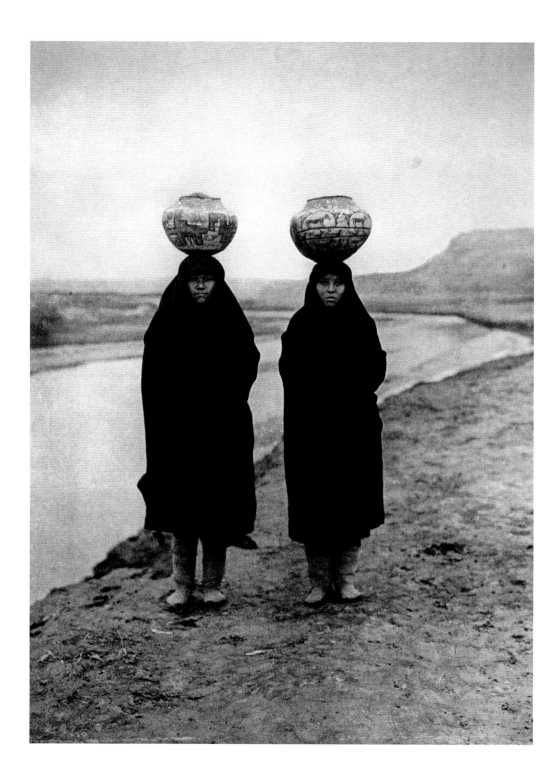

ROLAND W. REED | Location, date unknown

Like this Native American woman, Reed's work was solitary. In 1914, a Montana paper described his photography as "...sympathetic and understanding of the dying race."

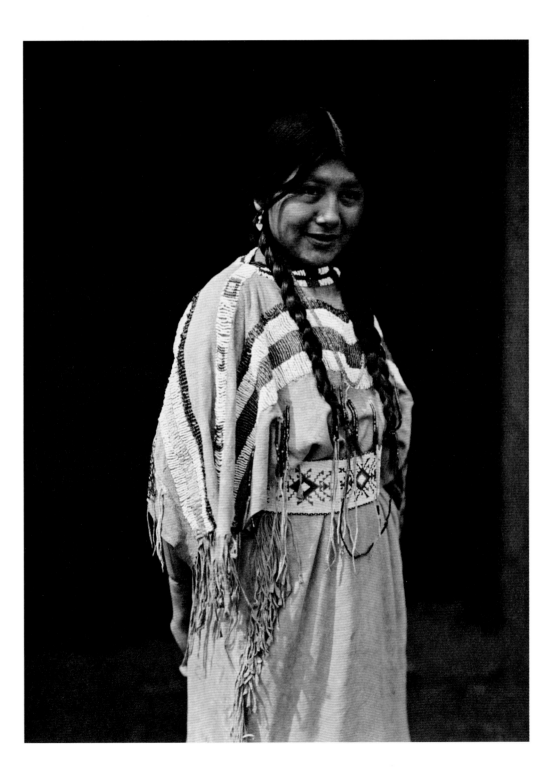

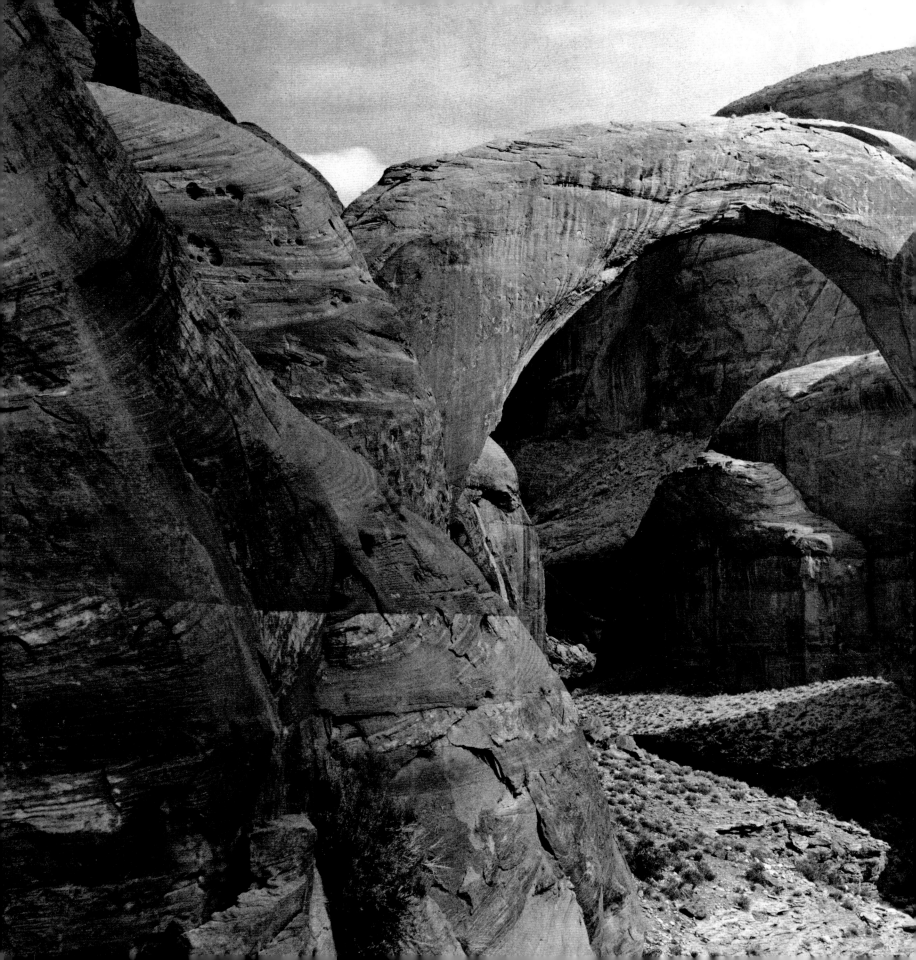

EDWIN L. WISHERD | Arizona, 1925

An early color photograph of Rainbow Bridge National Monument captures the geological glory of the 290-foot-high, 275-foot-wide natural arch.

following pages (60-61)
WILLIAM ALBERT ALLARD | Wyoming, 1971

Storm clouds gather as twilight falls across the craggy peaks and sagebrush foothills of the Gros Ventre Mountains.

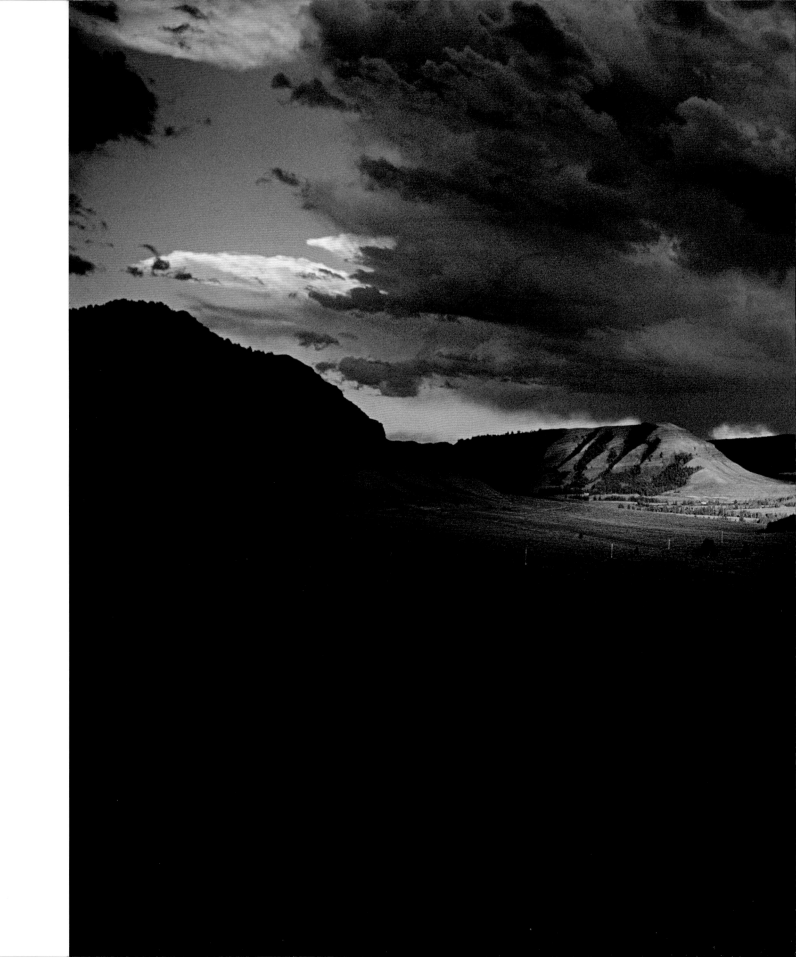

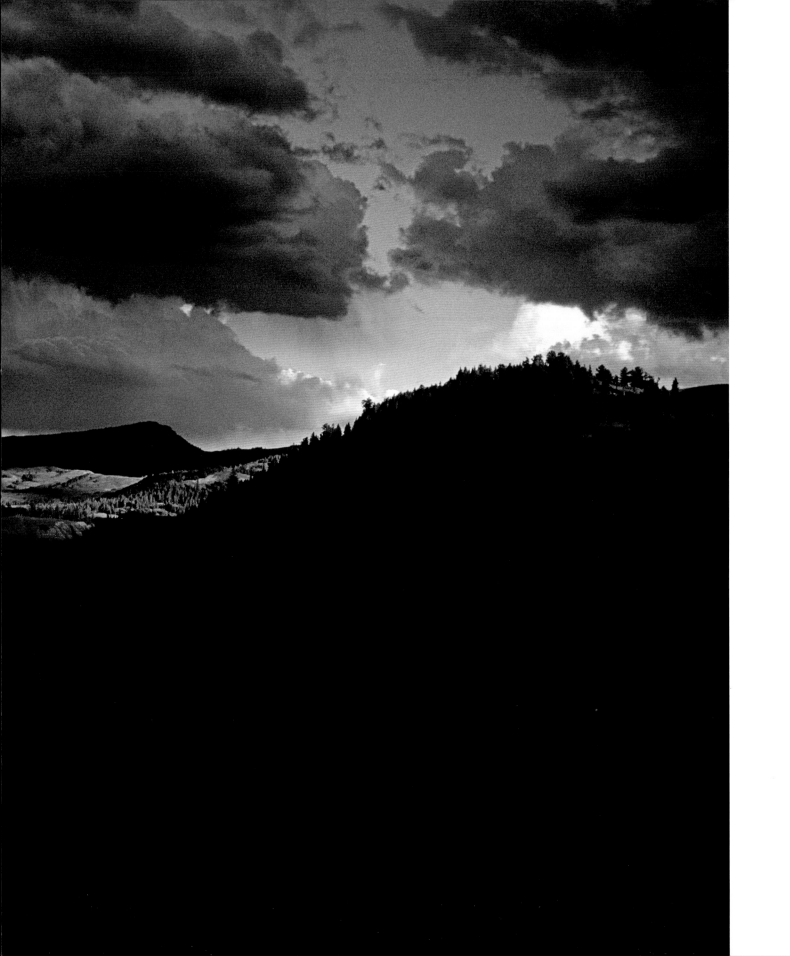

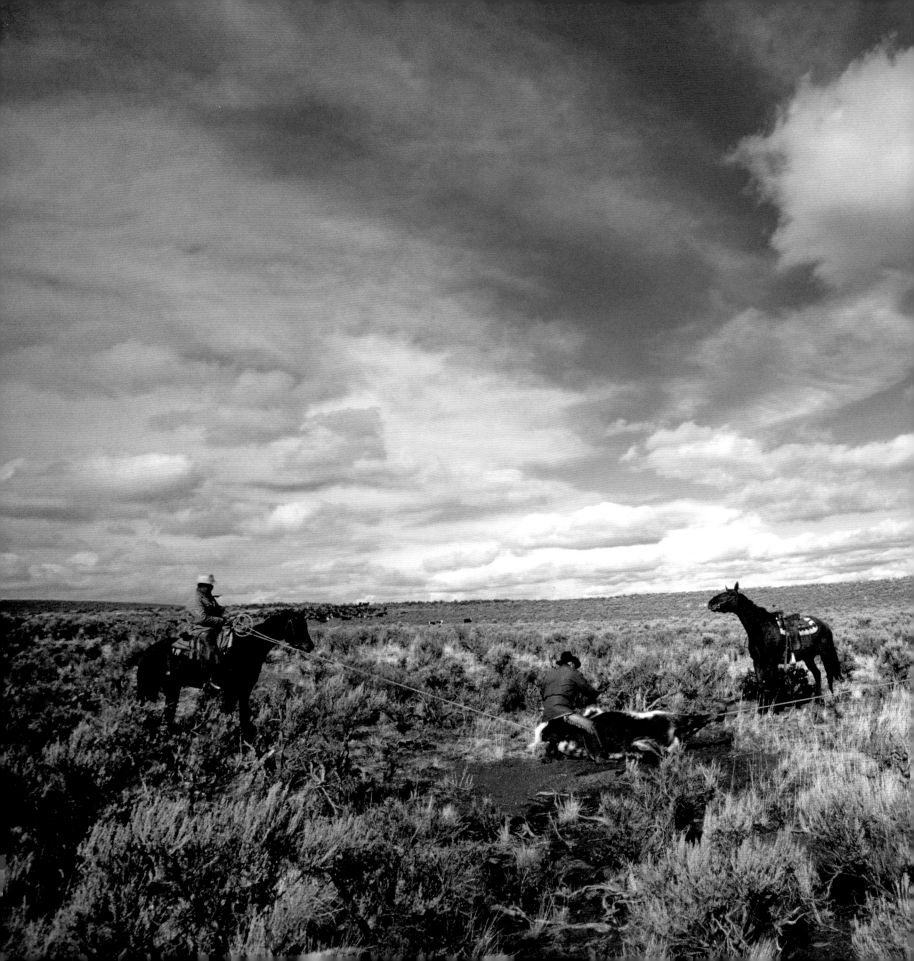

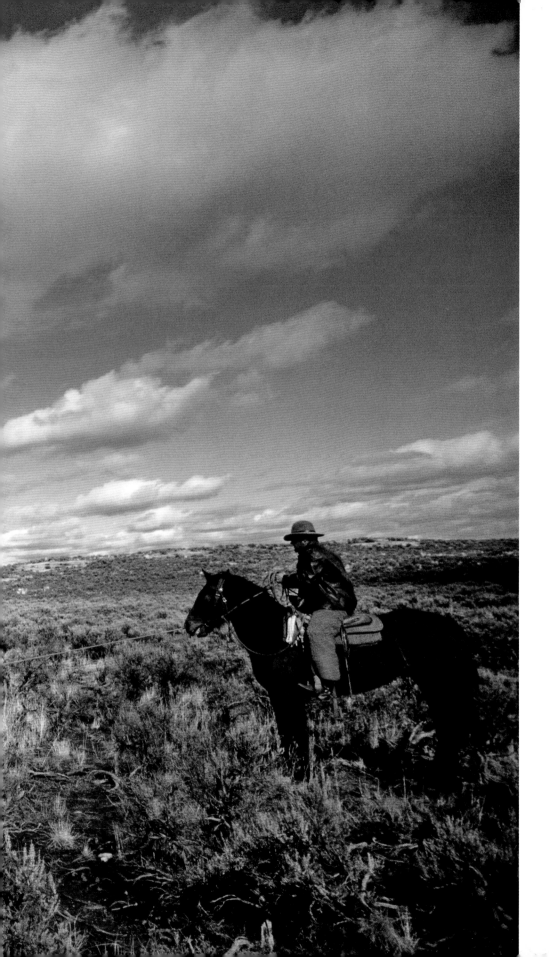

WILLIAM ALBERT ALLARD | Nevada, 1982

Branding cattle on the open ranch requires a team of two ropers to still the animal and a third to straddle it and apply the hot iron.

S.M.S. RANCH | Texas, 1936

In a scene repeated hundreds of times
a day during the spring works, a four-cowboy
crew head, brand, dehorn, and inoculate
a yearling calf.

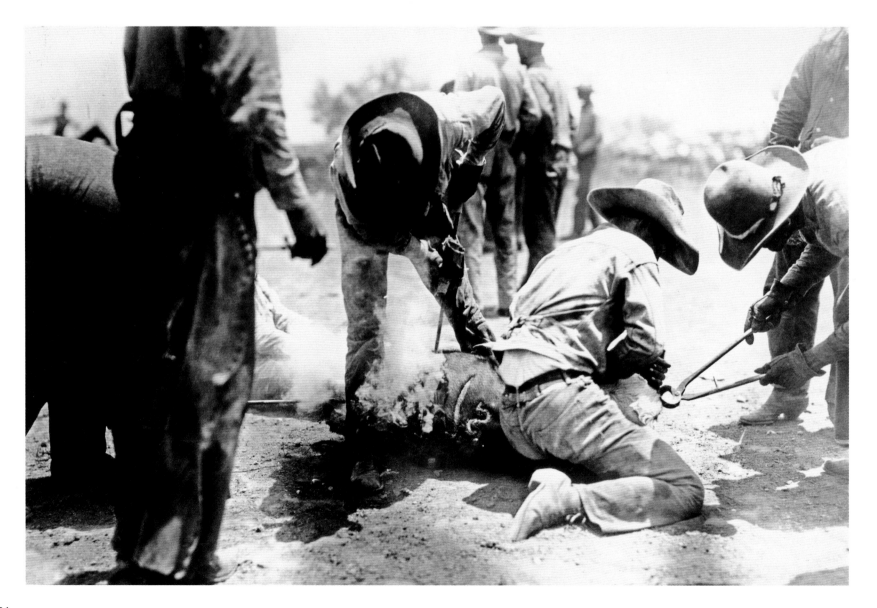

SAM ABELL | Montana, 1983

Some professions evolve, but little has
changed in the gritty life of the cowboy. The
method of turning a bull into a steer remains
a gory, hands-on occupation.

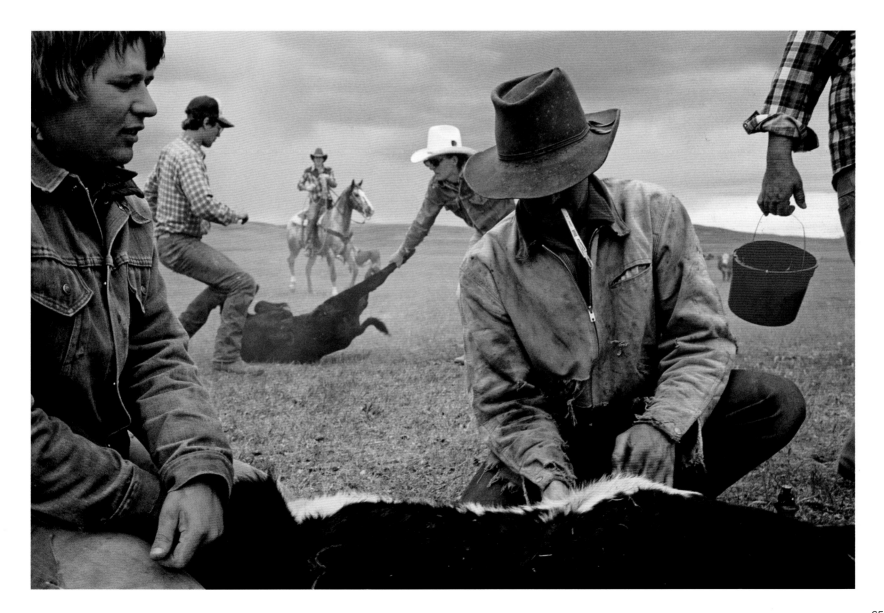

THOMAS CROFT & P. A. MILLER | Cherokee Outlet,1893

On September 16, more than 100,000 settlers, including the photographer's boss, William S. Prettyman, participated in the largest-ever government-sponsored land run—6,361,000 acres.

"WHOLE INDIAN NATIONS HAVE MELTED AWAY LIKE SNOWBALLS IN THE SUN BEFORE THE WHITE MAN'S ADVANCE. THEY LEAVE SCARCELY A NAME OF OUR PEOPLE EXCEPT THOSE WRONGLY RECORDED BY THEIR DESTROYERS."

—CHIEF DRAGGING CANOE, CHEROKEE, 1775

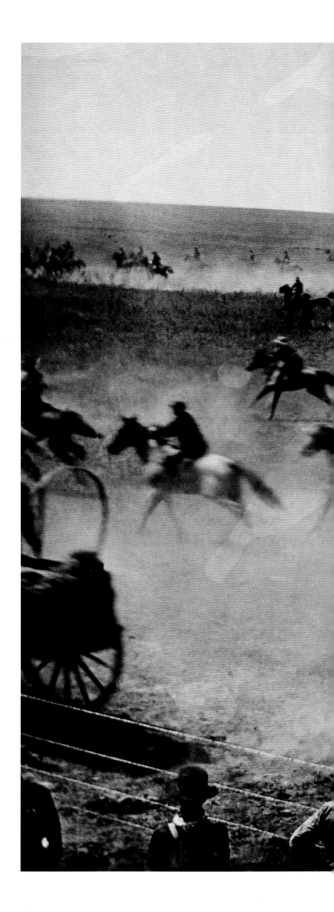

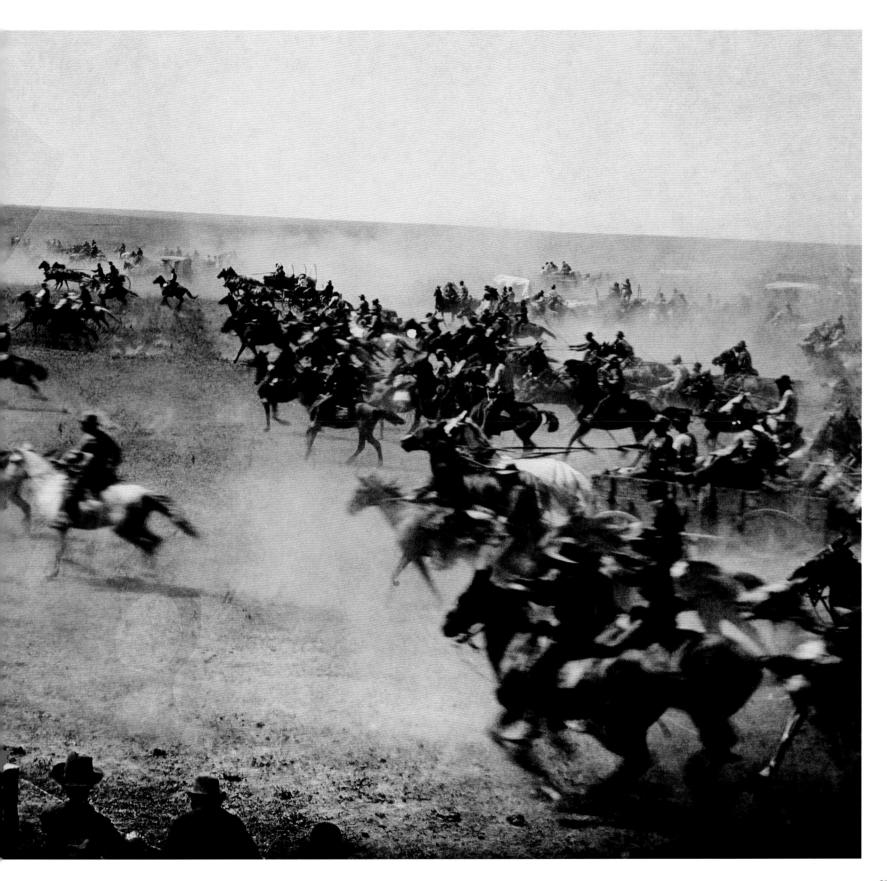

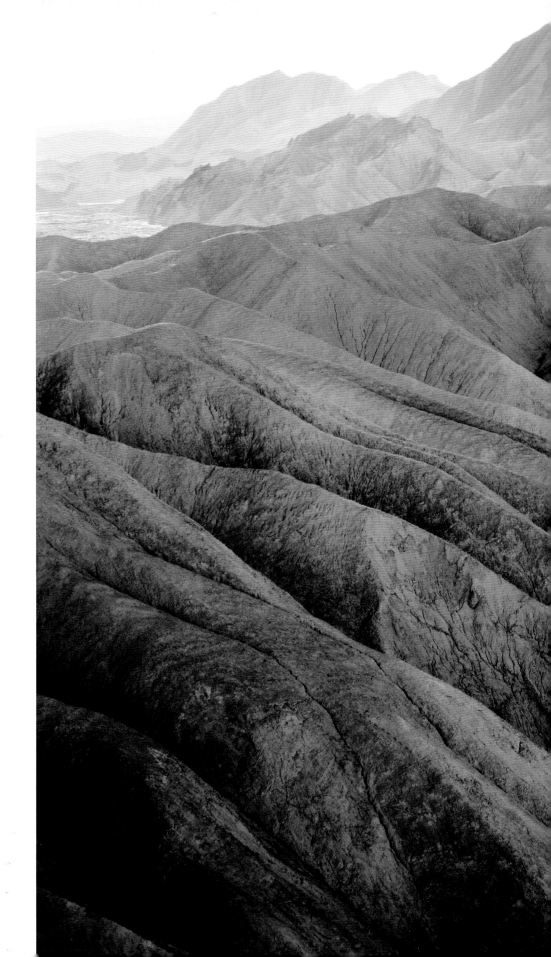

MICHAEL MELFORD | California, 2006

Rushes of water, not settlers, have defined dramatic badlands such as those found at Death Valley's Zabriskie Point.

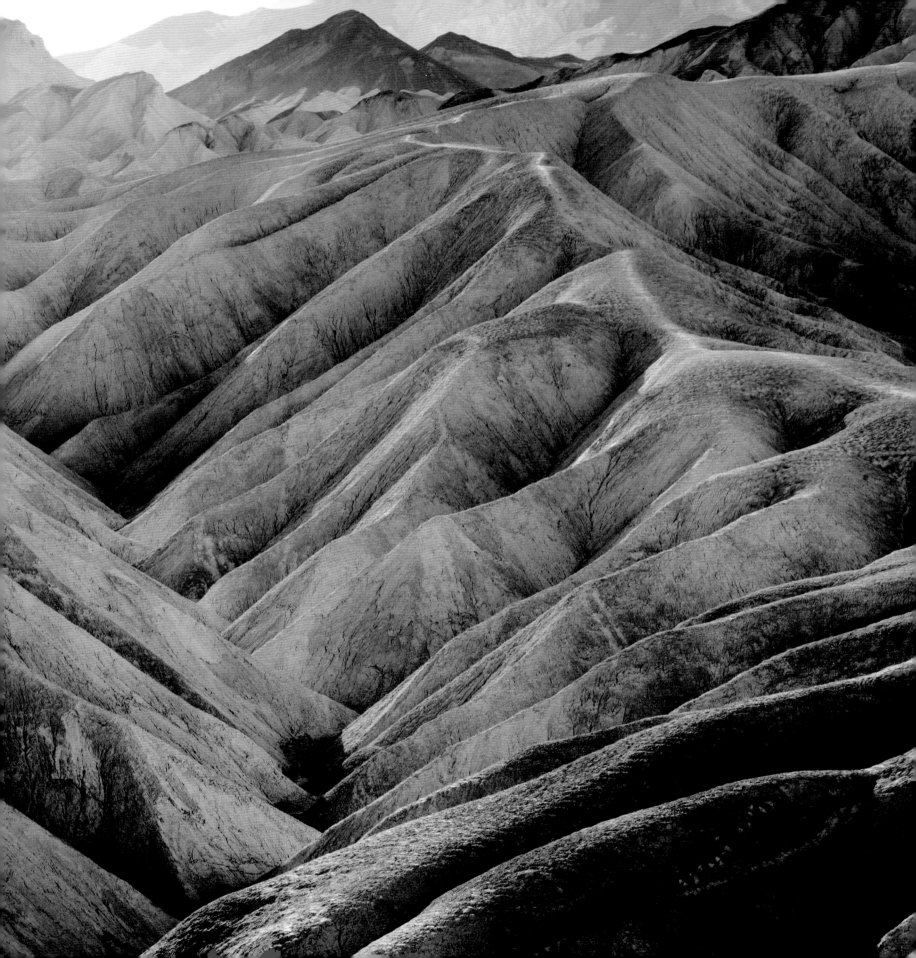

LUIS MARDEN | Texas, 1939

Dressed in her best rodeo outfit, a cowgirl
hitches her pony by dropping a nickel into
an El Paso parking meter.

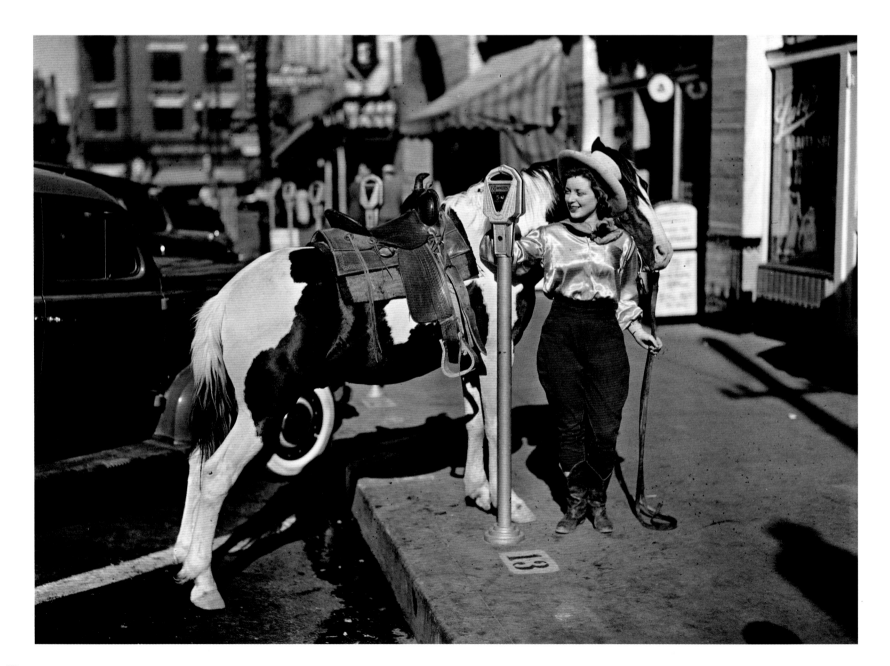

WALTER S. BOWMAN | Oregon, 1915

Rodeo Hall of Famer Bonnie McCarroll's fall
in her debut at the Pendleton Round-Up
presaged her fatal accident there in 1929.

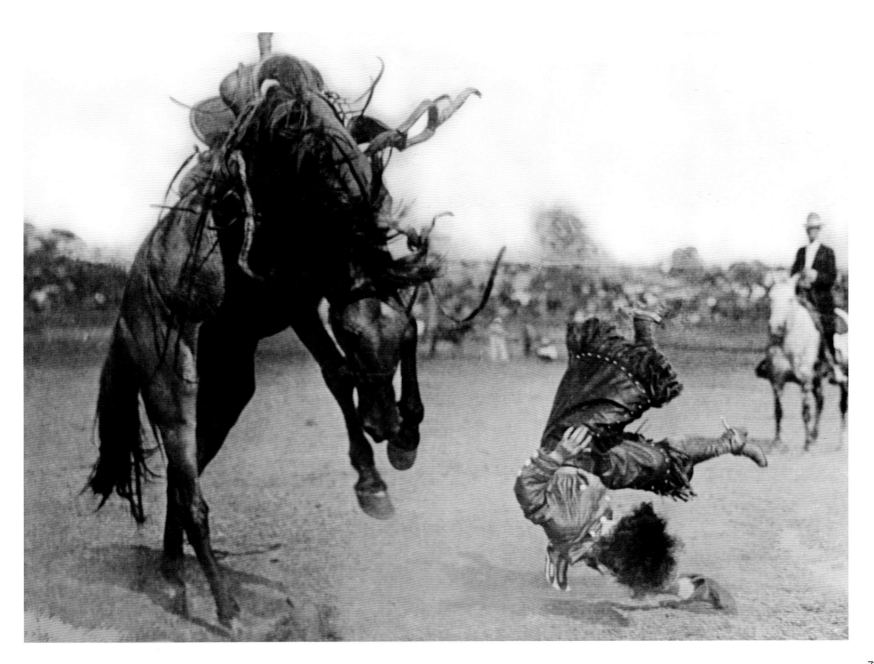

WILLIAM ALBERT ALLARD | Nevada, 1979

Every morning on the 1.3-million-acre
IL Ranch near Elko, buckaroo wranglers
rope horses for the day's cavvy.

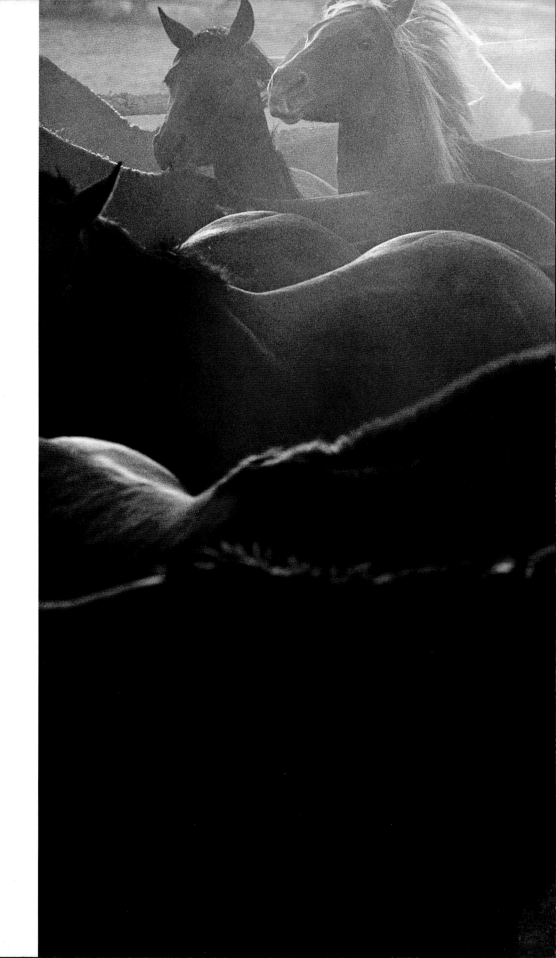

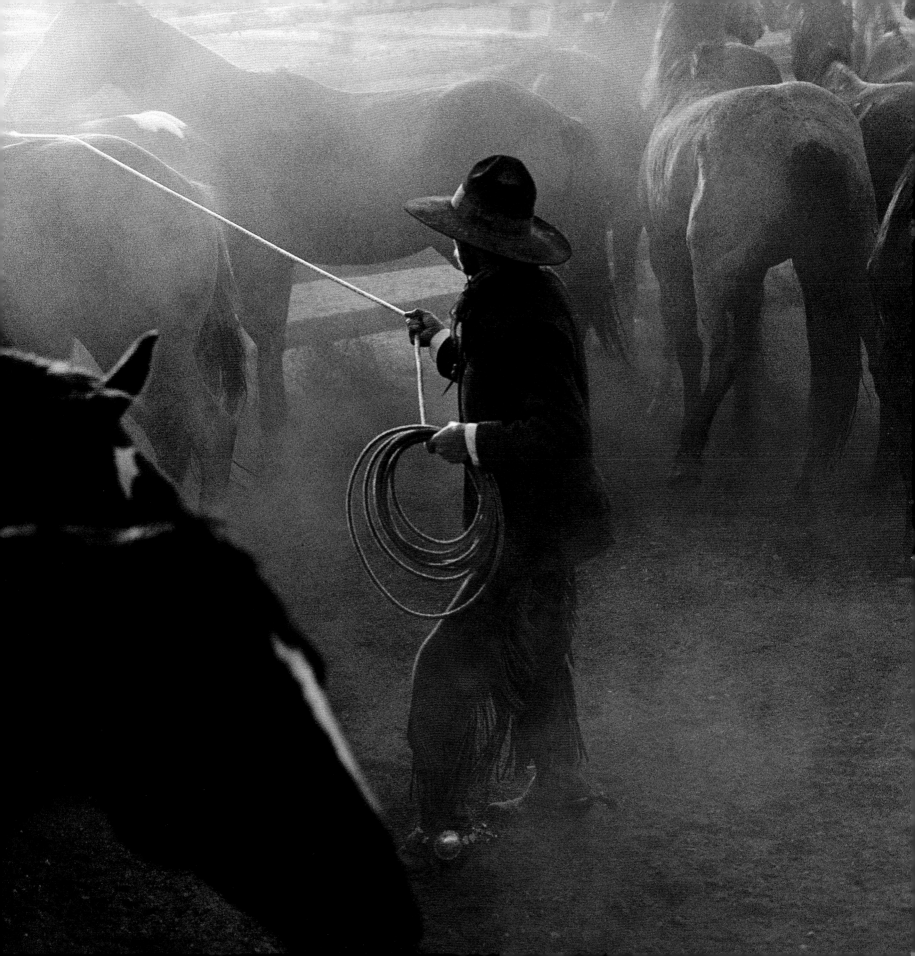

ROBB KENDRICK | Texas, 2007

Using the tintype process from the 1800s, the photographer immortalized cowboys like R. D. Horn beneath the upturned brim of a straw Palma "taco hat."

ROBB KENDRICK | Arizona, 2007

The distinct look of a slightly rolled hat brim and moustache-knotted scarf of Wyoming cowboy Tyrel Tucker found their ways to a Flagstaff horse ranch.

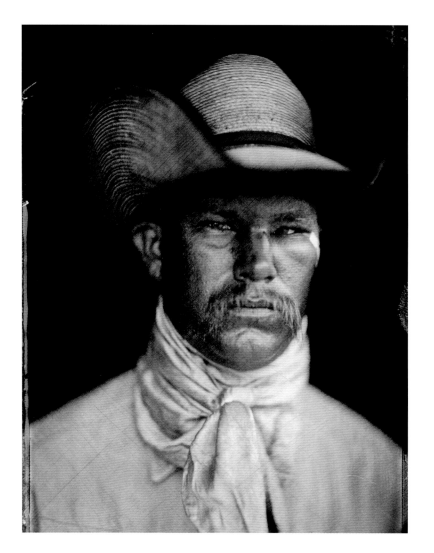

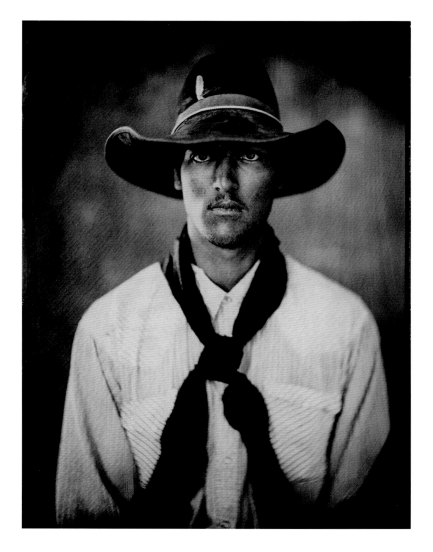

ROBB KENDRICK | Montana, 2007

Cowboy Wes Miner's flat-brimmed hat and patterned silk "wild rag" typifies the buckaroo style prevalent throughout the Great Basin and California.

ROBB KENDRICK | Oregon, 2007

Dandified buckaroo gear, as worn by cowboy Nathan Fuller, includes a flat-brimmed hat, oversized wild rag with a concho slide, and silver concho suspenders.

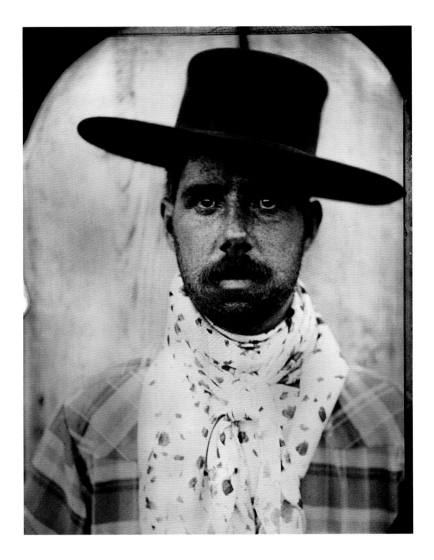

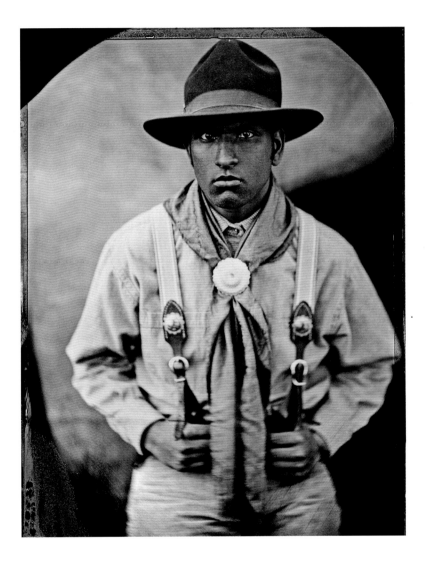

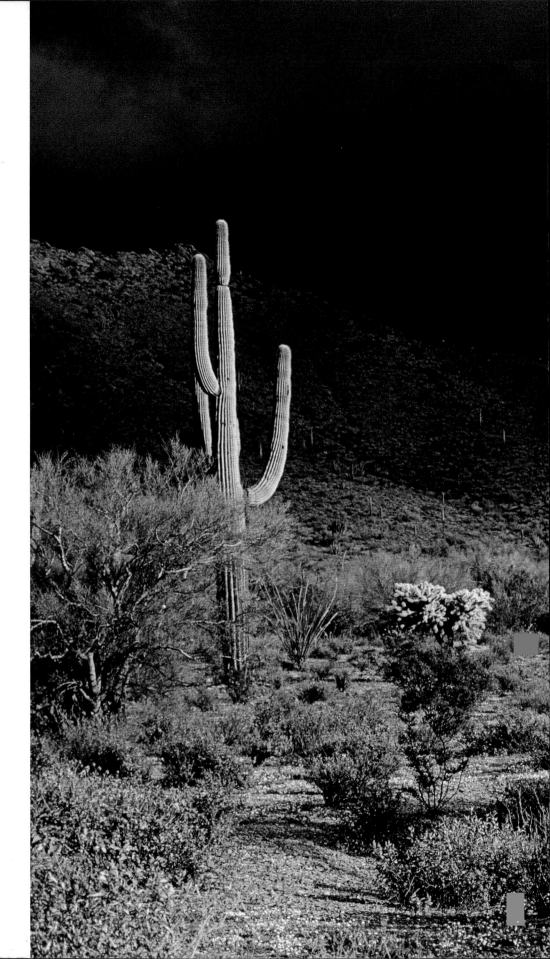

WALTER MEAYERS EDWARDS | Arizona, 1973

Storms come and go quickly across the wide western expanses near Organ Pipe National Monument and the Ajo Mountains.

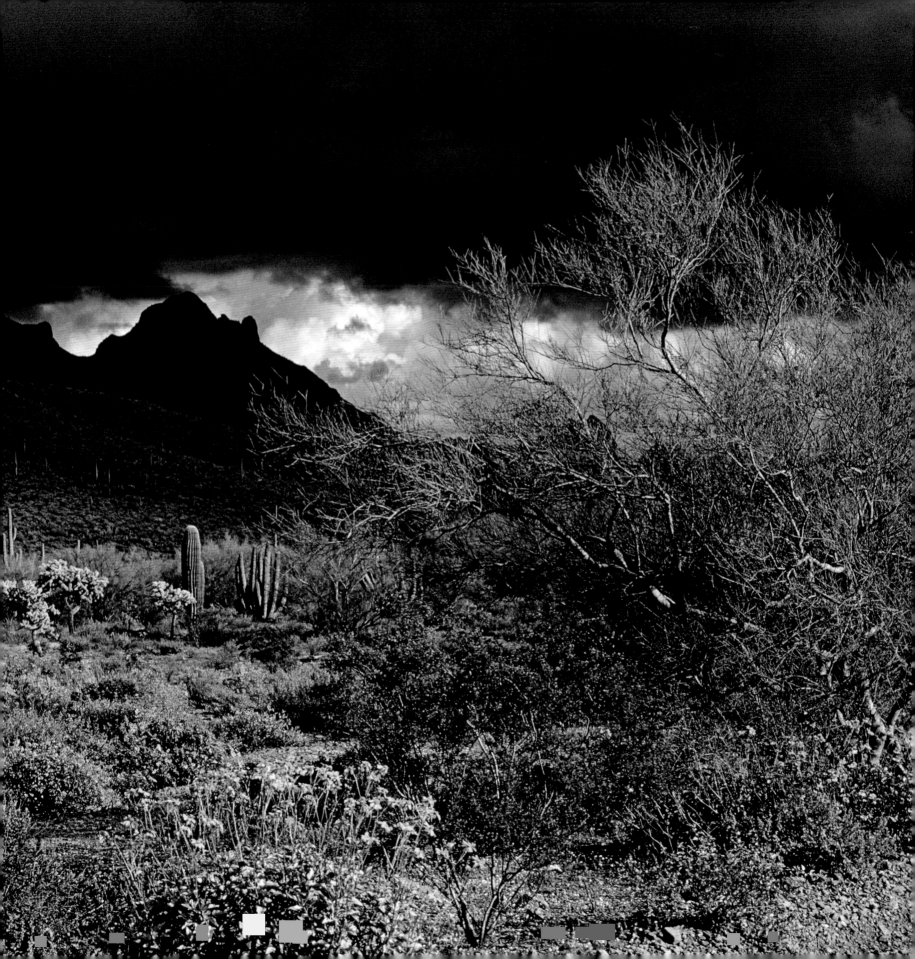

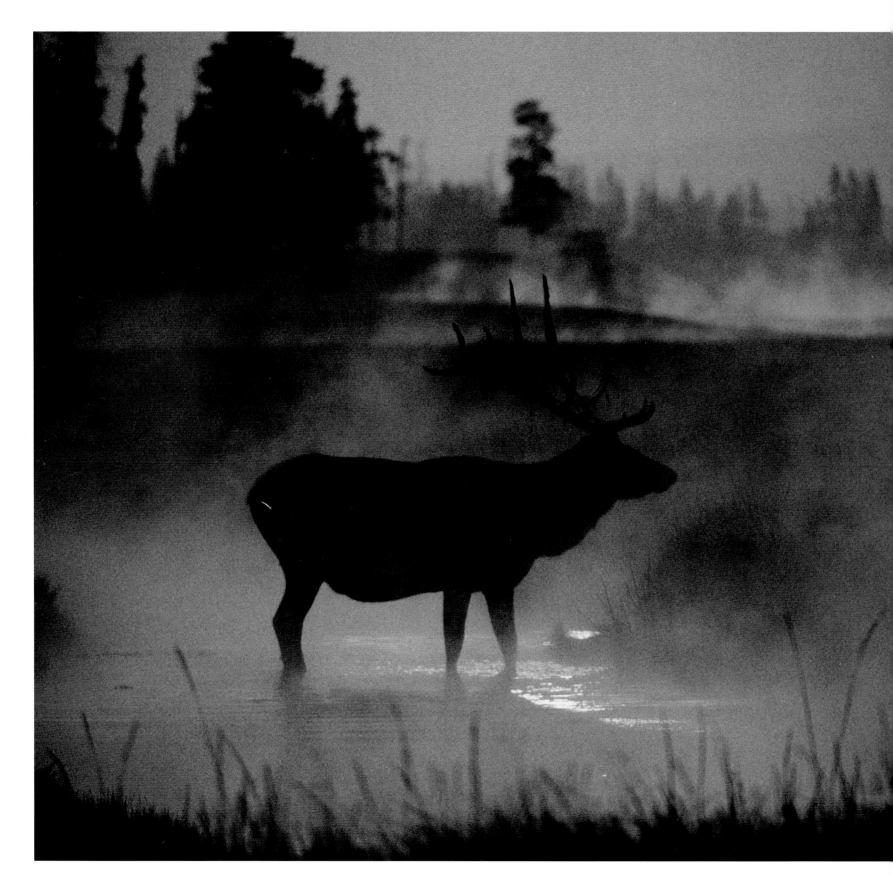

"NATURE IS ALWAYS LOVELY, INVINCIBLE, GLAD, WHATEVER IS DONE AND SUFFERED BY HER CREATURES. ALL SCARS SHE HEALS, WHETHER IN ROCKS OR WATER OR SKY OR HEARTS."

—JOHN MUIR, 1875

This tintype of a present-day Mennonite family suggests the hardscrabble nature of the ranching life has not changed in generations.

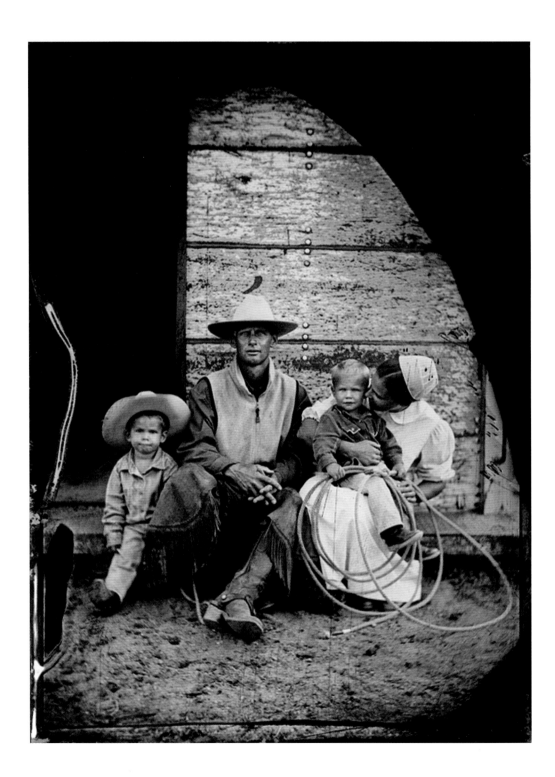

T. S. HITCHCOCK | Arizona, 1879

During the same year of this hand-colored, captioned "family portrait," the U.S. Supreme Court upheld a ruling against polygamy.

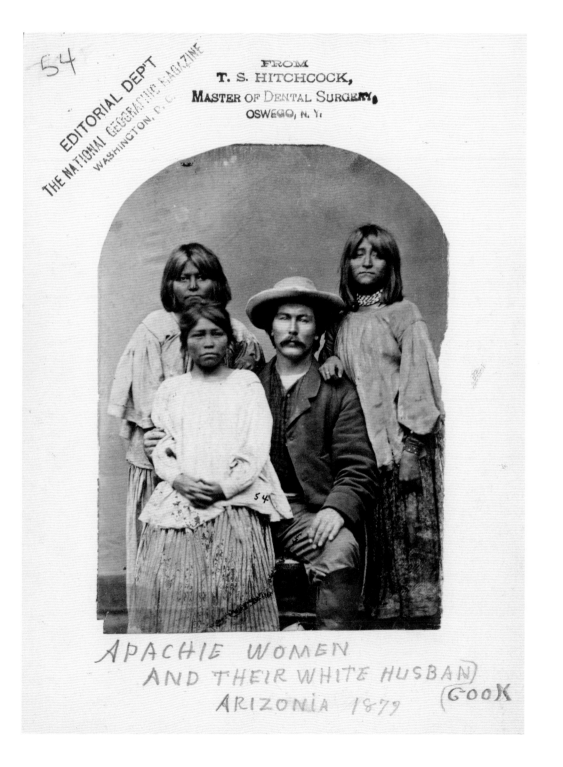

EDWIN L. WISHERD | Montana, 1927

Iconic images of the West—cowboys and Indians, horses and biplanes—all appear to coexist peacefully in this Autochrome from the Crow Reservation. In reality, it was a time of harsh adjustment for Native Americans, years before the 1934 Indian Reorganization Act gave them some fundamental rights.

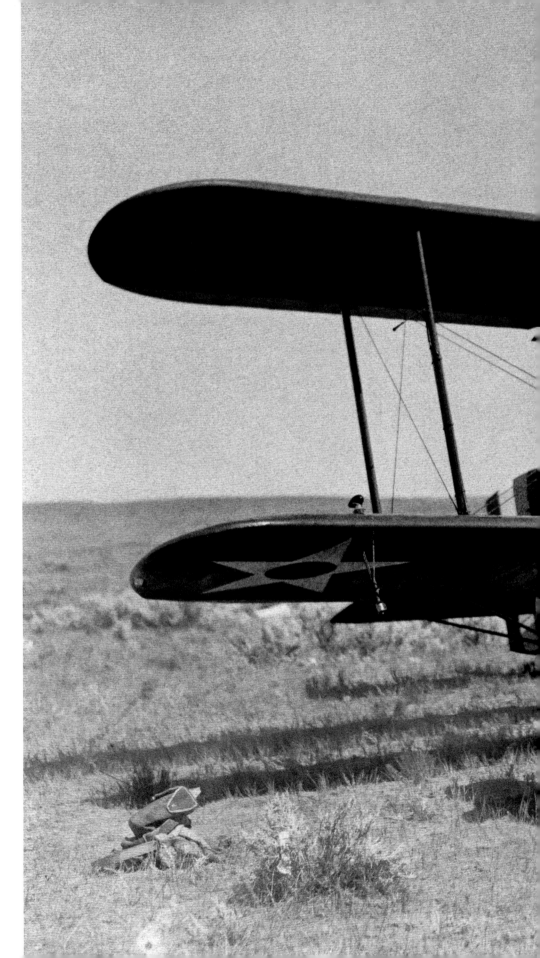

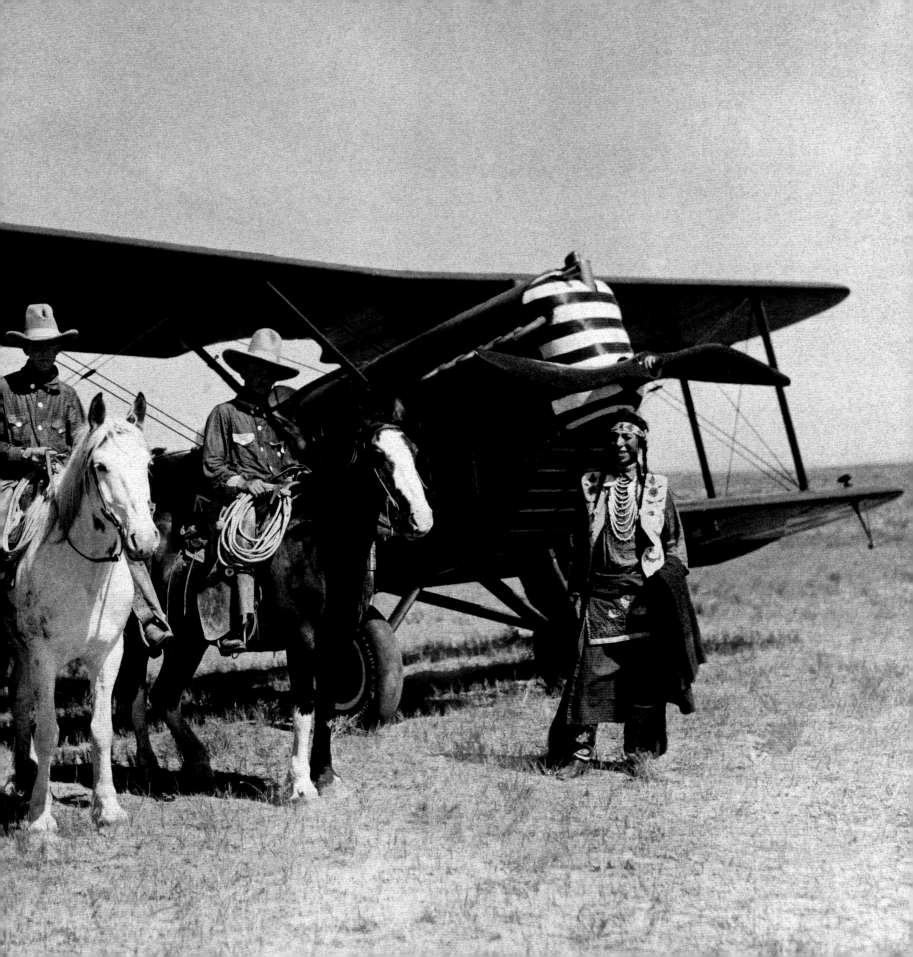

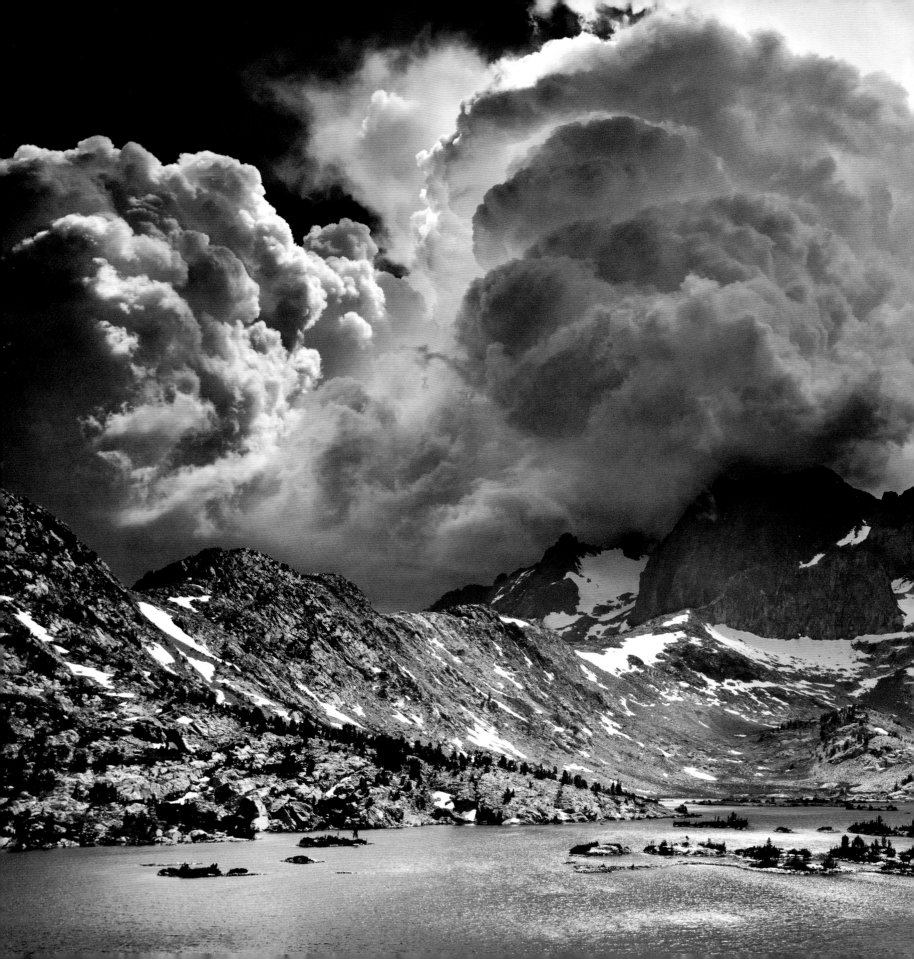

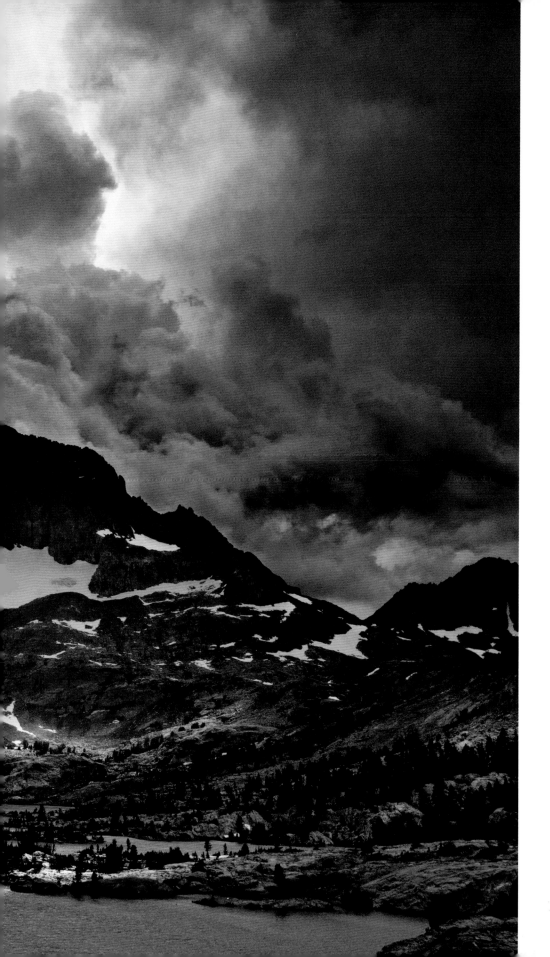

PETER ESSICK | California, 2010

Late summer thunderheads build above Garnet Lake in a seeming tribute to the photographer from whom the Ansel Adams Wilderness area takes its name.

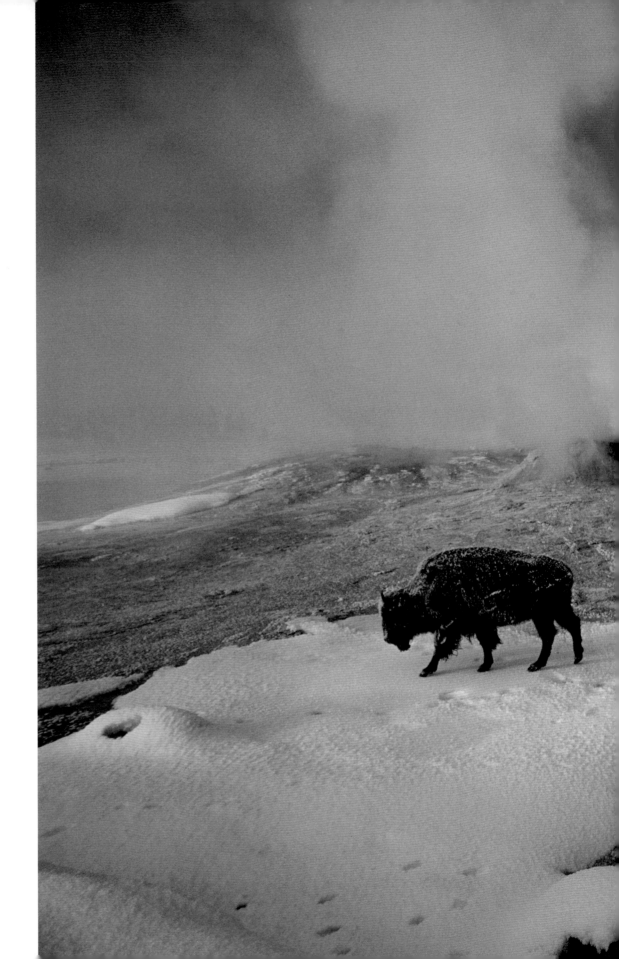

NORBERT ROSING | Wyoming, 1999

An enduring symbol of the American West, the mighty bison roams freely through another national icon—Yellowstone National Park's Lion Geyser.

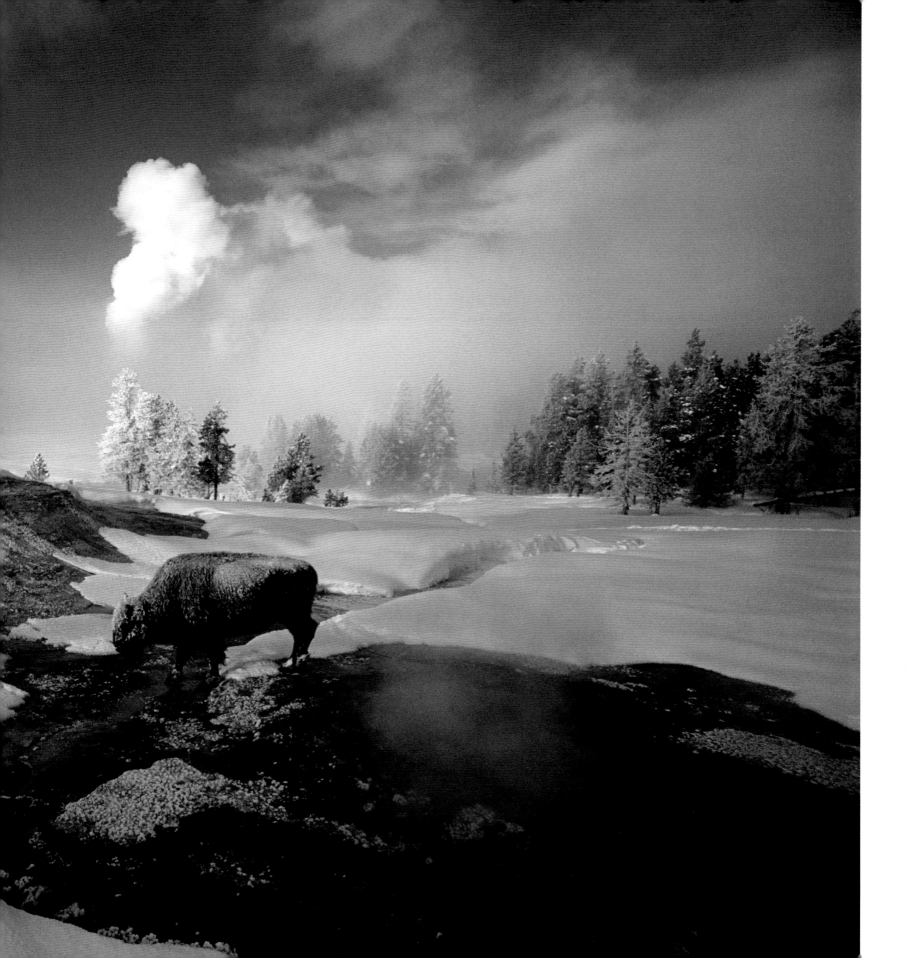

HARRIET CHALMERS ADAMS | California, 1915

Shots like this one of Vernal Falls and the Merced River have consecrated Yosemite National Park as an earthly Eden.

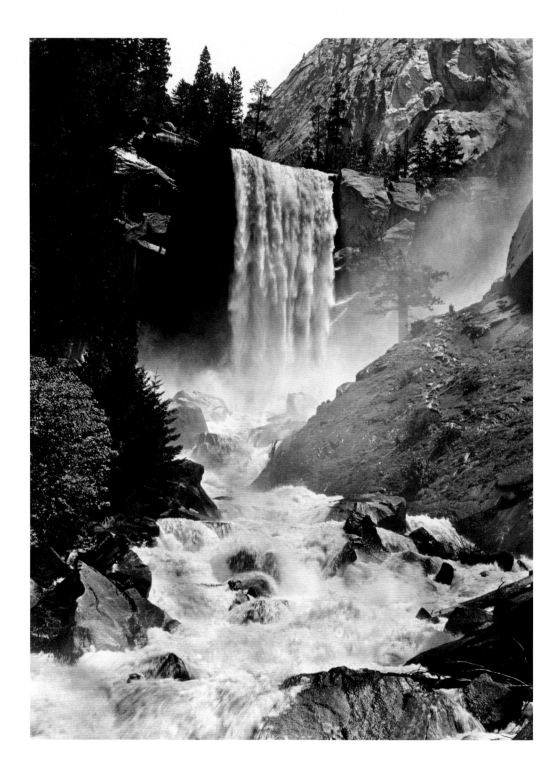

GABRIEL MOULIN | California, 1916

The atmospheric majesty of Yosemite's
El Capitan monolith looms large in the
popular imagination.

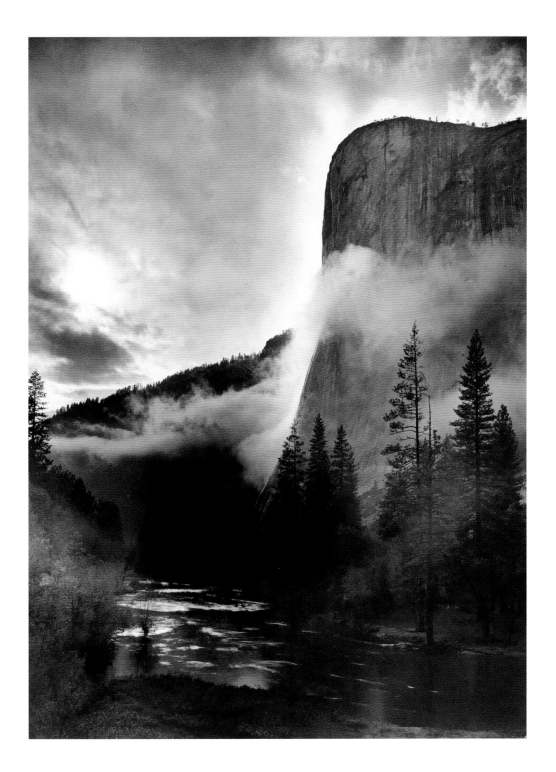

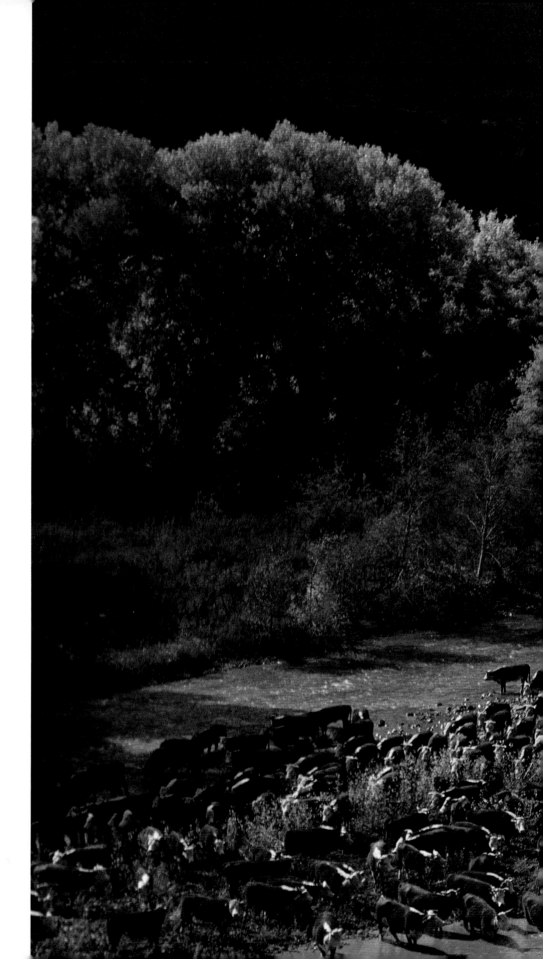

ROBERT SISSON | Arizona, 1962

As frost gilds the cottonwoods, the White River offers a cool respite to hundreds of cattle and their drivers.

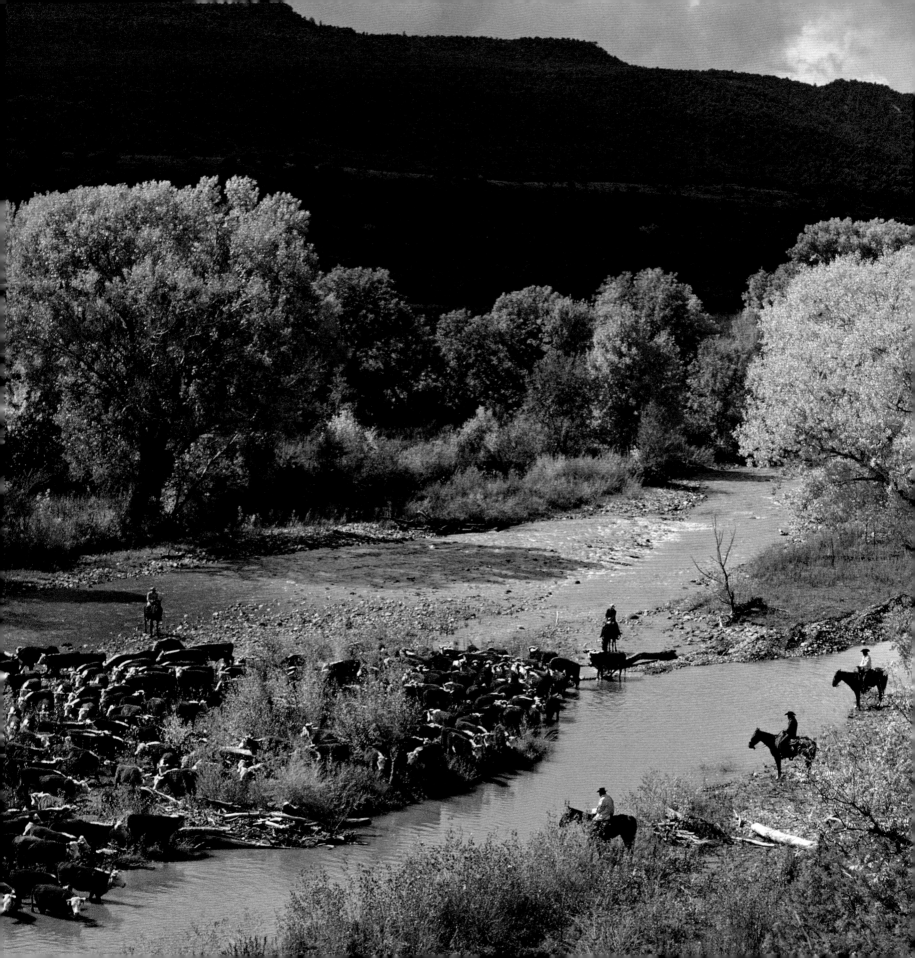

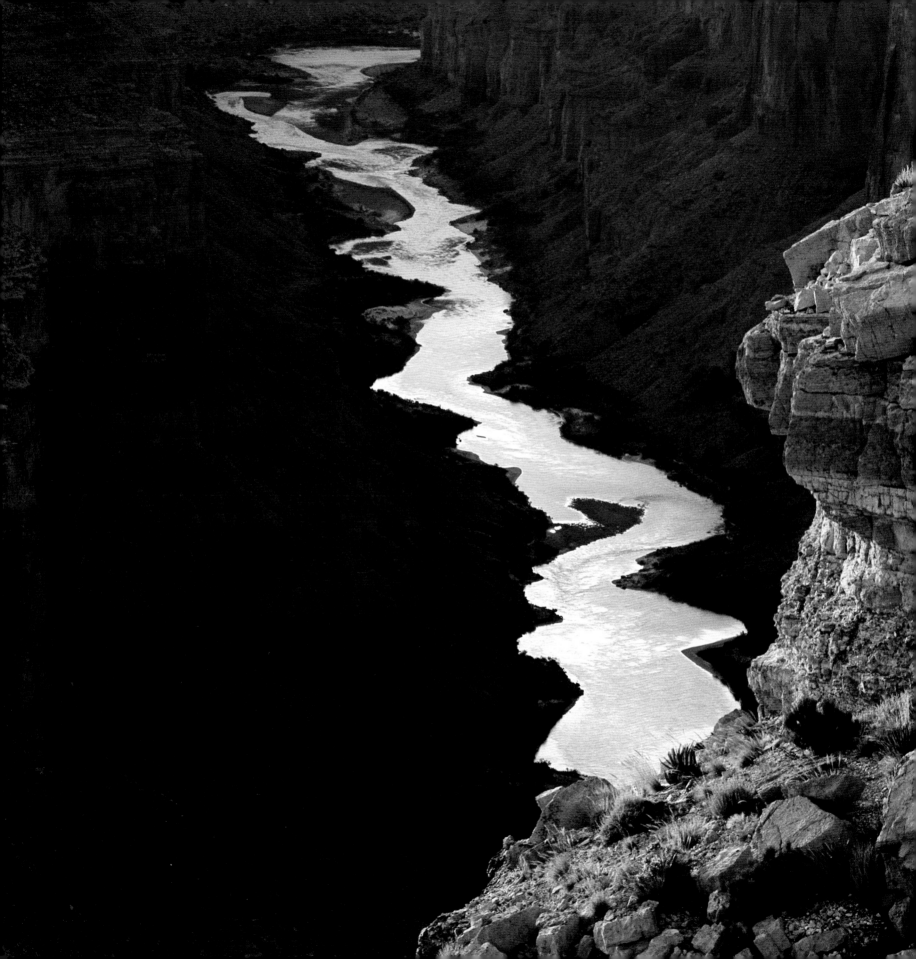

BRUCE DALE | Arizona, 2001

Cape Solitude, on the eastern edge of the Grand Canyon's North Rim, provides a multi-hued vision of the sandstone and the confluent rivers carving it—the travertine-blue Little Colorado and sulfur-green Colorado.

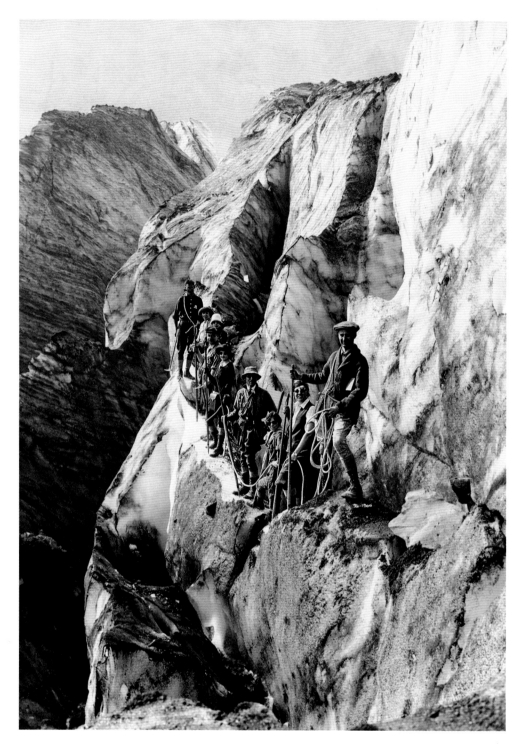

H. B. CUNNINGHAM | Washington, 1927

Led by Cunningham, a chief guide at Mount Rainier National Park, a group scales
the Nisqually Glacier, one of the largest on Mount Rainier's southern face.

[CHAPTER 2]

FOR GOLD. FOR FREEDOM OF RELIGION. FOR ESCAPE.
For solace. For the simple thrill of standing on the edge of the continent. We have gone
west for these and other reasons, and we keep doing so, hoping to discover new things
about our country and ourselves. And the scenes and people we encounter along the
way become the stories that attach to the landscape.

The larger story of the West combines the excitement and elation of discovery with the
caution of encounter. So Lewis and Clark's Corps of Discovery and other such expeditions
west offered one point of view; to the native cultures, those expeditions were less about
discoveries than about encounters. In a similar way, our continuing interactions with
the natural world embrace both discovery and encounter, whether we're seeing grizzlies
for the first time, or deciding whether to impound a waterway. *National Geographic*'s
coverage of the West presents us with a dual way of perceiving—are bears game, or
venerable icons? Is providing water to people for hundreds of miles worth the loss of a
pristine riparian habitat?

ENCOUNTERS

In the early days of the *National Geographic*, there were, unbelievably, still unexplored realms of the American West. A 1923 article detailed a pack train trek to a "hitherto untraversed region of our Southwest," and a piece from 15 years earlier enthused about a bear hunt in Montana. But the big wild outdoors ballyhooed back then by Teddy Roosevelt was also a territory that Roosevelt himself was legendary for protecting: 150 million acres of new national forests, 5 national parks, 18 national monuments, 51 federal bird reservations.

One of the first people to recognize that the West was not an unlimited resource, explorer and geologist John Wesley Powell was also a founding member of the National Geographic Society. Articles marked the 100th and 125th anniversaries of his 1869 pioneering voyage down the Colorado through the Grand Canyon. His explorations led him to champion a managed approach to the West's complex ecology. Another retrospective recognized photographer William Henry Jackson's groundbreaking work filming tribal peoples, Yellowstone, the Mesa Verde cliff dwellings, the Grand Tetons, the Union Pacific Railroad route, and other Western totems. Throughout the 20th century and beyond, *National Geographic* photographers would follow the trail he blazed.

National Geographic's larger-than-life photojournalism both glorifies our discoveries and defines our encounters. A shot of a grizzly strung up after a hunt contrasts with one of camera-wielding tourists getting up close with wildlife; a frame of roadside mechanics struggling to fix a car reminds us of pioneers stranded by broken wagons.

The culture clash that began with Indians and whites, evolved into ranchers versus homesteaders, and finally became longtimers against arrivistes, the government, and

everybody, played out so quickly it remains as palpable as a summer storm over the desert. "The entire American West . . . lies under massive assault by the industrial armies of Government and Greed," wrote cantankerous author Edward Abbey. While it is true that our first encounters with the West still, to some degree, dictate practice and policy about our stewardship of natural resources and our relations to different cultural groups—we still practice cattle ranching in arid regions, and whites and Indians still distrust each other—it's also true that we take joy from what remains of the original West. And viewers of *National Geographic* photos understand that the unknown and unexpected are still part of the Western experience. The unexpected can be as majestic as elks battling in a Wyoming meadow, or as intrusive as a band of land-hungry pioneers.

"In my book a pioneer is a man who turned all the grass upside down," said painter Charlie Russell to a group of Montana boosters in 1923, "strung bob-wire over the dust that was left, poisoned the water and cut down the trees, killed the Indian who owned the land, and called it progress. If I had my way, the land here would be like God made it, and none of you sons of bitches would be here at all." Of course, Russell and his fiercely independent ilk could be labeled, in the words of one modern Western writer, as "one of those damned old litigious autodidact unbathed loons we find all over the West."

The last one in shuts the gate and prays for a miracle, the way the Sioux ghost-danced for the return of the buffalo. But time wreaks change, sometimes too fast. As these images vividly convey, every generation discovers and encounters its own West.

FRANS LANTING | Arizona, 2010

Called "King Bend" by locals, the U-shaped meander of the Colorado River known to the world as Horseshoe Bend flows 1,000 feet below the overlook.

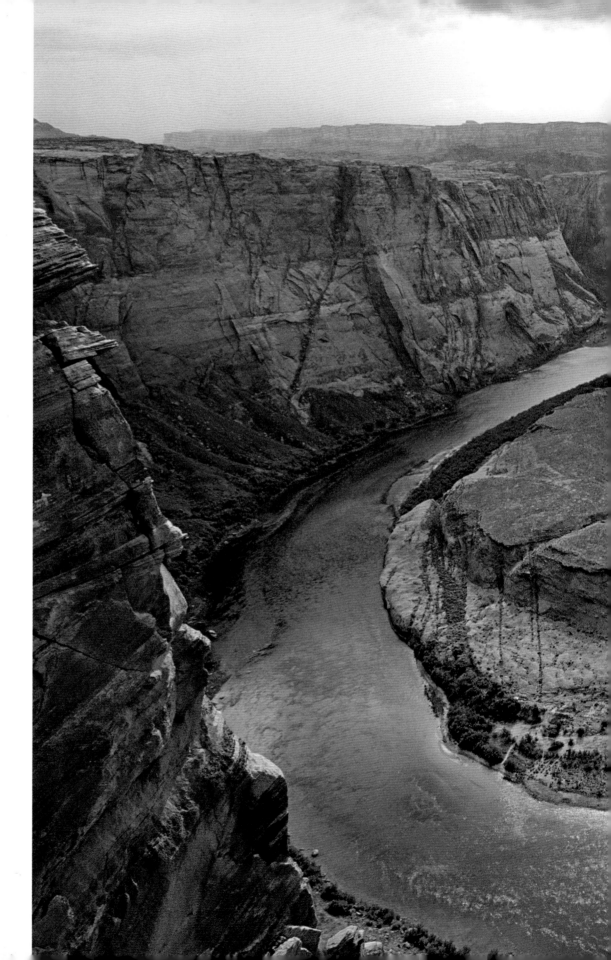

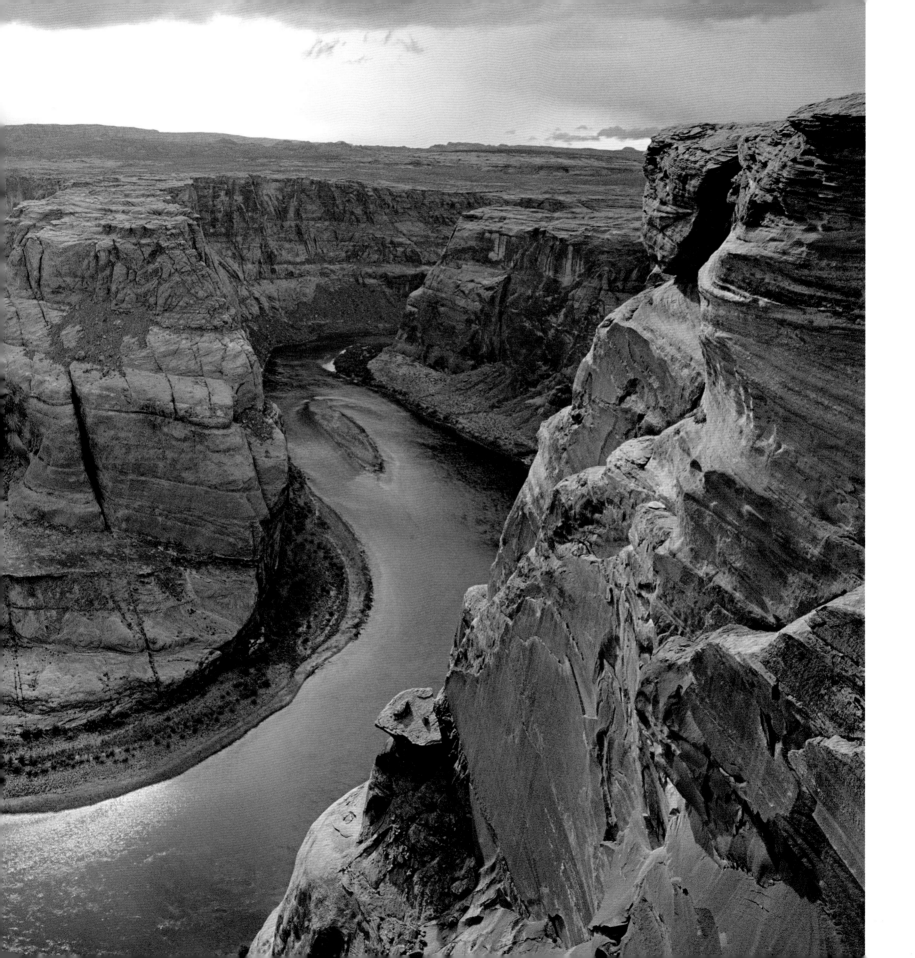

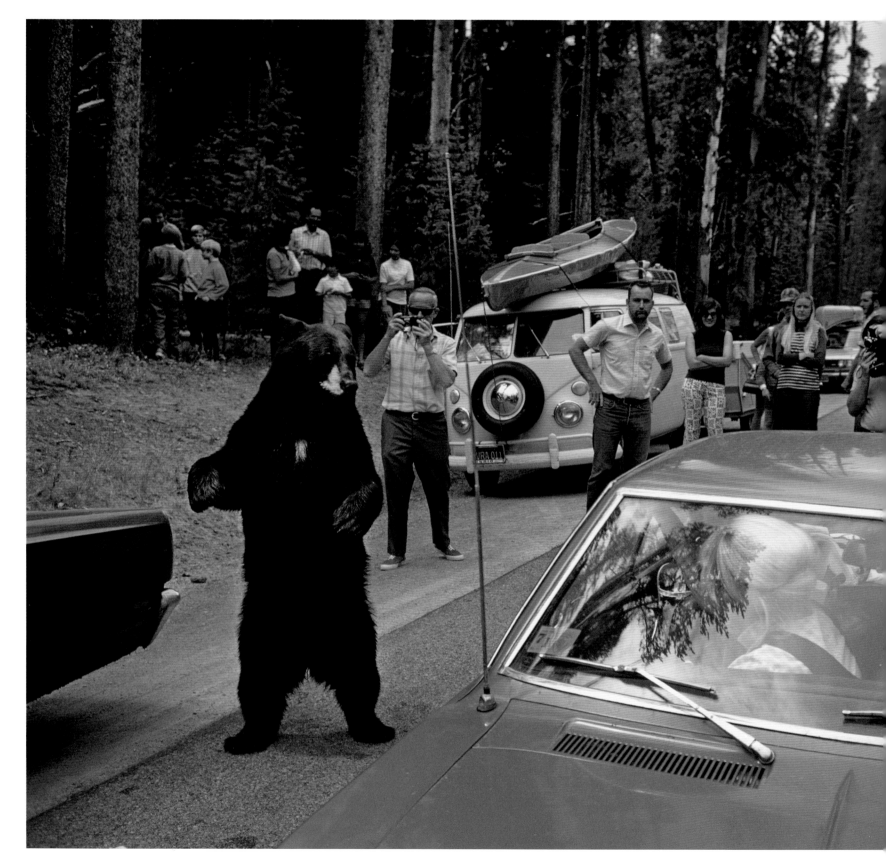

JONATHAN BLAIR | Wyoming, 1972

Despite official warnings since 1970 against approaching, crowding, and feeding "habituated" roadside bears, "bear jams" remain a regular occurrence in Yellowstone.

"TODAY'S YELLOWSTONE BEARS ARE LESS CHEAPLY ENTERTAINING BUT FAR MORE POTENT THAN THE ROADSIDE BEGGARS OF THE PAST. THEIR UNSEEN PRESENCE BOTH EXCITES AND UNNERVES US WITH EACH STEP FURTHER INTO THE WOODS."

—ALICE WONDRAK BIEL, 2006

WILLIAM HENRY JACKSON | Colorado, 1890

Ticket agents and visitors assemble beneath the Cathedral Spires at Garden of the Gods in Colorado Springs. The public has enjoyed the park for free since 1909.

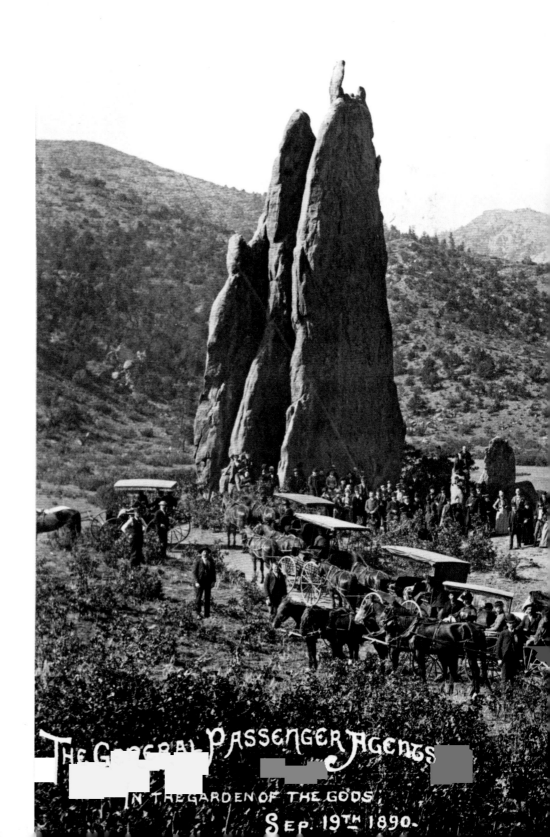

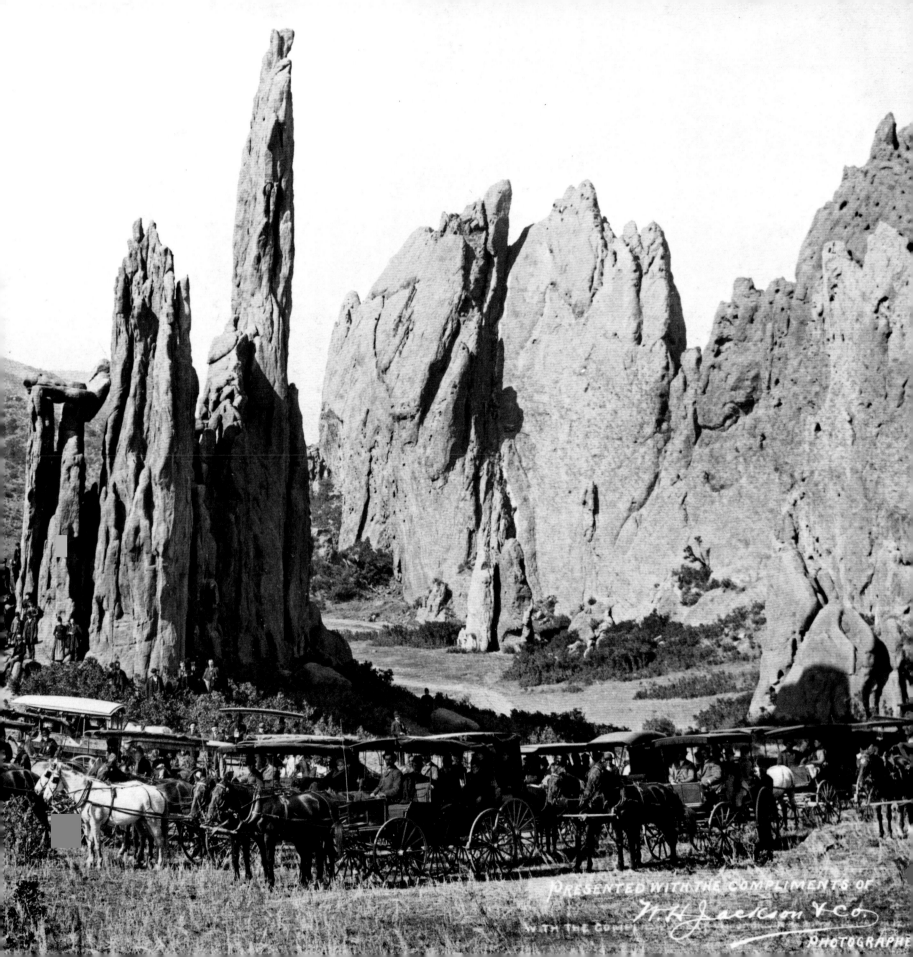

PRESENTED WITH THE COMPLIMENTS OF
W. H. Jackson & Co.
WITH THE COMPLIMENTS OF
PHOTOGRAPHE

MARC MORITSCH | California, 2001

One of the oldest known living trees on earth—
the bristlecone pine—has weathered 4,000
years in the White Mountains of the Great Basin.

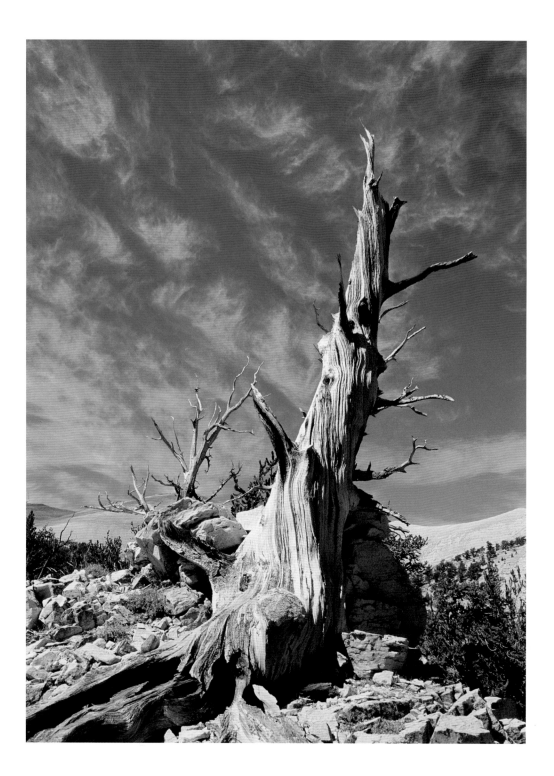

N. E. BECKWITH | California, 1892

Nicknamed "Mark Twain," this 331-foot-tall
sequoia lasted 1,341 years. It took loggers
8 days to saw its 90-foot-circumference trunk.

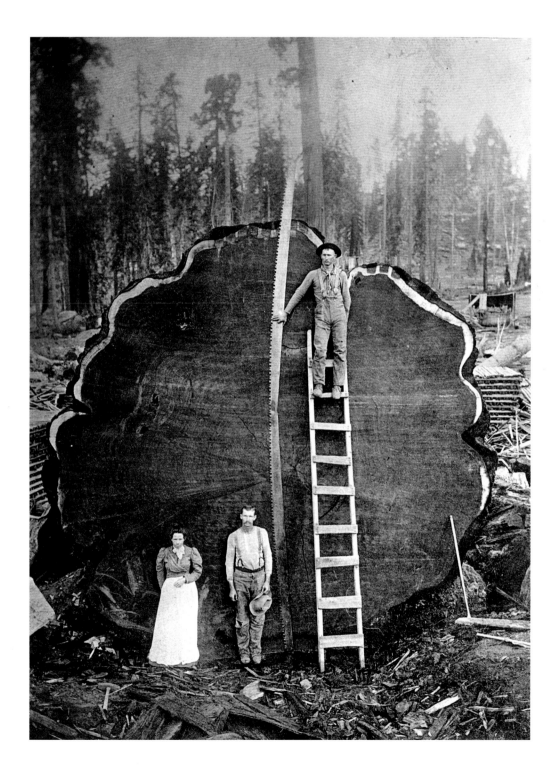

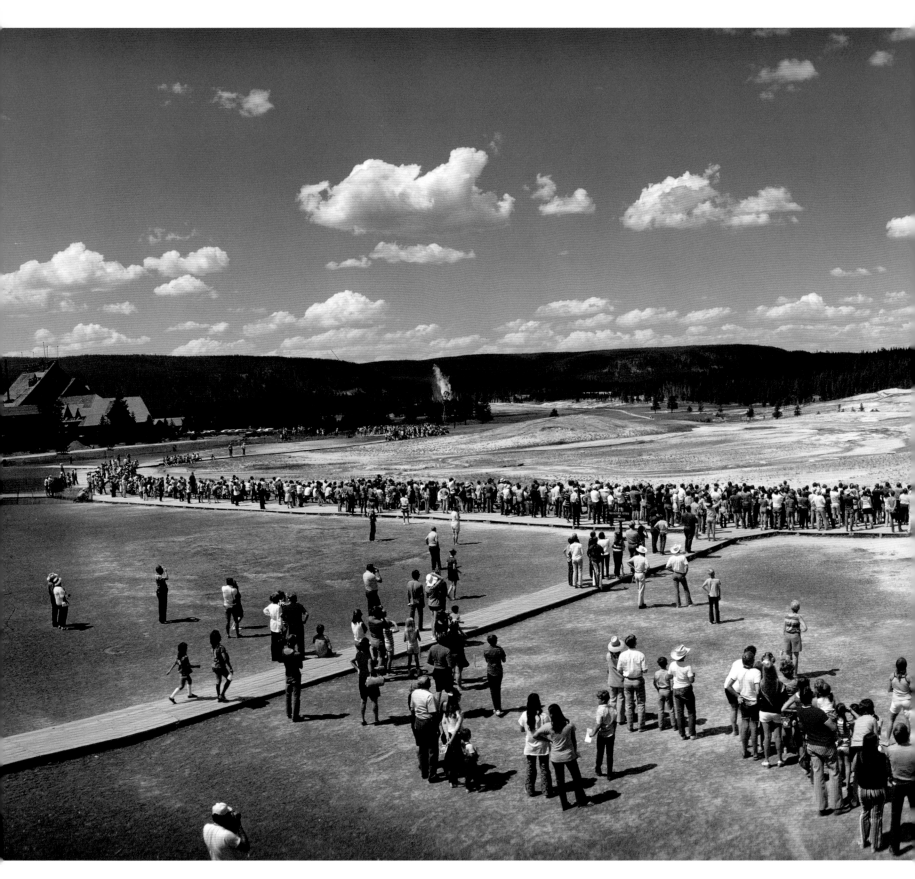

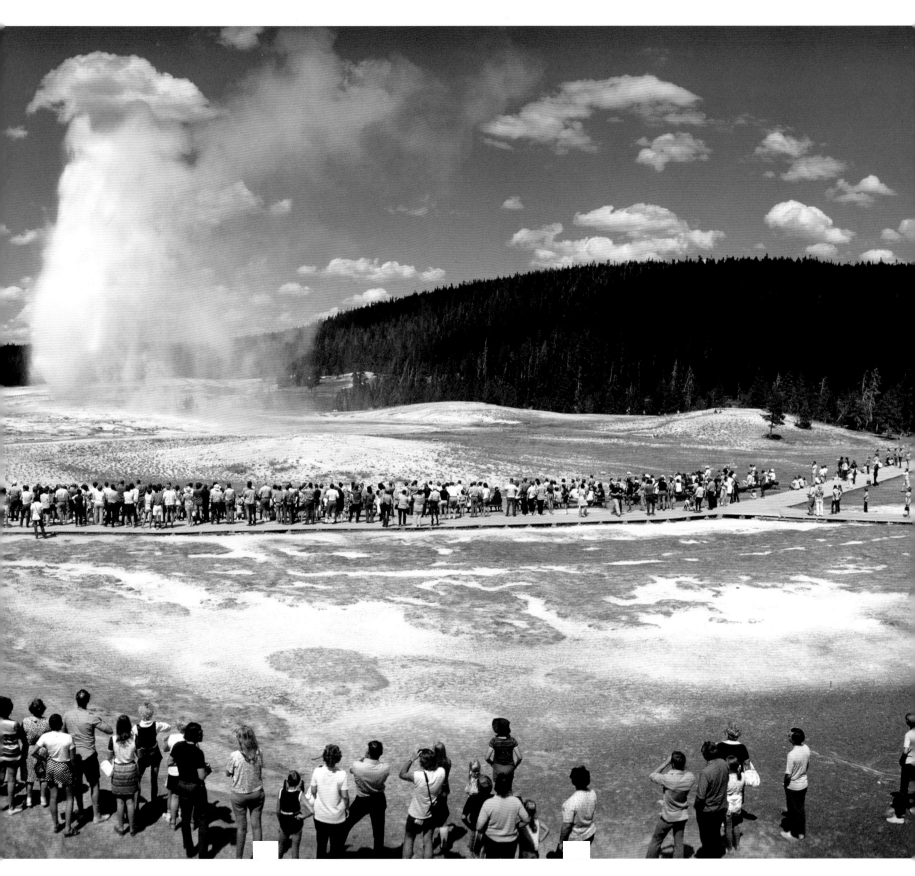

B. ANTHONY STEWART | California, 1935

Early car campers turn Death Valley
into an alfresco dining experience.

previous pages (106-107)
JONATHAN BLAIR | Wyoming, 1972

"Old Faithful" applies as much to Yellowstone
National Park's venerable cone geyser as it
does to those awaiting its eruption.

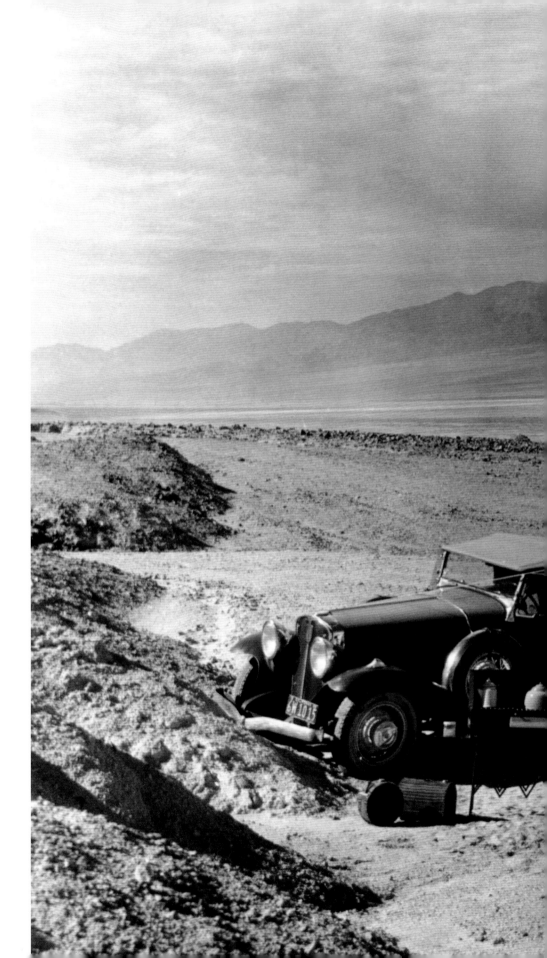

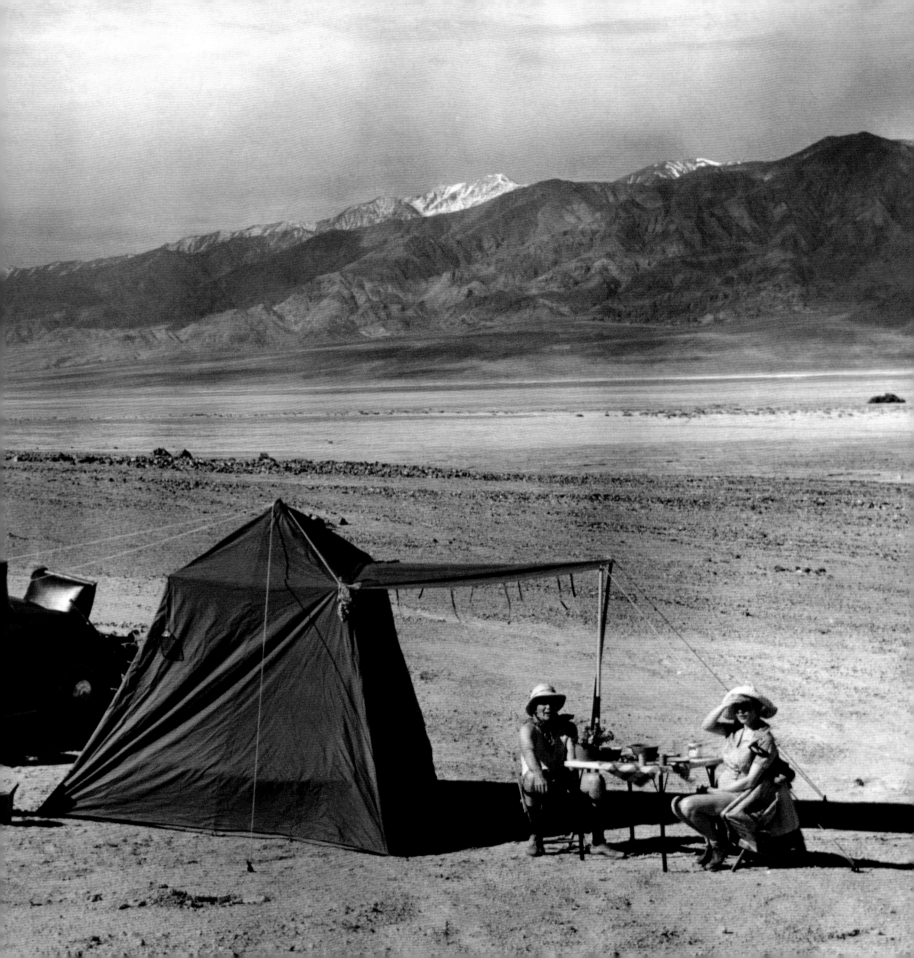

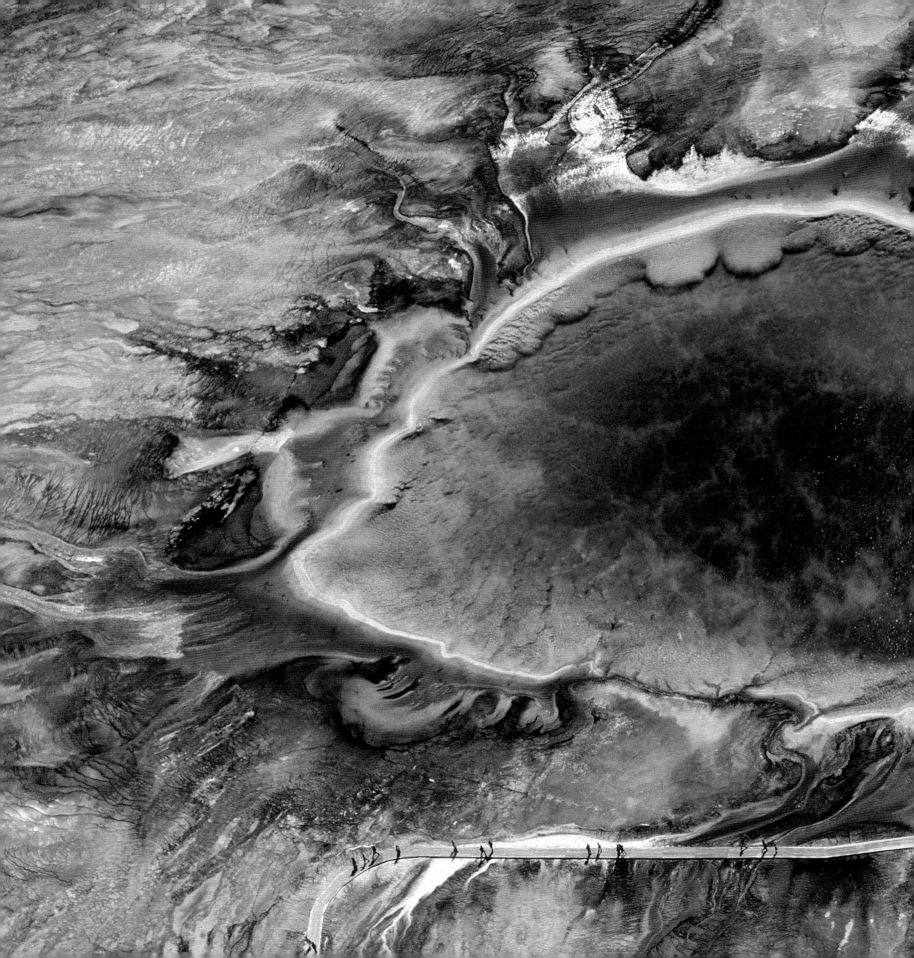

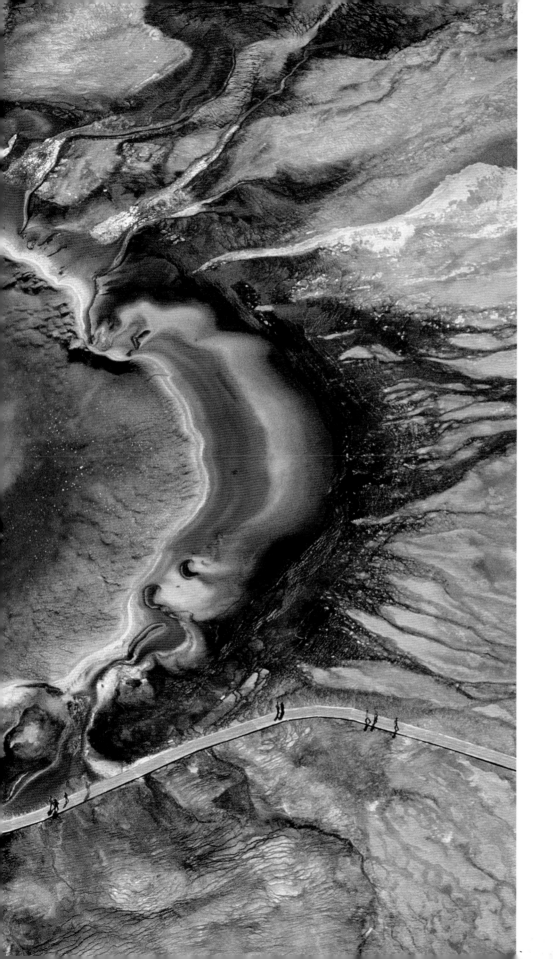

PAUL CHESLEY | Wyoming, 1981

In this aerial view, mats of brilliant orange algae and bacteria extend like lashes from the steamy blue eye of Yellowstone's Grand Prismatic Spring, the largest hot spring in the United States, at 250 by 300 feet.

U.S. ARMY AIR CORPS | California, 1933

Biplanes soar in formation above
Yosemite's Liberty Cap and Nevada Fall.

opposite page

KOLB BROTHERS | Arizona, 1915

A daredevil jumps a rock-wall chasm in the
Grand Canyon, where the entrepreneurial
Kolb brothers set up shop on the North Rim
taking images of tourists and selling the pho-
tos as souvenirs.

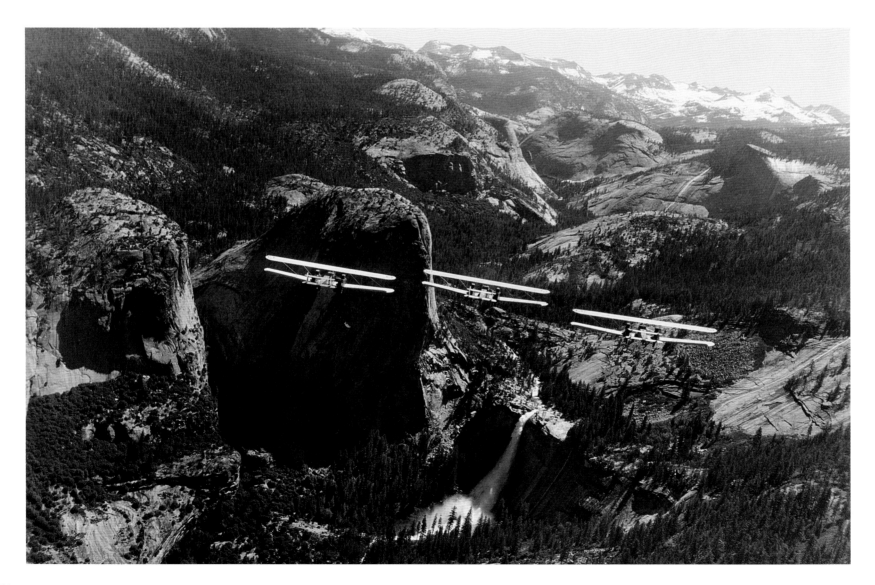

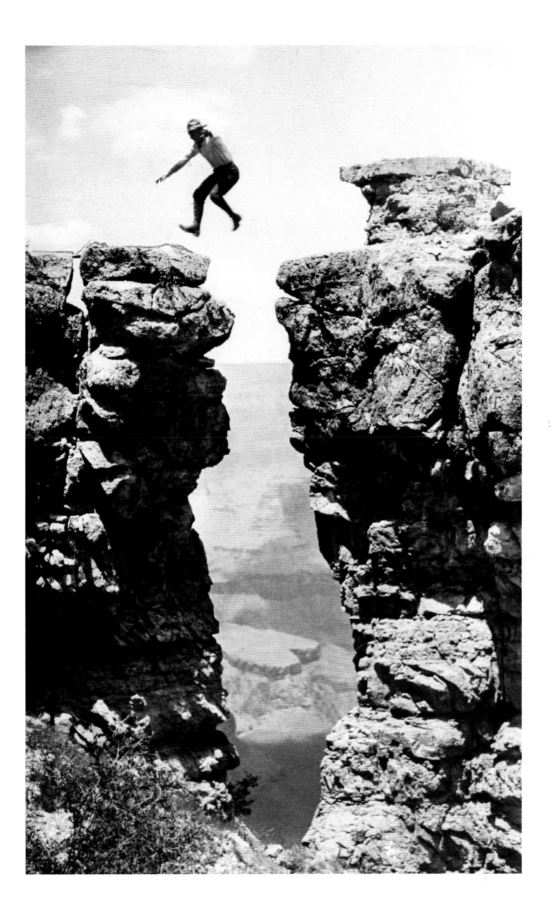

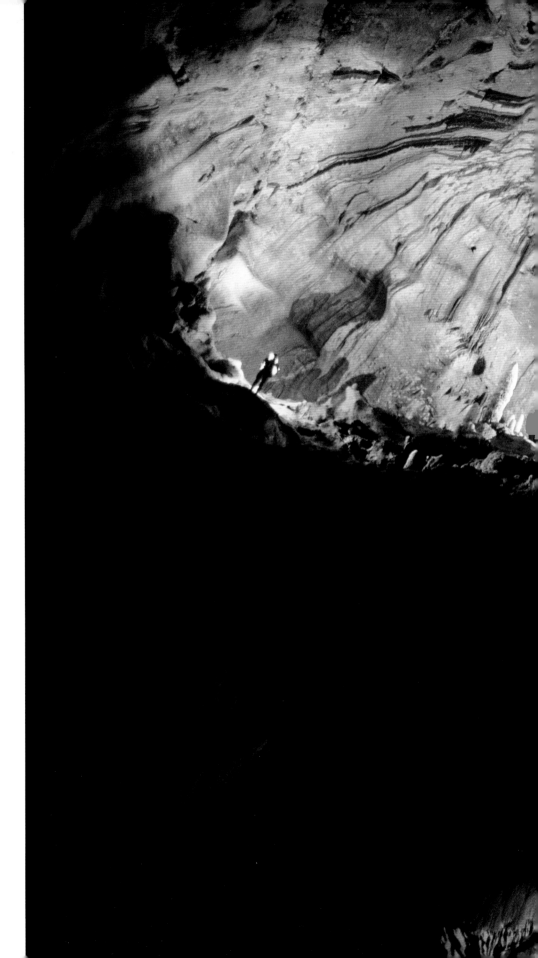

MICHAEL NICHOLS | New Mexico, 1989

To photograph the Carlsbad Caverns' Lechuguilla Cave, the deepest cave in the U.S., the photography team climbed, crawled, swam and spelunked 1,600 feet beneath the earth's surface.

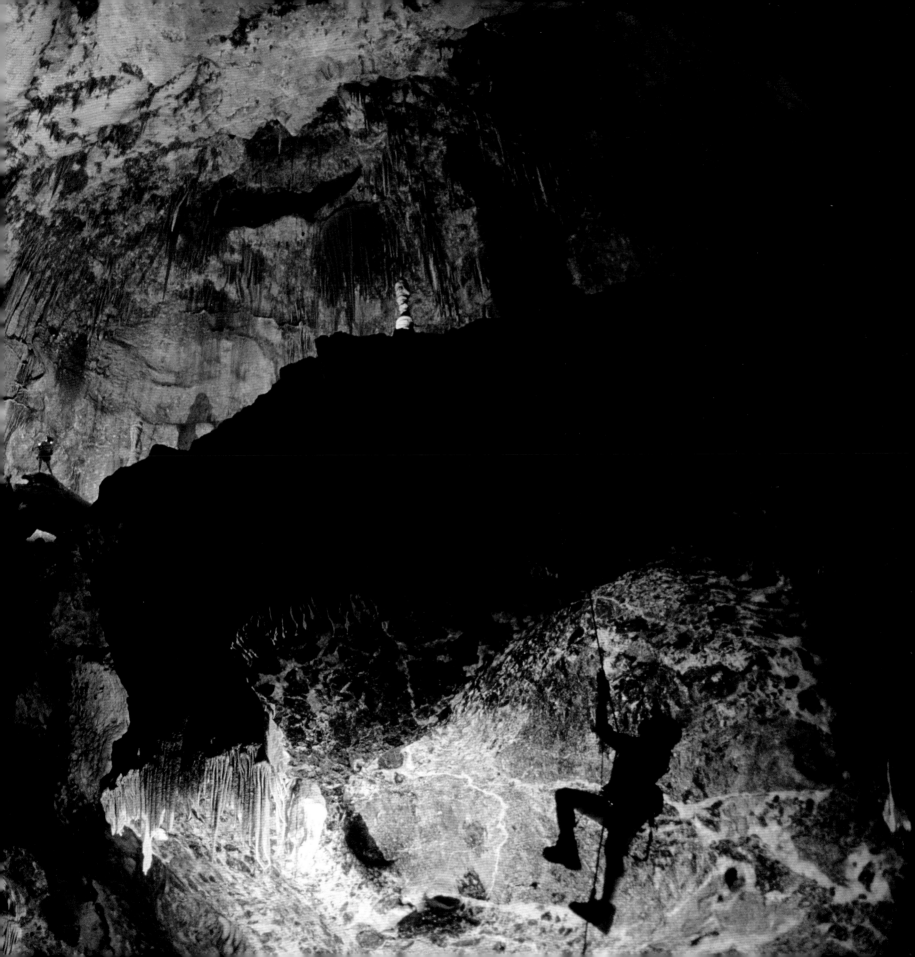

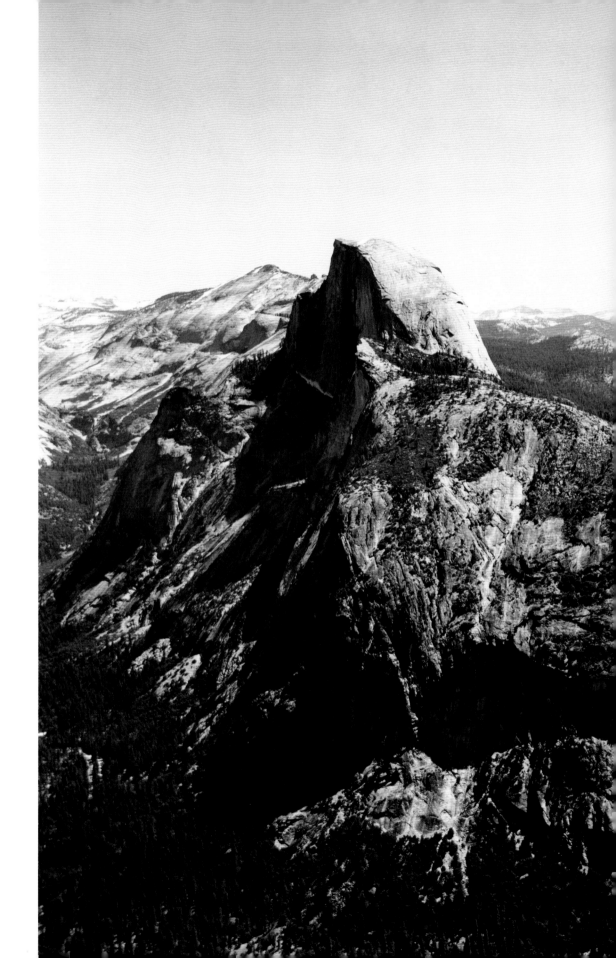

ANSEL ADAMS | California, 1937

The wee climber, upper right, contrasts against the enormous Half Dome, one of the most photographed granite formations in the Yosemite Valley.

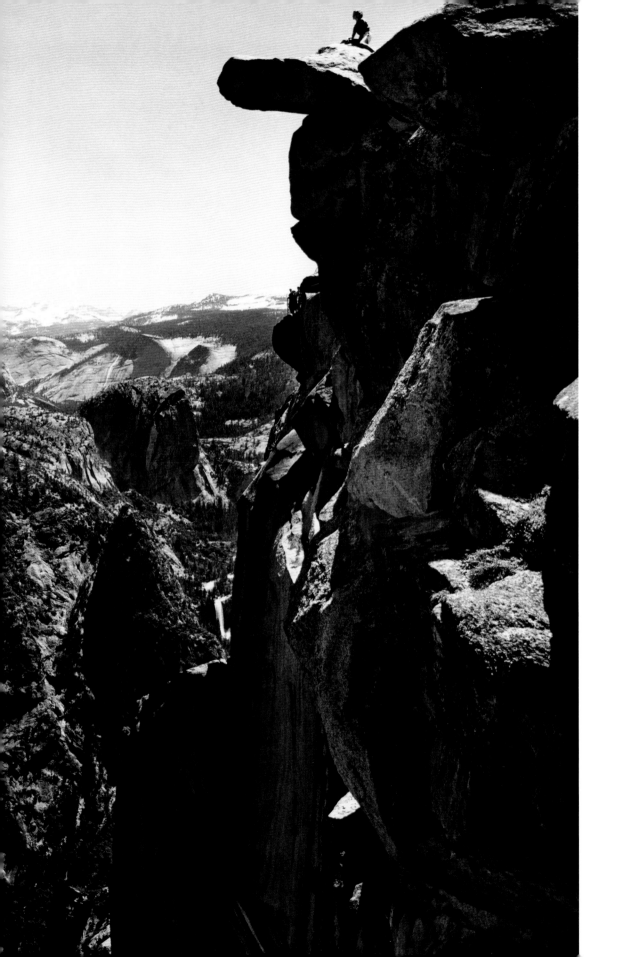

JIMMY CHIN | California, 2010

The aptly named "Thank God Ledge" supports a hiker walking this 40-foot-long sliver of granite on Yosemite's Half Dome.

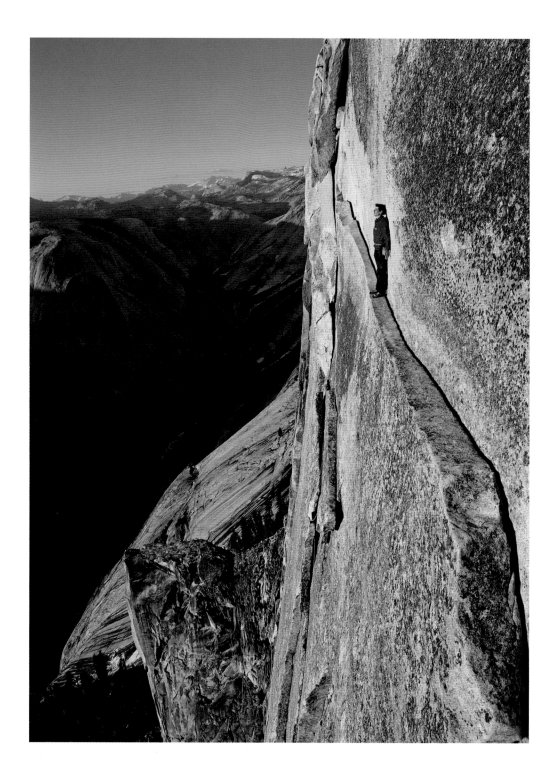

CHARLES D'EMERY | South Dakota, 1938

Emancipating Lincoln from the granite of Mount Rushmore suggests we share the same petro-glyphic impulses as ancient civilizations.

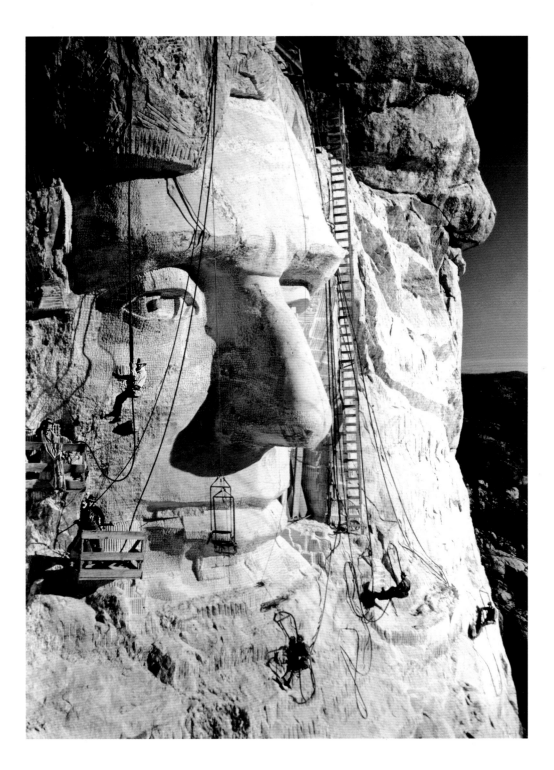

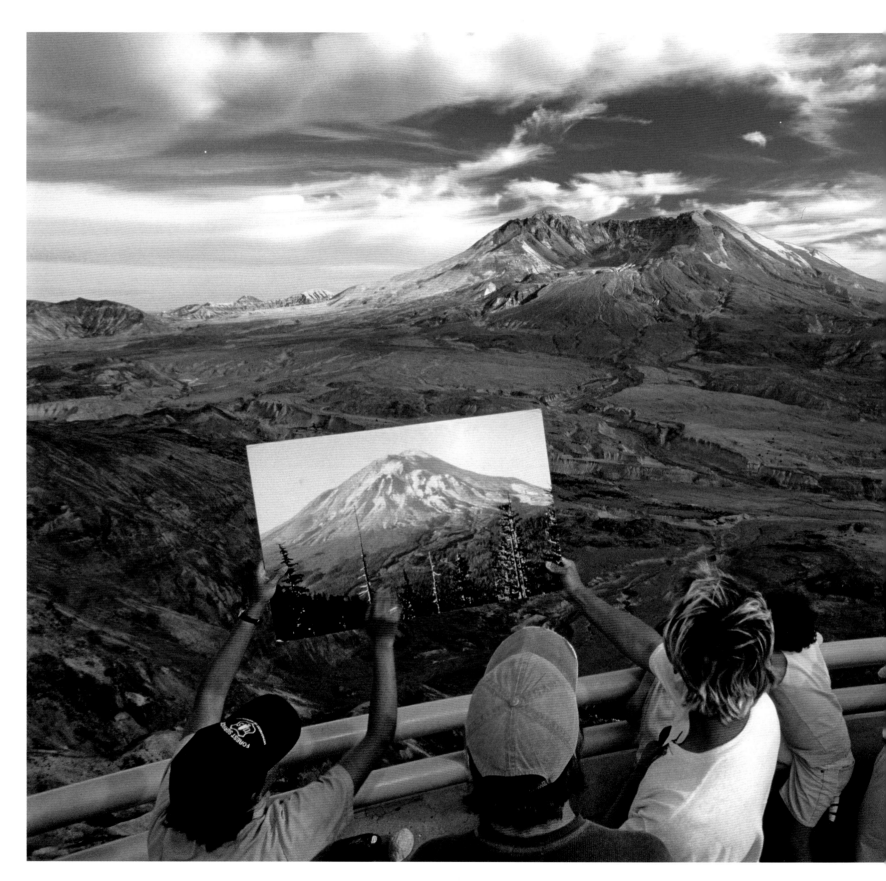

Eighteen years after the eruption of Mount St. Helens, visitors to the Johnston Ridge Observatory compare the current view of the cone with an earlier photo.

"THERE IS NO 'NORMAL' IN THE DYNAMIC LANDSCAPE OF THE AMERICAN WEST. AROUND MOUNT ST. HELENS, YOU SEE STATES OF VEGETATION FROM COUNTLESS PREVIOUS ERUPTIONS. THERE'S DRAMA EVERYWHERE. JUST SWITCH YOUR TIME FRAME, AND IT ALL COMES TO LIFE."

—JIM RICHARDSON, 2012

DIANE COOK & LEN JENSHEL | Utah, 1997

The human footprint, manifested in white jet contrails and brown buildings, intrudes on the colorfully striated Grand Staircase at Escalante National Monument.

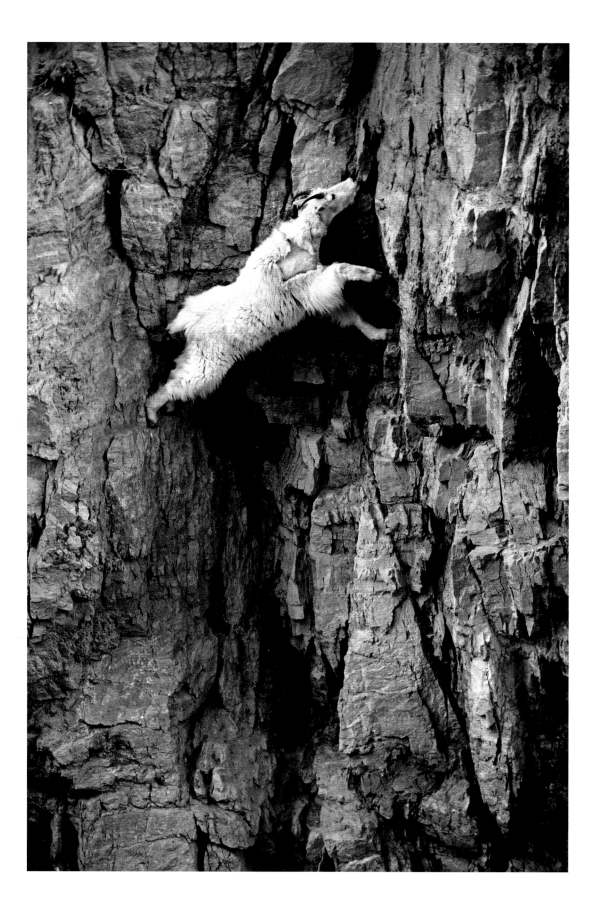

JOEL SARTORE | Nebraska, 1995

The monthly feather-dusting of the taxidermic bighorn sheep display at the Cabela's store in Sidney seems to fascinate one of the animals.

opposite page

JOEL SARTORE | Montana, 2009

The large, semisoft hooves of this nanny mountain goat afford the traction to escape predators and to scale Glacier National Park's sheer rock walls in search of a salt lick.

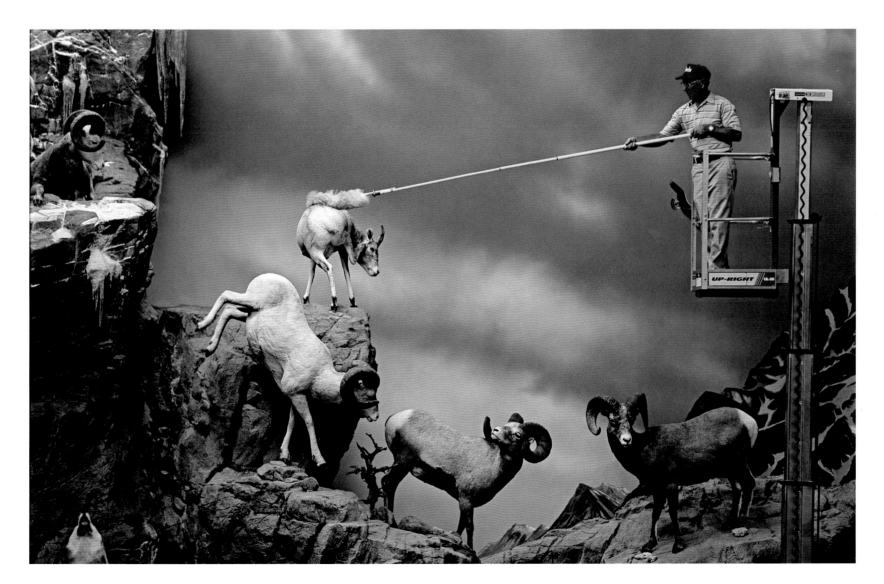

JIM BRANDENBURG | Arizona, 1990

For this spiny swift, the red rock outcroppings of the Navajo Nation provide the perfect spring sunning spot.

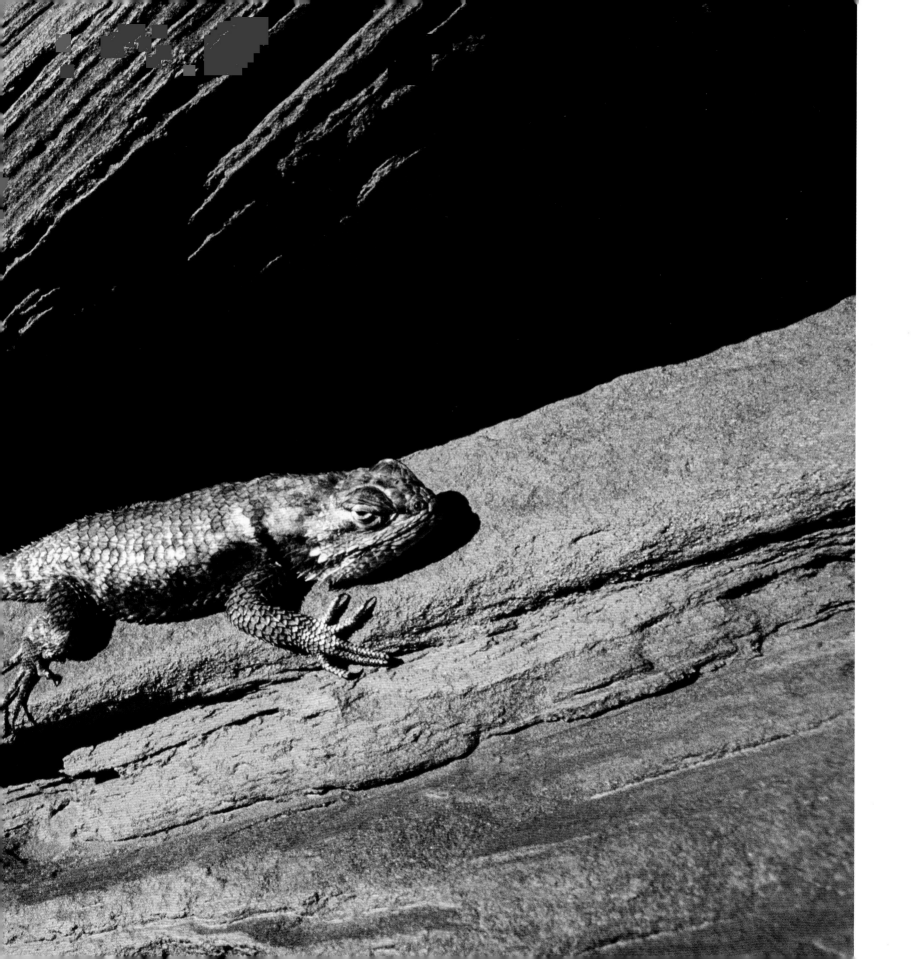

WALTER MEAYERS EDWARDS | California, 1971

The land is the loser as racing motorcycles shred through the Mojave Desert near Barstow on their way to Las Vegas.

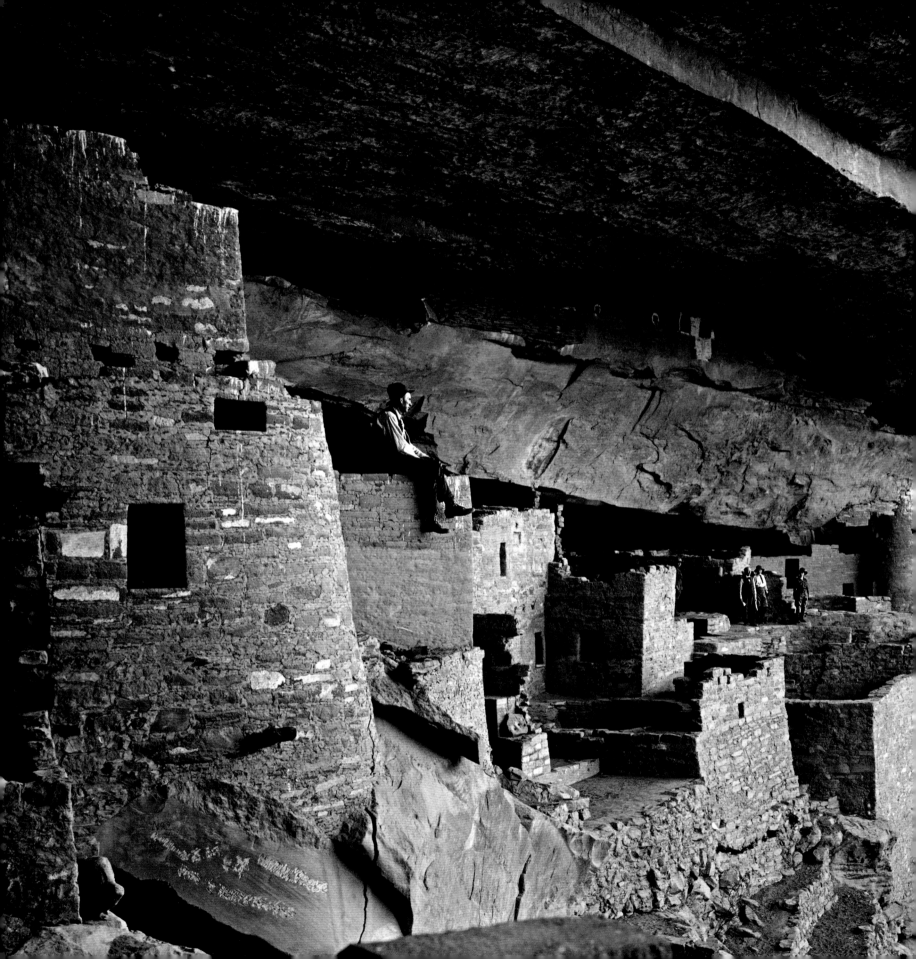

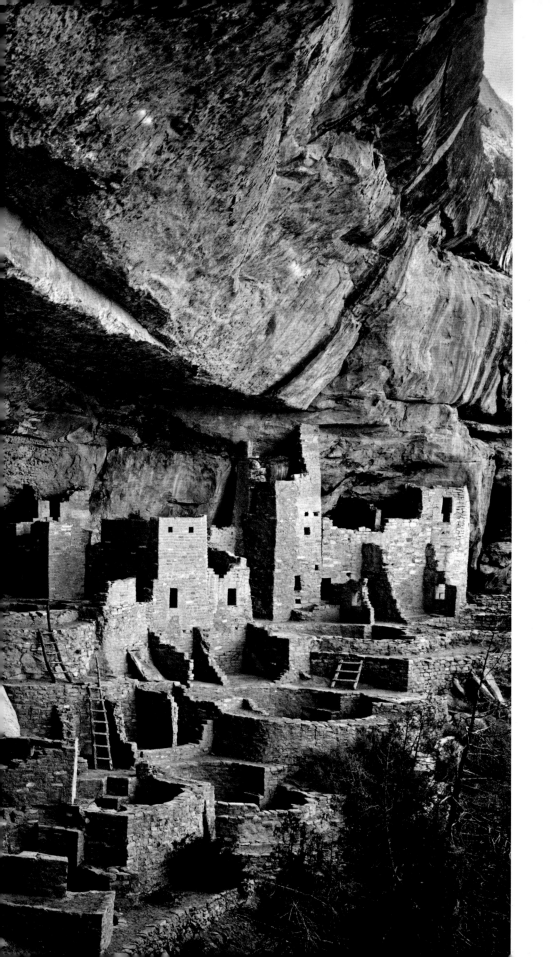

CHARLES MARTIN | Colorado, 1921

Inhabited by the Anasazi from approximately 650 to 1300, Mesa Verde's 150-room sandstone-and-wood Cliff Palace remained "undiscovered" until the 1880s.

CHARLES HERBERT | Arizona, 1955

Navajo officials—Howard H. Sorrell, district councilman; Jonathan Peterson, tribal policeman; and S. S. Jordan, U.S. Indian Service—belly up at Window Rock Lodge.

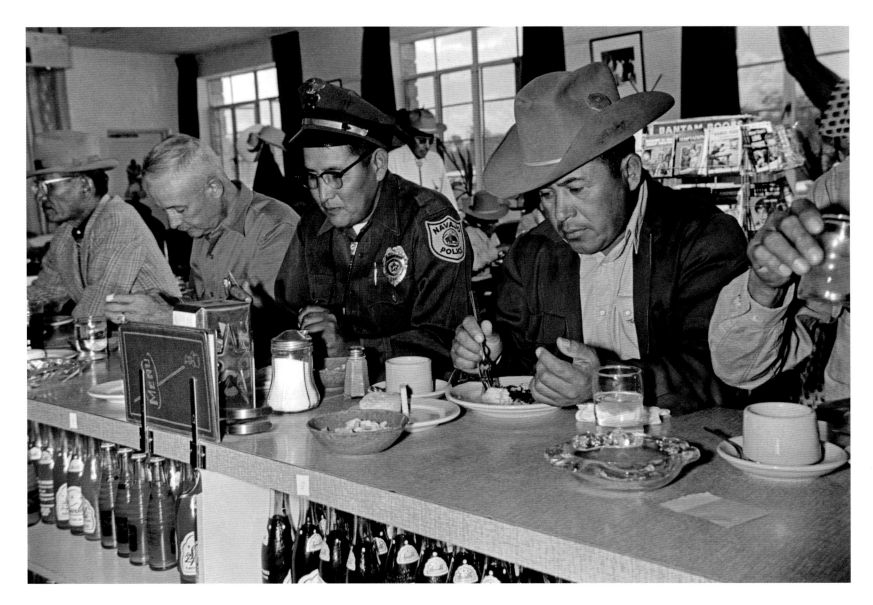

B. ANTHONY STEWART | New Mexico, 1941

In the desert outside Roswell, Navajos and other spectators gather around a Ford to watch from a distance the launch of Robert H. Goddard's P-series rocket.

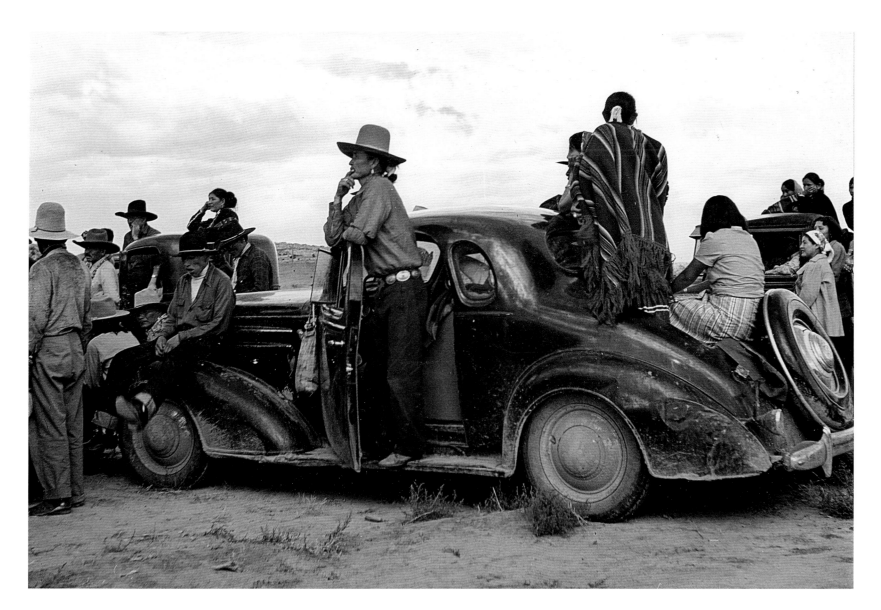

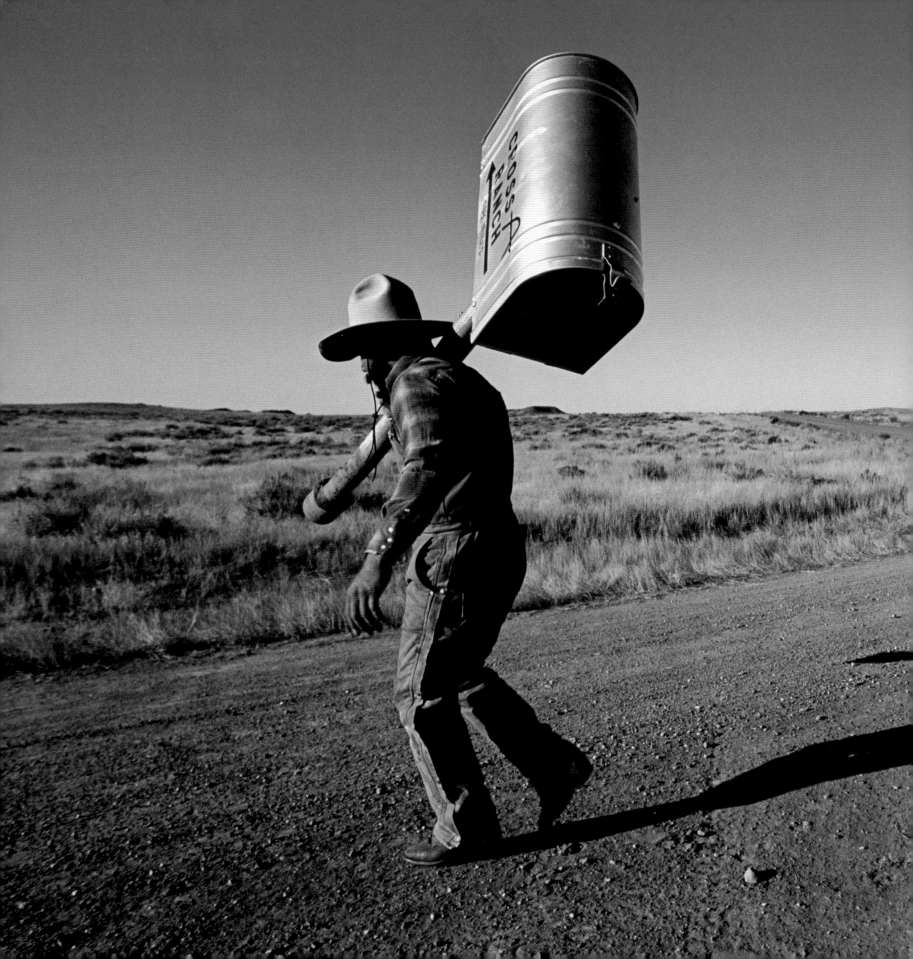

RICHARD OLSENIUS | Wyoming, 1993

Always moving, a cowboy from T Cross Ranch near Dubois hauls an oversized mailbox across a rural dirt road.

EUGENE RICHARDS | **North Dakota, 1997**

Symbolic of the High Plains migration, the earth consumes two skeletons—one of an animal and one of a home—as both decay in an Epping wheat field.

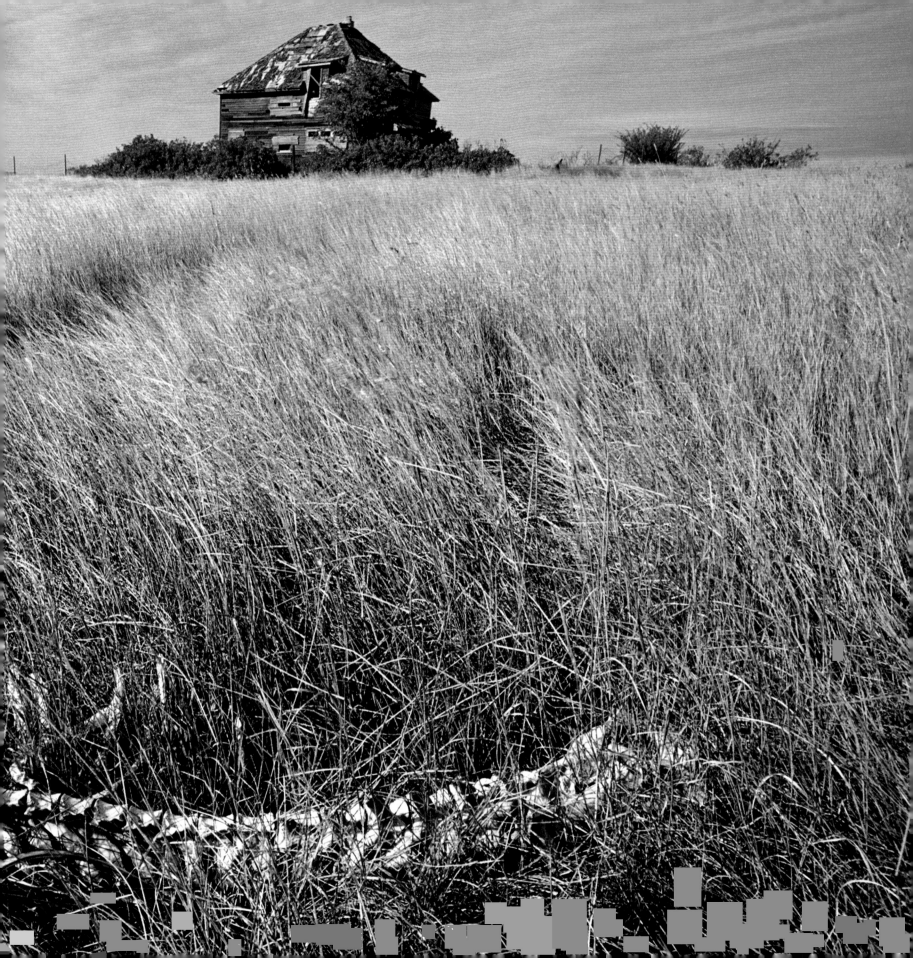

CHRIS JOHNS | Nevada, 1992

With cars approaching, a Great Basin rattle-snake winds its way across a rural stretch of U.S. Route 93 at twilight.

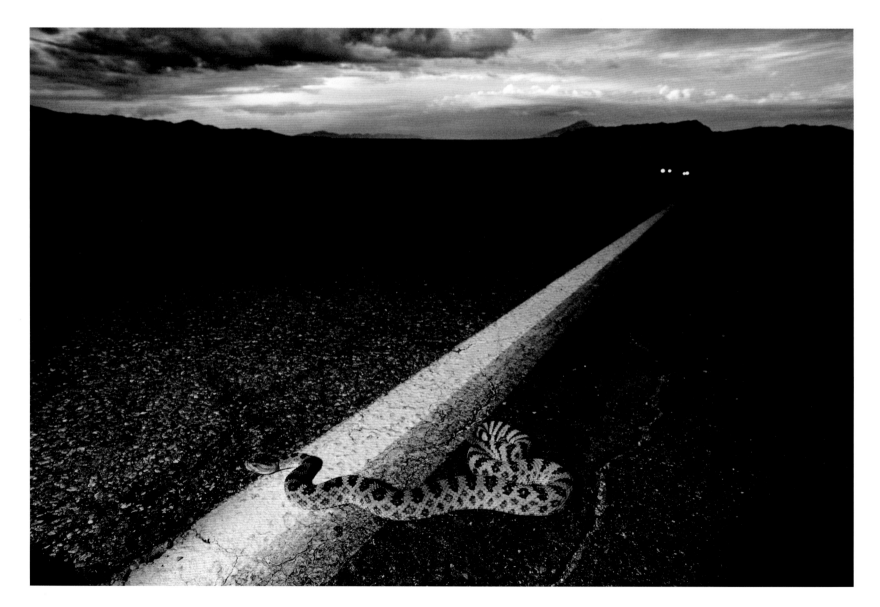

Capable of outsprinting a horse, one of Yellowstone National Park's hundreds of grizzly bears breaks into a full gallop.

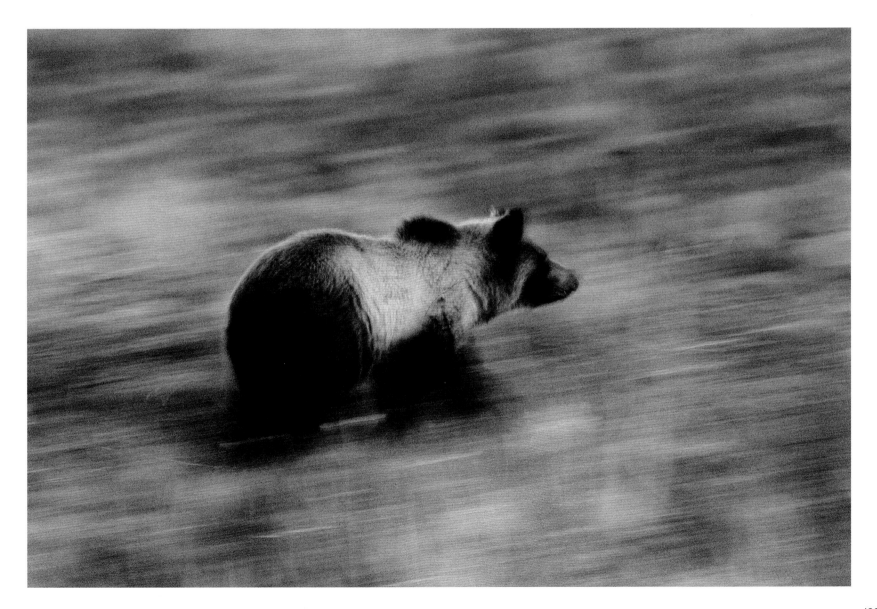

JOEL SARTORE | Idaho, 1992

As his grandson laughs, a rancher's hold on his snarling dog's leg prevents it from attacking the photographer.

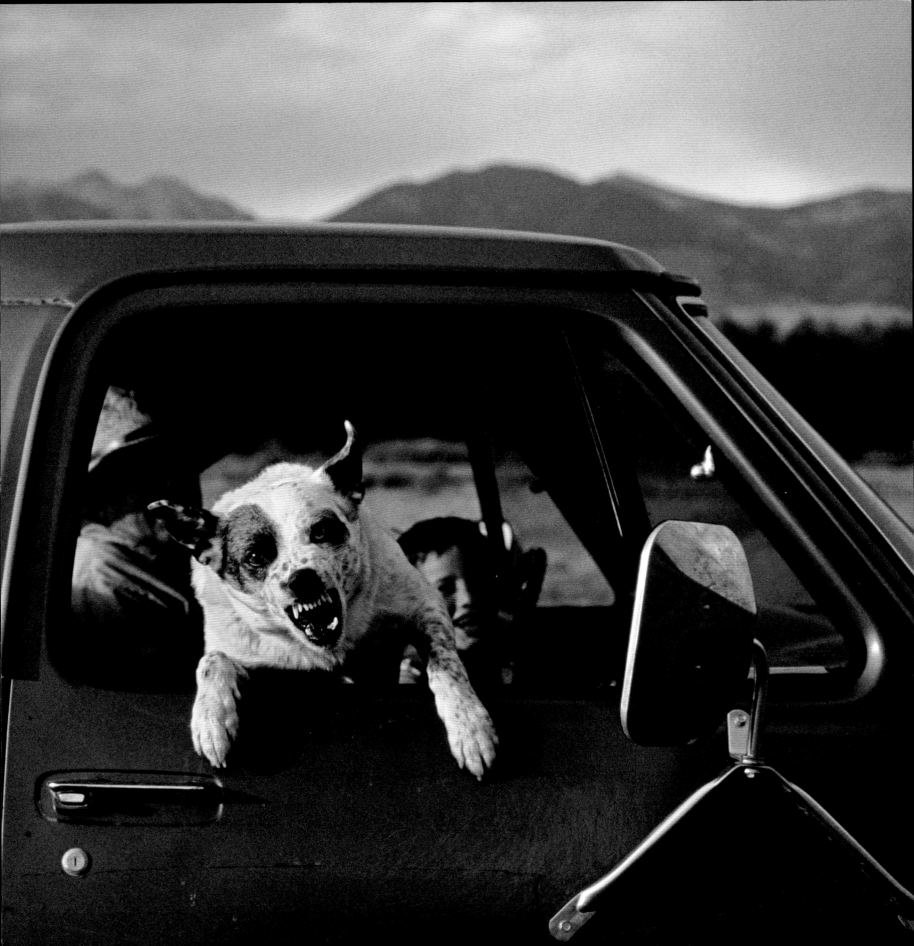

JAMES L. STANFIELD | **Texas, 1967**

One man's loss portends another's gain, as helpers offer a paid ride to stranded motorists in the Rio Grande riverbed near Big Bend.

"WHEN IT FULLY LEARNS THAT COOPERATION, NOT RUGGED INDIVIDUALISM, IS THE QUALITY THAT MOST CHARACTERIZES AND PRESERVES THE WEST, IT THEN HAS A CHANCE TO CREATE A SOCIETY TO MATCH ITS SCENERY."

—WALLACE STEGNER, 1969

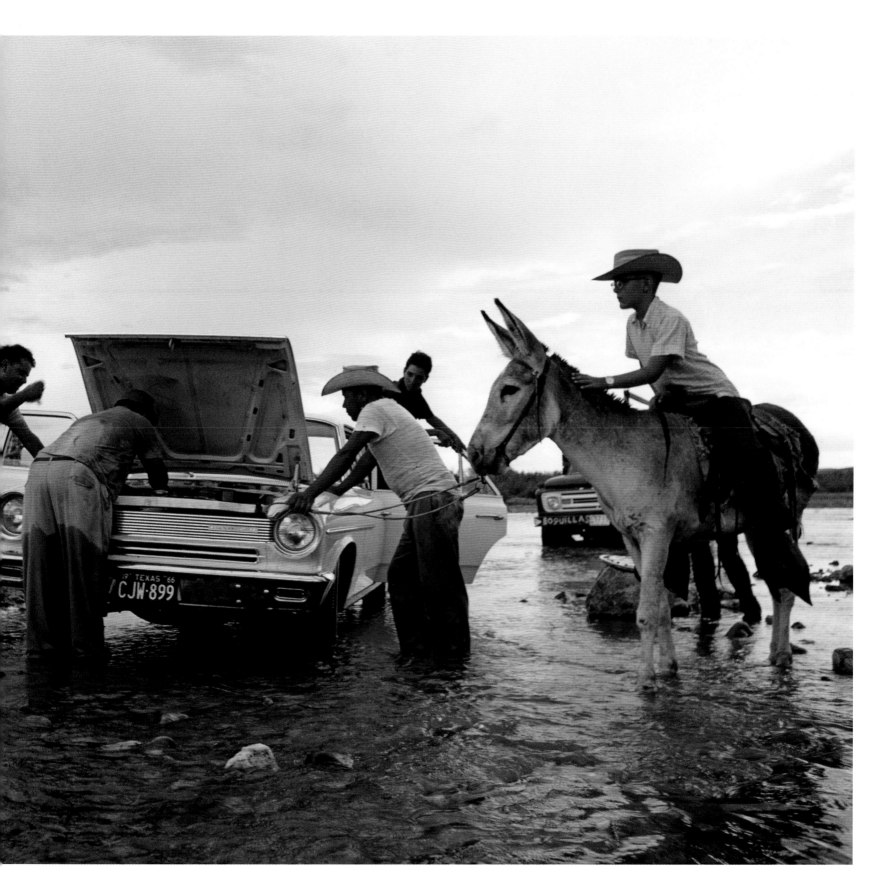

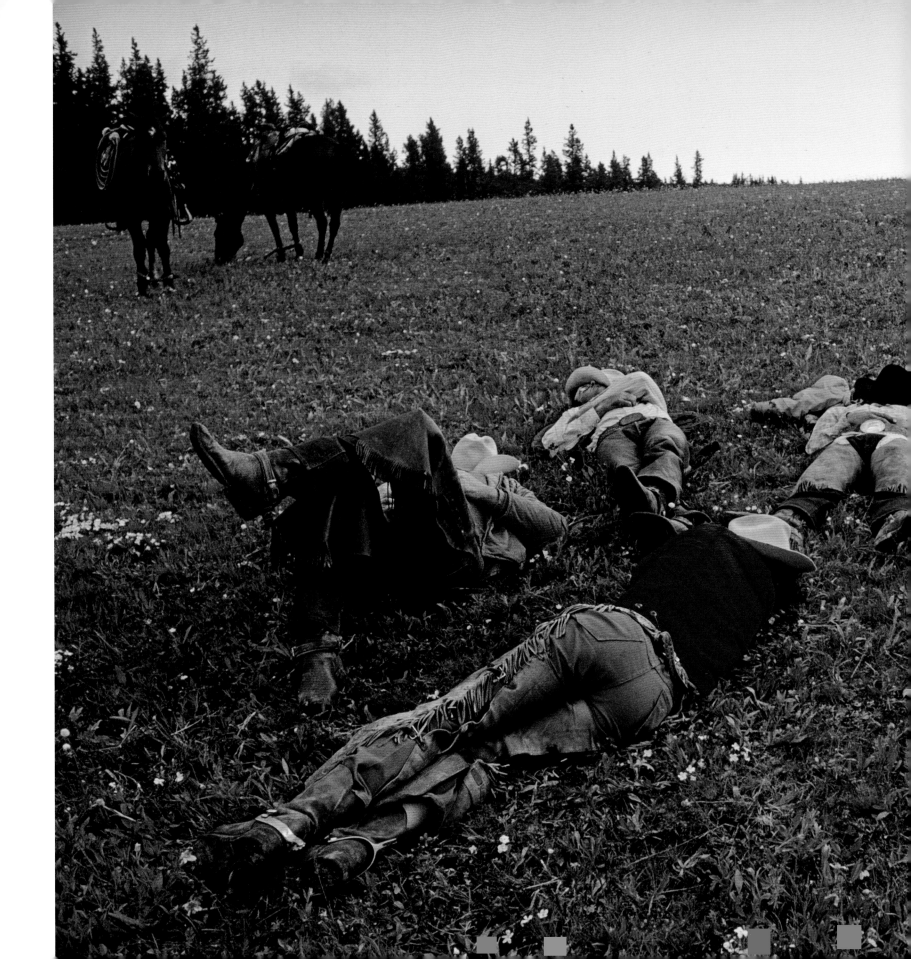

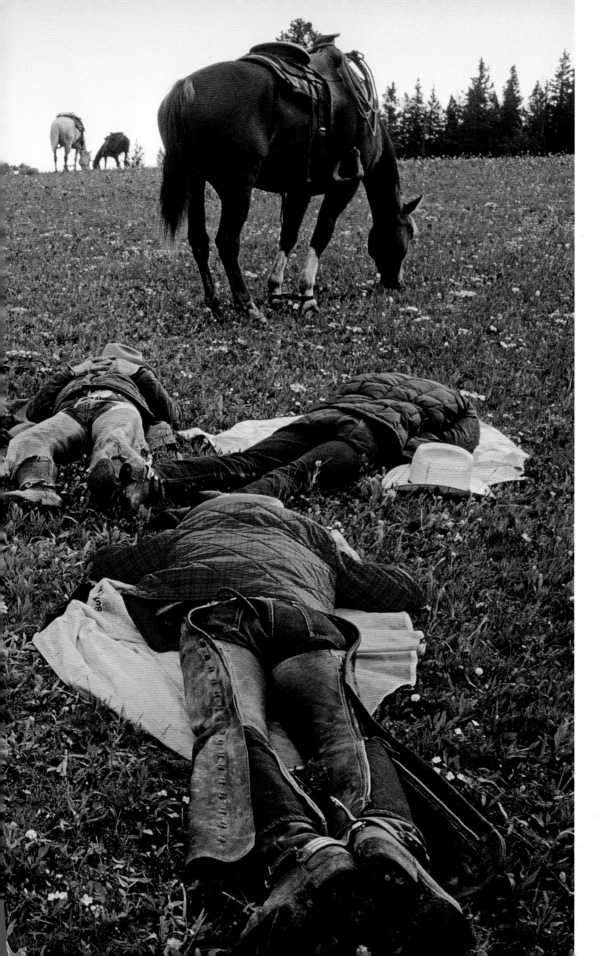

After rising at dawn to drive cattle to summer pastures, cowboys in the Bighorn Mountains take a midday rest before the chuck wagon arrives.

NICHOLAS DEVORE III | New Mexico, 1979

The hard-earned stoicism of Western character is etched into the visages of both father and son in the small ranching town of Datil.

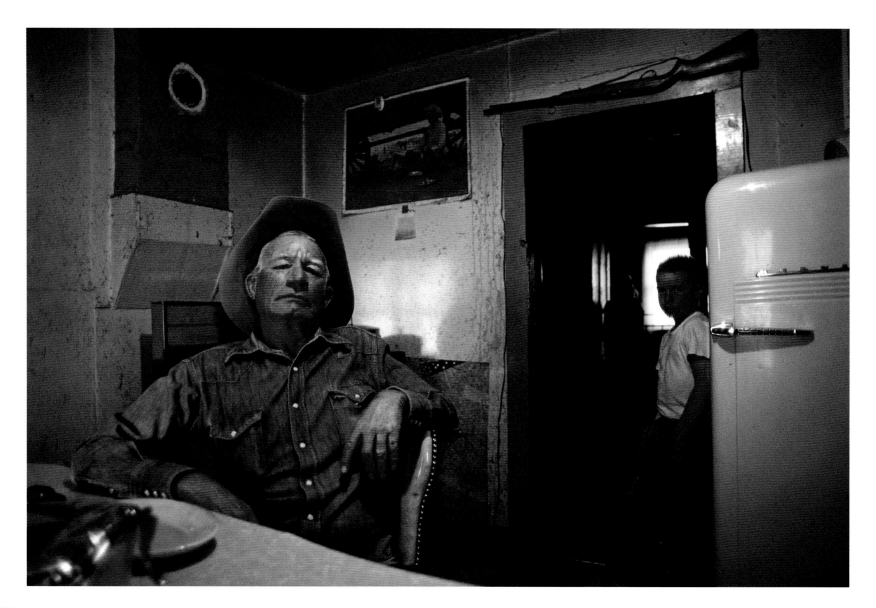

ANNIE GRIFFITHS | Oklahoma, 1982

A ticket seller at Cain's Ballroom smiles as wide
as Bob Wills, the famed bandleader whose
Texas Playboys helped make Cain's a legend.

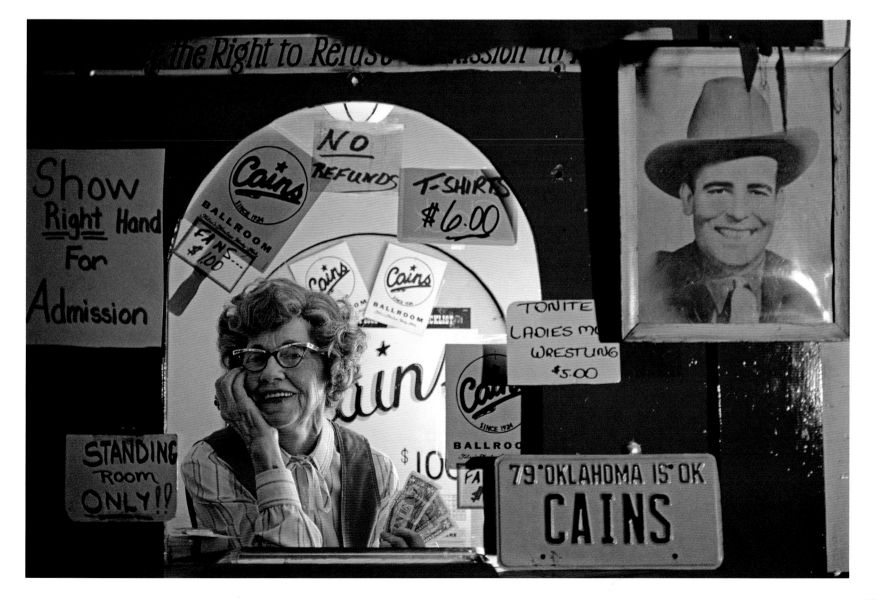

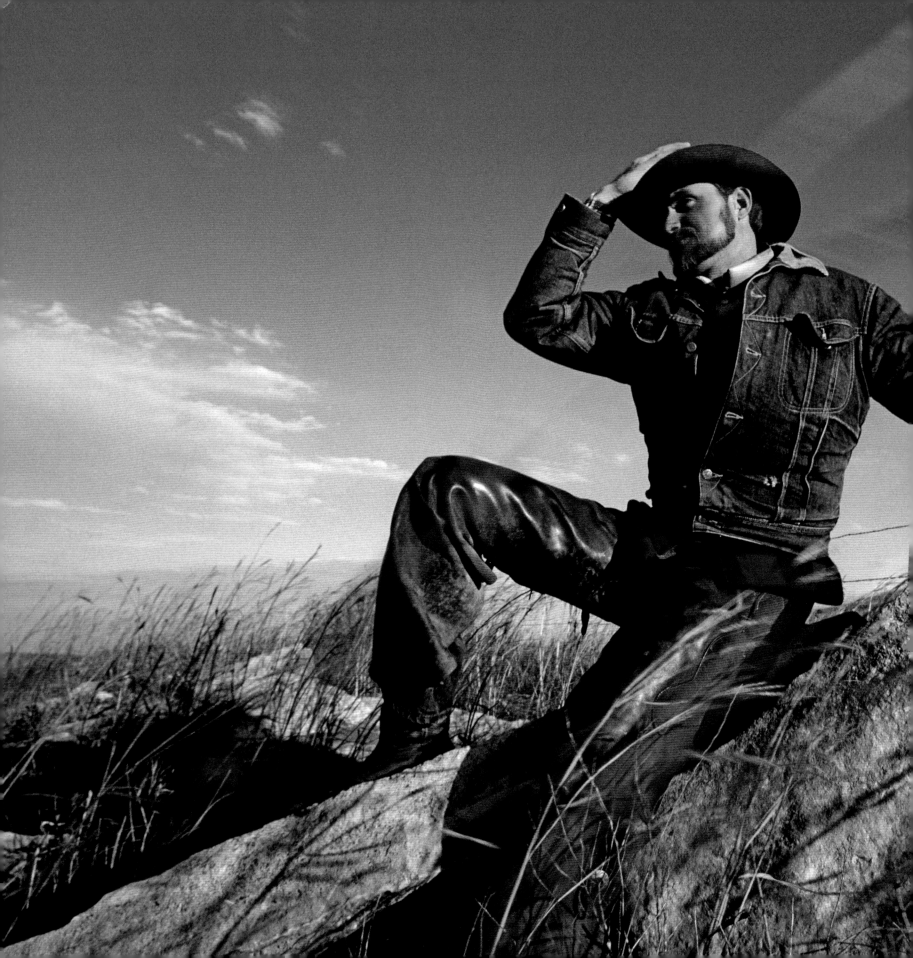

JIM BRANDENBURG | Kansas, 1980

A Flint Hills rancher surveys the vast prairie preserve his family has worked for five generations.

149

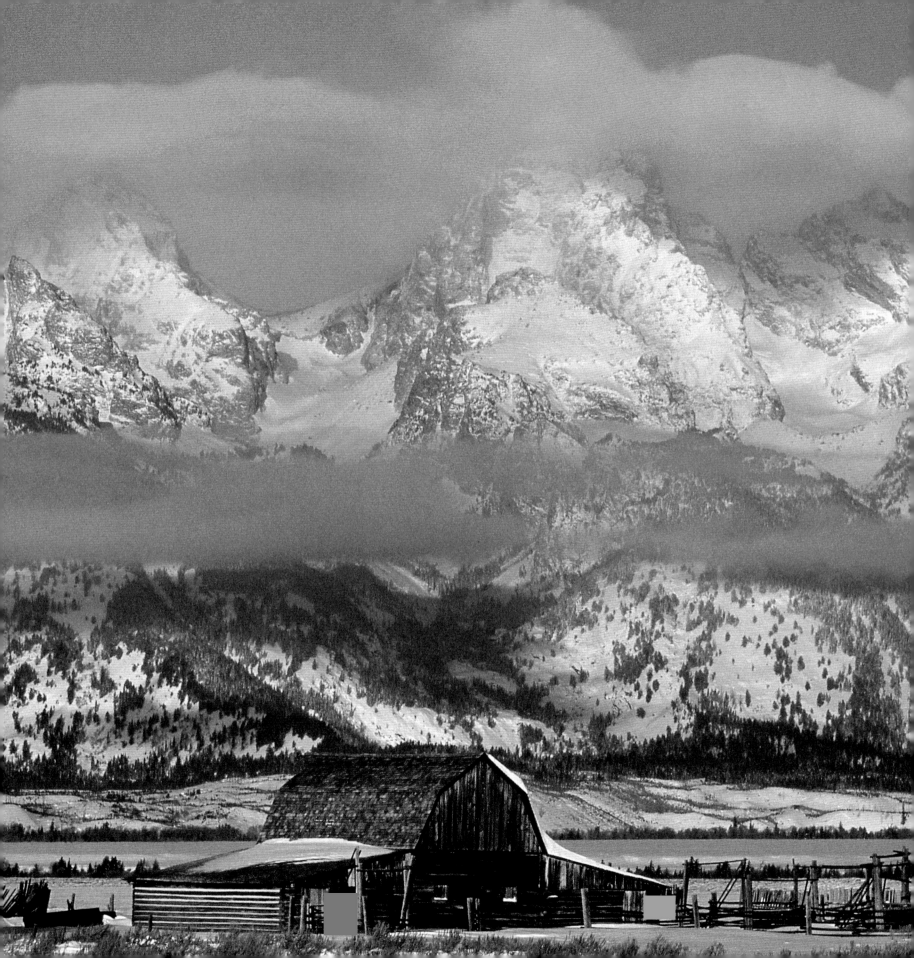

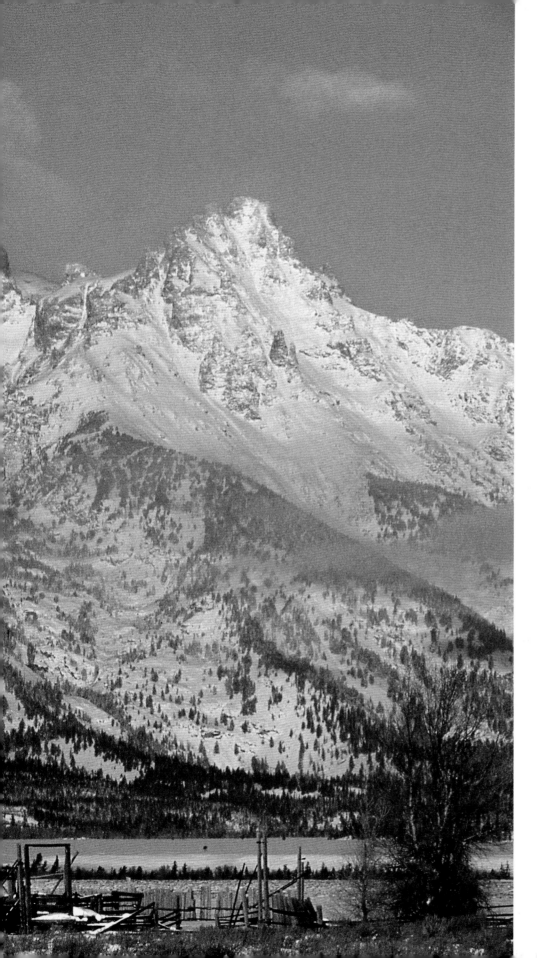

IRA BLOCK | Wyoming, 2006

Echoing the shape of the snow-covered Grand Tetons, this Mormon Row barn in Jackson represents one of 27 homesteads settled by migrating Mormons in the 1890s.

JOEL SARTORE | Montana, 2005

Back at the cabin at the end of a day in the Choteau backcountry, hunters and a dog admire their multi-pointed trophies.

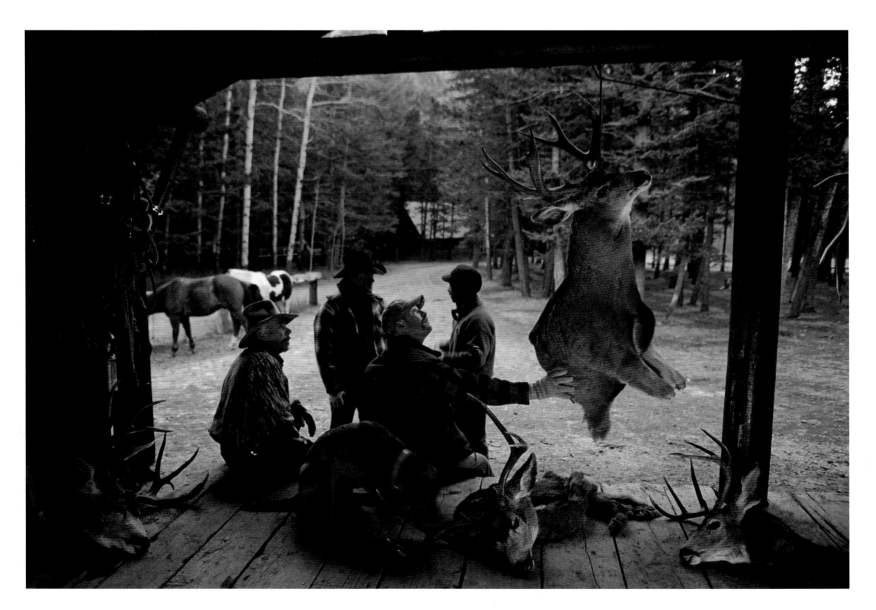

WILLIAM ALBERT ALLARD | South Dakota, 2007

Fluorescently clad hunters in the High Plains
near Eureka take a break as a recently killed
rooster pheasant cools in the truck bed.

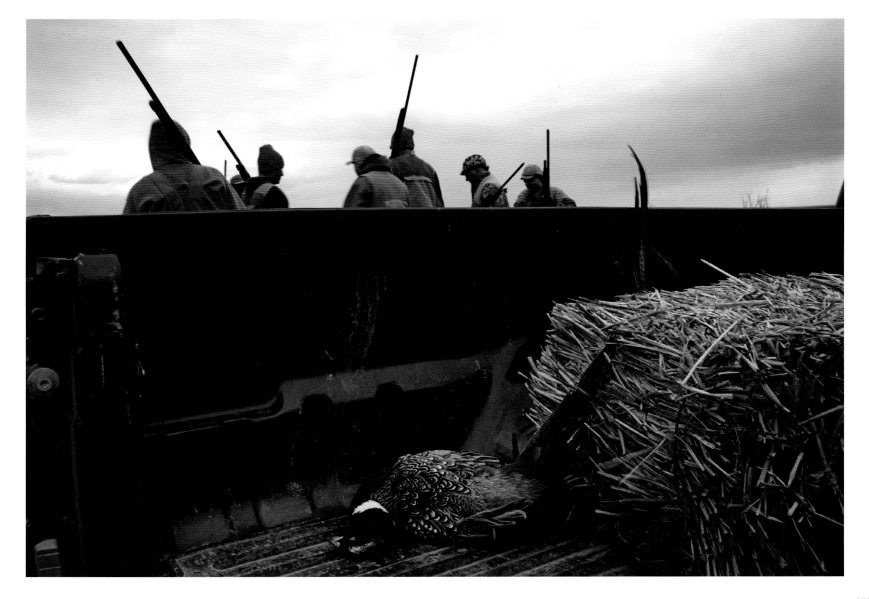

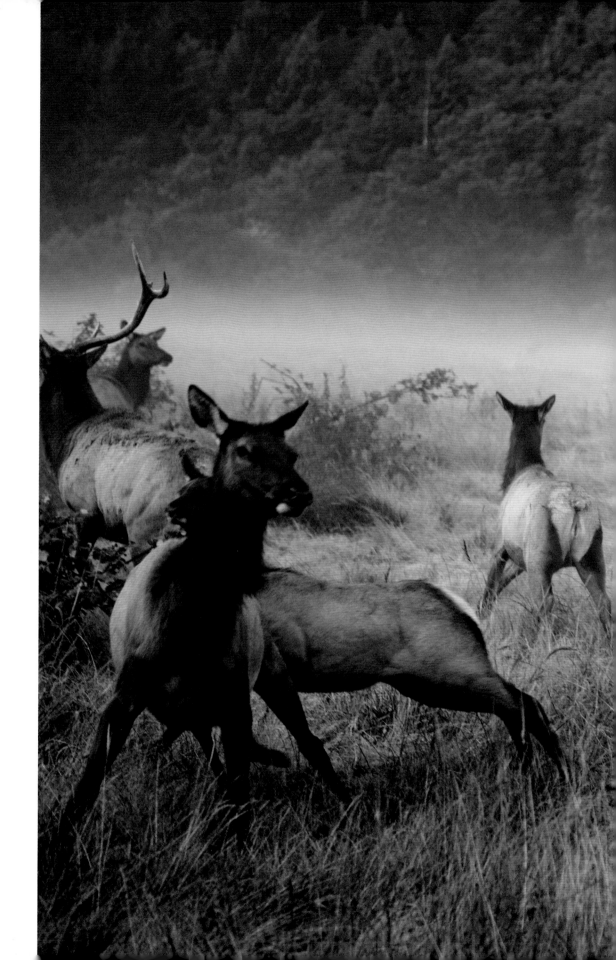

MICHAEL NICHOLS | California, 2008

A herd of once-endangered Roosevelt elk—
the physically largest elk subspecies in North
America—scatters across a meadow in Prairie
Creek Redwoods State Park.

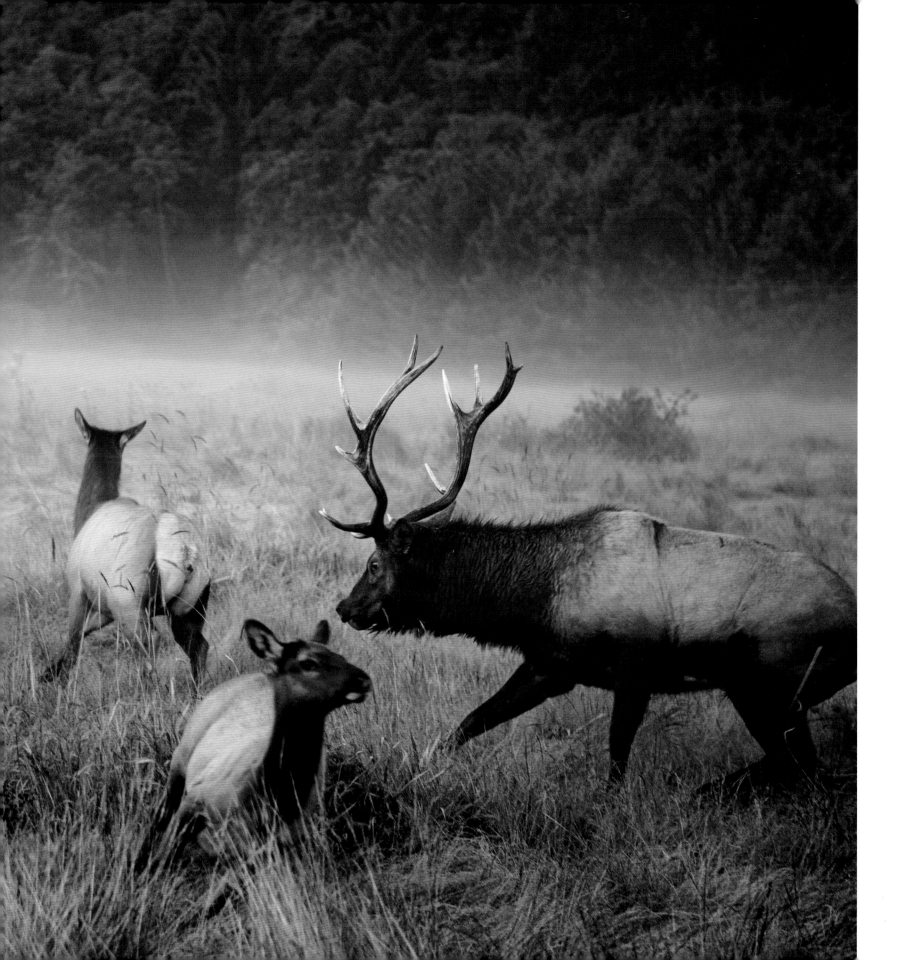

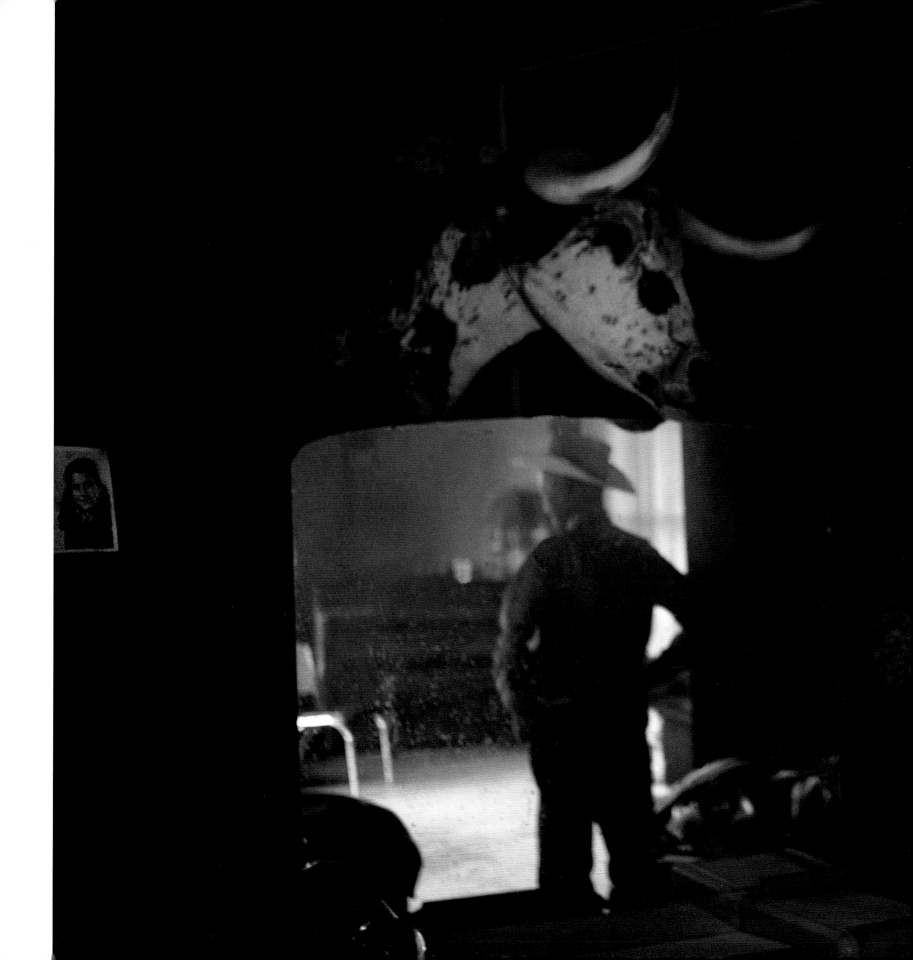

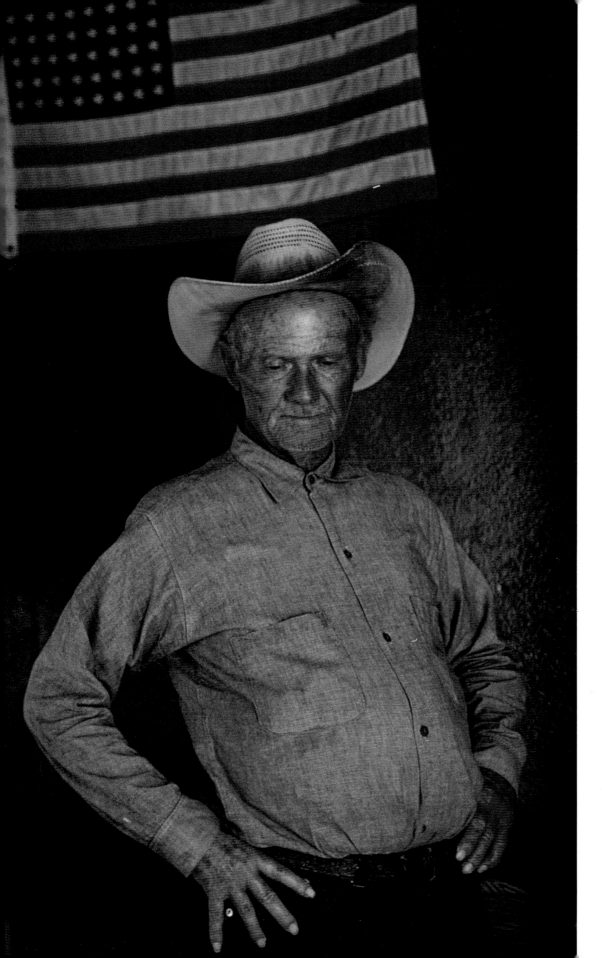

WILLIAM ALBERT ALLARD | Arizona, 1970

Beneath a sweat-stained hat and a 48-star flag, Henry Gray frets losing the federally owned rangeland on which he ran cattle for 50 years.

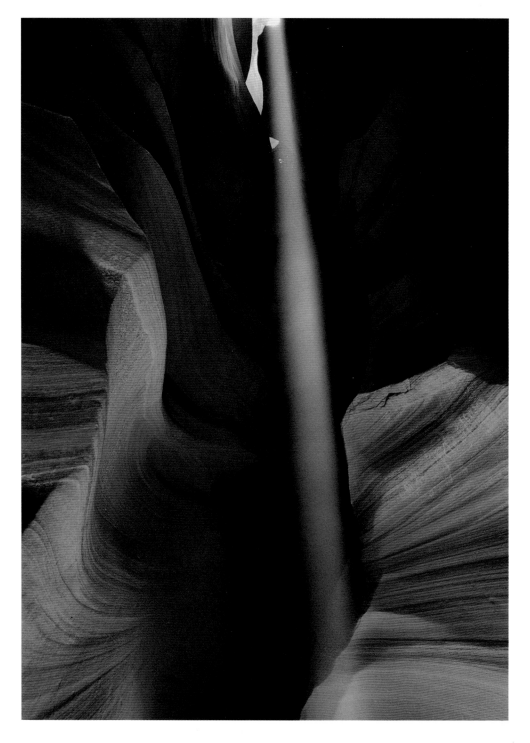

FRANS LANTING | Arizona, 2007

A shaft of light bisects the distinctive Navajo Sandstone shapes of Antelope
Canyon, a slot canyon near Page formed by millennia of flash flooding.

ASK PEOPLE WHAT COMES TO MIND WHEN THEY THINK

of the West, and the answer is often "open spaces" or "boundless skies." For more than a century, *National Geographic* photography has confirmed these expectations, capturing remote and sublime views in magnificent landscape portraits. Spread after eye-popping spread, we have stepped into the bigness of the West through the lens of *National Geographic*.

While wide-open spaces suggest freedom and opportunity, topography creates boundaries and divisions. Hot, dry deserts forbid crossings; mountain ranges rise up and canyons fall away, posing barriers to travel. And people create boundaries—political, economic, and even spiritual. The range-and-fencing wars and the painful settlement of Native Americans early on morphed into fights over water, mineral rights, immigration, and endangered species, all waged in the tacit recognition that open spaces do not mean unlimited resources.

In the first few decades of the 20th century, *National Geographic* recorded the amazement people felt at our ability to tame the natural world's boundaries. A 1905 story

BOUNDARIES

about Roosevelt Dam in Arizona—"the highest dam in the world"—found much to praise about the "reclamation" of the Salt River. A story from 1932 on Colorado spoke of the region as a travel barrier that had become a shining example of how dry plains could be transformed into verdant farms, and highways could open up mineral and scenic wealth. Fast-forward to the 1990s, and the magazine was already lamenting the overuse of rivers such as the Colorado—"a river drained dry"—and the questionable creation of such controls as the Glen Canyon Dam and Lake Powell, which resulted in "the Grand Managed Canyon."

The boundary between East and West is invisible. The real West begins around the 100th meridian, which roughly corresponds to the Missouri River in the Dakotas and the western third of Nebraska and Kansas. It's the line, as Pulitzer-winning writer Wallace Stegner notes, "beyond which unassisted agriculture is dubious or foolhardy and beyond which one experiences the western feel—a dryness in the nostrils, a cracking of the lips, a transparent crystalline quality of the light, a new palette of gray, sage-green, sulphur-yellow, buff, toned white, rust red, a new flora and fauna, a new ecology."

East of the Missouri in the Dakotas, for example, the land lies flat and unbroken, but cross the river and the scenery begins bulging into hills, blossoming out in buttes and mesas, twisting into dry gullies, as if the smooth carpet of the Midwest ran out of room and had to crumple before it hit the Rockies. West, the landscape is more untamed, the climate drier, the population sparser. Because fewer crops can grow here, ranches are far more common than farms.

You can drive for miles and miles through such scenery and, with a little imagination, never be bored—there is always a sense something is getting ready to happen. On

the horizon, a butte suddenly rises a thousand feet above the plain; steel gray clouds in the distance portend rain; the rain comes and in the mist afterward a tremendous heart-filling rainbow arcs across a quarter of the entire sky. The sky seems limitless, larger than the largest ocean you have ever beheld, and you cannot help looking to it for drama; peering skyward, you often find your spirits lifting, your sense of permanence becoming unmoored. Edward Abbey, stunned by the implausible sensory grandeur of big spaces, described it as a kind of illusion: "The silence, like the visual setting, seems unreal. Overdramatic. Contrived."

In earlier days, promoters of Western settlement lured people with false slogans such as "rain follows the plough," but their come-ons did get generations up and moving—farmers, ranchers, miners, oilfield workers, and builders turned the Western plains into the world's breadbasket and the desert into a fount of energy. The photographs have both followed and contributed to the massive migration west. Today's artificial boundaries are a natural response, signifying our need to fence off our own private paradises. While the Golden Gate Bridge serves as a grand gateway to the continent, welcoming home countless sailors and seafarers, the fence along the border of Mexico stands for "keep out, there's no more room."

Regardless of all boundaries, the limits to population in arid climates, and the grab for natural resources, the visual power of seemingly unlimited open space persists as a jolt to the imagination. Whereas early images of subjects like the Mountain of the Holy Cross, giant redwoods, and vast, open plains staggered the imaginations of our predecessors, new aerial photos expand everyday vision and provide new perspectives on our wide-open West.

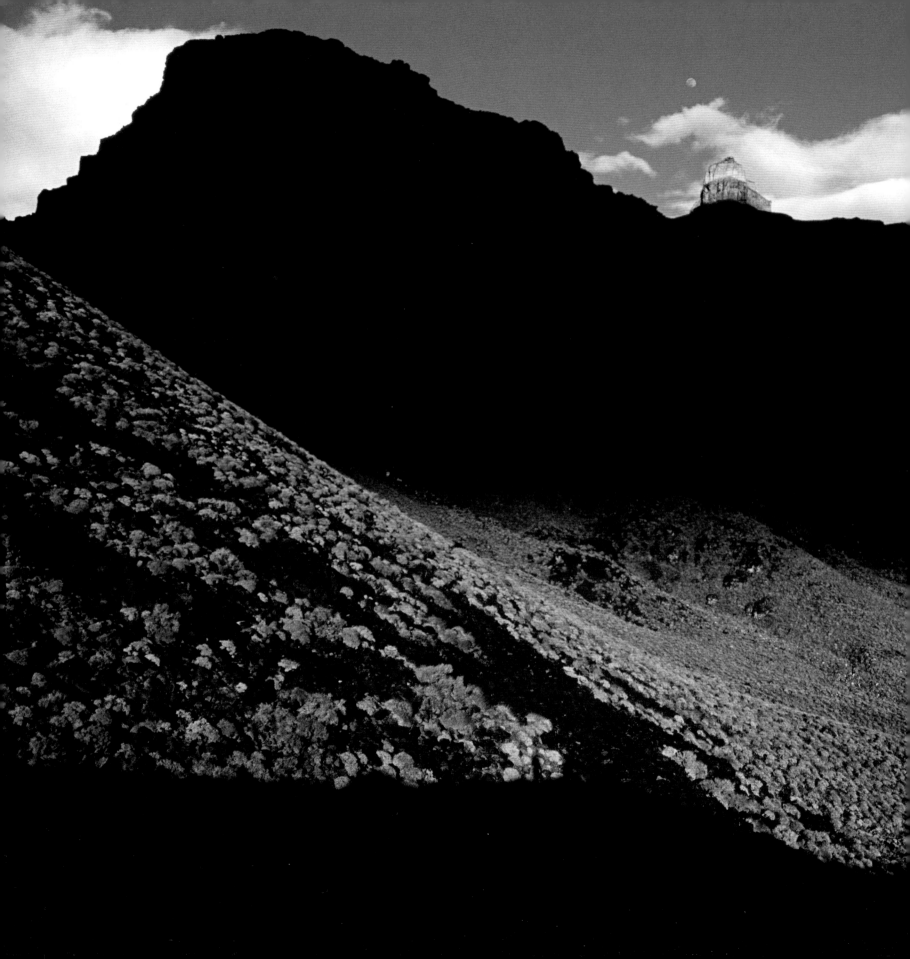

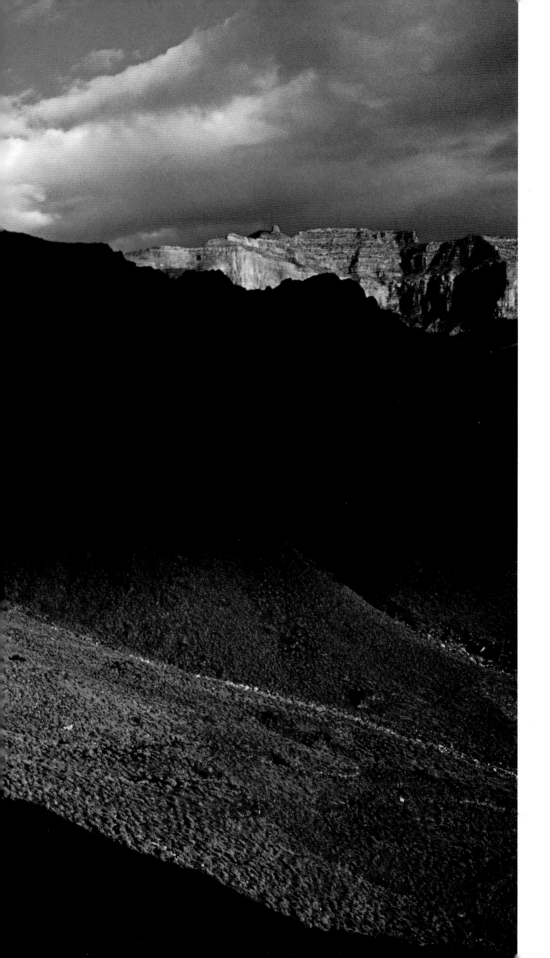

MICHAEL NICHOLS | Arizona, 2007

Dramatic cloud shadow, texture, color, and weather illuminate the verdant hillsides and geological vastness of the Grand Canyon.

JIM RICHARDSON | Nebraska, 2004

A pair of workers halts haying in the Sand Hills to watch with concern and awe as rolling thunderheads fill the afternoon sky.

"FOR FOLKS ON THE PLAINS AND GRASSLANDS, WEATHER IS AN EVERYDAY PARTNER. IT'S NOT A SOMETIMES THING—IT'S A CONSTANT THING. THEY WORK WITH IT, AROUND IT, AND RESPECT IT. THEY DON'T HAVE THE LUXURY OF A NICE AIR-CONDITIONED OFFICE."

—JIM RICHARDSON, 2012

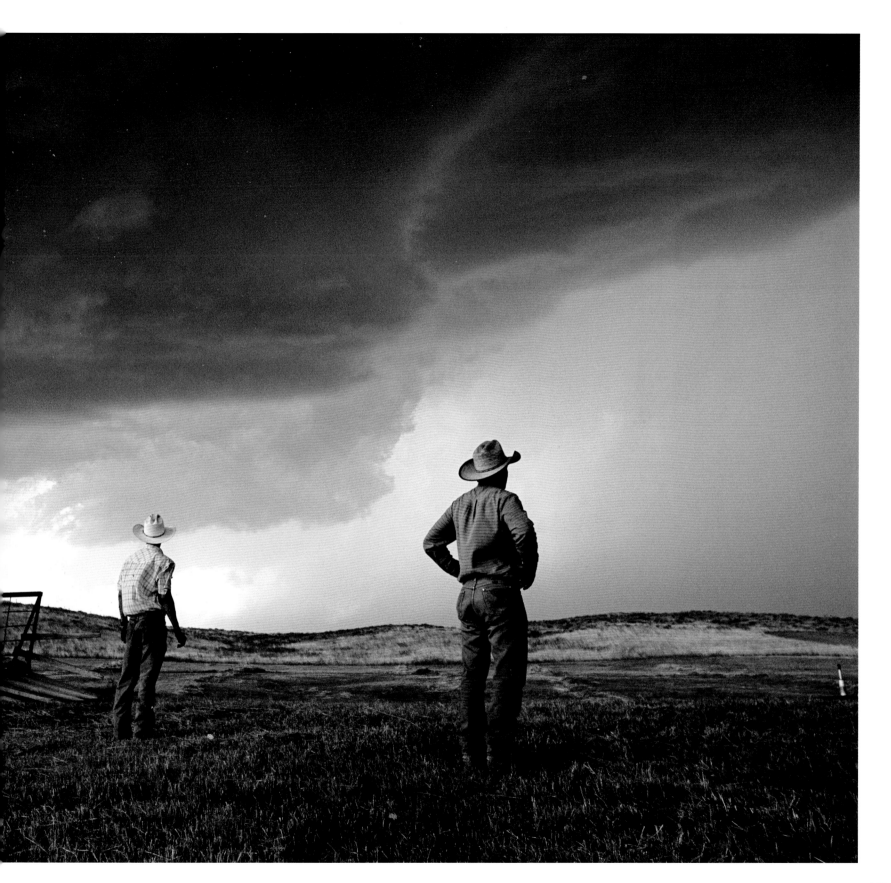

Agricultural plots run to the edge of Snake
River Canyon, suggesting the power of water
on the earth's fissures and fertility.

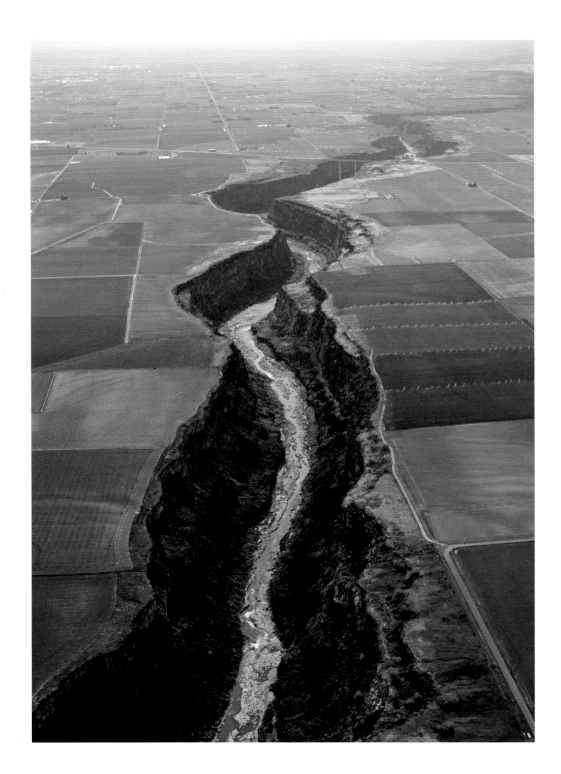

FRANS LANTING | California, 2011

Nature's palette expresses itself as moss, ferns, rocks, and hardwoods harmonize in Big Sur's Point Lobos State Natural Reserve.

following pages (168-169)

SAM ABELL | Montana, 1984

Jutting 2,400 feet above the infinite plains, Square Butte appears to rise as the sun sets over the boundless pink horizon.

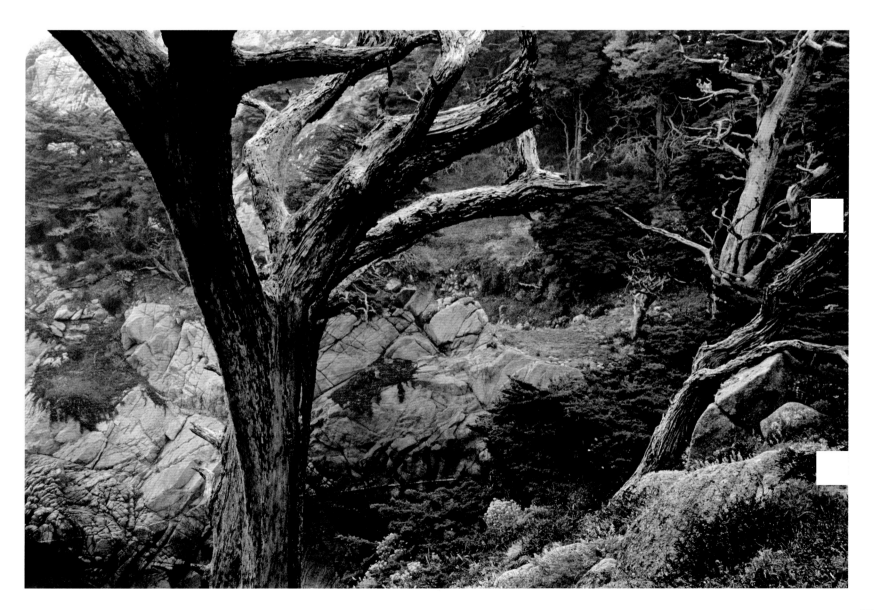

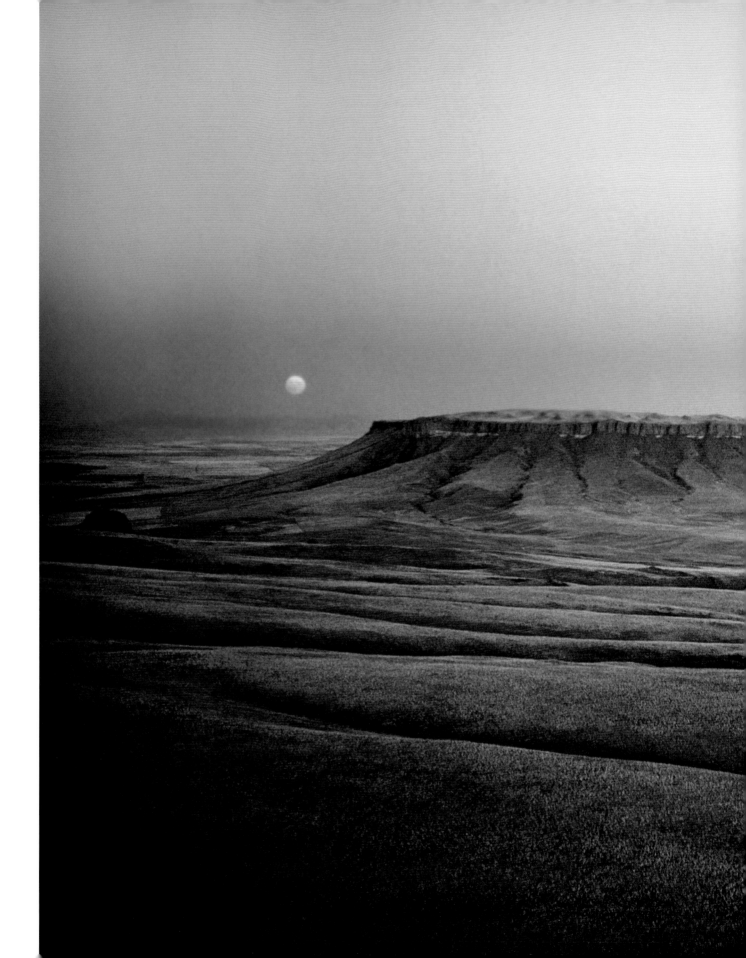

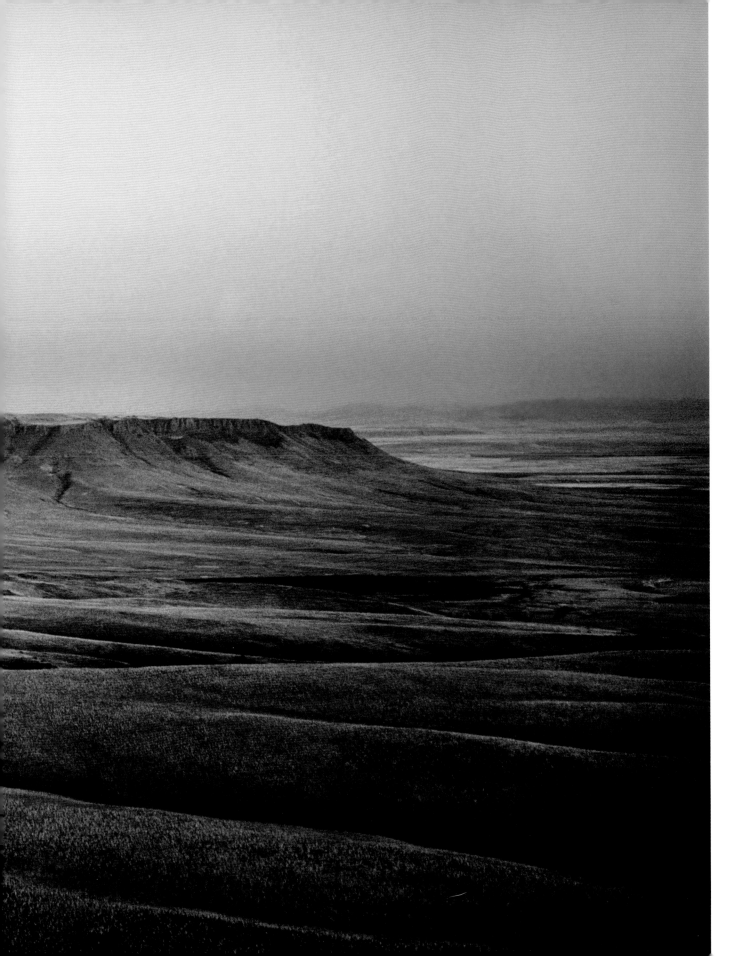

Carved by ancients into mesas east of the Big
Maria Mountains, the Blythe intaglios are so
huge in outline and so shallow in indentation
that they are only visible to those in the heavens.

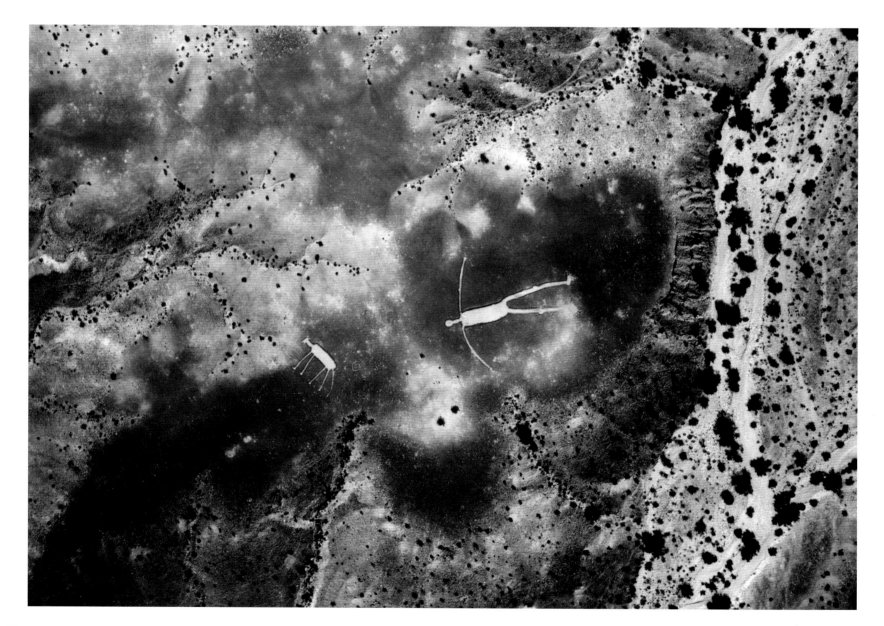

Modern civilization's need for ritual self-expression takes form in Black Rock City, the temporary desert community of 45,000 that partakes in the weeklong Burning Man festival.

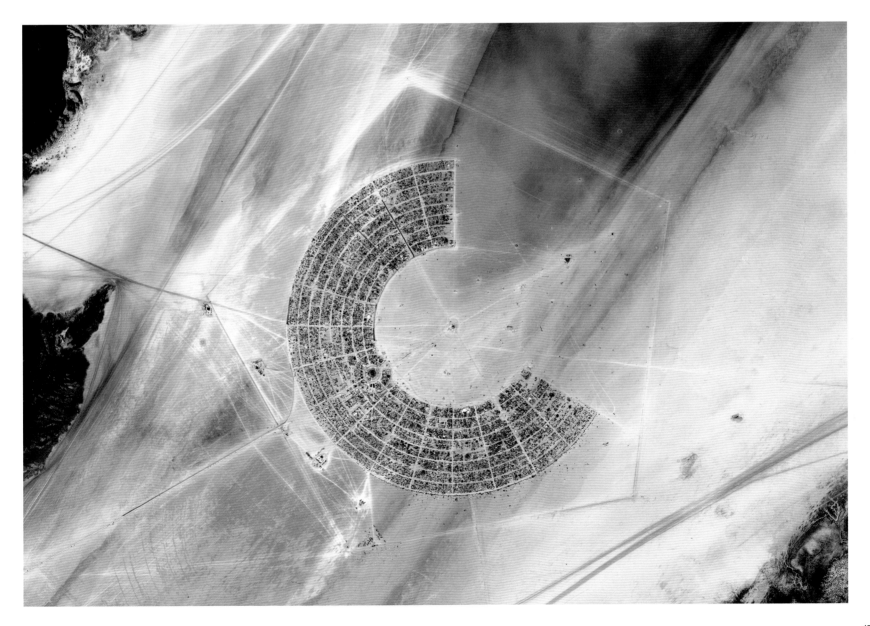

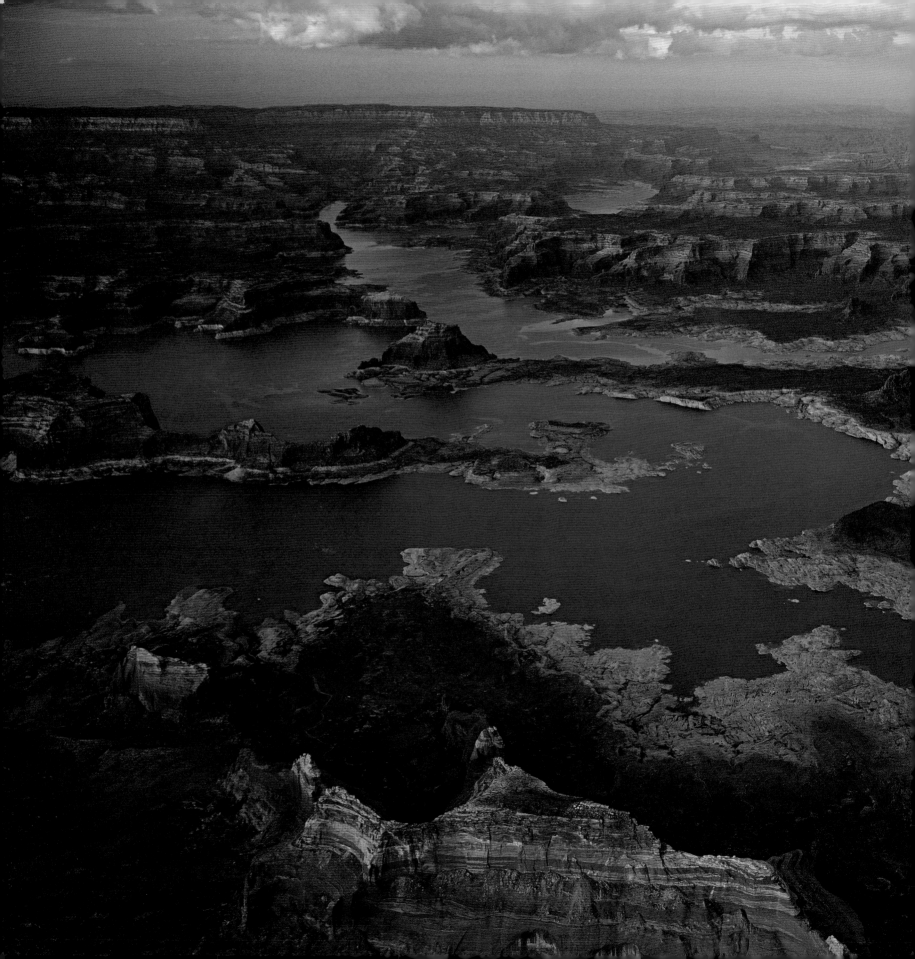

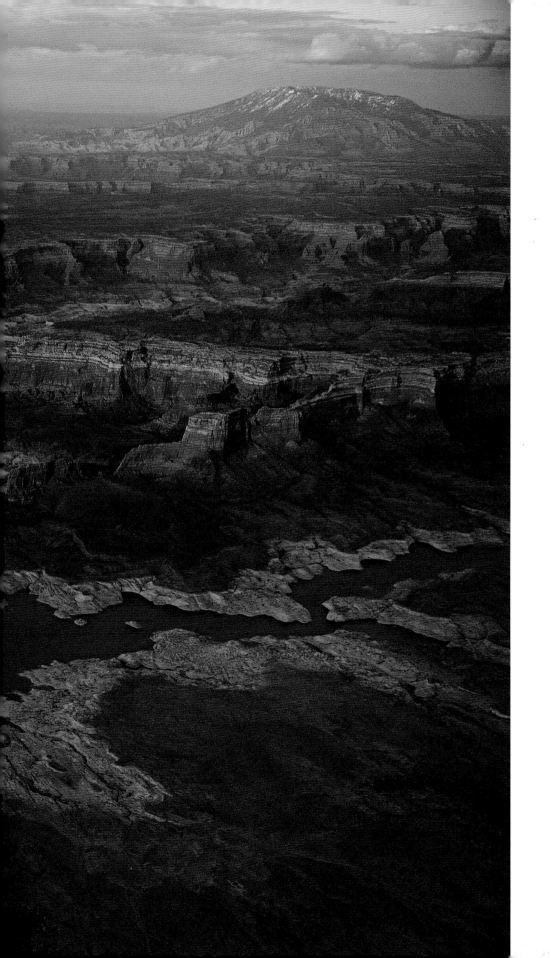

MICHAEL MELFORD | Utah, 2006

Drought-induced levels of water in Lake Powell reveal the latticework of Glen Canyon for the first time since the Colorado River was dammed to create the reservoir in 1963.

JIM RICHARDSON | Arizona, 1991

A long twilight exposure sets aglow hundreds of campers on Lake Powell's Lone Rock Beach as they batten down against a dust storm created by high winds and a beach expanded by drought.

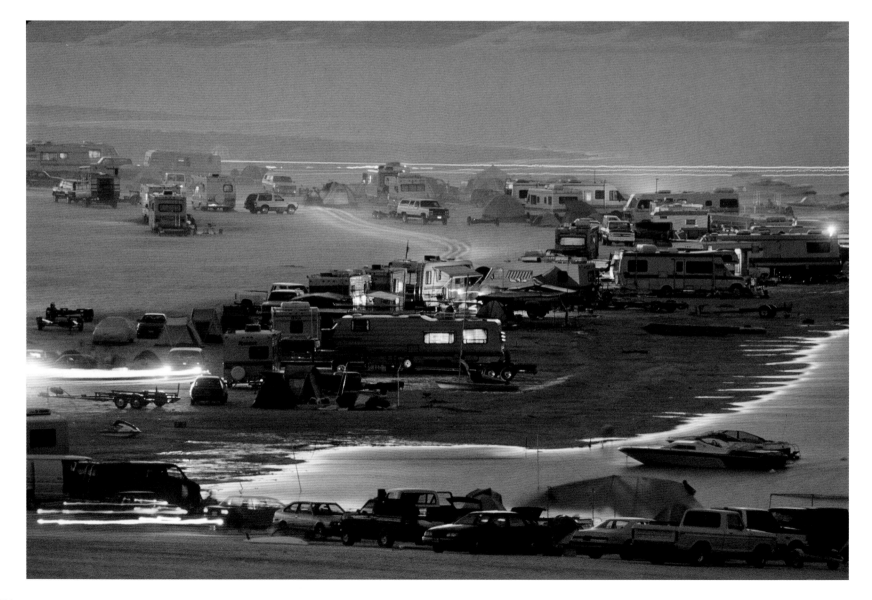

GERD LUDWIG | California, 2005

Without irrigation canals delivering Colorado
River water, the half-million acres of Imperial
Valley croplands—which use more water than
Los Angeles and Las Vegas combined—
would revert to desert.

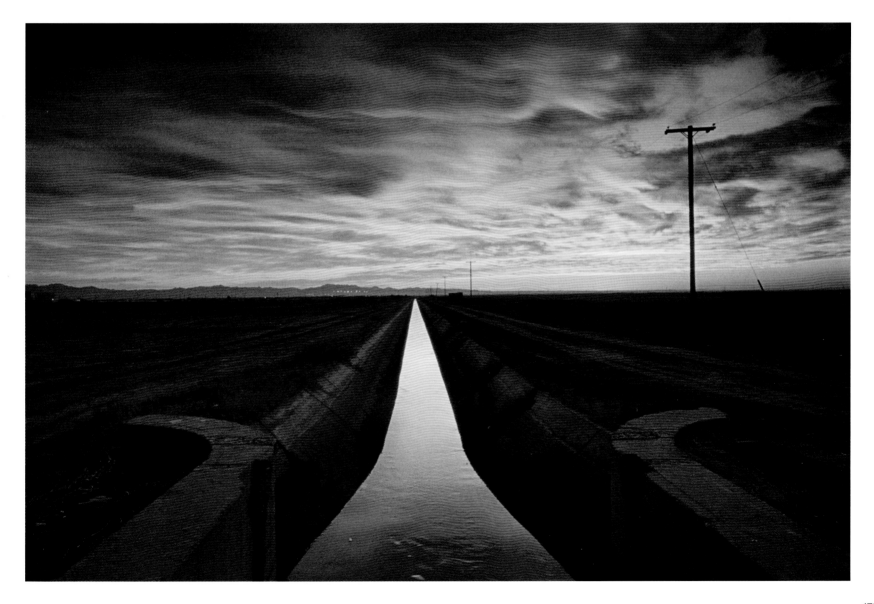

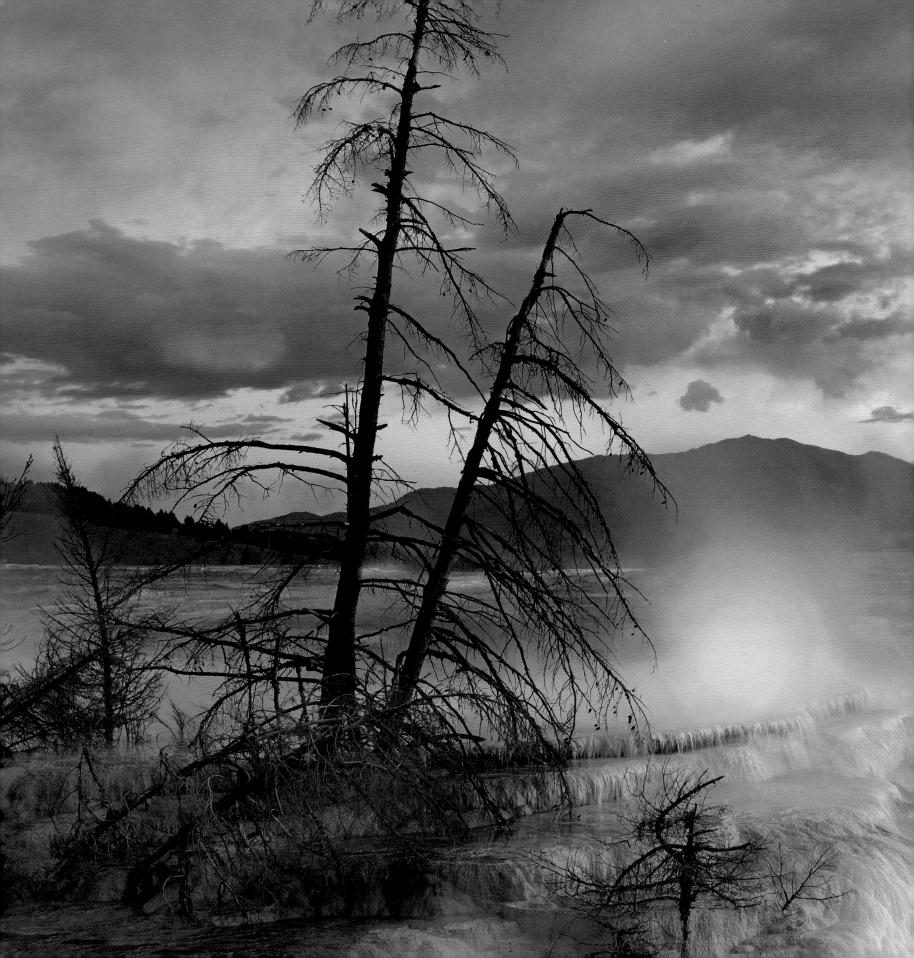

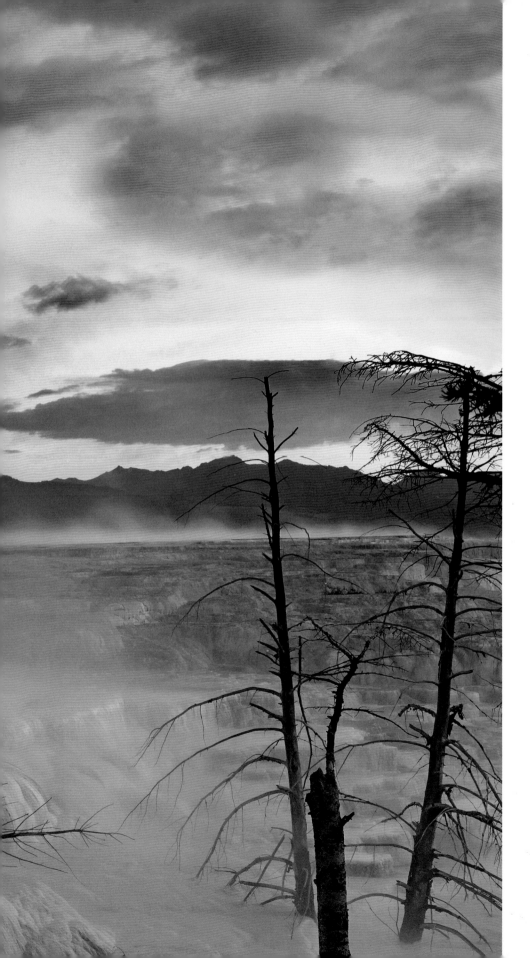

TIM FITZHARRIS | Wyoming, 2007

Beneath a dappled sky, geothermal steam rises mystically from the multihued travertine formations of Minerva Terrace at Yellowstone's Mammoth Hot Springs.

Dawn breaks over Big Bend Ranch State Park
on the border of the U.S. and Mexico, bathing
in warm pastels the corrugated cliffs of
Chihuahua along the sinuous Rio Grande.

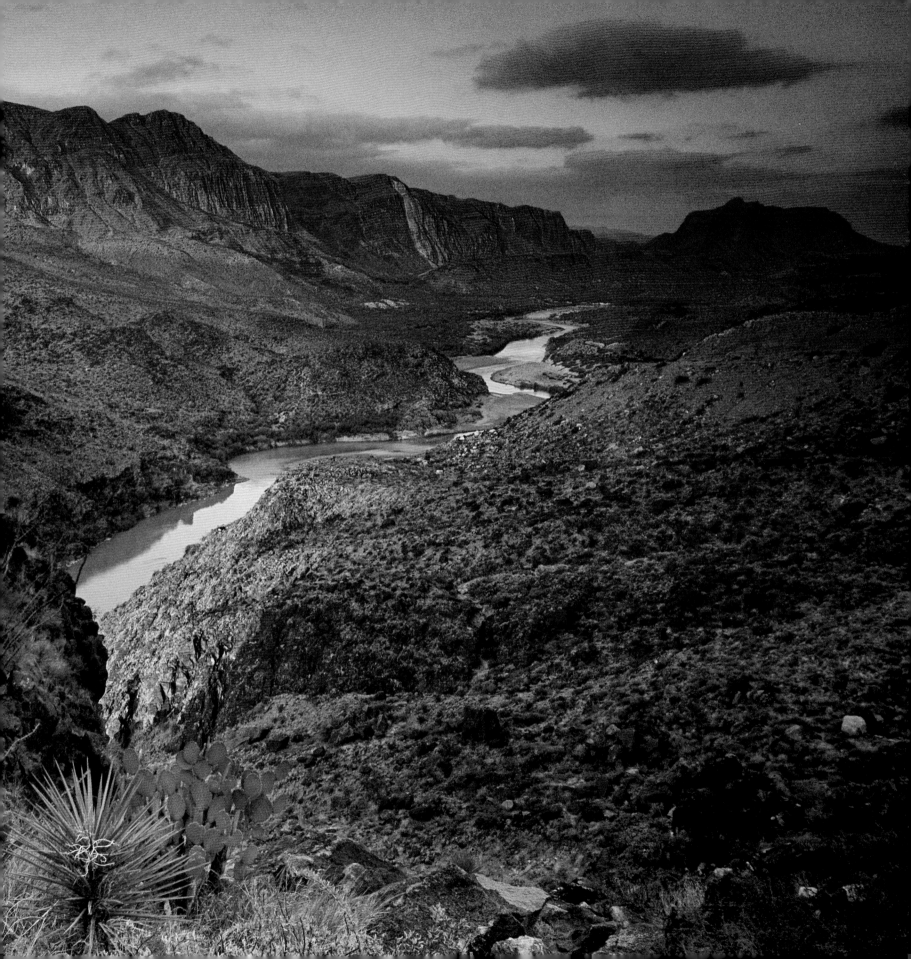

JIM BRANDENBURG | Oklahoma, 1993

Smoke and fire, backlit by the sun, resemble volcanic lava flows as a prescribed burn engulfs part of the Tallgrass Prairie Preserve to remove old growth and sustain the prairie ecosystem.

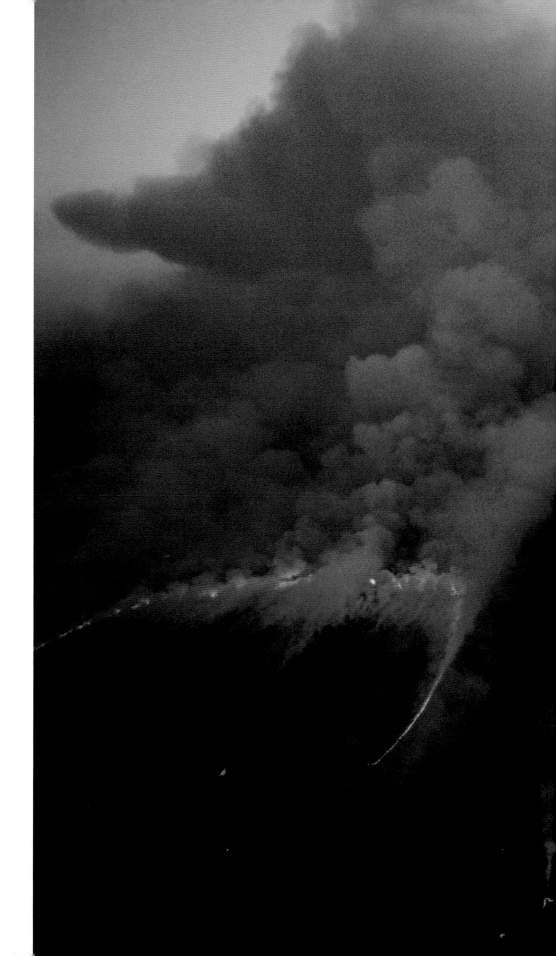

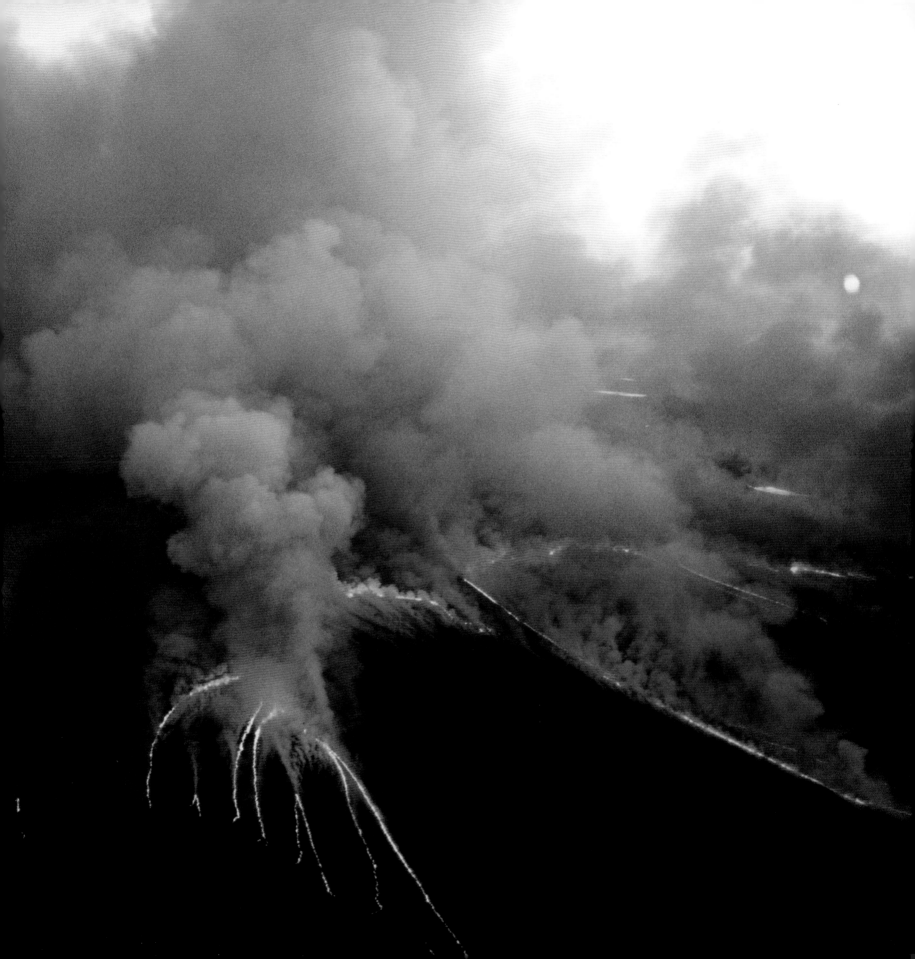

JOEL SARTORE | Wyoming, 2005

Photographing the minnows of the muddy
Powder River in a clear, thermal-glass
aquarium creatively reveals the aquatic life
that would suffer from natural gas drilling.

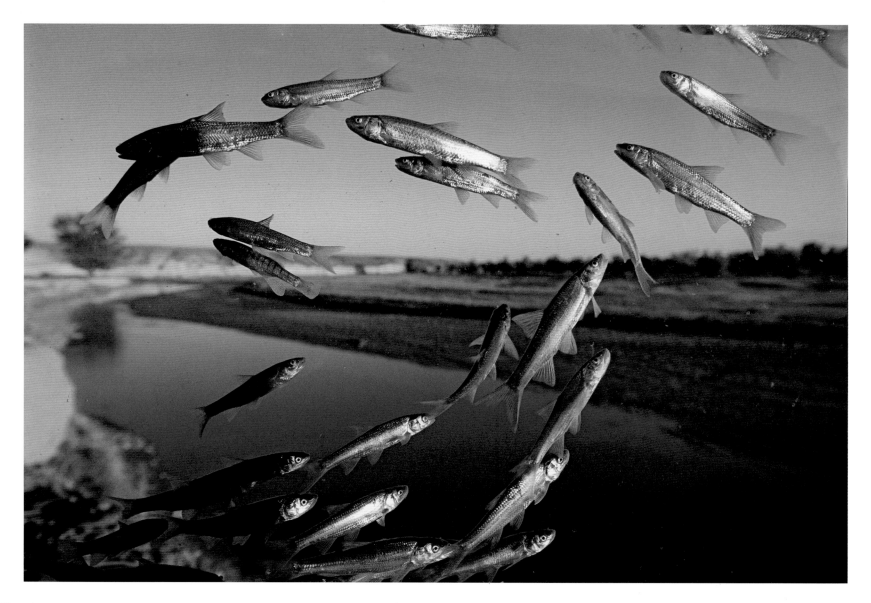

JIM RICHARDSON | California, 1990

From the acres of Salton Sea lake bed desiccated by salt and agricultural runoff emerges an intricate pattern of layered lines and shadows—the visual equivalent of a musical fugue.

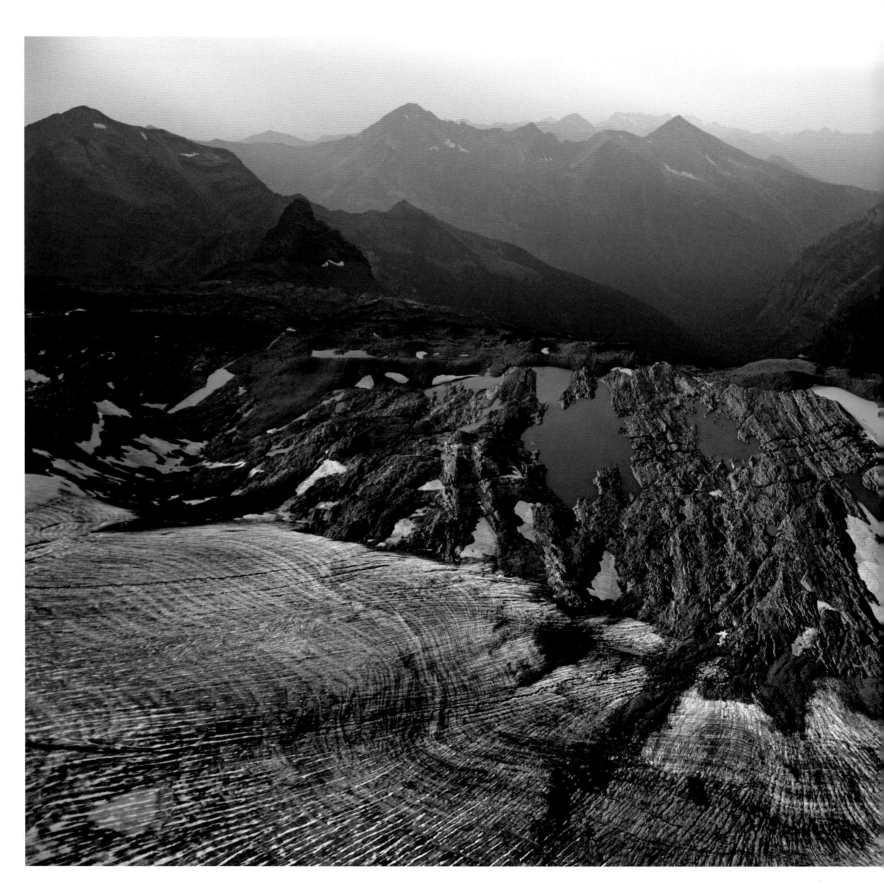

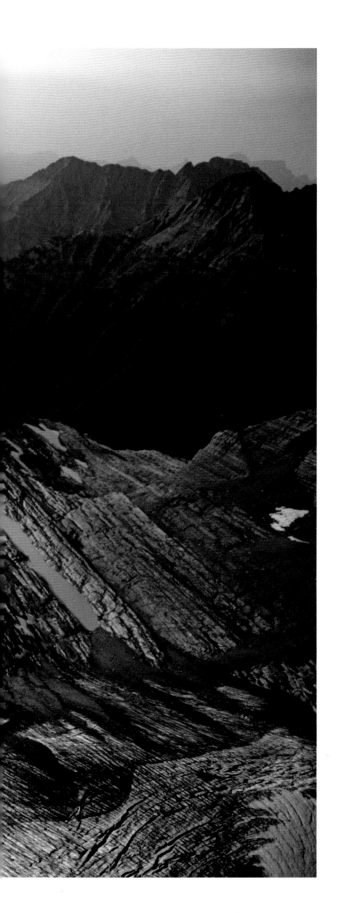

Climate change has reduced by 80 percent the number of Glacier National Park's namesakes. Bare rock and meltwater pools mark the edge of the largest one, Harrison Glacier.

"THERE LAY THE GLACIER, SHRIVELED AND SHRUNKEN FROM ITS FORMER SIZE, ALMOST SENILE . . . PUTTING UP ITS LAST FIGHT FOR LIFE. IT WAS STILL WHAT SEEMED TO BE A LUSTY GIANT, BUT IT WAS DYING, DYING, DYING."

—ALBERT SPERRY, IN GLACIER NATIONAL PARK, 1894

Moss coats a copse of alders in one of Big Sur's numerous lush, fern-covered, and unspoiled wilderness areas.

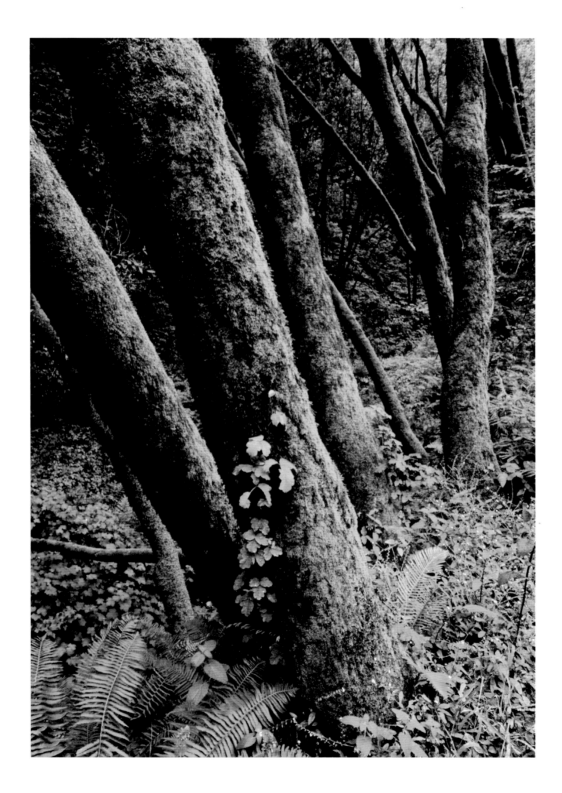

MARK THIESSEN | Idaho, 2007

Forest fires present greater danger than ever in
the West. This blaze near Warm Lake claimed
a half-million acres of subalpine forest.

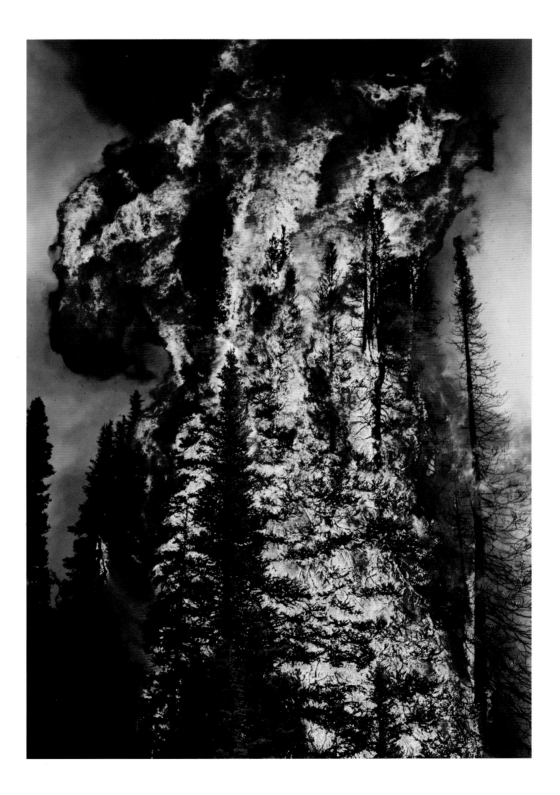

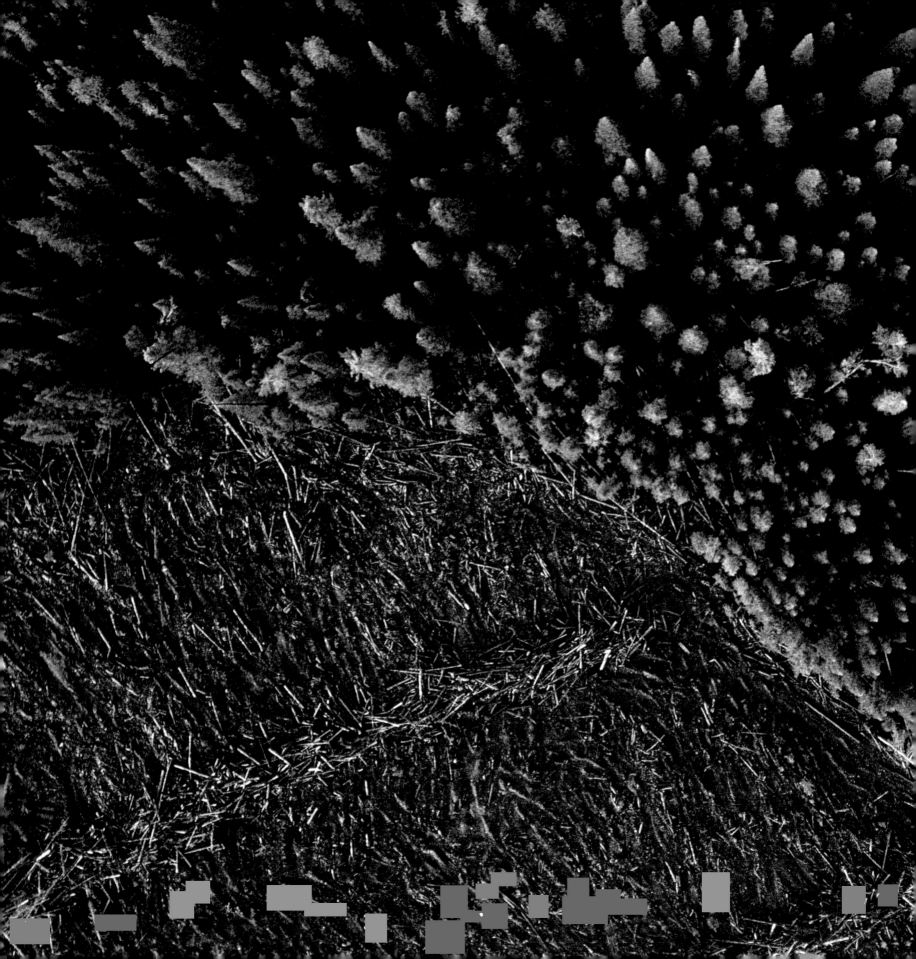

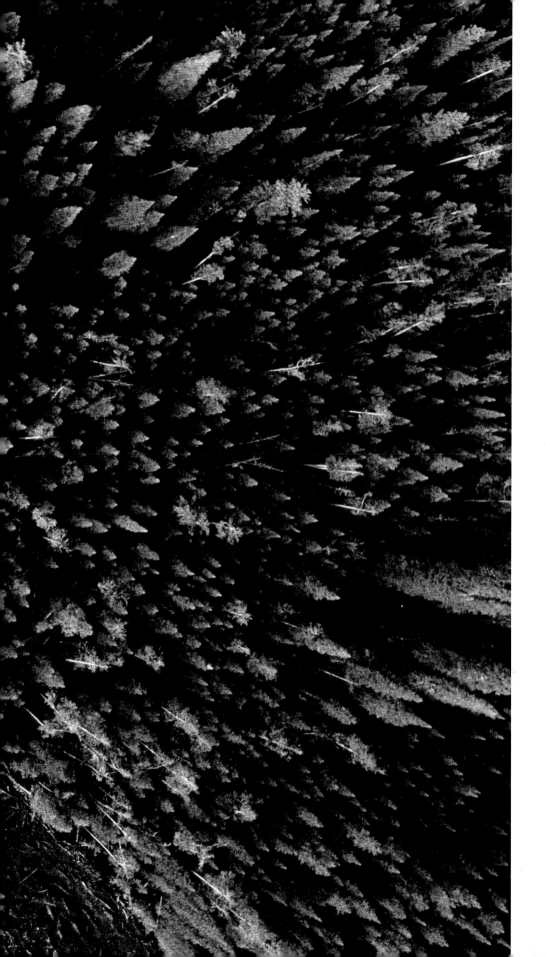

JOEL SARTORE | Idaho, 2009

Clear-cutting on federal land, such as Salmon-Challis National Forest, endangers not just trees but entire ecosystems. The aerial view dramatizes the contrast between lumber and forest.

BRUCE DALE | Colorado, 2005

Sunlight peeks between the straight white trunks and turning leaves of 404 members of an aspen colony in the San Isabel National Forest.

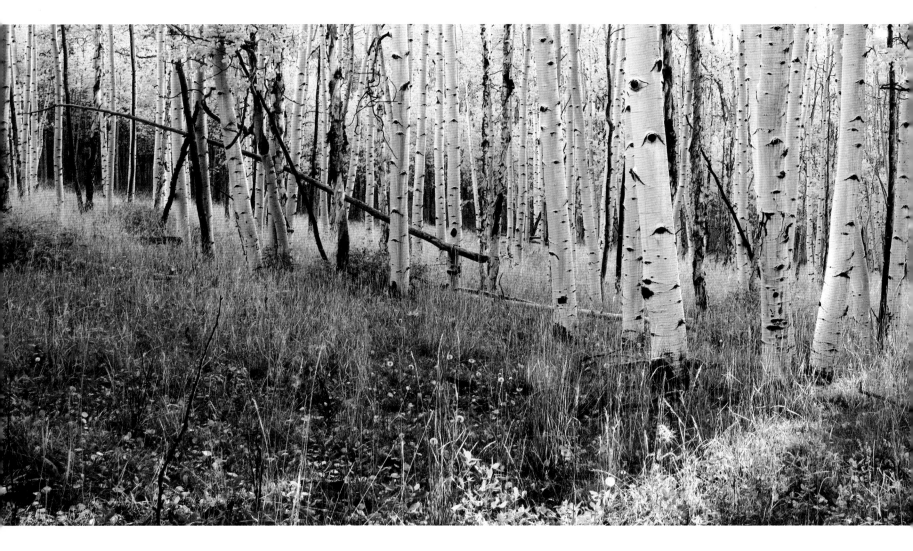

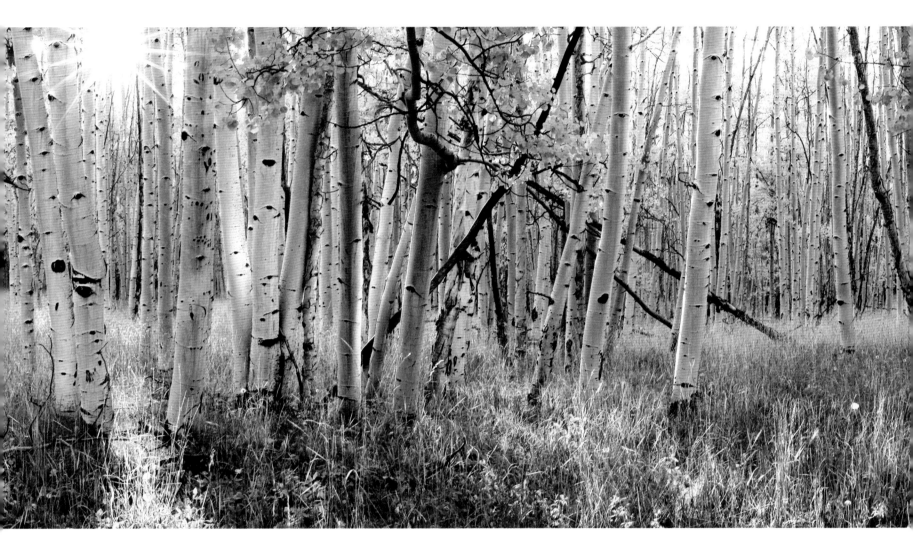

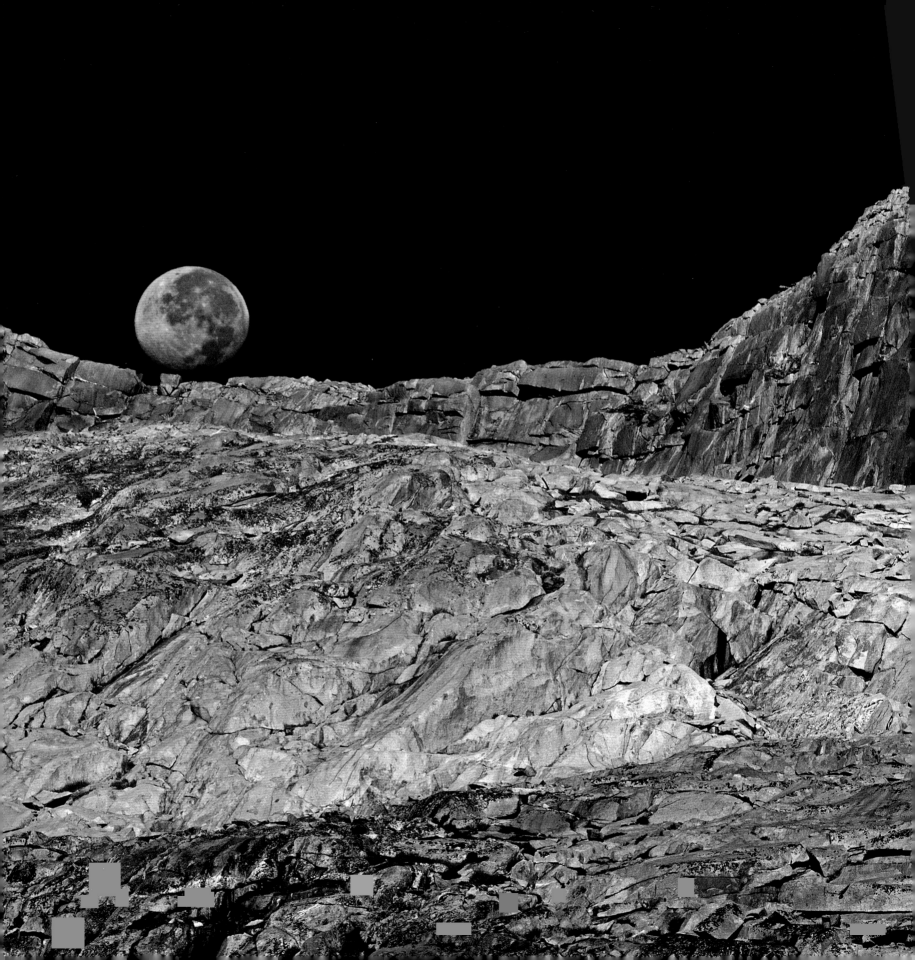

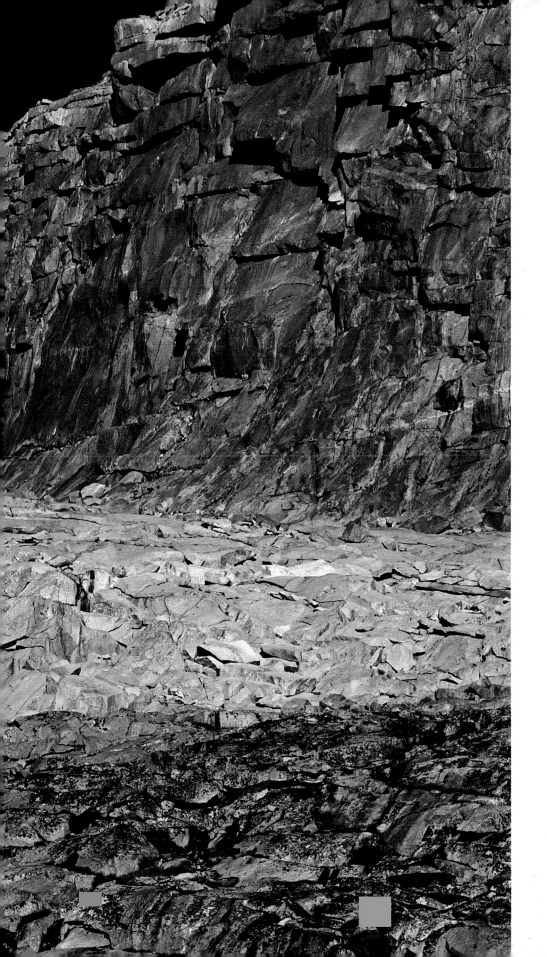

PETER ESSICK | California, 2011

A setting moon creates an appropriately otherworldly backdrop for the lunar-like landscape near Donohue Pass on the northern reaches of the Ansel Adams Wilderness area.

"God's gift to the United States Air Force," the
470 square miles of Edwards Air Force Base
provide the ideal conditions to test aircraft
and spacecraft to explore the next frontier.

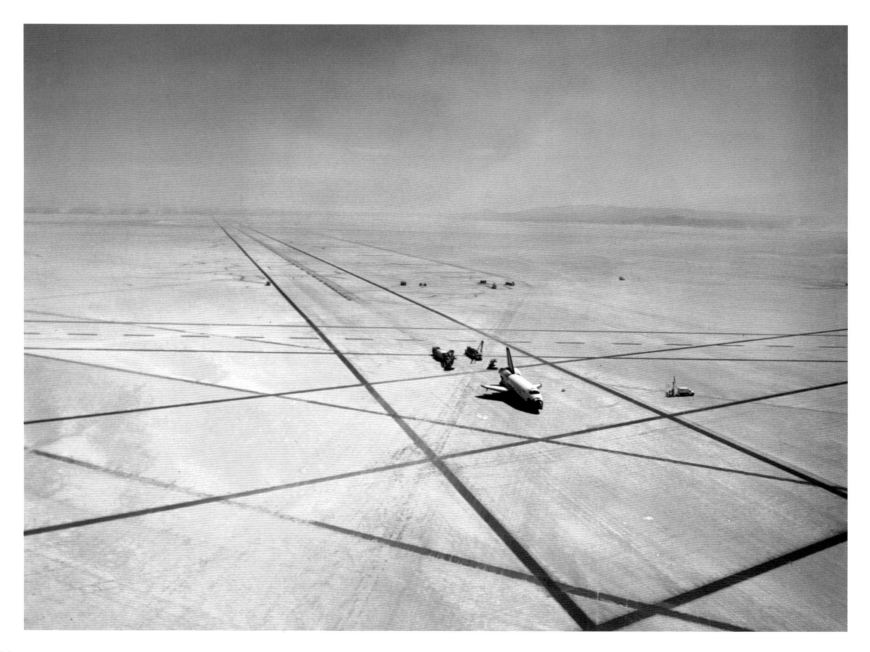

After wildfires destroyed three million acres of Idaho and Montana timberland in 1910, fire patrol vehicles such as this one in the Sierra National Forest became commonplace.

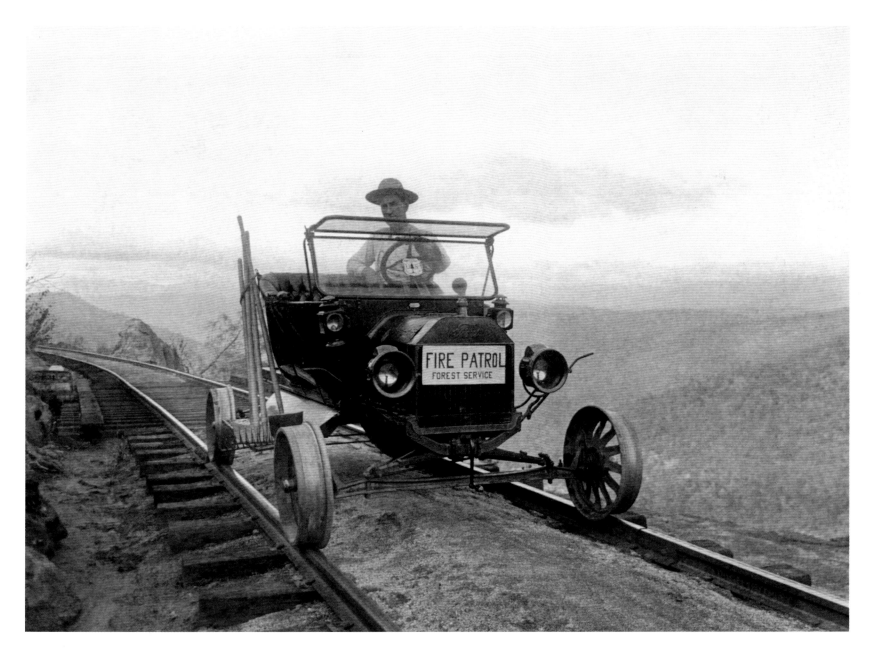

J. M. MAURER | Texas, 1913

Catering to trains, cars, and pedestrians,
the two-mile Galveston Causeway opened in
1912, connecting the island to the mainland.

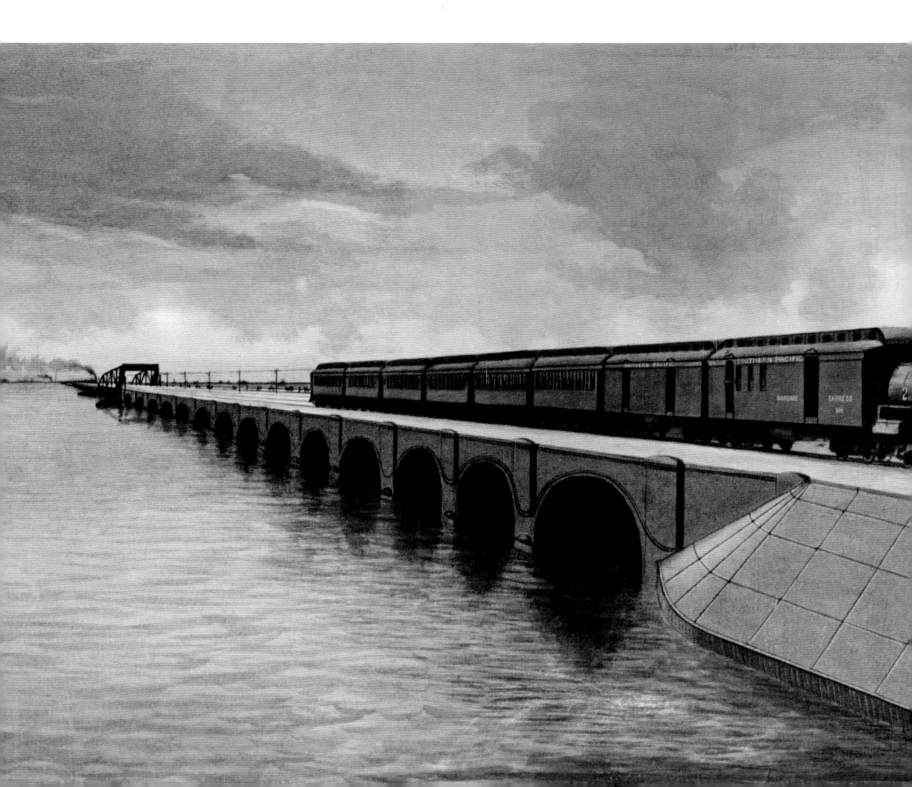

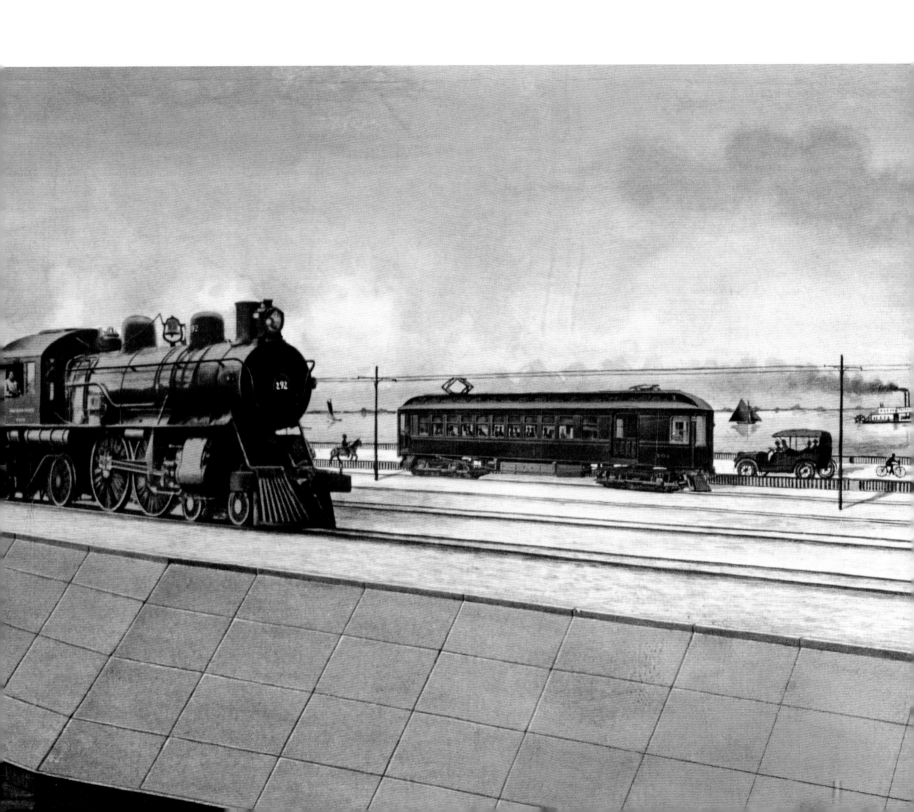

DIANE COOK & LEN JENSHEL | Arizona, 2007

Flags jut like bayonets toward the border of Mexico in Naco. A private group built the nearly mile-long fence on a local rancher's land, promising to seal the border if the government does not.

"JUST AS OUR HOUSES HAVE DOORS AND LOCKS, SO DO BORDERS CALL FORTH GARRISONS, CUSTOMS OFFICIALS, AND, NOW AND THEN, BIG WALLS. THEY GIVE US DIVIDED FEELINGS BECAUSE WE DO NOT LIKE TO ADMIT WE NEED THEM."

—CHARLES BOWDEN, 2007

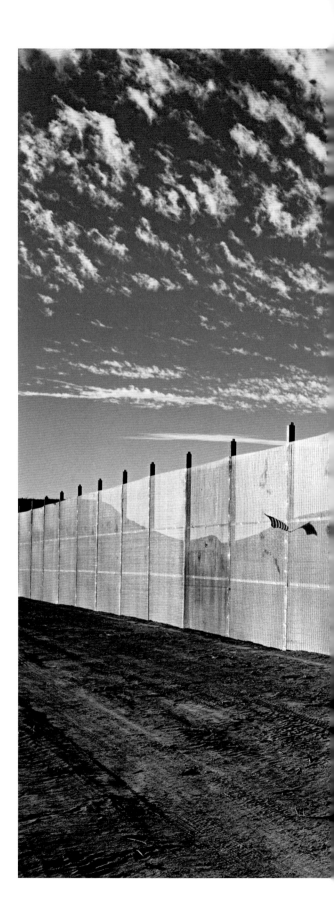

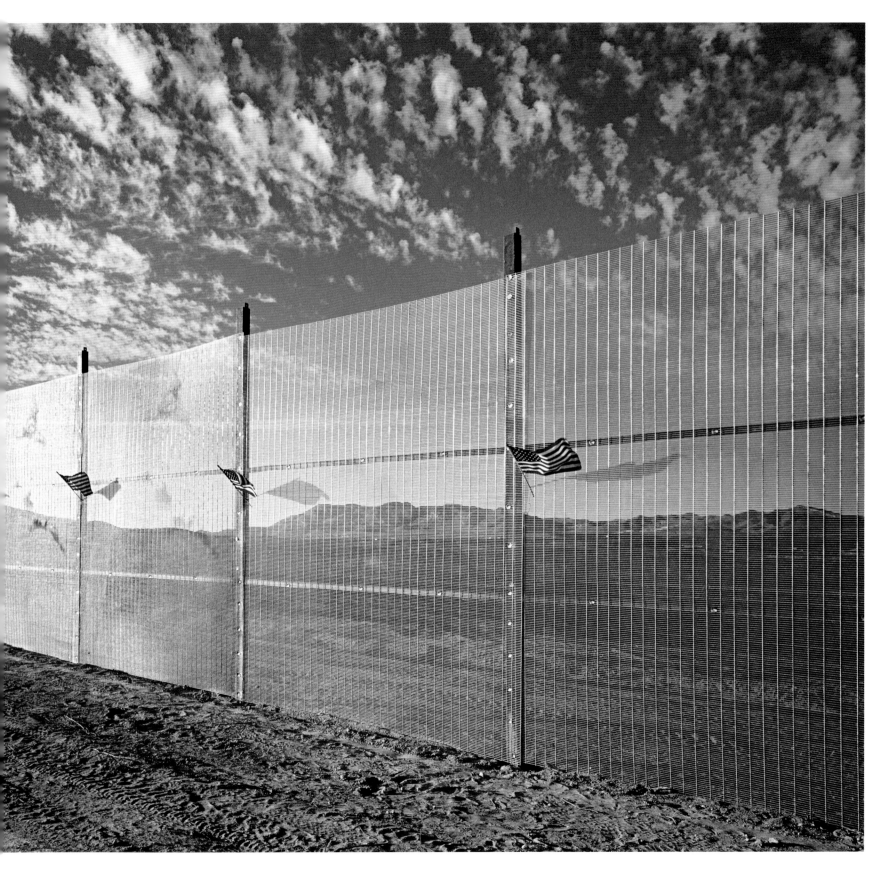

VINCENT LAFORET | *Arizona, 2007*

Phoenix's verdant exurbs push the boundaries of the desert and nature's ability to sustain mankind's unquenchable thirst for water and environmental control.

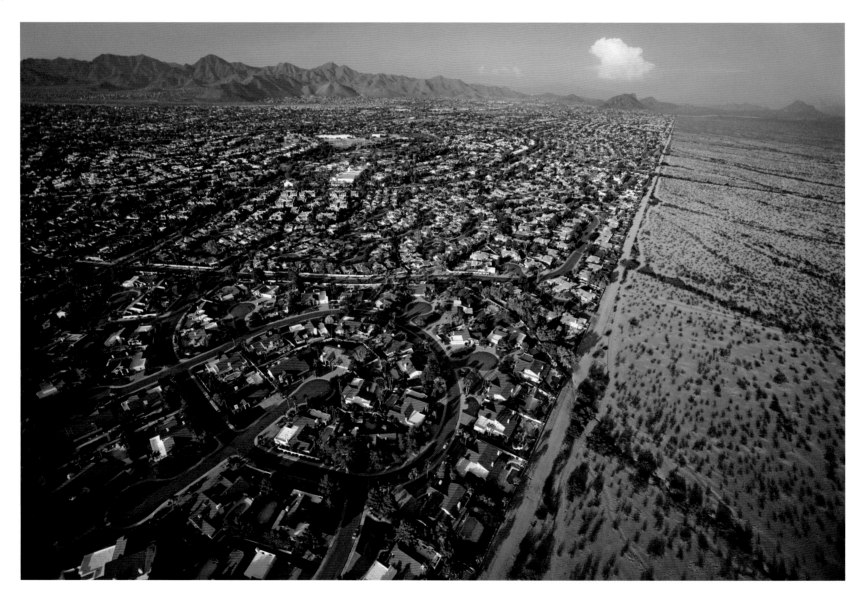

JIM RICHARDSON | Colorado, 1996

Unlike eastern growth, which is organic and responsive, western growth is intentional and proactive. East of Denver, highway interchanges are built to places that do not yet exist.

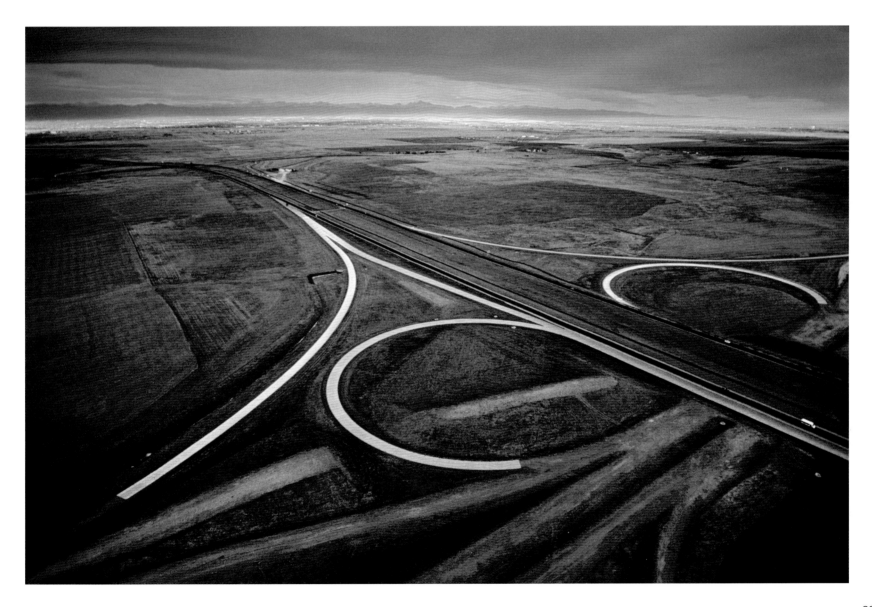

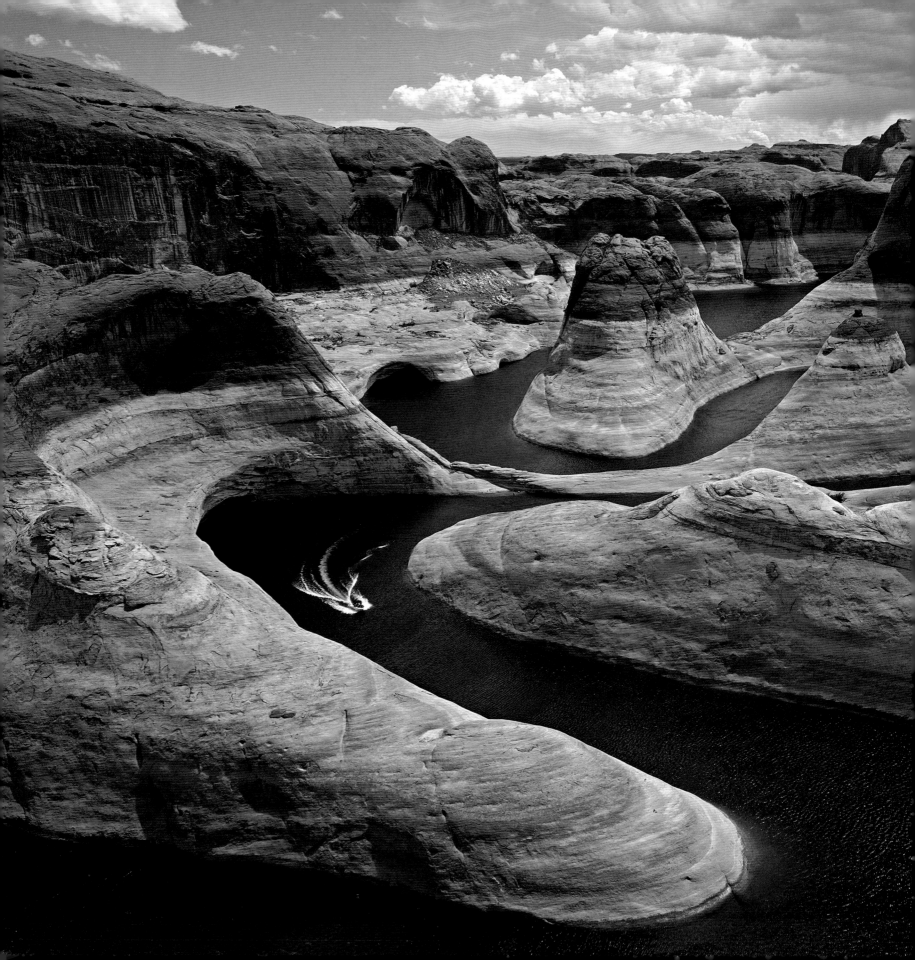

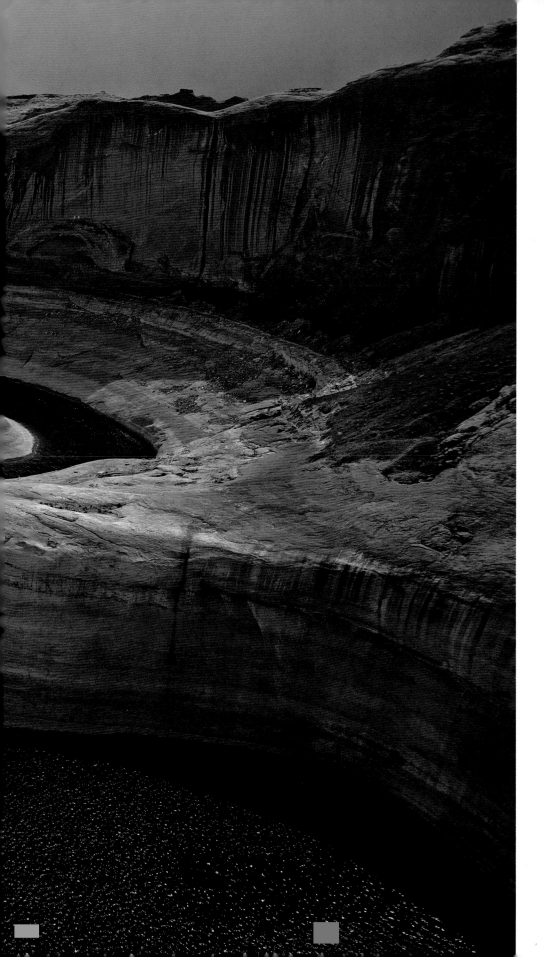

MICHAEL MELFORD | Utah, 2006

A lone speedboat's wake pattern echoes the curvilinear contours of Reflection Canyon, a side canyon of Lake Powell and the popular Glen Canyon National Recreation Area.

following pages (204-205)

B. ANTHONY STEWART | California, 1954

Seen through the clouds above Marin County's pristine Golden Gate National Recreation Area, the Golden Gate Bridge and city of San Francisco pulse with metropolitan energy.

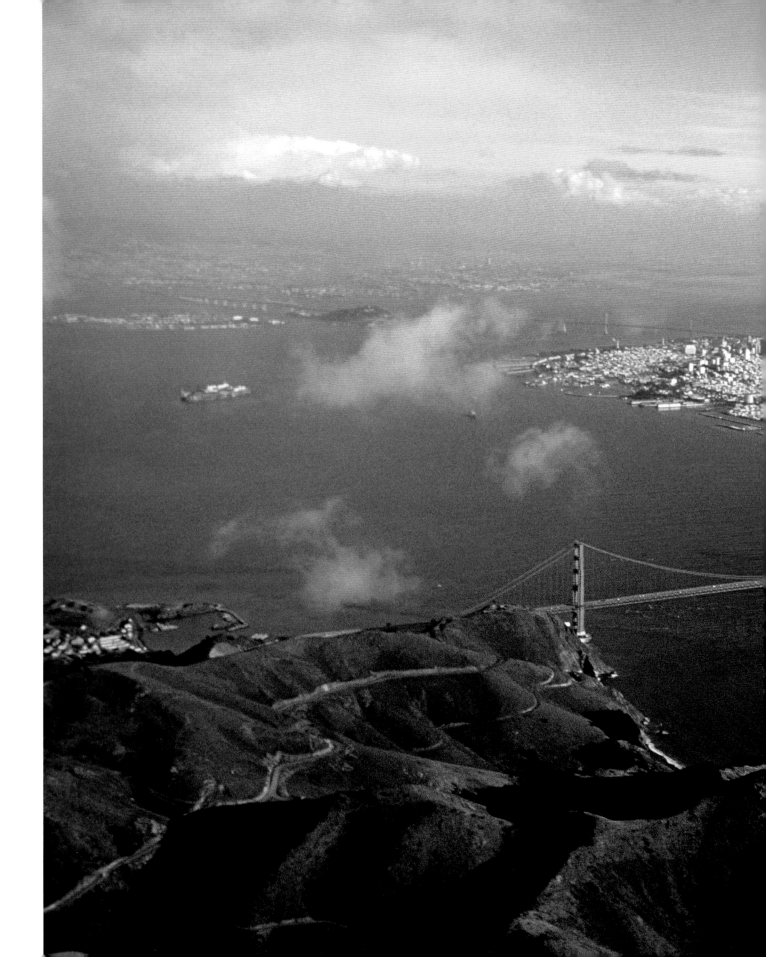

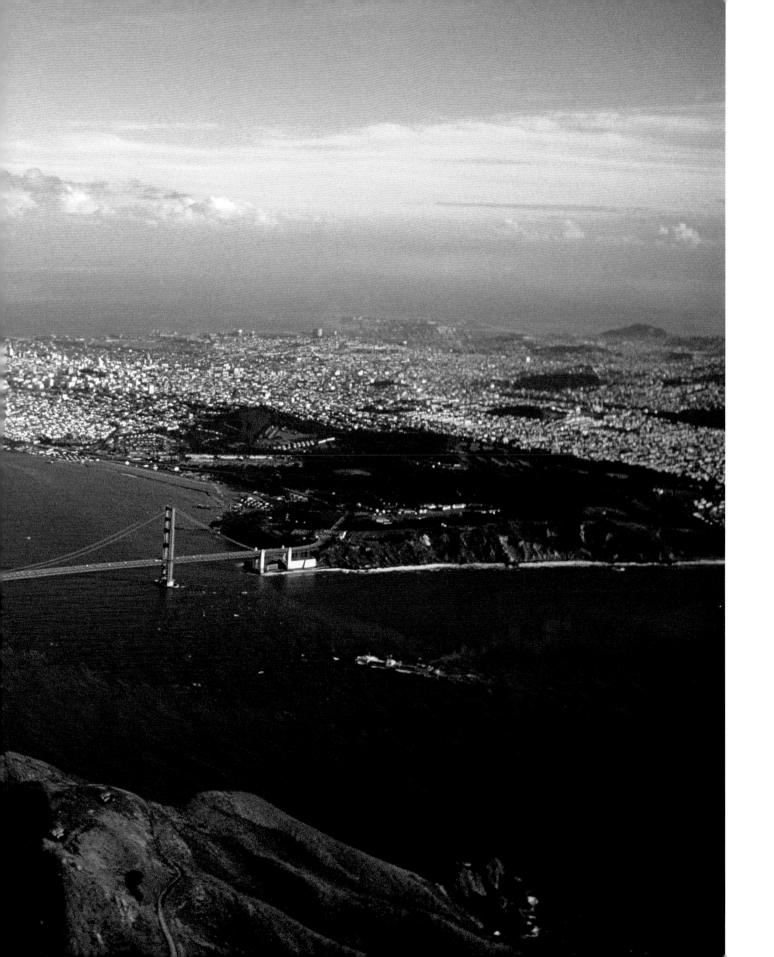

L. A. SANCHEZ | California, 1935

The buoy bells are almost audible in this award-winning amateur photograph of a dockworker silhouetted against the fog-shrouded, soon-to-be-completed San Francisco-Oakland Bay Bridge.

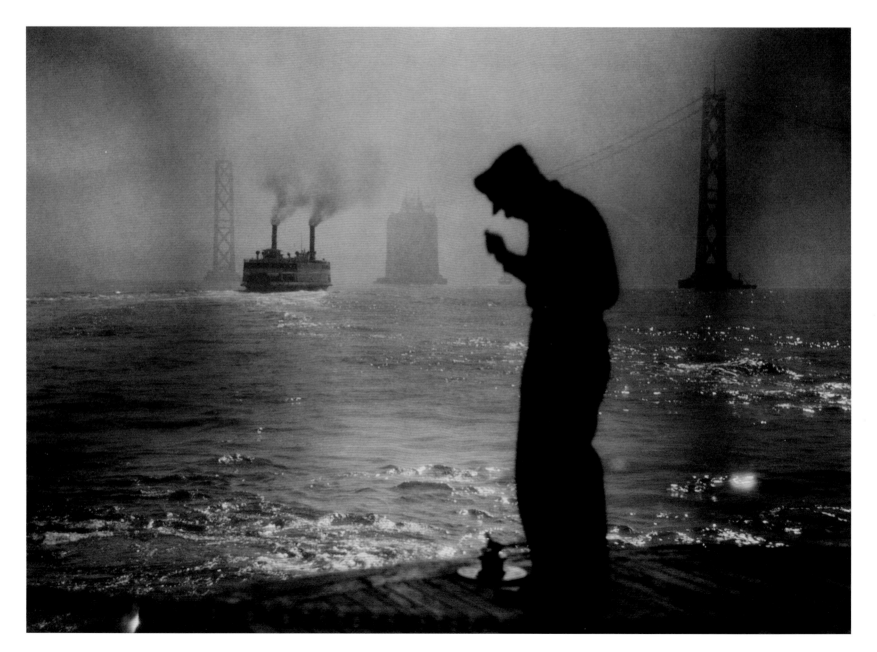

Viewed from Yerba Buena Island, between San Francisco and Oakland, partial illumination of the San Francisco-Oakland Bay Bridge suggests the progress of its pending completion the following year.

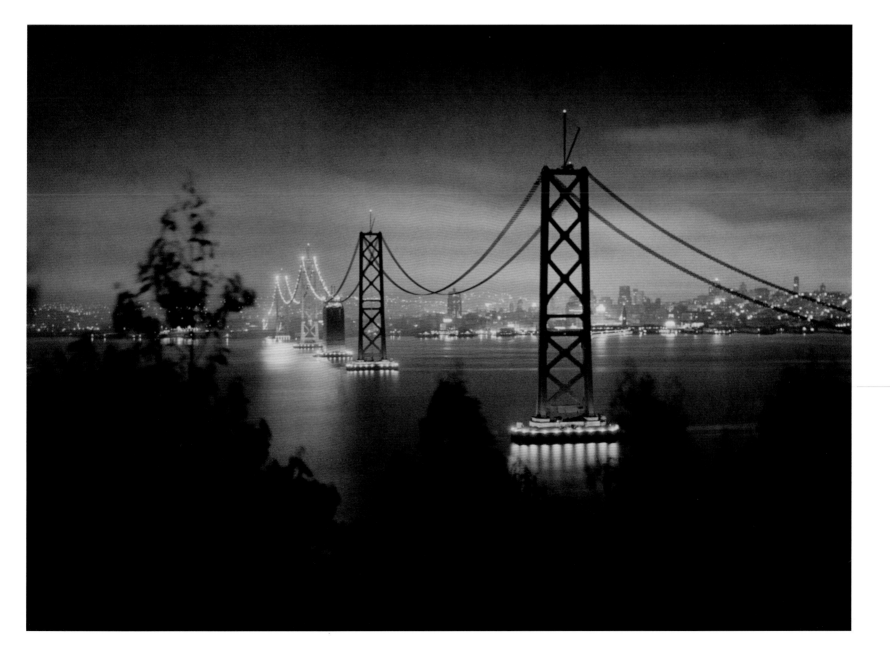

PETER MCBRIDE | *Arizona-Nevada border, 2010*

Construction of the Hoover Dam Bypass aims to improve traffic flow across the Colorado River, but little can be done to improve the flow of the river itself and the markedly low water levels of Lake Mead.

"THE COLORADO IS ONE OF THE MOST LOVED AND LITIGATED RIVERS IN THE COUNTRY. BUT THE RIVER THAT SCULPTED THE GRAND CANYON HAS BECOME OVERTAPPED AND NOW DIES WITHOUT EVER REACHING THE SEA."

—PETER MCBRIDE, 2010

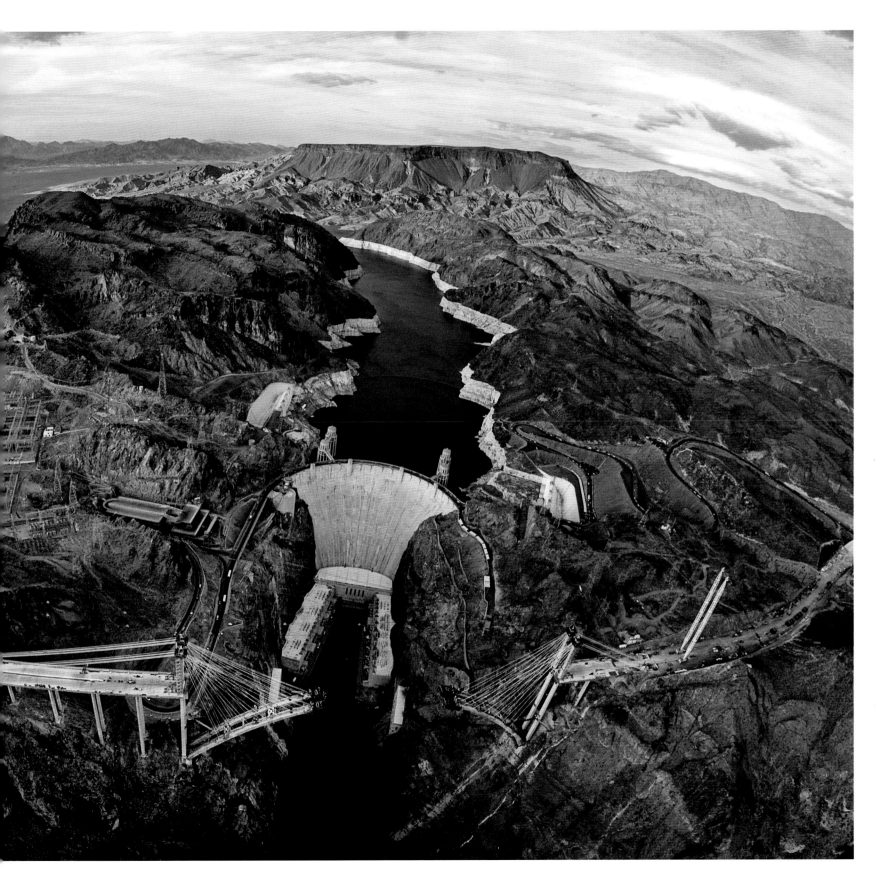

JACK KRAWCZYK | Montana, 2008

The snow-covered peaks of Glacier National Park's Lewis Range emerge from behind the clouds above pristine St. Mary Lake and wee Wild Goose Island.

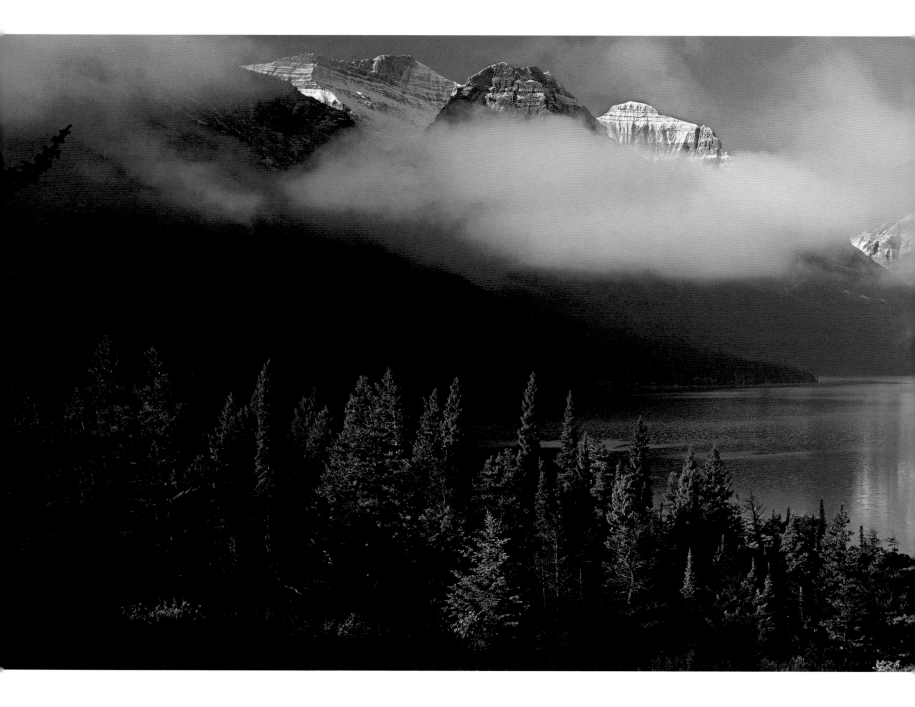

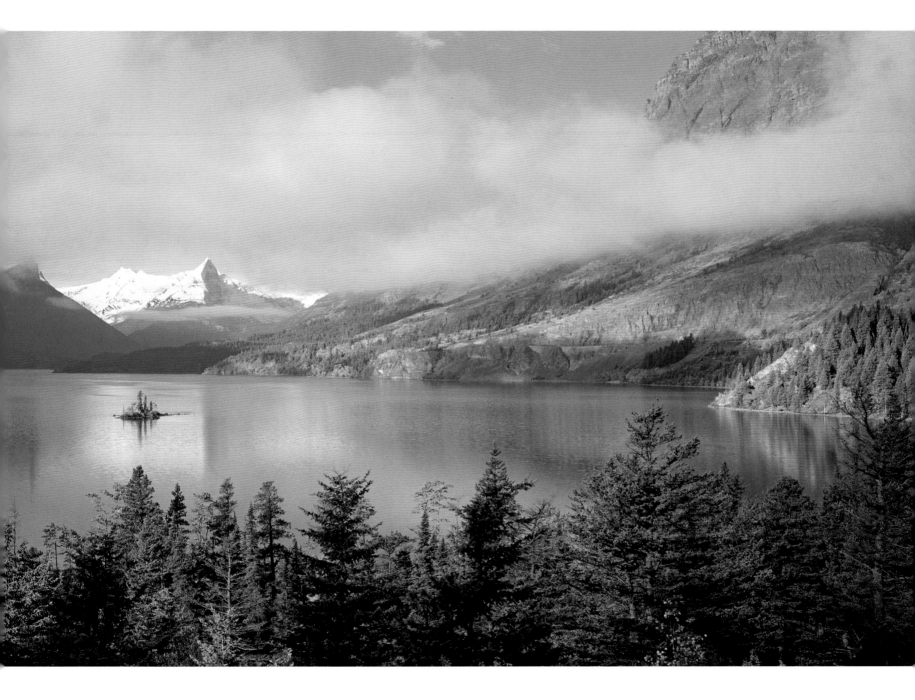

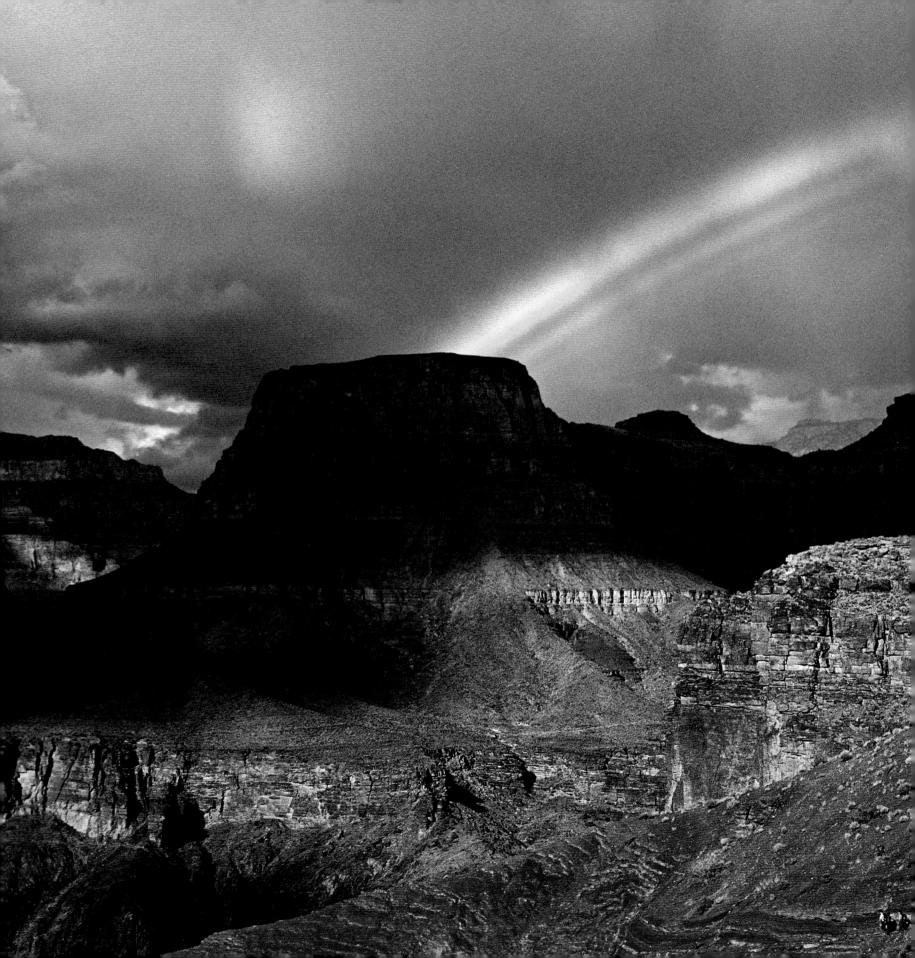

RALPH LEE HOPKINS | Arizona, 2008

Sun-drenched hikers on Grand Canyon's South Kaibab Trail head toward a rainbow created by a late-afternoon storm. Precipitous weather patterns contribute mightily to the canyon's prismatic drama.

DOUGLAS MILLER | Washington, 1980

Three hours after the eruption of Mount St. Helens, 60-mile-per-hour winds deliver a menacing dark cloud of volcanic ash to the tree-lined streets of Ephrata, 144 miles away.

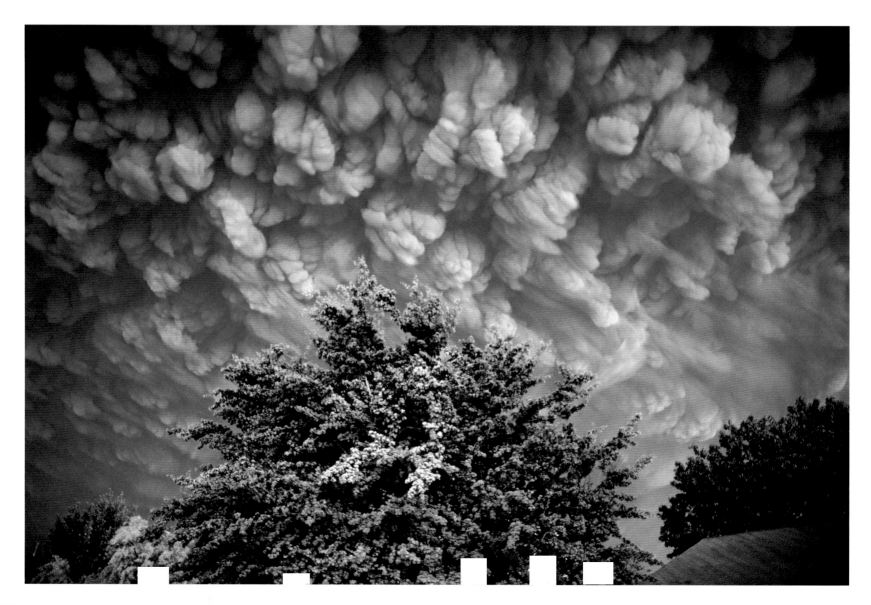

BRUCE DALE | Utah, 1991

Wind-blown grass seed blankets Crouse Canyon, evoking naturalist John Wesley Powell's 1895 vision: "Hills laugh with delight as burgeoning bloom is spread in the sunlight."

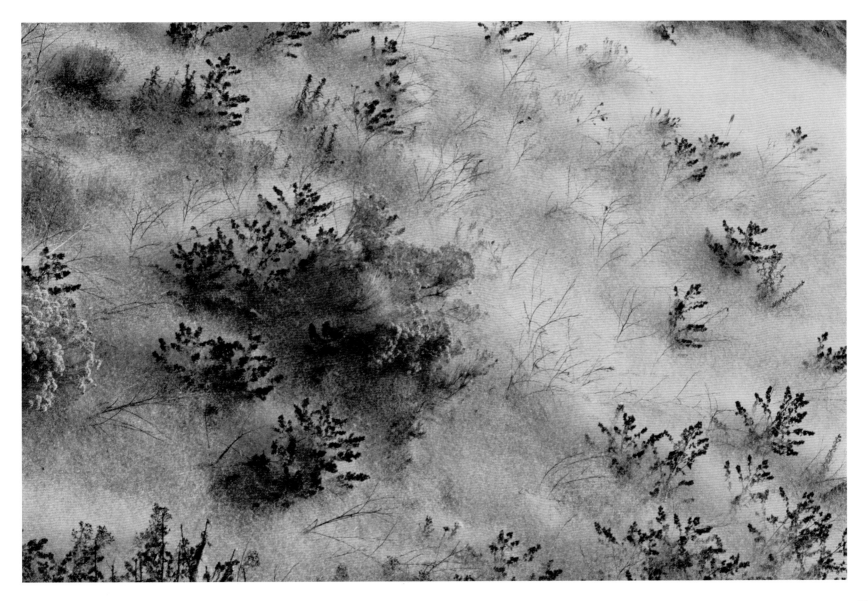

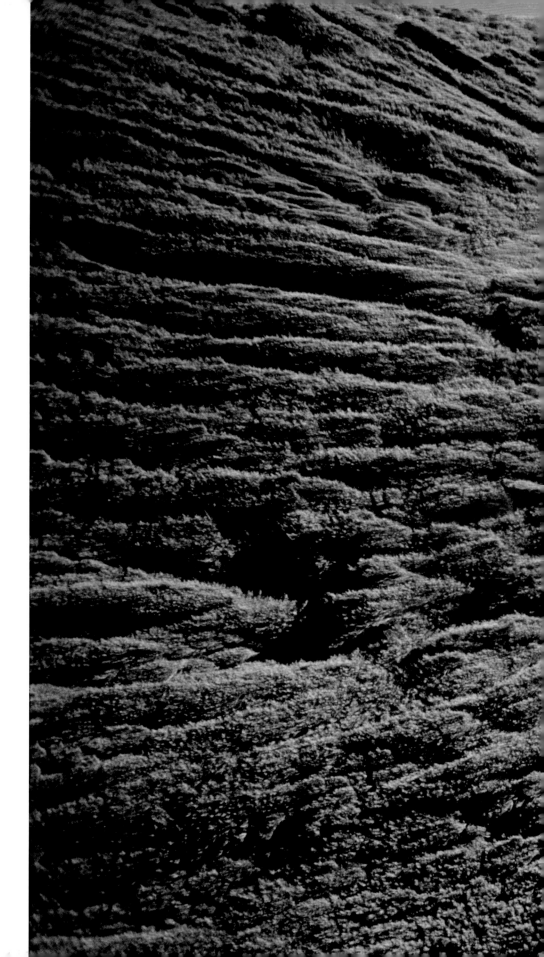

FRANS LANTING | California, 2010

Nature's chisels—wind and water—groove
the coastal maritime chaparral in Big Sur's
Garrapata State Park.

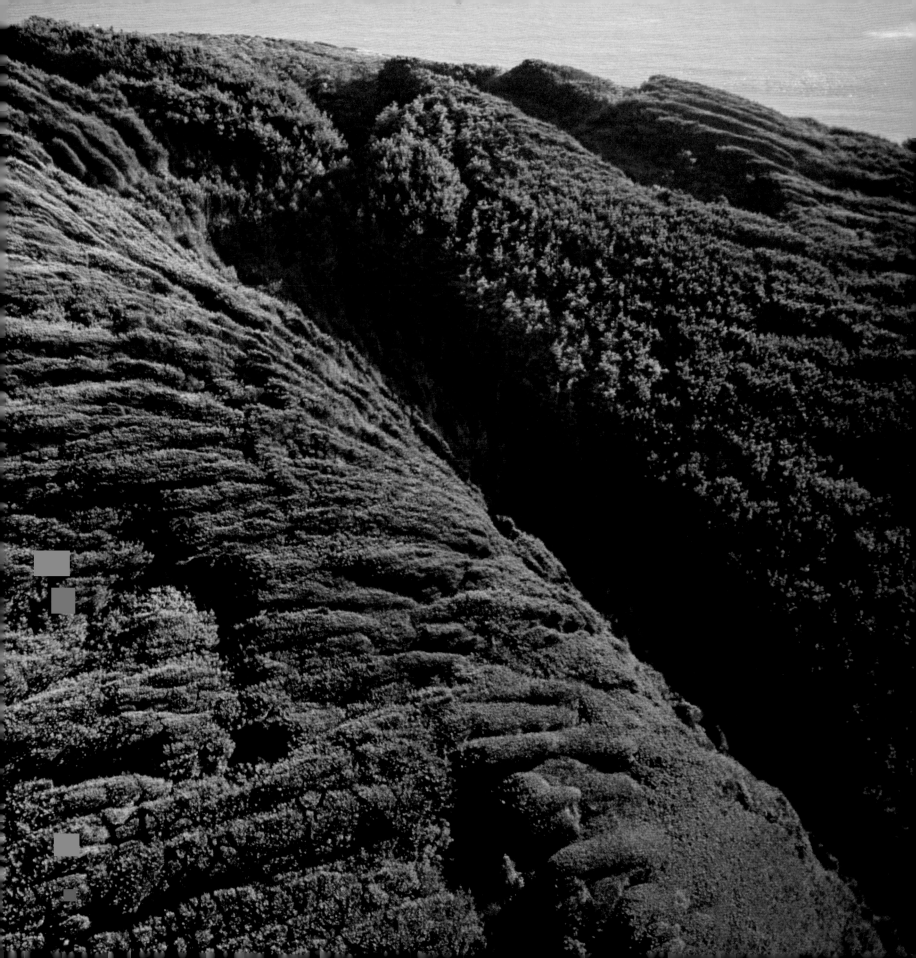

VINCENT LAFORET | Colorado, 2007

More efficient than the flood irrigation it replaced, center-pivot irrigation crafts the geometry of an alfalfa field in the San Luis Valley, one of many arid areas where agriculture can now prosper.

"THE FARMER IS A GOOD FARMER WHO, HAVING ENABLED THE LAND TO SUPPORT HIMSELF AND TO PROVIDE FOR THE EDUCATION OF HIS CHIL-DREN, LEAVES IT TO THEM A LITTLE BETTER THAN HE FOUND IT HIMSELF."

—THEODORE ROOSEVELT, 1912

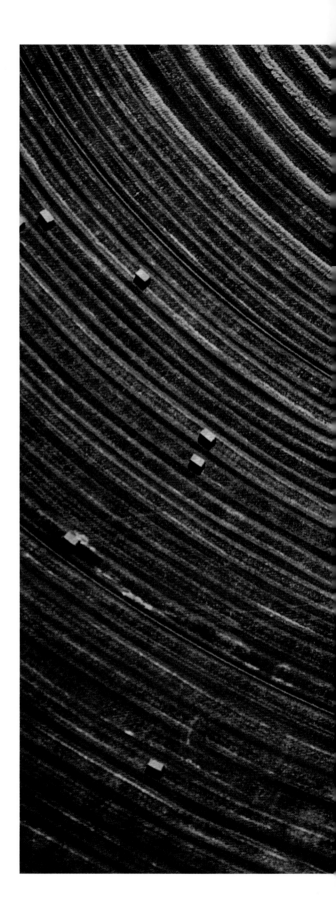

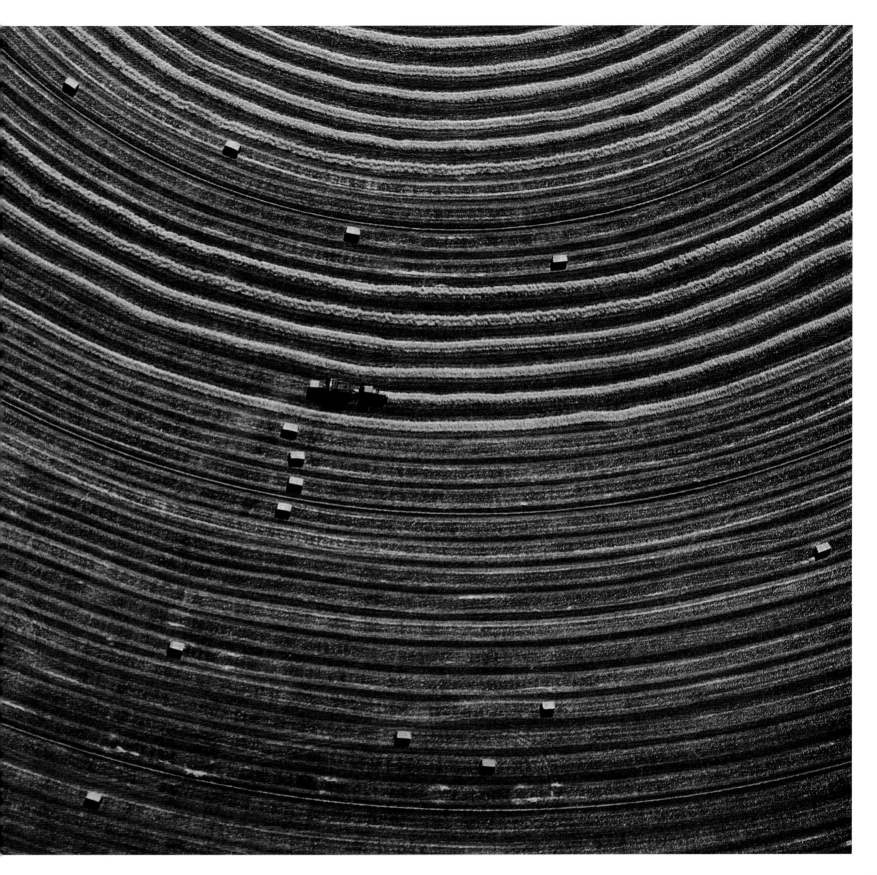

MICHAEL MELFORD | California, 2007

Backlight from the sun captures blowing silicate as a sandstorm rages through the mesquite and arrowweed of Death Valley.

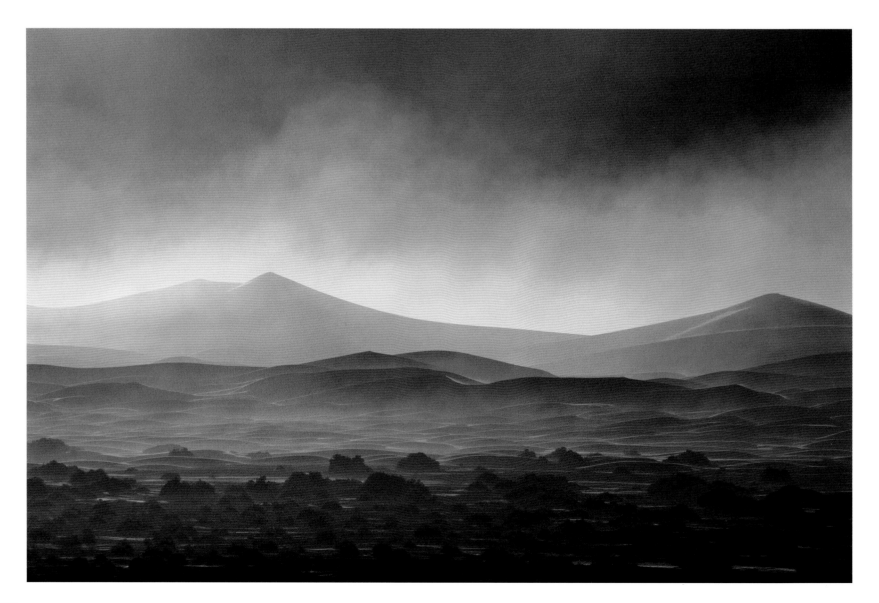

MICHAEL MELFORD | California, 2007

Joshua trees stand tall and translucent as the wind picks up and dust starts to fly in the Lee Flat area of Death Valley.

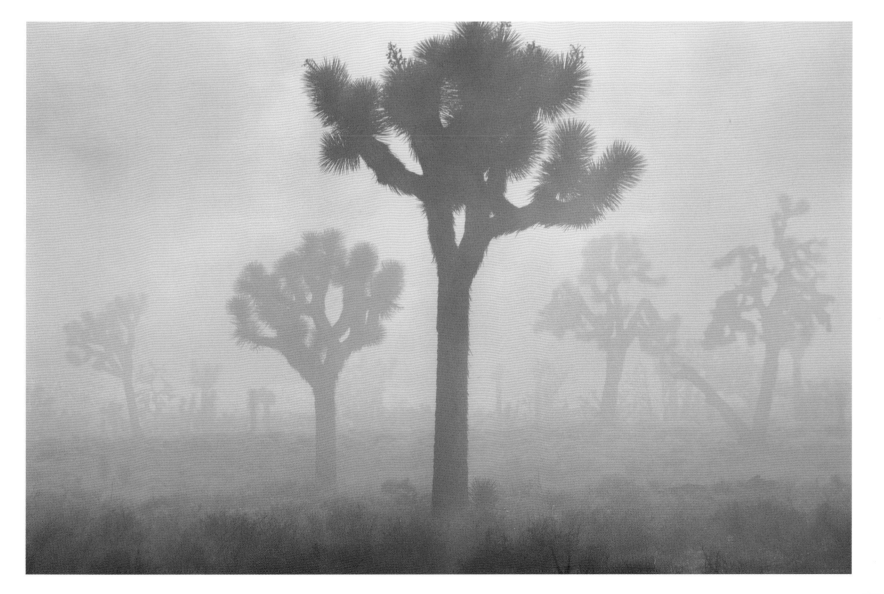

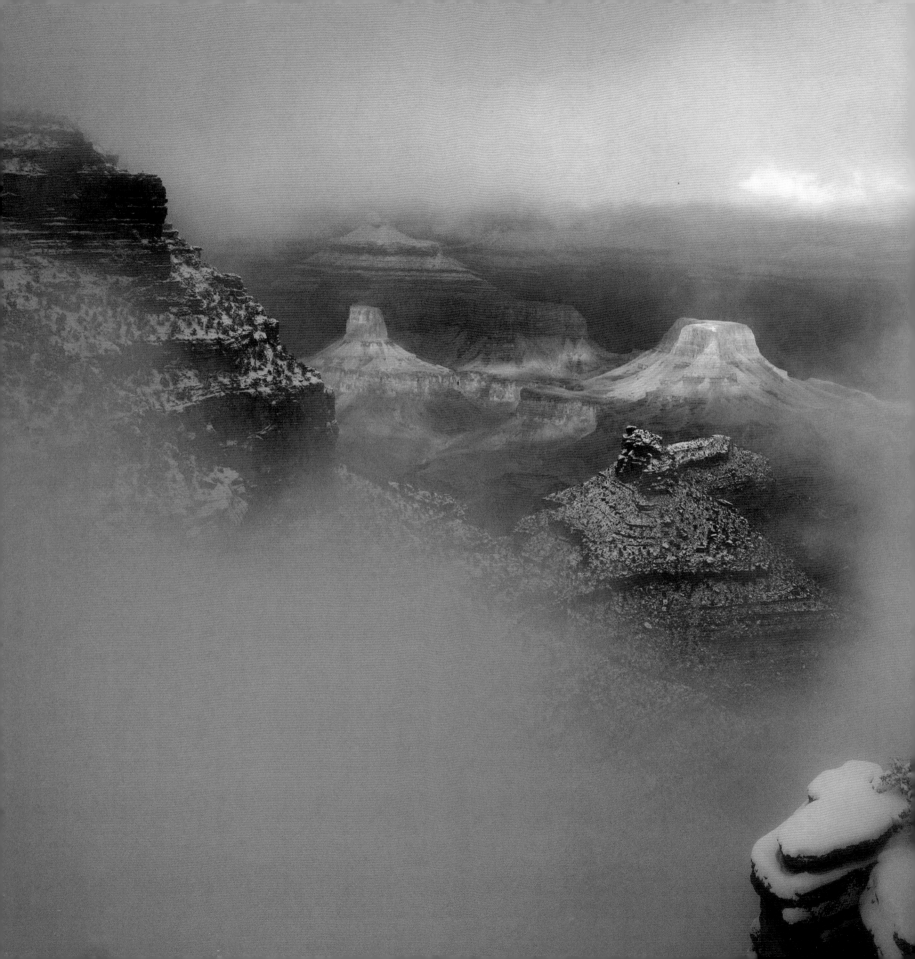

MICHAEL NICHOLS | Arizona, 2006

With the sun pushing through, a gauze of snow and mist barely conceals the vibrantly colored formations along Grand Canyon's Bright Angel Trail.

BRUCE DALE | Colorado, 1999

As they have since 1880, the narrow-gauge tracks of the Cumbres and Toltec Scenic Railroad snake through sagebrush along the New Mexico-Colorado border toward the San Juan Mountains.

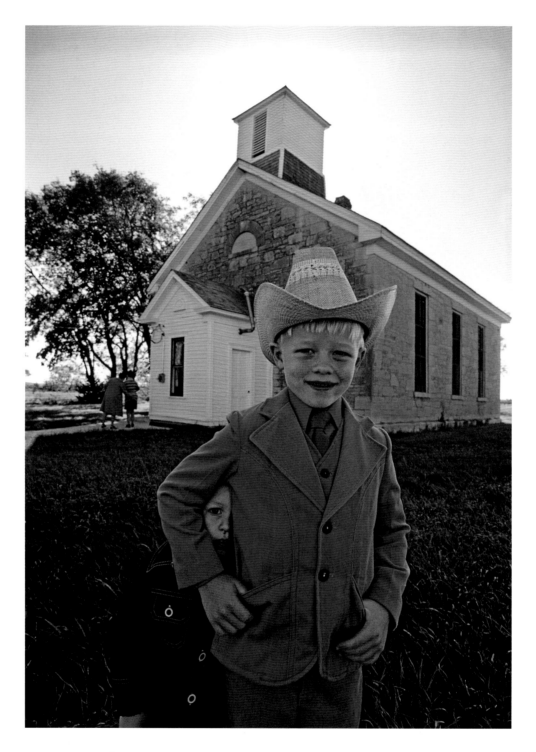

JIM BRANDENBURG | Kansas, 1980

Boys wait outside Wabaunsee's Beecher Bible and Rifle Church, named for the Rev. Henry Ward Beecher, who helped smuggle rifles past proslavery forces in crates marked "Beecher's Bibles."

[CHAPTER 4]

WHERE DO WE GO WHEN THE ONLY FRONTIER LEFT IS
that of the mind, when our myths have been debunked, and our discoveries and encounters
have put boundaries around our seemingly infinite spaces? Why, we do as we have always
done. Like the mountain men of old, like the entrepreneurs and escapists and get-rich-quickers
who headed West and found something new, we turn to our inventive American spirit—
shambling, competitive, friendly, if at times misguided—and that inventiveness more and
more insistently tells us to find the new in the old.

We heard the call of the West, and we heeded it; we came, we saw, we conquered. We went
west to seek our fortune or to have a second chance. And what we encountered was bigger
and better than any dream. The Canyon was so much wider and deeper than we believed
possible, the grassy Plain inconceivably wide, the Peak higher and more dazzling than hope
itself, the hardships almost unendurable, the beauty incomparably heartbreaking. And we
met there our fellow Americans, whose ancestors journeyed across the Siberian land bridge
into the abundant garden of the Americas. The locals weren't perfect, but they reminded us to

take a little more care of what we were doing: "What is man without the beasts?" said Chief Seattle. "If all the beasts were gone, men would die from loneliness of spirit, for whatever happens to the beasts also happens to the man."

But we kept pushing west. As readers, we went west with the splendor of *National Geographic* as our guide and our own boundless imaginations as our compass. West of what? Without the East, there would be no West. We define the West in terms of what it isn't— flat, old, urban, well-mannered. "Only remember," wrote F. Scott Fitzgerald, "West of the Mississippi it's a little more look, see, act. A little less rationalize, comment, talk." Yet now the West is every bit as sophisticated and urban, in some places, as the East.

What's left, then, is the land itself, which has the newness of possibility, of discovery. The Rockies, geologists tell us, are much more recent than the Appalachians, and they are higher and more challenging—for hikers and skiers, if no longer for travelers. And now, yes, we can grieve for the paradise we lost. But in our hearts we know it was always in transition. The wars fought for the West are as dust devils to the maelstroms of blood wrought in the Old World, yet they hurt us because they seem an insult to God's handiwork: Why can we not leave one place in perfection?

The vision and promise of the future is not a return to the old ways but a melding of past and present. For without respecting the heroes and understanding the failures of the past we cannot hope to arrive where we want to, and without respecting the needs of the community, while still respecting those of the individual, we can only expect more lost dreams.

Is the West a land of realistic optimism? Or is it, as Stegner would have it, "a region where optimism consistently outruns resources"? National Geographic used to refer to itself, in egalitarian style, as Your Society. And it was eternally optimistic. "The Call of the West," one

1909 article trumpeted, "Homes Are Being Made for Millions of People in the Arid West." Now, Your Society is sounding notes of caution. But it remains optimistic about a region that we have not yet loved to death. If going west is now a journey of the imagination, one way is through photographs. And they can inspire and move us, get us up and doing something for the West we all own and love.

We are left with the wisdom of the ancients. In the late 1880s, the Lakota danced and sang for the return of the thundering herds:

The whole world is coming,

A nation is coming, a nation is coming.

The eagle has brought the message to the tribe.

The father says so, the father says so.

Over the whole earth they are coming.

The buffalo are coming,

the buffalo are coming,

Give me back my bow.

It was a vain hope, when the only nation coming was a nation of new people.

But it was a beautiful idea.

We have run out of places to go. There is no more wilderness except what we say there is, what we fence off and protect and guard as something sacred, to be honored as the spirits of our ancestors. Now we must circle the wagons, make a stand together, and figure out the best way forward.

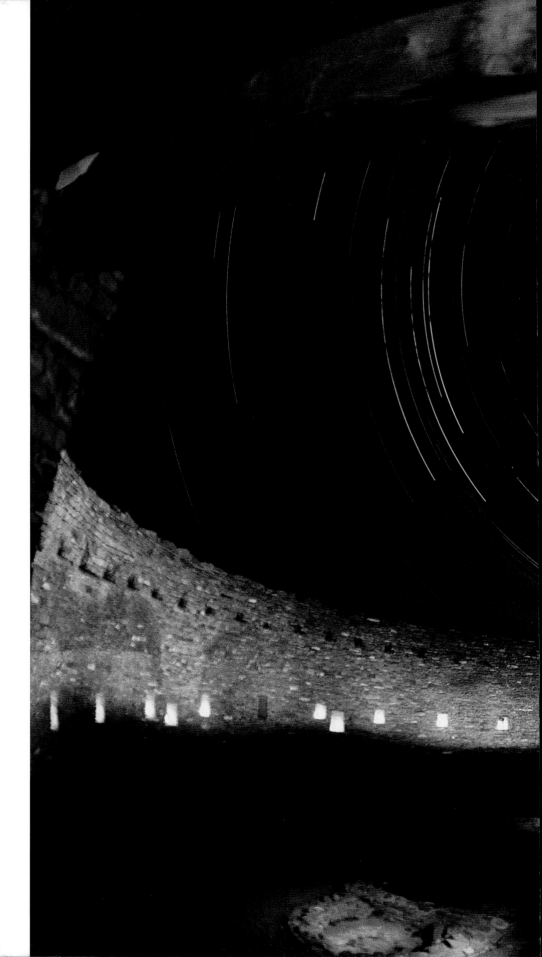

BOB SACHA | New Mexico, 1988

The ancient past meets the future, as stars appear
to circle the earth above kiva Casa Rinconada, an
Anasazi observatory in Chaco Canyon.

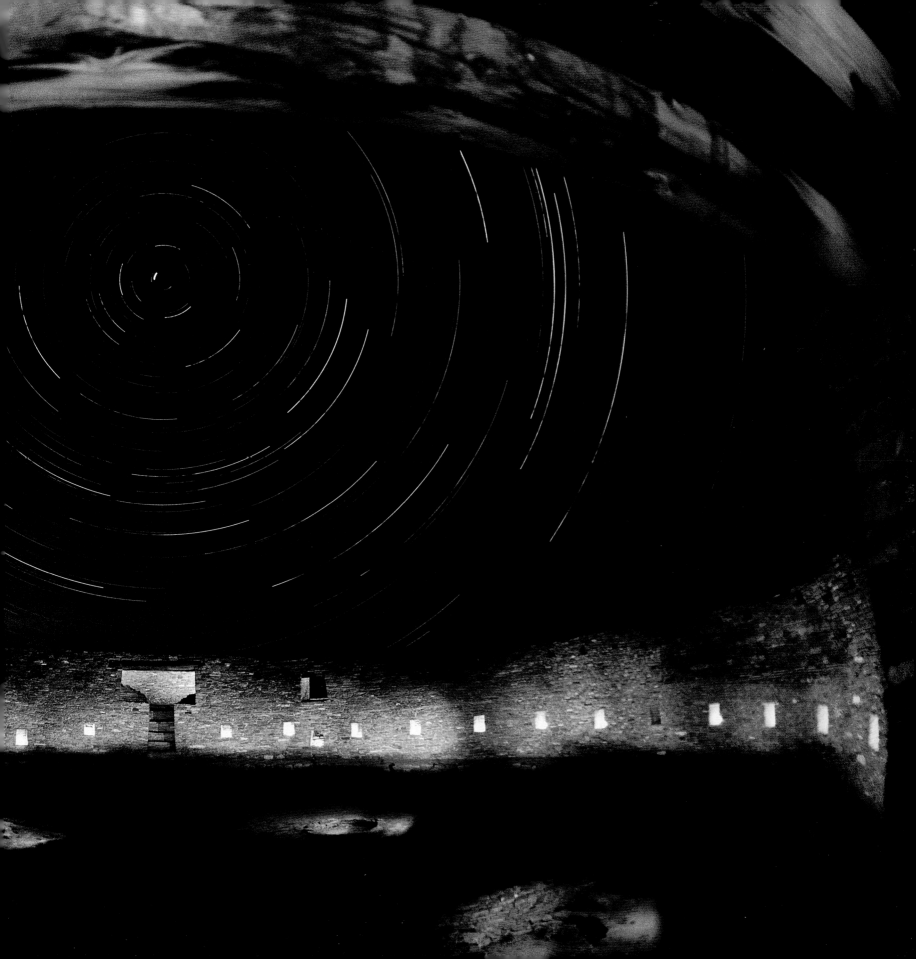

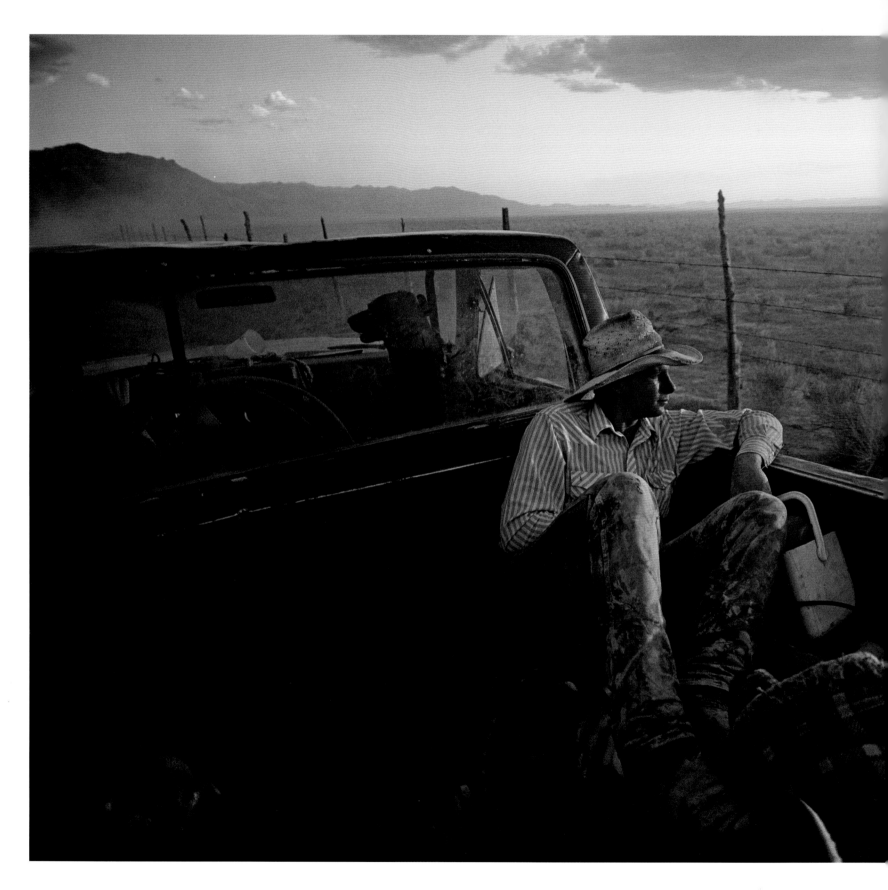

CHRIS JOHNS | Nevada, 1991

After 14 hours on the job, 19-year-old cowboy Cheth Wallin gazes reflectively westward from the bed of a pickup truck.

"PEOPLE WHO CHOOSE TO LIVE ON THE VAST WESTERN LANDSCAPES KNOW THE IMPORTANCE OF ADAPTING. THERE CAN BE SOME ACHY PARTS IN THESE TRANSITIONS. BUT YOU FIND INTERESTING WAYS TO SURVIVE AND LIVE IN THE WORLD YOU DEEPLY LOVE."

—CHRIS JOHNS, 2012

JEFF KROEZE | California, 2008

A long exposure on a breezy, starry night seems to transform some of the 5,000 turbines at Tehachapi Wind Farm into futuristic flowers producing 800 million kilowatt-hours of electricity a year.

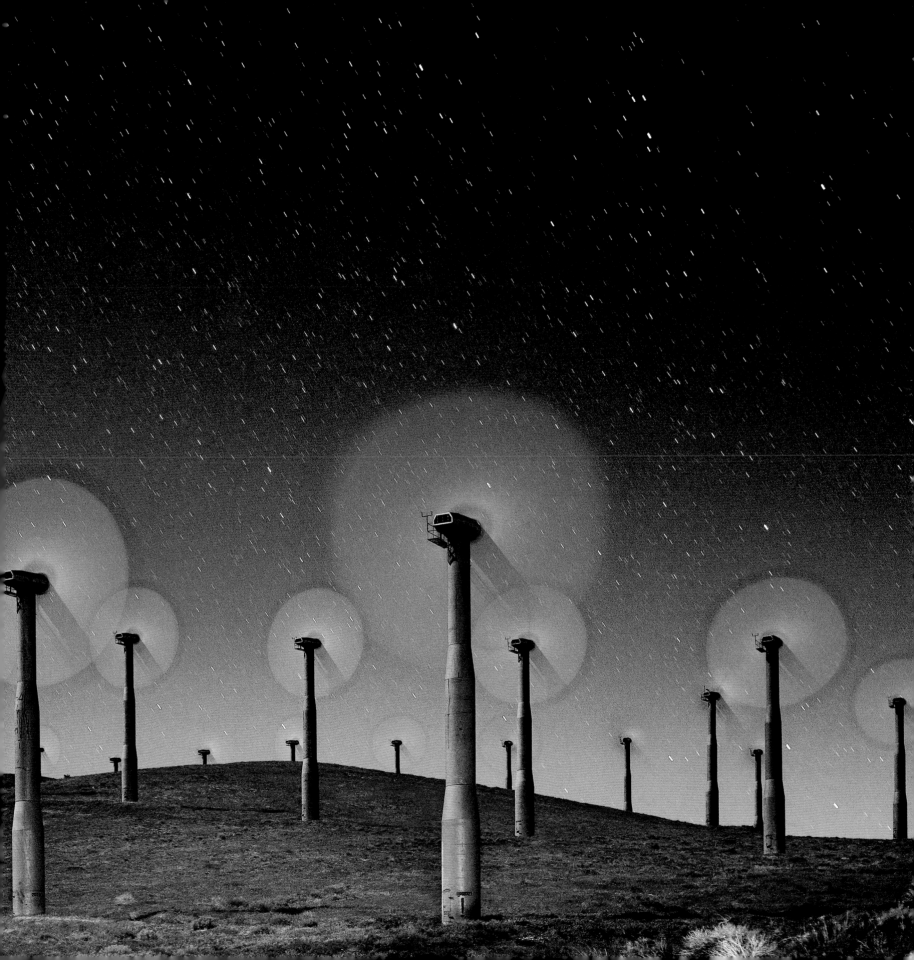

LYNN JOHNSON | New Mexico, 2011

Following the research tradition that led to the atomic and hydrogen bombs, scientists at Los Alamos National Laboratory use colorful 3-D simulations to analyze nuclear energy and explosions.

DANNY LEHMAN | New Mexico, 1987

Characterized by ion-firing, incandescent electrical arcs, Sandia National Laboratories' Particle Beam Fusion Accelerator II can pump out more than 50 times the total power of the U.S. utility grid.

SUSAN SEUBERT | California, 2009

The twilight radiance of metropolises like San Francisco requires infinite amounts of energy to sustain.

STEPHANIE MAZE | *California, 1980*

Some punch cows; others punch people. In the shadow of a training boxer, a poster advertises a match. For Latino youth in East Los Angeles, the boxing ring holds the brass ring.

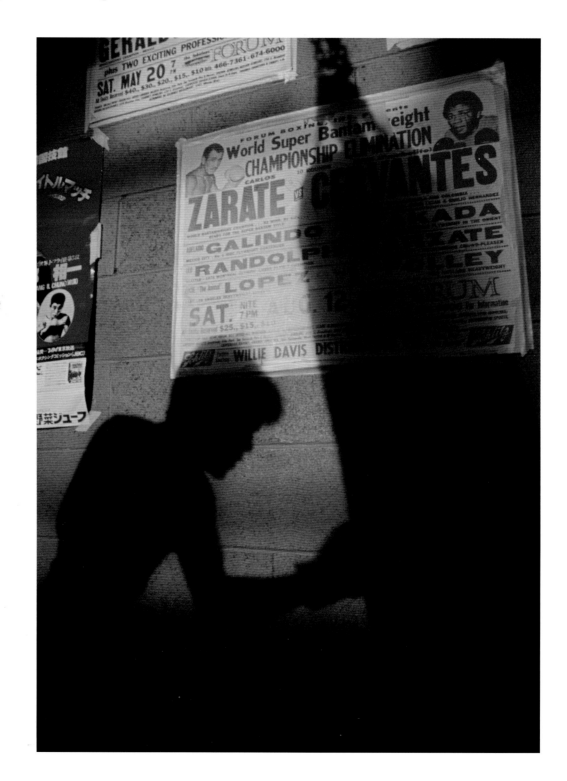

Laredo's annual Society of Martha Washington Colonial Ball presents ornately dressed debutantes, called "Marthas," with ancestry on both sides of the border.

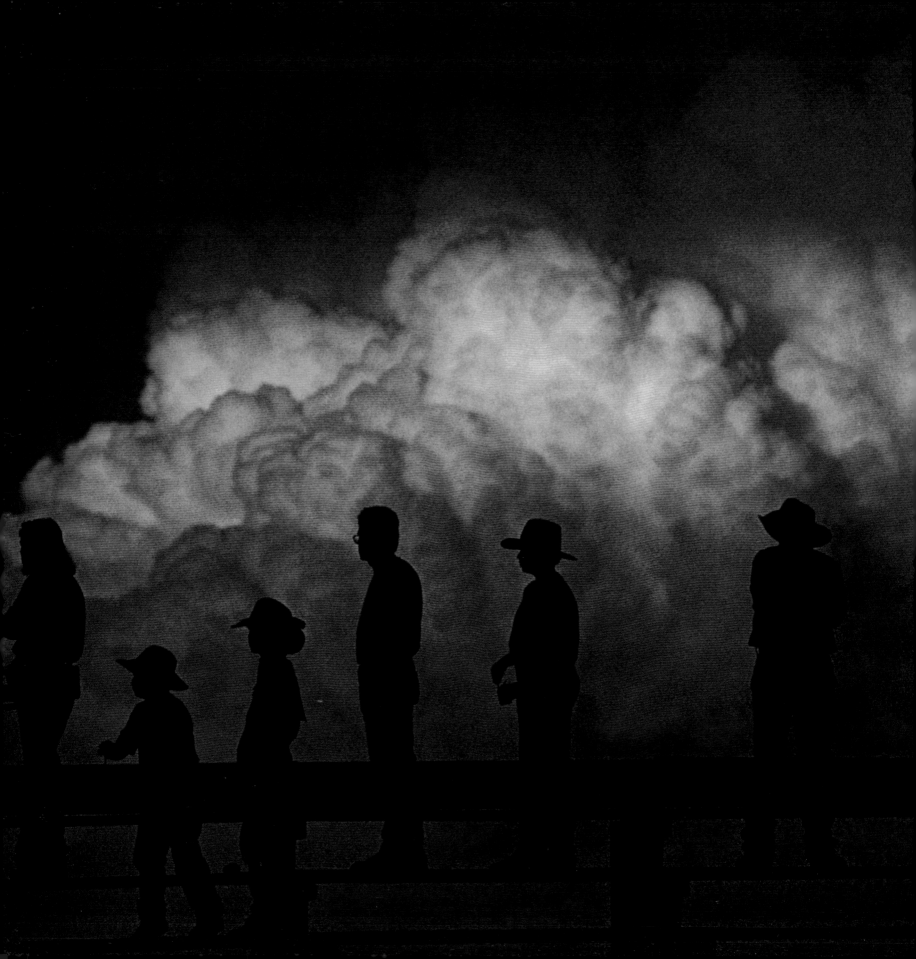

Silhouetted at sunset against a radiant
cumulus cloud, spectators take in the action
at Nebraska's Big Rodeo, held annually in
Burwell since 1921.

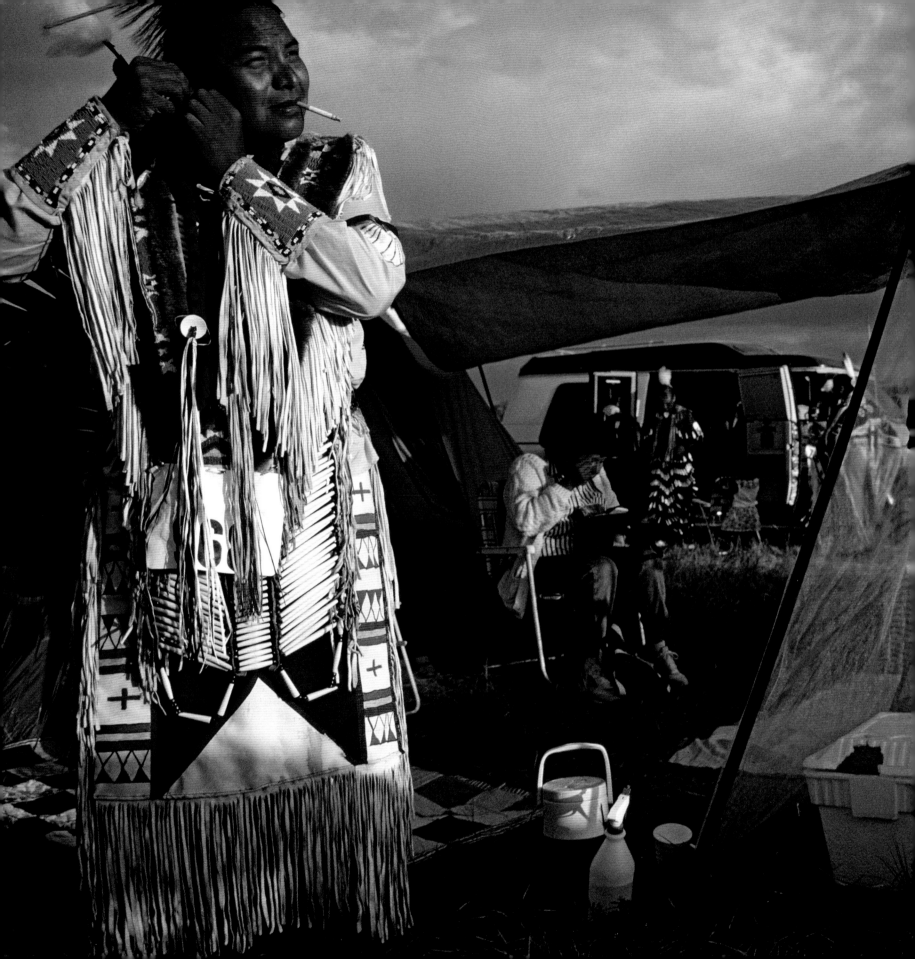

DAVID ALAN HARVEY | Montana, 1994

Ed Blackthunder, a South Dakota Sioux, proudly dons his traditional dance outfit during the annual Rocky Boy's Indian Reservation Pow-Wow, one of many celebratory gatherings of indigenous peoples across the West.

MARTHA COOPER | Arizona, 1983

Despite attempts at acculturation, Native American rituals thrive. Dried cattail pollen, central to all Apache rites of passage, showers a White Mountain Apache during her ceremonial transition into womanhood.

DAVID ALAN HARVEY | **Washington, 1994**

Swaddled in a cradleboard similar to one his ancestors used, tiny James Winterhawk Seymour naps beneath a traditional beaded dreamcatcher during a powwow on the Yakama Reservation.

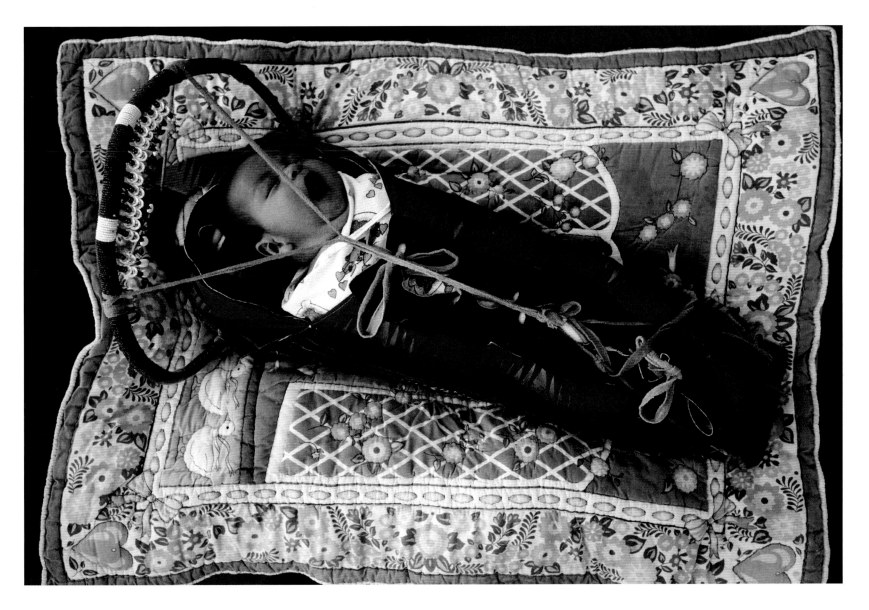

WILLIAM ALBERT ALLARD | Montana, 2005

A teenage member of the Surprise Creek Hutterite colony plays baseball with other boys and girls on a makeshift field. The game goes on until other demands—such as killing turkeys—halt it.

"THERE'S LITTLE PLACE IN THE COLONY FOR INDIVIDUALISM IN DRESS, THOUGHT, OR OTHER PERSONAL RIGHTS MOST AMERICANS TREASURE . . . ON THE OTHER HAND, EVERYONE IS CLOTHED, FED, AND GIVEN A SENSE OF BELONGING."

—WILLIAM ALBERT ALLARD, 2006

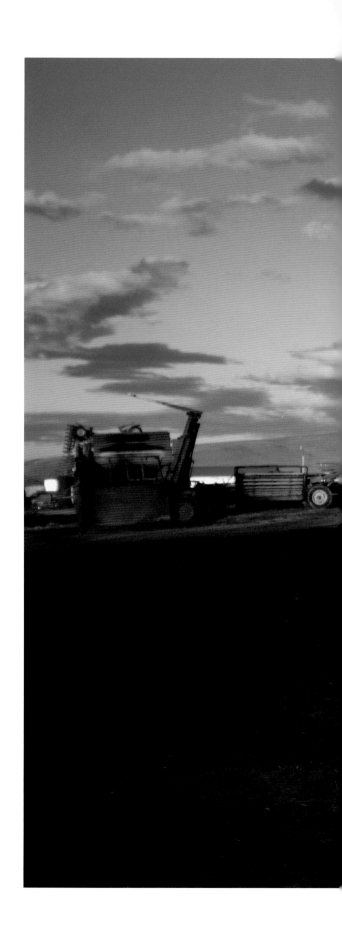

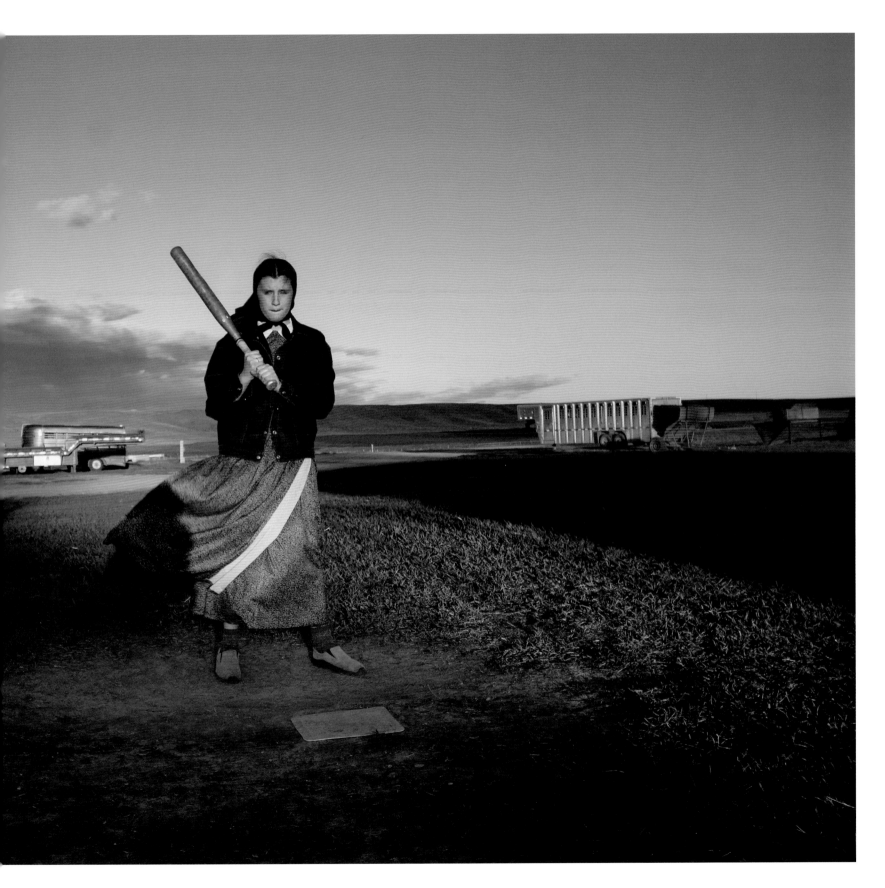

WILLIAM ALBERT ALLARD | Montana, 1970

Hutterite preacher Paul Walter leads
evening prayer in the one-room Spring Creek
schoolhouse, where the congregation sits
according to age and sex—youngest in front,
females to the right.

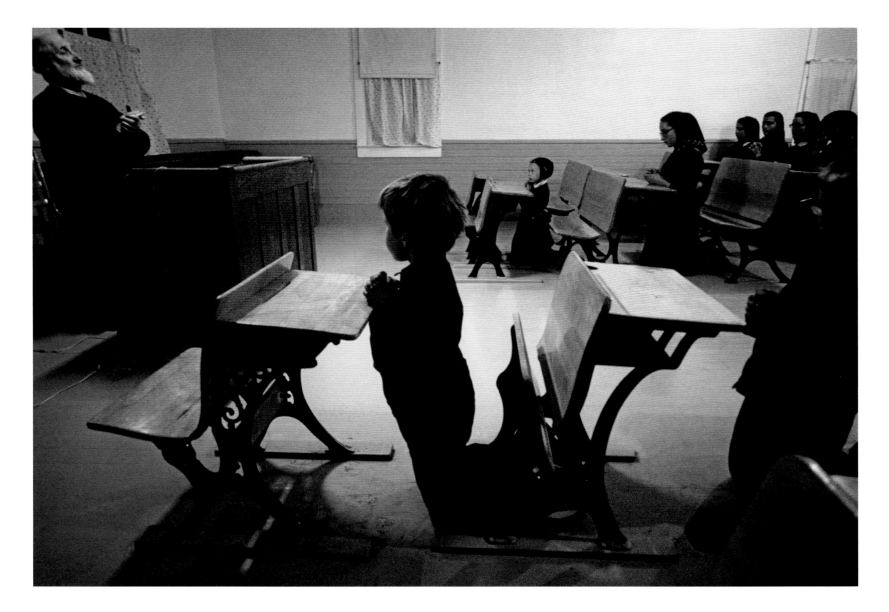

WILLIAM ALBERT ALLARD | Montana, 2005

Leaders of the Surprise Creek Hutterite colony, preacher Sam Hofer (foreground) and Darius Walter discuss families and finances on the 10,000-acre operation that supports upwards of 125 people.

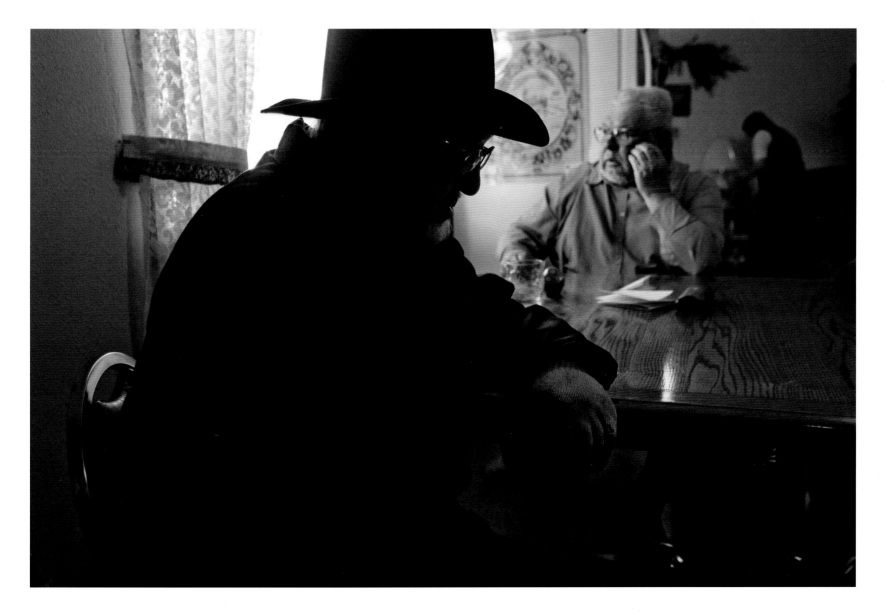

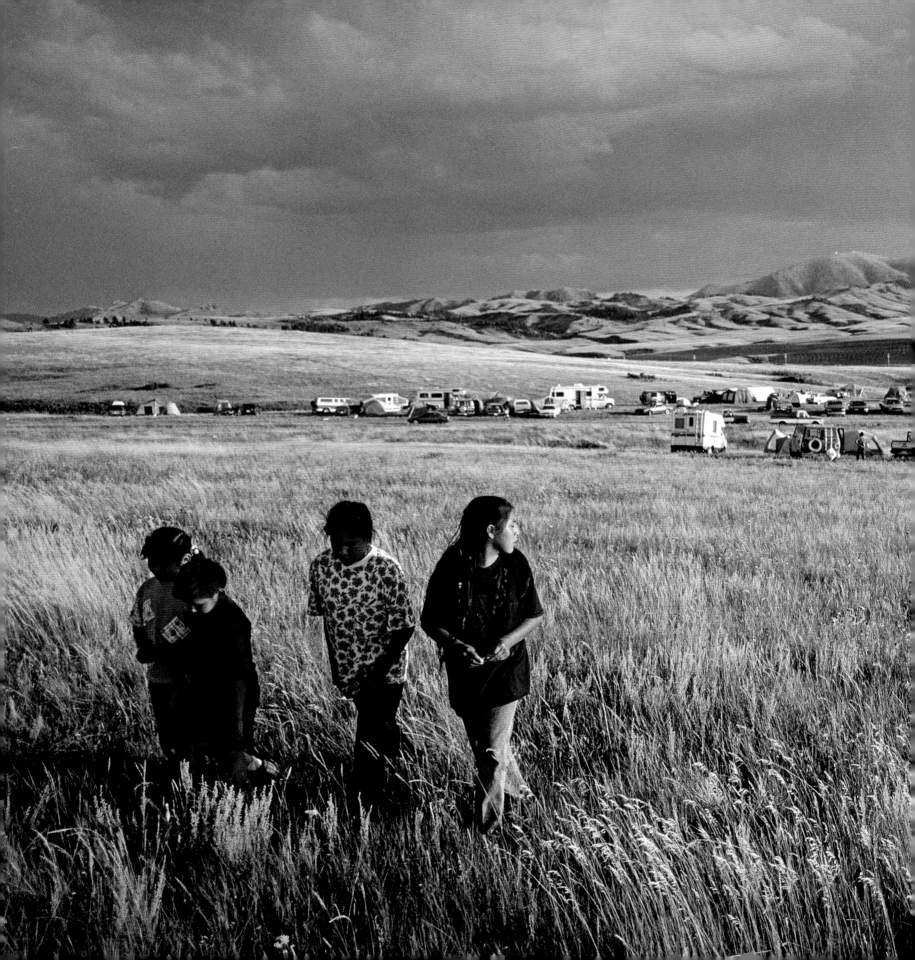

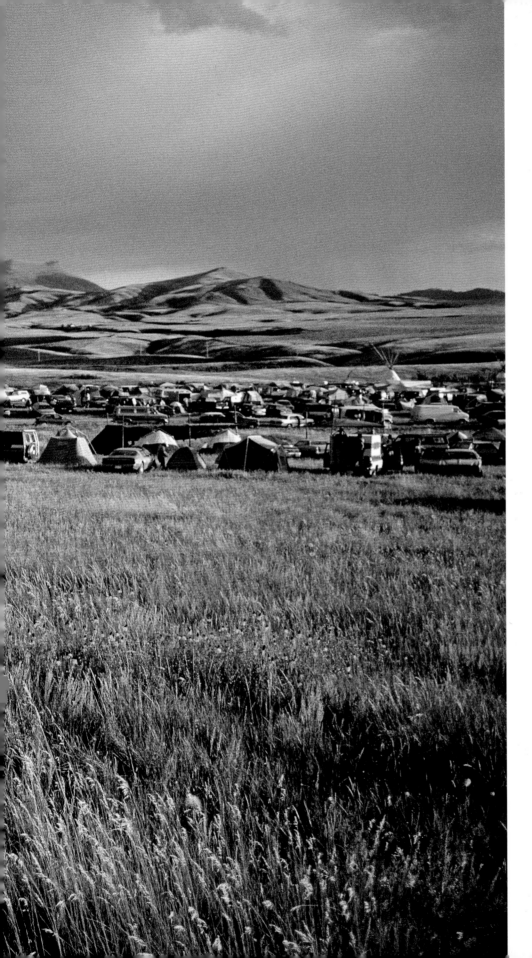

DAVID ALAN HARVEY | Montana, 1994

Stepping away from the annual Chippewa Cree Tribe Pow-Wow, Rocky Boy's Reservation resident Rena Denn proudly leads visitors from other tribes on a tour of the Bear Paw Mountain foothills.

following pages (254-255)

DAVID ALAN HARVEY | Colorado, 1991

Two granddaughters in the tightly woven family of National Endowment for the Arts National Heritage Fellow Eppie Archuleta (left) wrap themselves in the elaborately handmade wool blankets her mother, Dona Agueda Martinez (far right), taught her to weave.

DAVID ALAN HARVEY | New Mexico, 1991

Famous for her polished blackware, legendary Santa Clara Pueblo potter and NEA National Heritage Fellow Margaret Tafoya admires one of her redware pitchers. Although she died in 2001, many of her 13 children continue the family tradition.

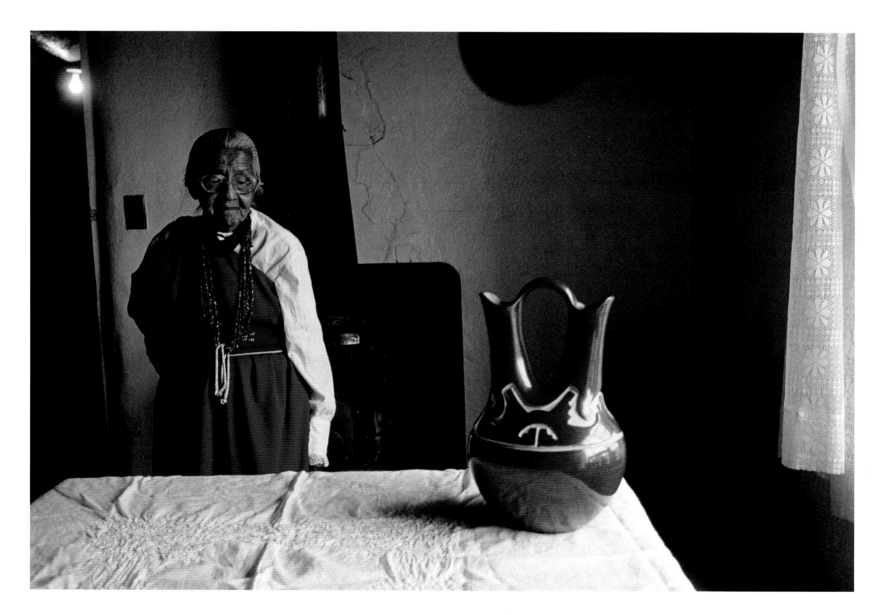

DAVID ALAN HARVEY | Oregon, 1991

The first leatherworker to become an NEA National Heritage Fellow, master saddle maker Duff Severe of Pendleton sits beside one of his signature creations—called "the Mercedes-Benz of the business" by one rodeo rider.

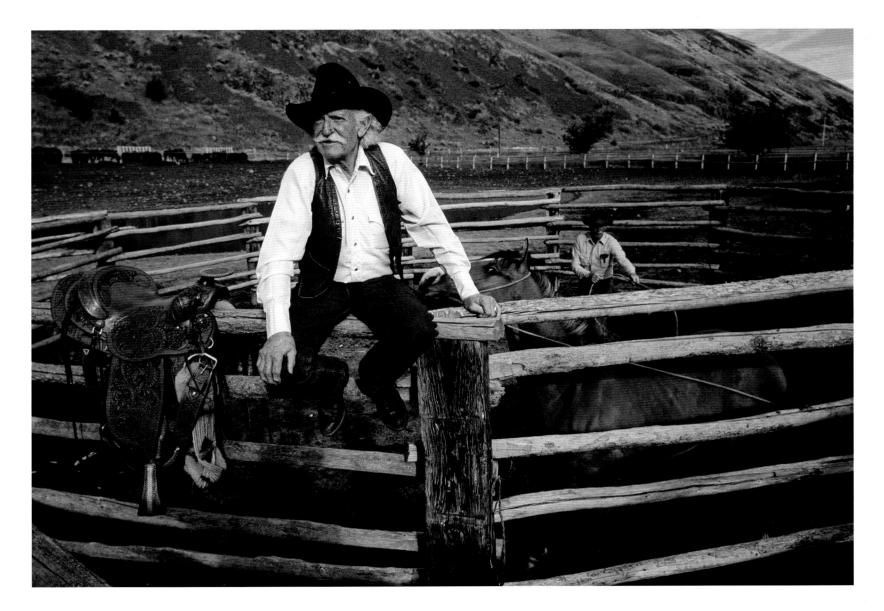

MICHAEL MELFORD | New Mexico, 2008

The rapid depletion of nonrenewable energy sources prompts today's pioneer to look skyward for new frontiers. Outside Albuquerque, multiple mirror arrays concentrate light, converting solar energy to thermal energy and electricity.

"IT IS HARD TO IMAGINE A POWER PLANT SO BEAUTIFUL: 250 ACRES OF GENTLY CURVED MIRRORS LINED UP IN LONG TROUGHS LIKE CANALS OF LIGHT . . . MORE THAN 182,000 OF THEM AWAKENING TO FOLLOW THE SUN."

—GEORGE JOHNSON, 2009

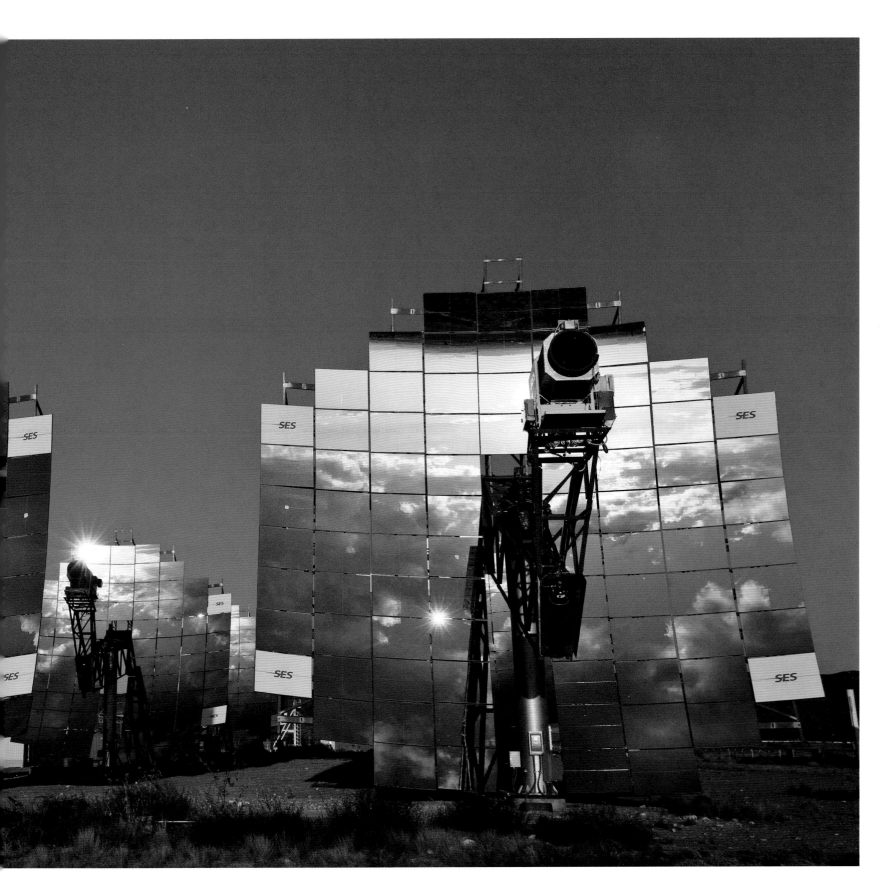

JIM RICHARDSON | **Washington, 1999**

Grand Coulee Dam workers shut off water flow to grind out the cavitation that occurs when enormous turbines spin billions of gallons of Columbia River water into electricity.

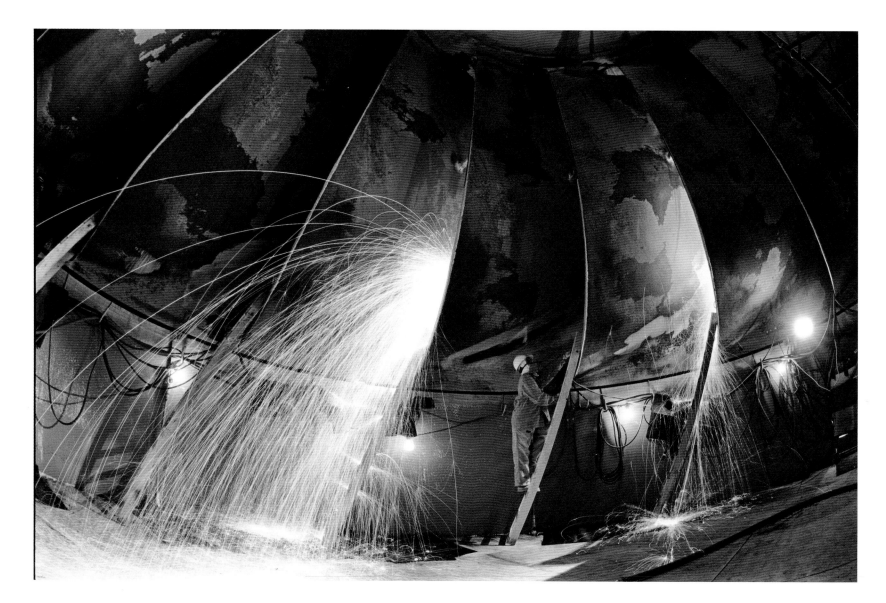

SARAH LEEN | California, 2005

Festooned with a giant U.S. flag, British
Petroleum's Carson refinery rises above
the streets and trees as an eerily iridescent
monument to American oil production.

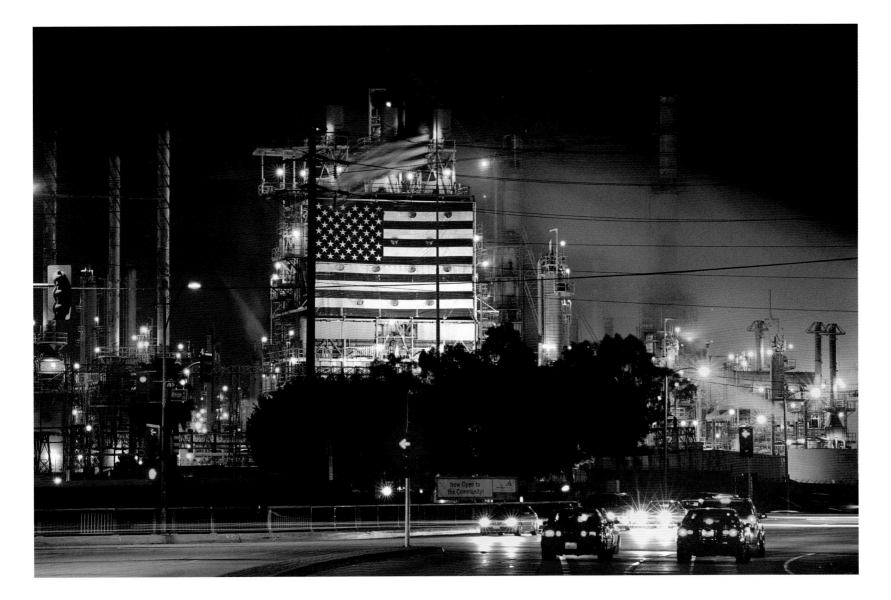

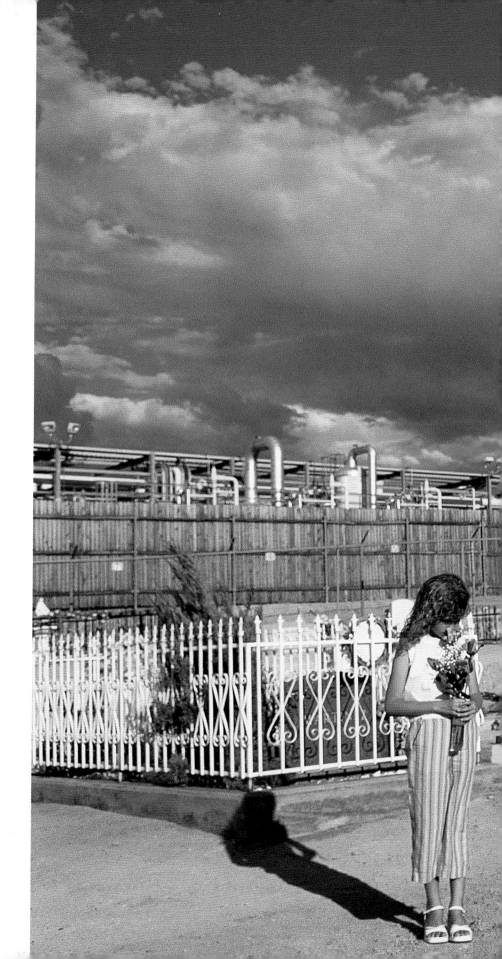

JOEL SARTORE | New Mexico, 2005

In the encroaching shadow of the Four Corners refinery, mourners leave one of the 60 graves at St. Mary's Cemetery in Bloomfield.

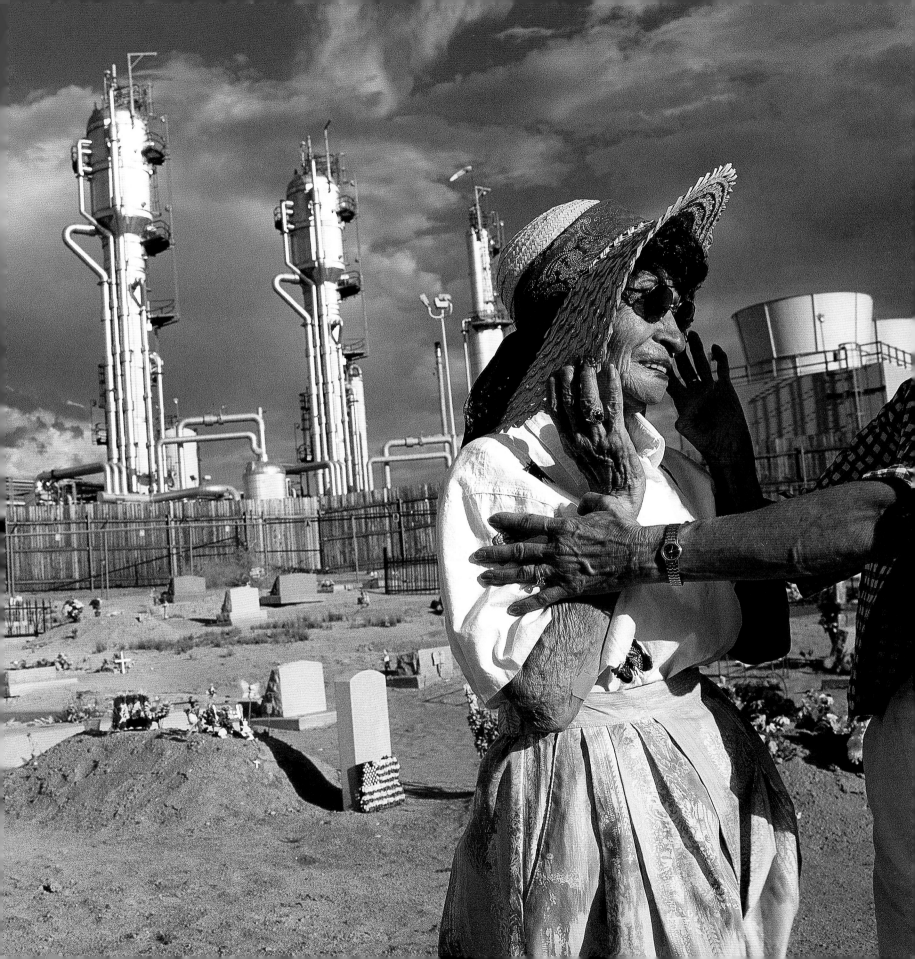

WILLIAM ALBERT ALLARD | Nevada, 1979

The glowing, jelly-colored lights and dream-like bar name reflected in a Suburban's window beckon drinkers in the cow town of Elko.

DAVID ALAN HARVEY | Texas, 1984

With Dallas a blur in the background, a driver helps an elegantly dressed model emerge from a limousine.

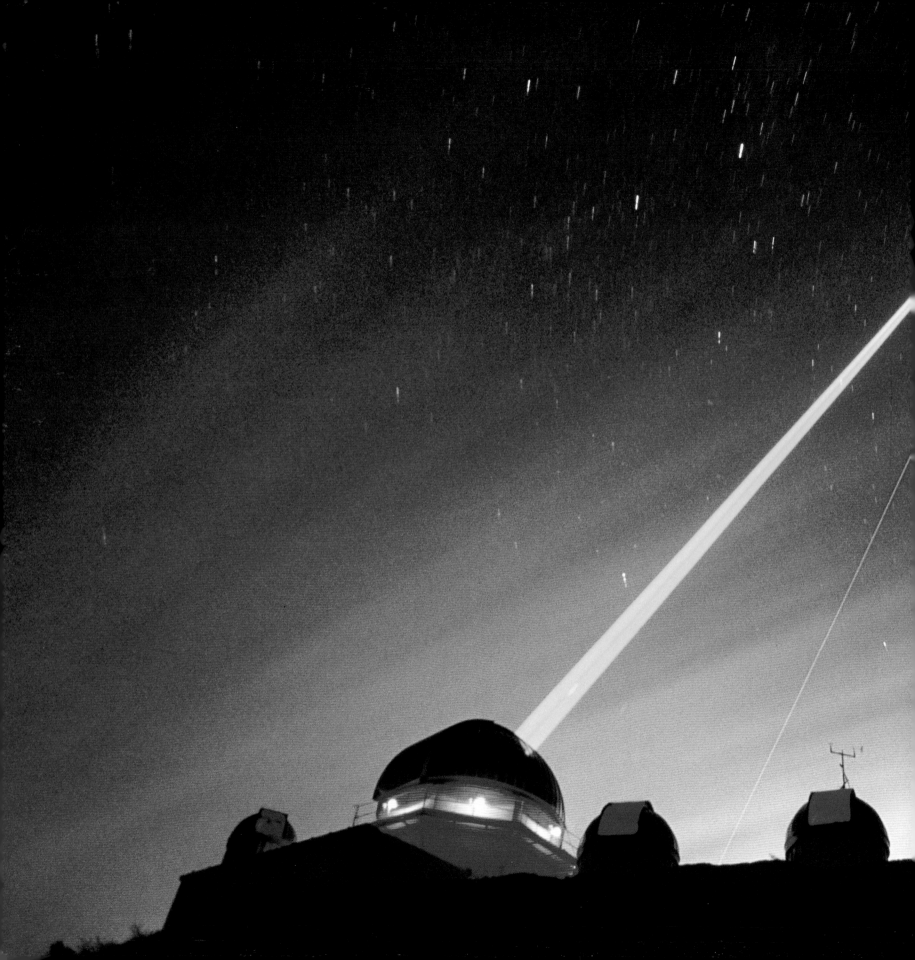

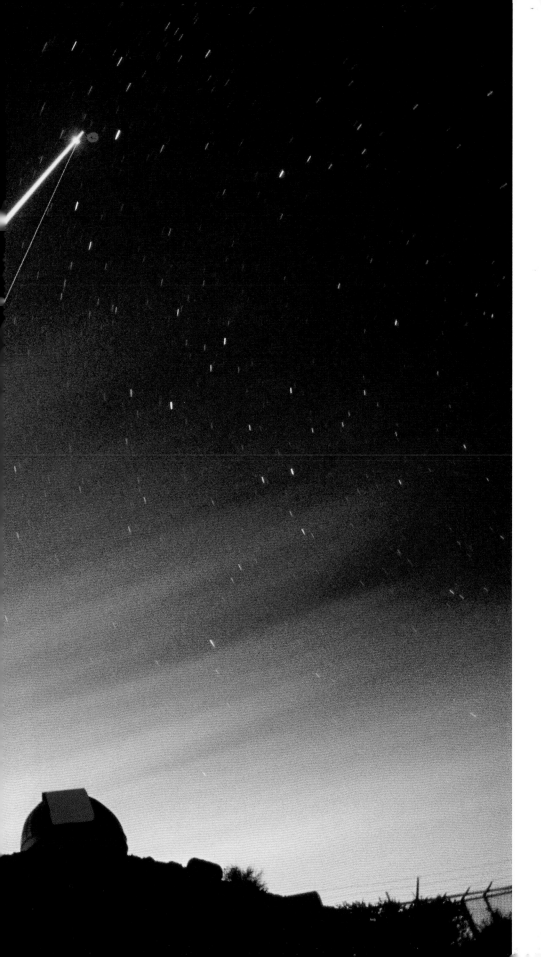

ROGER RESSMEYER | New Mexico, 1993

Continuing mankind's timeless quest to understand the cosmos, telescopes at Kirtland Air Force Base's Starfire Optical Range beam a green copper-vapor laser and an orange sodium-wavelength laser into the atmosphere to create an artificial star.

JAY DICKMAN | Texas, 2002

Before dawn, three of the world's premier chiropterologists (bat experts) float in a hot air balloon 40 feet above a Uvalde cave from which a cloud of bats would explode.

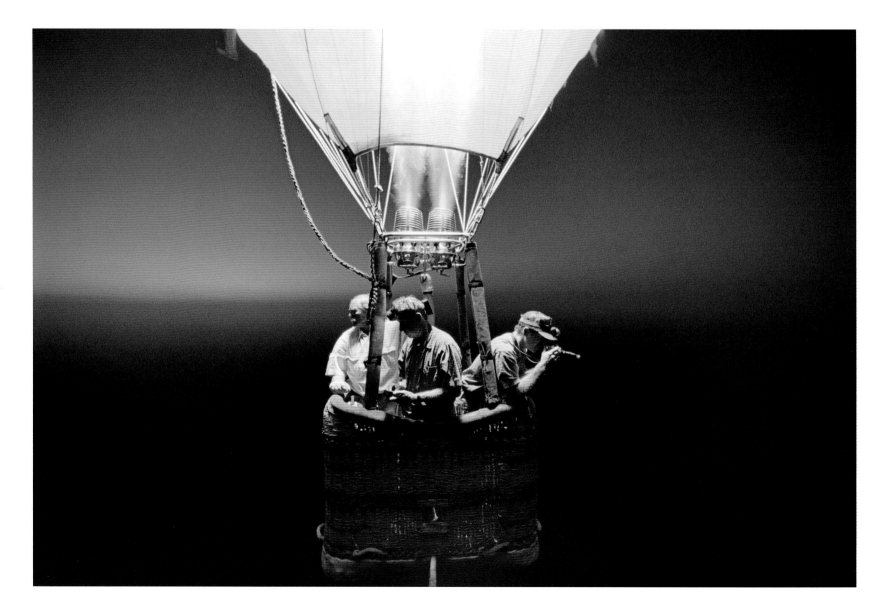

PETER ESSICK | New Mexico, 2000

An alien mannequin basks in glowing green light at the UFO Museum and Research Center in Roswell, where a purported 1947 spaceship crash continues to fuel speculation.

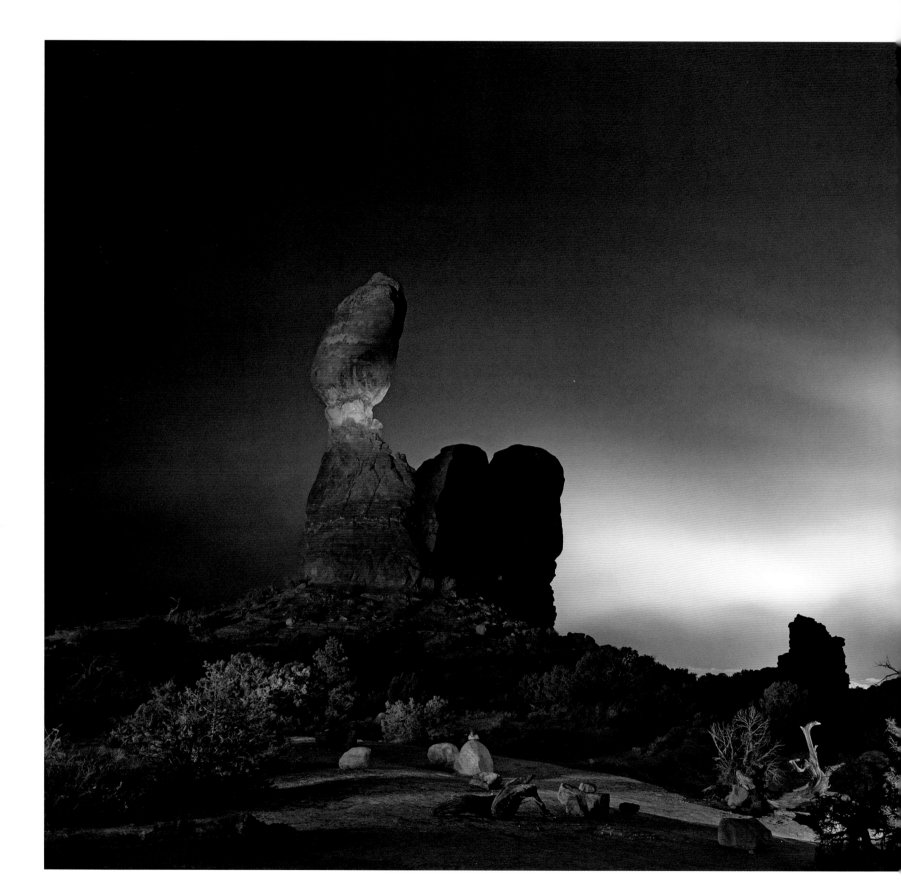

"THE BEAUTY OF THE AMERICAN WEST IS ITS OWN WORST ENEMY. WITH PEOPLE COME STREETLIGHTS, YARDS, AND CARS. THE SPLENDID DARK SKY WITH ITS CANOPY OF STARS IS DISAPPEARING. ARE WE LOVING THE WEST TO DEATH?"

—JIM RICHARDSON, 2012

TOM LEESON | Wyoming, 2008

A gray wolf pup eyes the camera curiously near Yellowstone's Norris Geyser Basin. After being driven to near-extinction, packs have resurfaced in the western U.S.

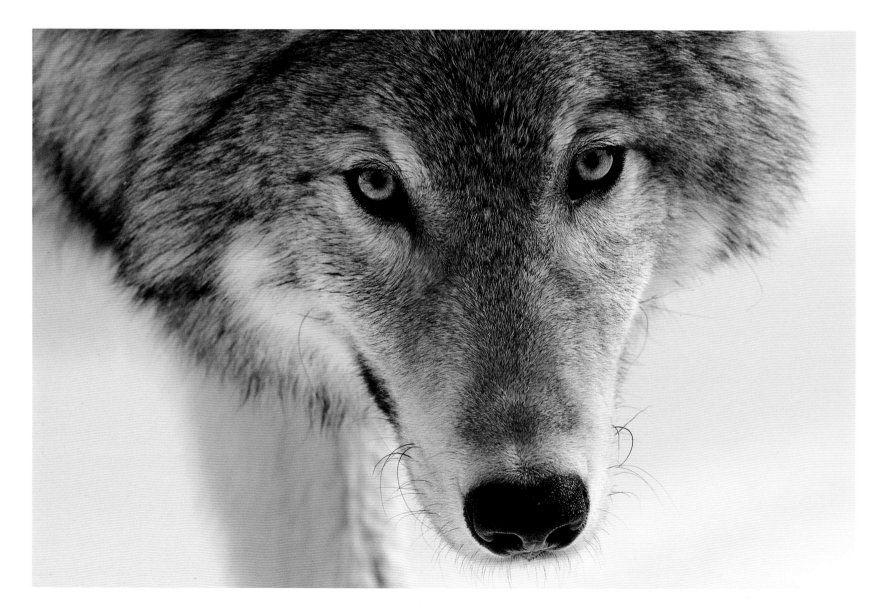

JOEL SARTORE | Oklahoma, 2007

No longer endangered, revered by Native Americans, and turned into a national symbol, America's most recognized raptor—the bald eagle—reveals a rarely seen side.

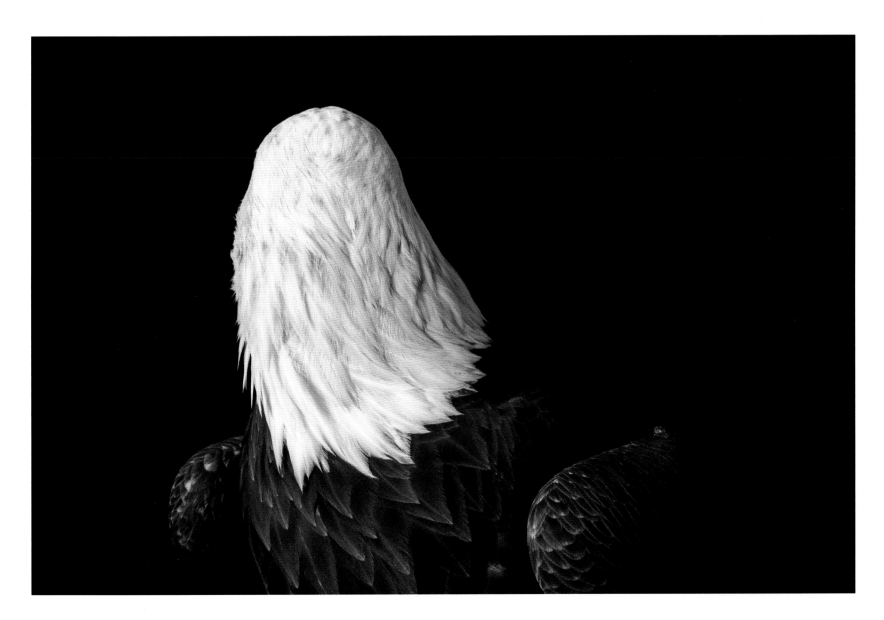

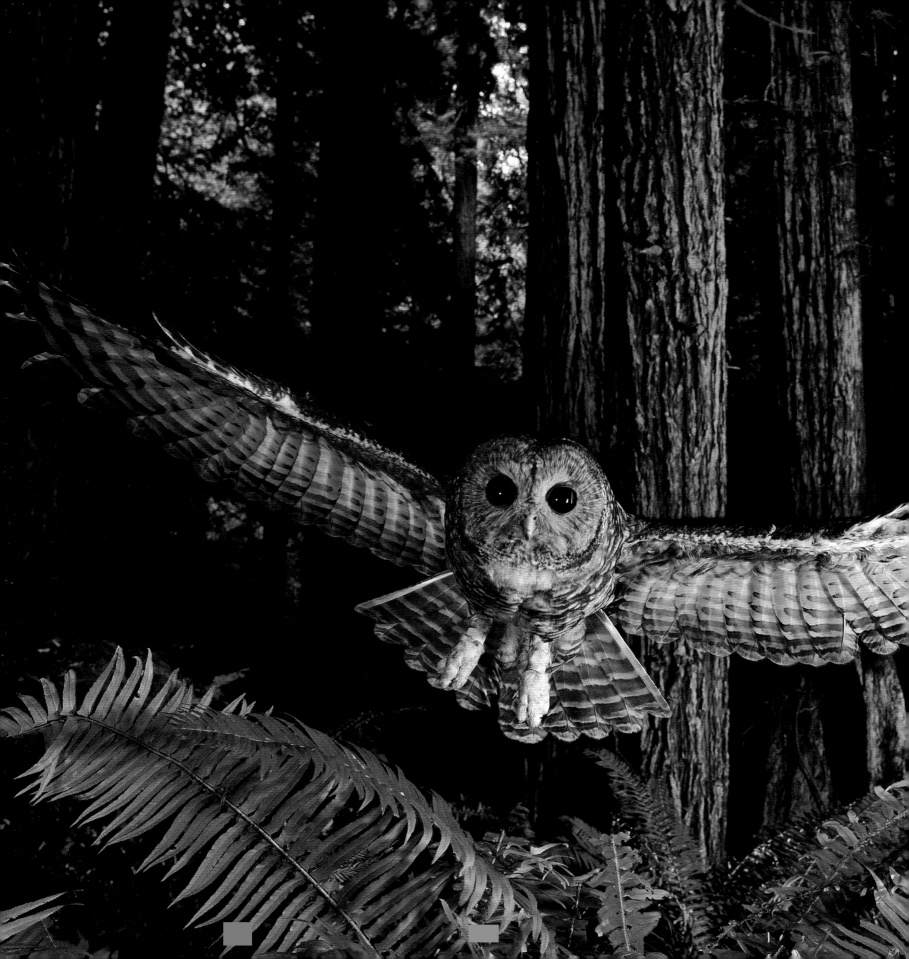

MICHAEL NICHOLS | California, 2008

A tagged Northern spotted owl, emblematic of logger-conservationist controversy, swoops strikingly from a young redwood forest in Marin County.

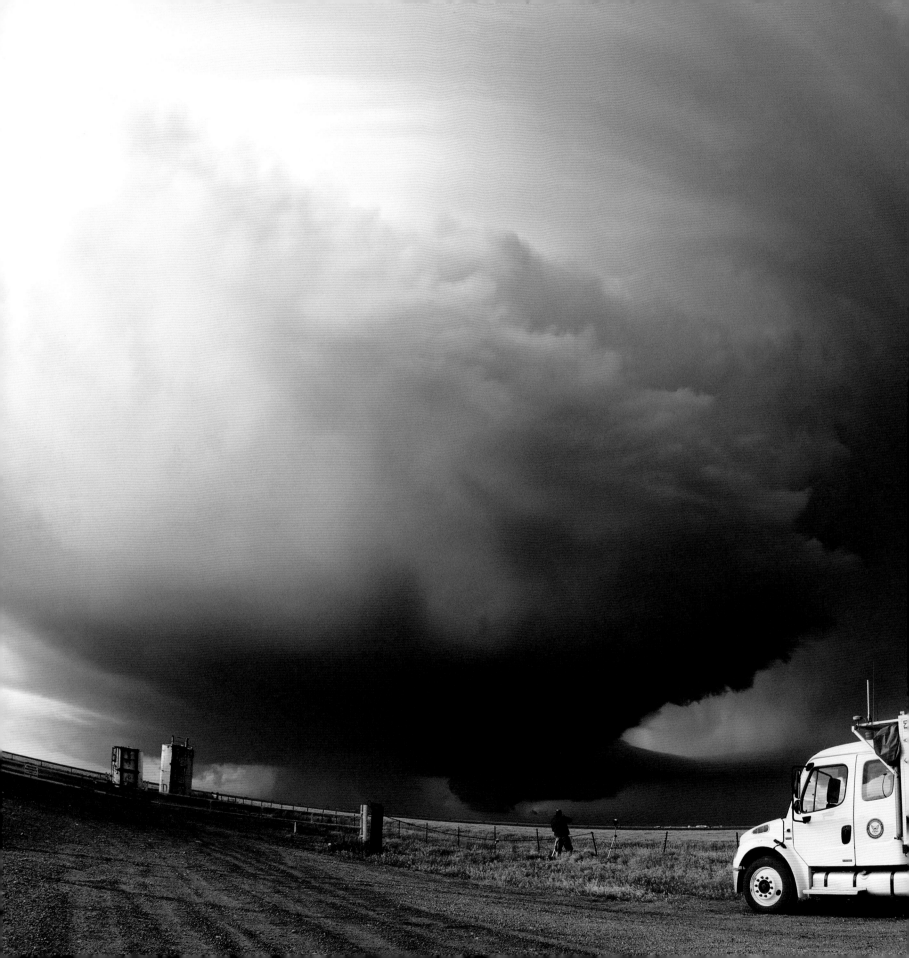

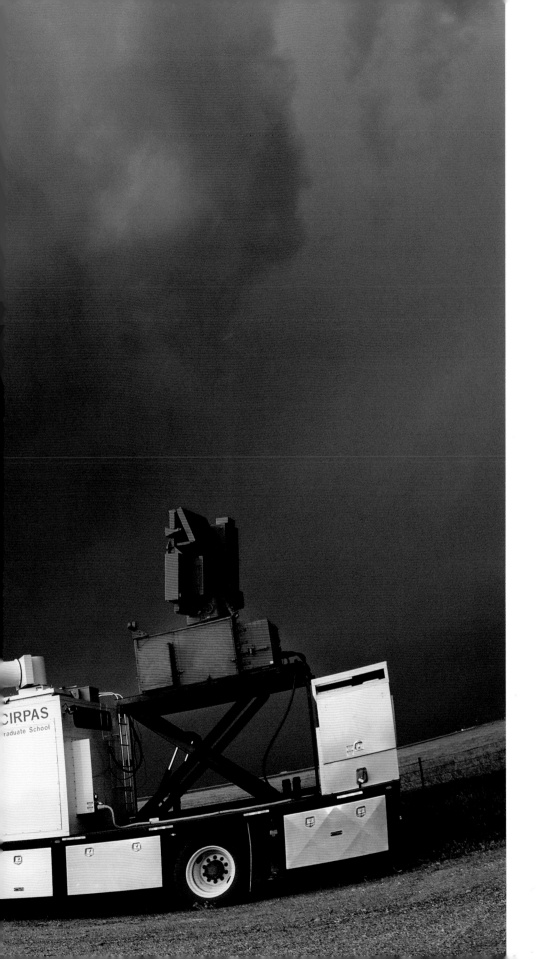

MIKE THEISS | Texas, 2010

As clouds begin to funnel, a fisheye photograph captures researchers and a Phased Array Radar truck of VORTEX-2—a multimillion-dollar field program devoted to understanding and predicting tornadoes.

SARAH LEEN | Texas, 2009

Developed as a minimally invasive method
of oil and gas exploration, seismic imaging
colorfully reveals a 3-D cross section of earth.

SARAH LEEN | Texas, 2004

A crew works to plug a played-out West Texas oil well. New extraction techniques could bring workers back to reopen it.

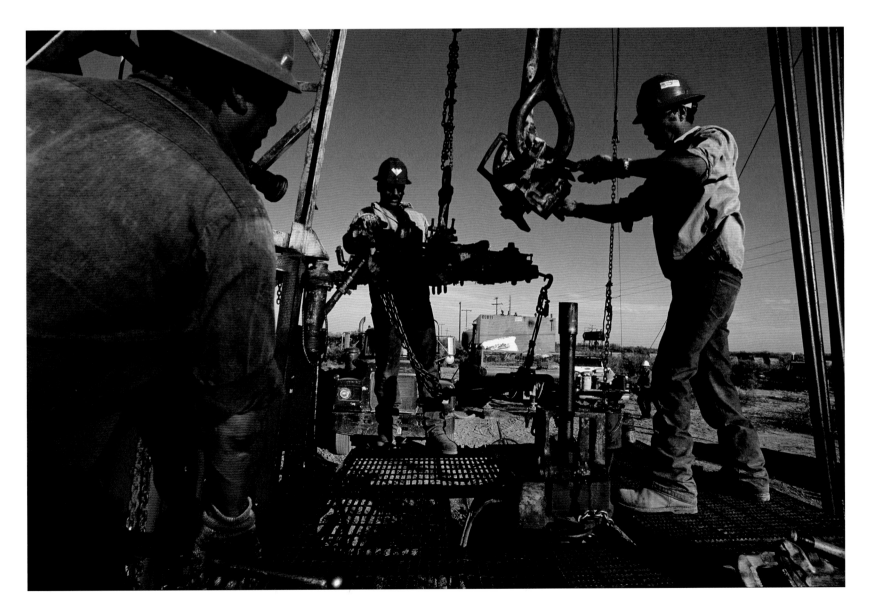

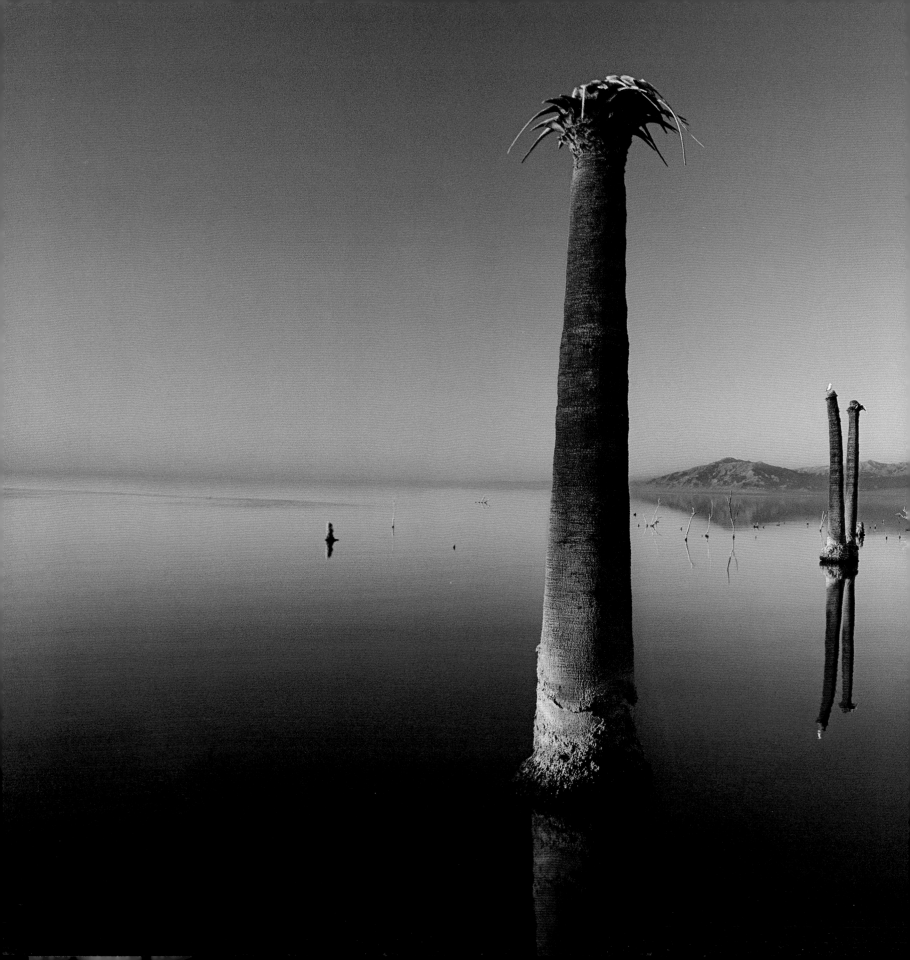

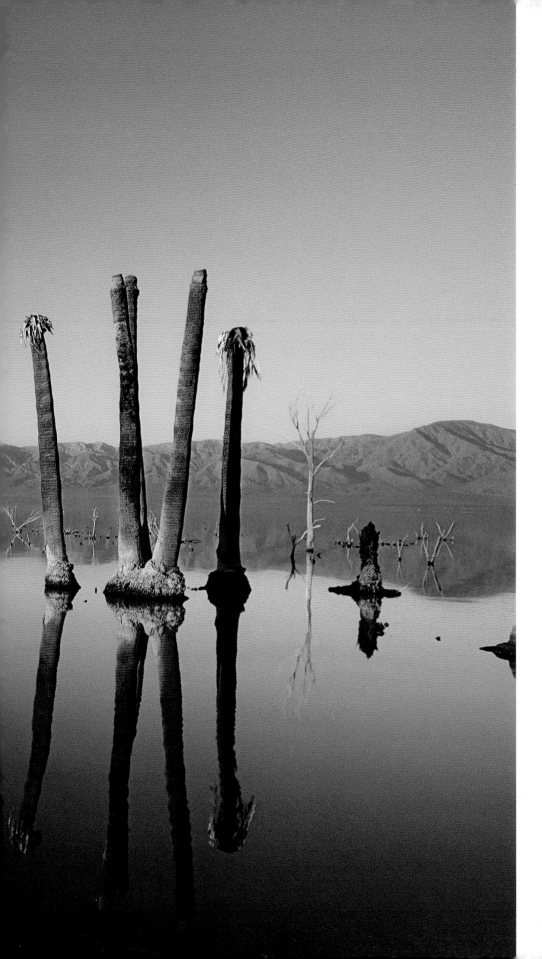

GERD LUDWIG | California, 2005

Sunken palm trees in the Salton Sea suggest the catastrophic environmental decay of a "sea" formed 227 feet below sea level by agricultural runoff. With little rainfall, no outlets, and 25 percent more salt than the Pacific Ocean, the state's largest lake could soon be biologically dead.

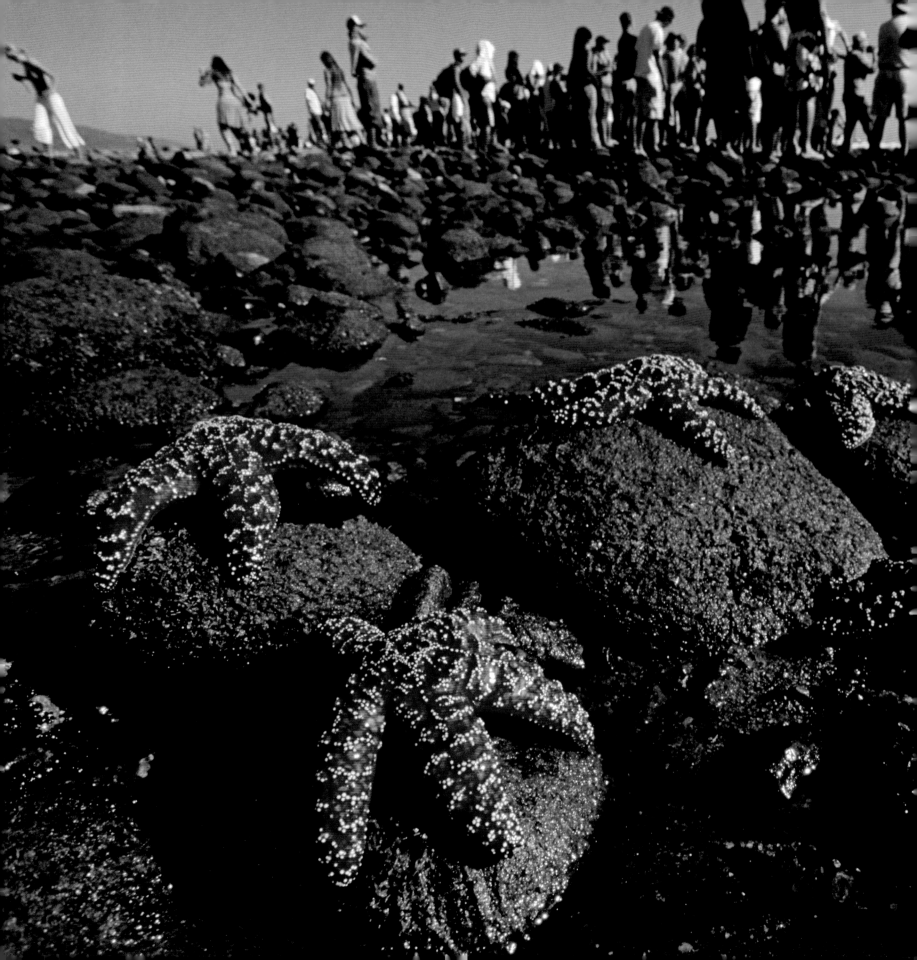

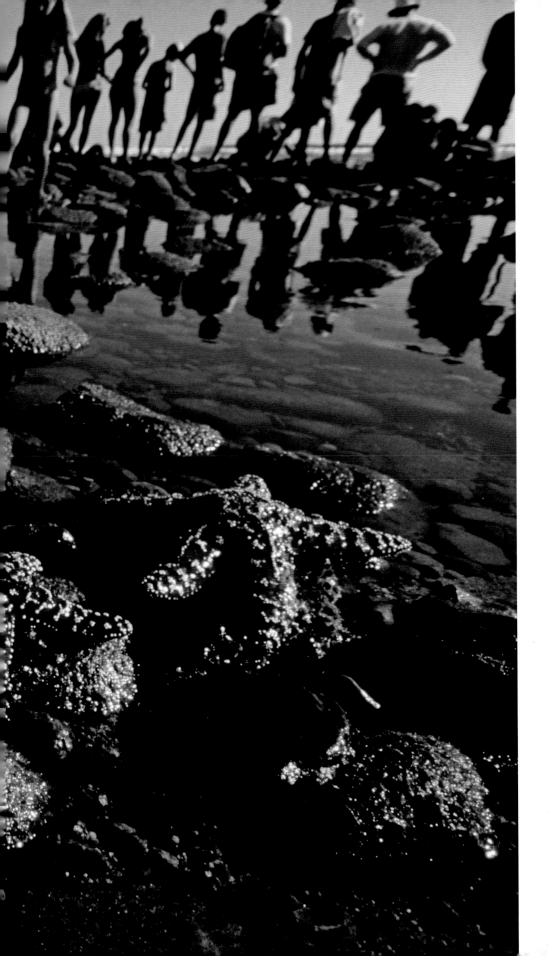

Ochre sea stars sprawl on tidal pool rocks while a crowd takes in a surfing competition at San Onofre State Beach.

JAMES A. SUGAR | California, 1981

Forming a geometric pattern in San Francisco Bay, a system of levees spreads seawater through shallow ponds—some 800 acres in size—that produce salt through evaporation.

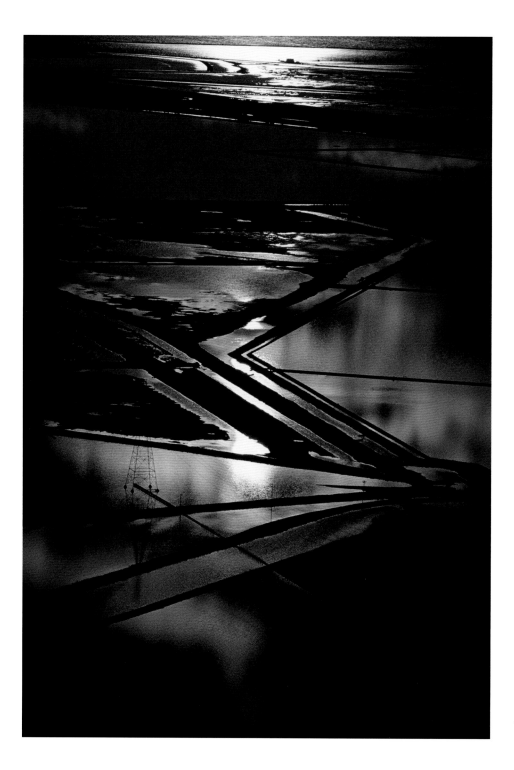

JAMES L. AMOS | Utah, 1975

A dusting of snow dramatizes an open-pit copper mine in the Oquirrh Mountains that runs nearly three miles wide, almost a mile deep, and has yielded close to 20 tons of copper.

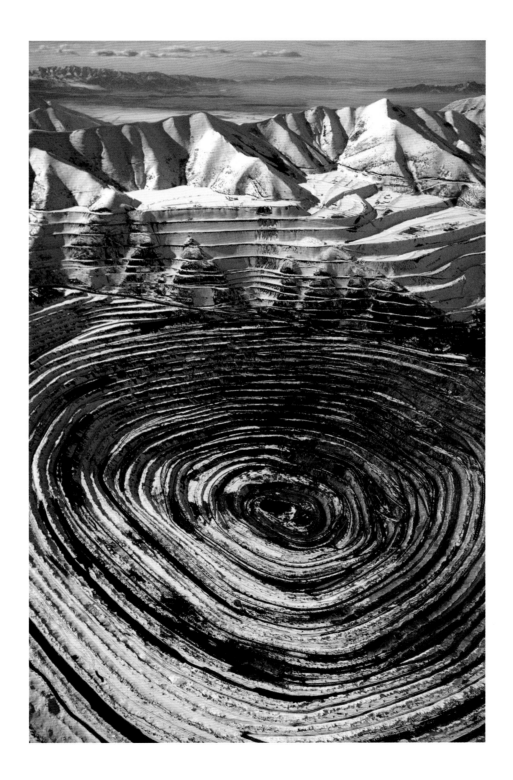

DUGALD BREMNER | Wyoming, 1994

Glaciers, such as this one in the Grand Tetons, may be retreating, but these mountaineers, like others descending them, certainly aren't.

"THE WIND, THE COLD, A BULKY PACK AND HUNDREDS OF FEET OF BLACK ABYSS MADE IT TERRIFYING. YET IT WAS THRILLING, TOO . . . NEVER HAD STEP BY STEP BEEN SO MEANINGFUL A DESCRIPTION OF PROGRESS."

—JAMES M. CLASH, 2003

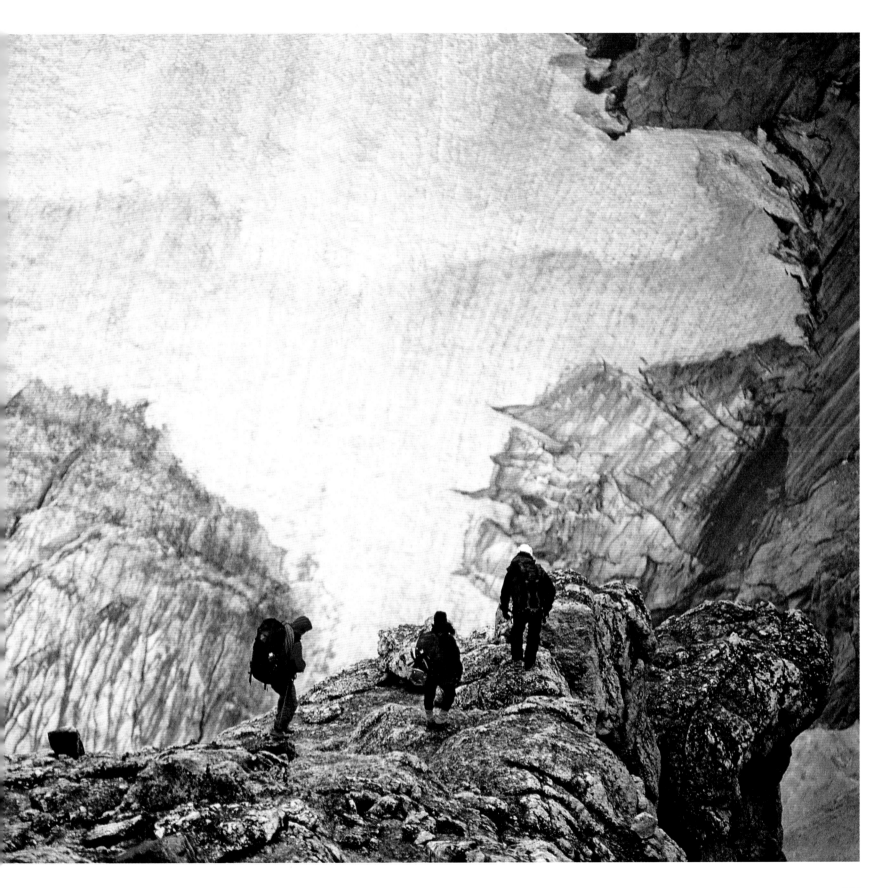

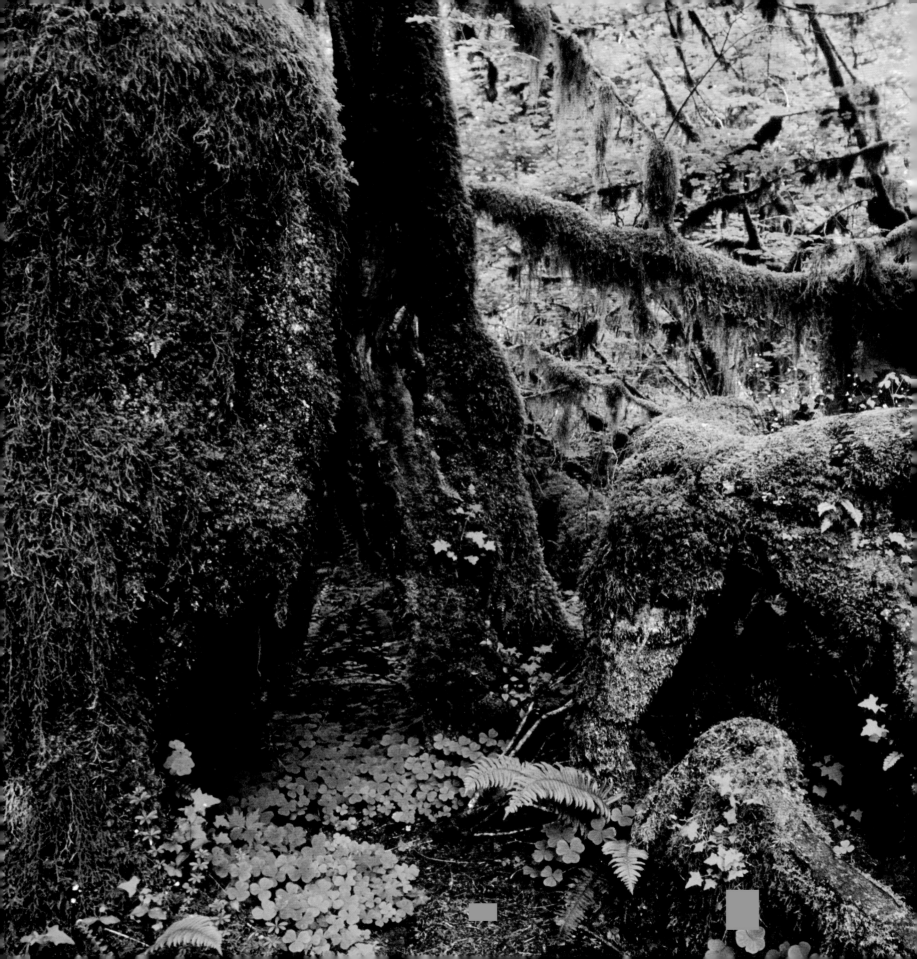

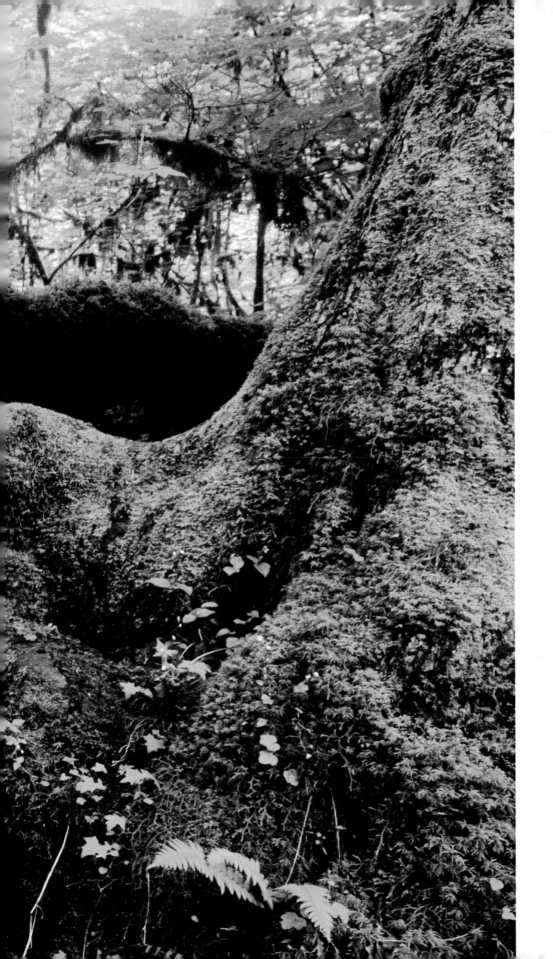

BATES LITTLEHALES | Washington, 1992

Cool, moist conditions promote the growth of moss on old-growth trees in Olympic National Park's Hoh Rain Forest, one of the largest temperate rain forests in the U.S.

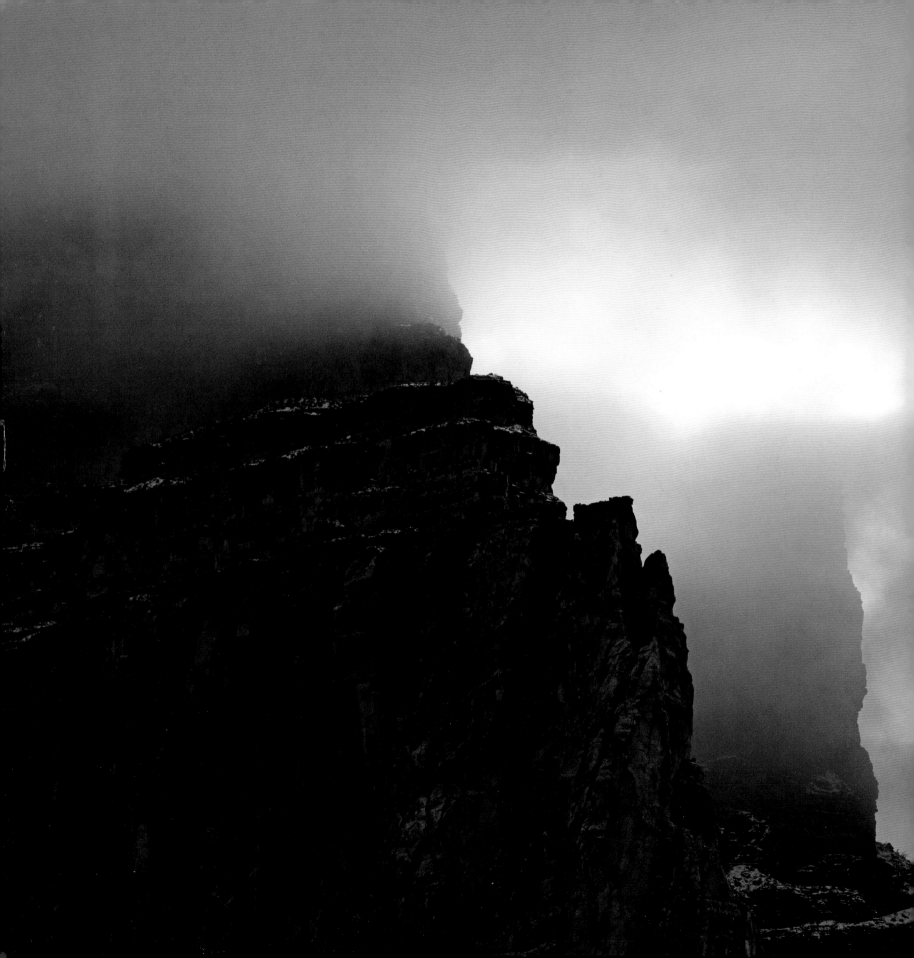

MICHAEL NICHOLS | Arizona, 2006

The numinous clearing of storm clouds near Point Hansbrough in the Grand Canyon reveals cliffs frosted with snow.

[AFTERWORD]

GROWING UP IN THE MAGICAL TOWN OF CODY, WYOMING, IN THE 1930s WAS A WARM and memorable experience for my brother Pete and me. Still active in our 80s, we think back often to those days with clearer reflection and nostalgia than one would imagine. Among the "simple pleasures" that cheered us immeasurably was the monthly delivery of the *National Geographic* magazine. I can see it now—the yellow, the white, the columns on the side, the index on the front. And what was inside? Imagination, curiosity, images that stirred and excited you: the Seven Wonders of the Ancient World; the blasting and sculpting of Mount Rushmore; zeppelins and dirigibles; pictures of Africa and its people; the North and South poles. When Pete and I tried to emulate the Hanging Gardens of Babylon by flipping potted plants onto the ceiling of our room, Mom and Pop did not share our enthusiasm!

The glorious West, so vividly portrayed in the *National Geographic*, is truly in my blood and at the heart of my patriotism. My great-grandfather, Finn Burnett, came to Wyoming in 1862. An adventurous man, his life was chronicled in the book *Finn Burnett, Frontiersman*, and he was game for anything! Six generations have lived here and helped to preserve the West and nurture it.

We worked at the B-4 Ranch near Cooke City, Montana, then owned by Buffalo Bill's grandson, Freddie Garlow. It was just across the river from where Ernest Hemingway often stayed and wrote. We also worked at the historic T E Ranch, which had been Buffalo Bill's home ranch, where he'd always loved to return from his worldly travels. We worked with cowhands, wranglers, hobos, drunks, and I fear it was the irrigators who left me with my most pungent and earthy vocabulary! I've grabbed calves and held them down during branding, I've ridden 50 miles on a horse in one day (it still pains me to think of it!), I've hunted and fished, and I was good at both, too!

We had pack trips into the Thoroughfare with our folks and later with our own children. When you live 52 miles from the paradise of Yellowstone Park and 16 miles from the site of the Heart Mountain

War Relocation Center from World War II, you gain a unique understanding and sensitivity. When the great leveling agents of life—the plains, the sagebrush, the rivers, the mountains, the geysers, the caves, the trails, and all the "secret places" one can go just to think, reflect, and refresh—are all around you, you realize how damn fortunate you are to live in such a special safe harbor of nature in all its splendor.

After our granddad died in Jackson in 1940, Pop went there to close his law practice, and we lived at "The Woodbury Place" a mile from Moose, Wyoming, and attended a one-room school. That later became the home of Mardy Murie, the iconic figure of conservation. When I was in the U.S. Senate, she would prod me a bit about some of my votes, especially those concerning the sensitive balance between development and preservation. She'd say, "Now, Alan, you vote right, or I won't bake any more cookies for you!"

This marvelous book you hold in your hands contains some of the most magnificent photography one could envision. What doesn't leap from the pages in your tactile world will remain with you in "the eye of the mind." I grew up surrounded by the photography of renowned Charles Belden and a local legend, Jack Richard. The vivid photo craft of Edward Curtis, William Henry Jackson, and Ansel Adams was at our fingertips in our own home.

Those photographs capture the transcendent and transformative character of the West. It's the same character that makes someone "different" when he or she pulls on a cowboy hat. Why else would the great Paul Gauguin buy and wear one immediately after seeing Buffalo Bill Cody perform in Paris?

This exhibition will convey pure power and emotion to jar our jaded senses. It will make us realize that all the "stuff" that puzzles, confounds, irritates, and benumbs us amounts to minuscule blemishes. Of this glorious photo portrayal of our West, Rudyard Kipling might observe these artists did indeed "…splash at a ten-league canvas with brushes of comet's hair!"

—ALAN K. SIMPSON
U.S. Senator, Wyo. (Retired)

PARTICIPATING MUSEUMS

• **Booth Western Art Museum** Cartersville, GA

• **Buffalo Bill Historical Center** Cody, WY

• **C.M. Russell Museum** Great Falls, MT

• **Eiteljorg Museum of American Indians and Western Art** Indianapolis, IN

• **Gilcrease Museum** Tulsa, OK

• **National Cowboy & Western Heritage Museum** Oklahoma City, OK

• **National Geographic** Washington, DC

• **National Museum of Wildlife Art** Jackson Hole, WY

• **Rockwell Museum of Western Art** Corning, NY

• **Stark Museum of Art** Orange, TX

GREATEST PHOTOGRAPHS OF THE AMERICAN WEST

This volume is the exclusive companion to a special exhibition of photographs of the American West from the National Geographic Image Collection in Washington, D.C. In collaboration with Rich Clarkson and Associates of Denver, Colorado, and the National Geographic Society, the National Museum of Wildlife Art of the United States, located in Jackson Hole, Wyoming, developed the exhibition. Underscoring the significance of the project, members of Museums West—a consortium of institutions across the nation that specialize in the art, history, and culture of the West—committed to the highly unusual practice of opening the exhibition in multiple locations on the same day.

The opening date, October 27, 2012, is the occasion for widespread public access to the exhibition itself, an educational website, and special events.

The project reflects two significant accomplishments. First, it reveals the incredible range of photographic resources about the American West compiled by the National Geographic Society over 125 years. Second, it demonstrates the potential of the collective impact of museums as essential cultural institutions in their communities and across the nation.

As presenting sponsors and underwriters of the project, the Mays Family Foundation of San Antonio has made an extraordinary contribution that signifies the importance of cultural arts and cultural institutions in the life of the nation.

NATIONAL GEOGRAPHIC IMAGE COLLECTION

Many of the images in this book and the exhibit are available as high-quality prints for your home or office. The available images are listed here. To order them, use this guide to find the corresponding NG Image Number(s), then visit www.NationalGeographicArt.com, where you can enter the Image Number(s) and choose among size and framing options. While you are there, browse the many thousands of other beautiful images available from the National Geographic Image Collection.

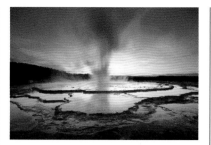

Pages 20-21, No. 1196845

Page 44, No. 1413136

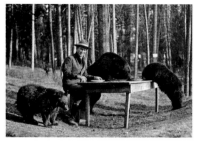

Page 23, No. 1411197

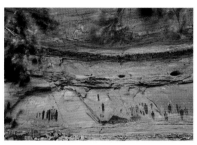

Page 45, No. 1049436

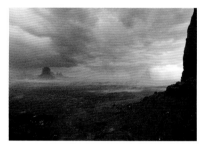

Pages 26-27, No. 77808

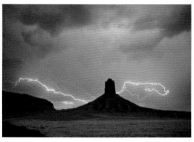

Pages 48-49, No. 110189

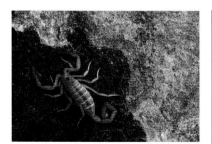

Page 1, No. 1086990

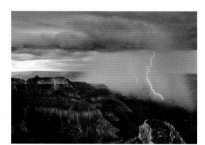

Page 13, No. 983558

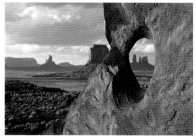

Pages 34-35, No. 692578

Pages 50-51, No. 1049429

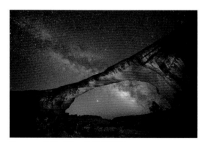

Pages 2-3, No. 1191501

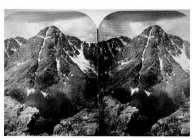

Page 14, No. 440788

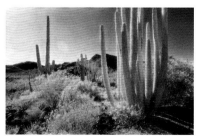

Pages 36-37, No. 698290

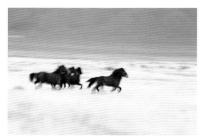

Pages 52-53, No. 621082

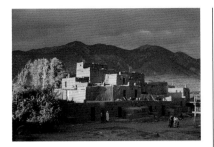

Pages 54-55, No.1127718

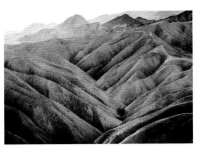

Pages 68-69, No. 1094036

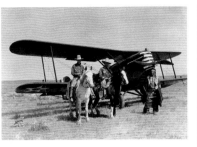

Pages 82-83, No. 953611

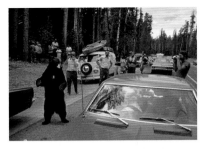

Pages 100-101, No. 620103

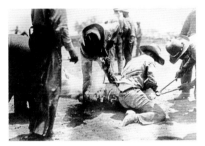

Pages 58-59, No. 606418

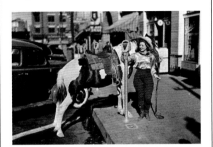

Page 70, No. 989759

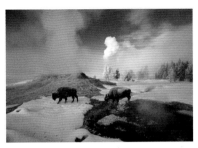

Pages 86-87, No. 720133

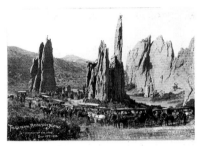

Pages 102-103, No. 440851

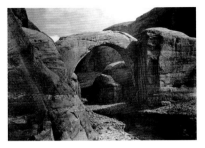

Page 64, No. 1412152

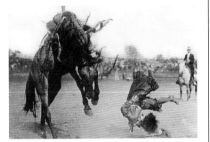

Page 71, No. 936152

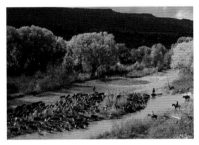

Pages 90-91, No.1069581

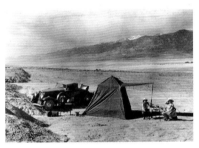

Pages 108-109, No. 1389311

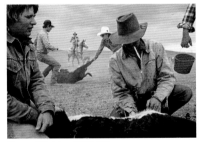

Page 65, No. 427115

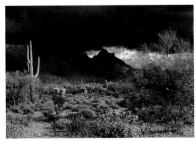

Pages 76-77, No. 620801

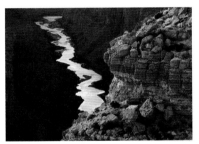

Pages 92-93, No. 692573

Page 112, No. 1411066

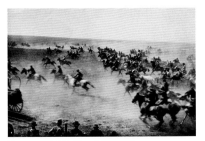

Pages 66-67, No. 1411528

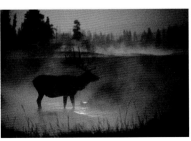

Pages 78-79, No. 455525

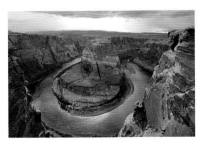

Pages 98-99, No. 1055028

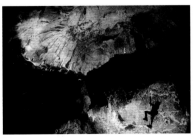

Pages 114-115, No. 456638

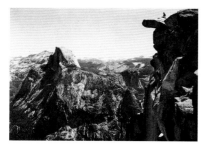

Pages 116-117, No. 1411123

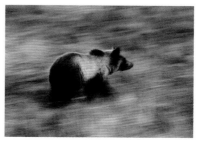

Pages 130-131, No. 604269

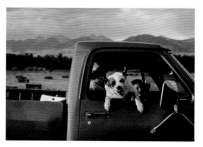

Page 139, No. 392055

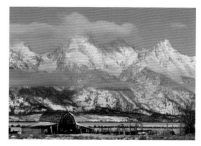

Pages 150-151, No. 1003101

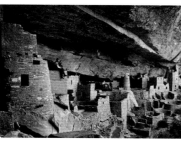

Pages 120-121, No. 516112

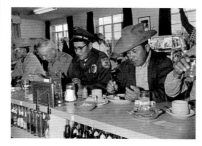

Page 132, No. 1386496

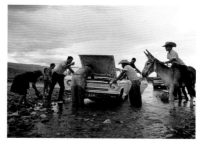

Pages 140-141, No. 131230

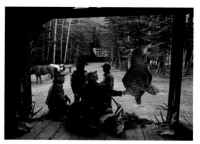

Page 152, No. 965541

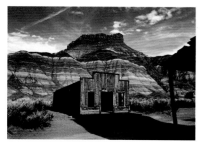

Pages 126-127, No. 522011

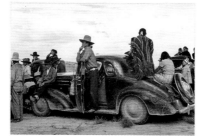

Page 133, No. 951062

Pages 142-143, No. 1052134

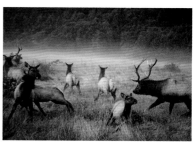

Pages 154-155, 1260353

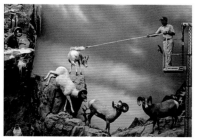

Page 125, No. 507916

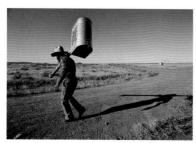

Pages 134-135, No. 110356

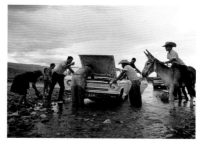

Page 146, No. 23113

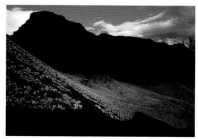

Pages 162-163, No. 1087026

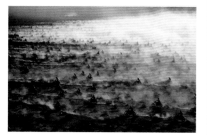

Pages 128-129, No. 193055

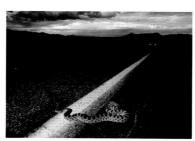

Page 138, No. 533265

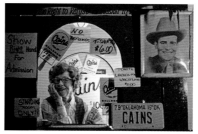

Page 147, No. 425574

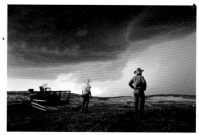

Pages 164-165, No. 750998

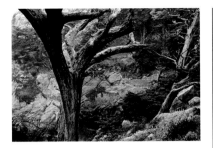

Page 167, No. 1369382

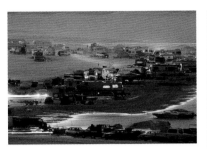

Page 174, No. 465920

Pages 188-189, No. 1203890

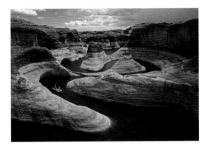

Pages 202-203, No. 999408

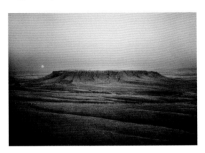

Pages 168-169, No. 110172

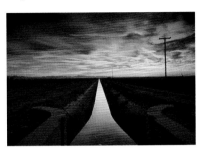

Page 175, No. 975514

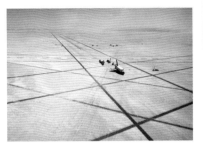

Page 194, No. 271717

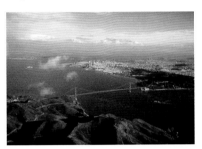

Pages 204-205, No. 1110194

Page 170, No. 115837

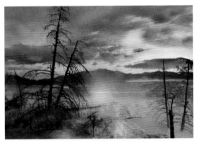

Pages 176-177, No.1164946

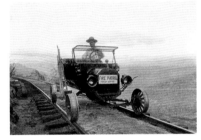

Page 195, No. 1389375

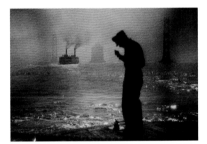

Page 206, No. 1389341

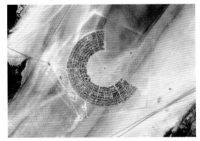

Page 171, No. 1258562

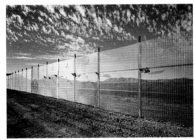

Page 182, No. 965513

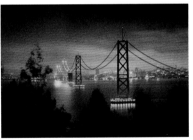

Pages 198-199, No.1059163

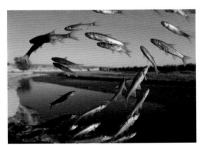

Page 207, No. 1389343

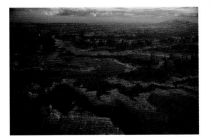

Pages 172-173, No. 999418

Page 183, No. 465863

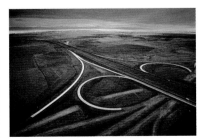

Page 201, No. 494231

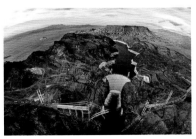

Pages 208-209, No. 1410954

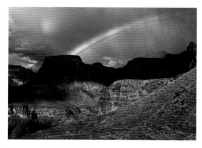

Pages 212-213, No. 1130995

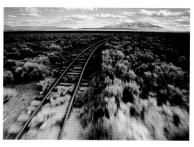

Pages 224-225, No. 404215

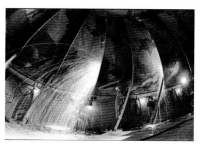

Page 260, No. 673578

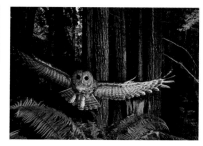

Pages 274-275, No. 1260350

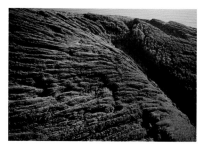

Pages 216-217, No. 1369376

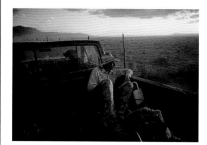

Pages 232-233, No. 475051

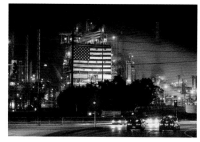

Page 261, No. 968096

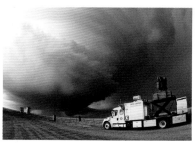

Pages 276-277, No. 1348371

Page 220, No. 1094042

Page 236, No. 715912

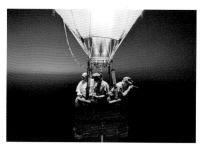

Page 268, No. 697667

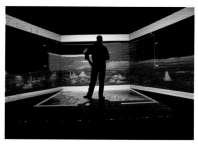

Page 278, No. 761738

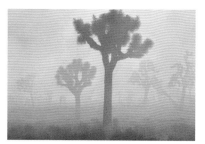

Page 221, No. 1094035

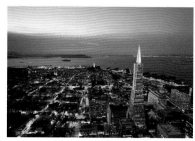

Pages 238-239, No. 1214505

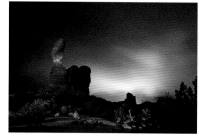

Pages 270-271, No. 1191549

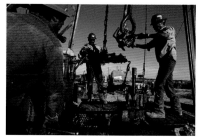

Page 279, No. 752408

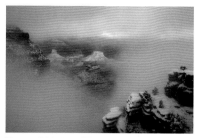

Pages 222-223, No. 983542

Pages 242-243, No 507921

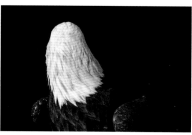

Page 273, No. 1299678

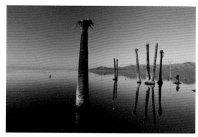

Pages 280-281, No. 765943

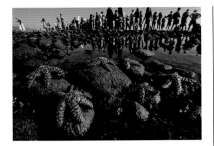

Pages 282-283, No. 1027177

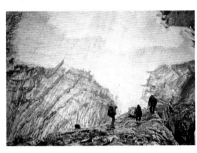

Pages 286-287, No. 1131065

Pages 288-289, No. 1408224

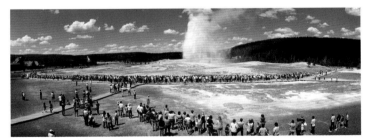

Pages 106-107, No. 620107

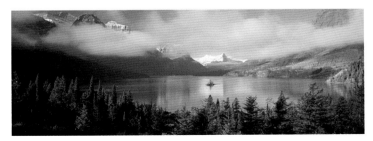

Pages 210-211, No. 1137341

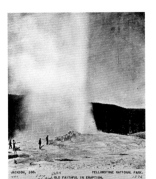

Page 18, No. 440835

Page 30, No. 644899

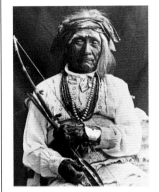

Page 38, No. 572643

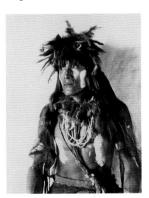

Page 38, No. 604281

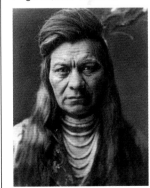

Page 39, No. 1386700

Page 39, No. 769643

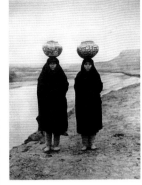

Page 56, No. 769913

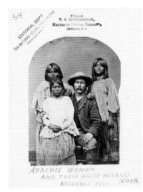

Page 81, No. 752171

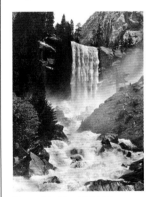

Page 88, No. 603126

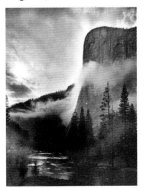

Page 89, No. 1020615

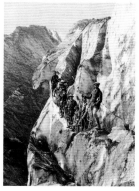

Page 94, No. 1411050

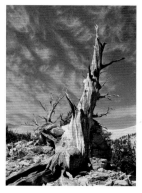

Page 104, No. 647912

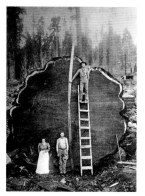

Page 105, No. 655215

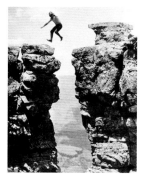

Page 113, No. 1317244

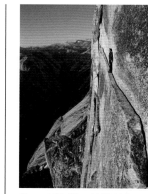

Page 118, No. 1389409

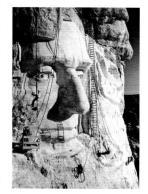

Page 119, No. 1412113

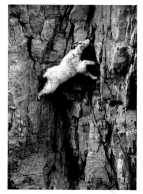

Page 124, No. 1353537

Page 158, No. 1049426

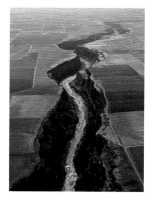

Page 166, No. 1083178

Page 186, No. 1369426

Page 187, No. 1166362

Page 240, No. 103484

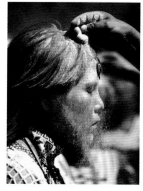

Page 246, No. 423326

Page 284, No. 104116

Page 285, No. 117387

National Geographic Greatest Photographs of the American West

INTRODUCTION by James C. McNutt

PUBLISHED BY THE NATIONAL GEOGRAPHIC SOCIETY
John M. Fahey, Jr., Chairman of the Board and Chief Executive Officer
Timothy T. Kelly, President
Declan Moore, Executive Vice President; President, Publishing and
 Digital Media
Melina Gerosa Bellows, Executive Vice President and
 Chief Creative Officer, Books, Kids, and Family

PREPARED BY THE BOOK DIVISION
Hector Sierra, Senior Vice President and General Manager
Anne Alexander, Senior Vice President and Editorial Director
Jonathan Halling, Design Director, Books and Children's Publishing
Marianne R. Koszorus, Design Director, Books
R. Gary Colbert, Production Director
Jennifer A. Thornton, Director of Managing Editorial
Susan S. Blair, Director of Photography
Meredith C. Wilcox, Director, Administration and Rights Clearance

STAFF FOR THIS BOOK
Susan Straight, Editor
Sanaa Akkach, Art Director
Sarah Leen, Senior Photo Editor
Jane Menyawi, Illustrations Editor
William Bonner, Photo Researcher
Rebecca Dupont, Illustrations Specialist
Judith Klein, Production Editor
Lisa A. Walker, Production Manager
Katie Olsen, Design Assistant

RICH CLARKSON AND ASSOCIATES, LLC
Rich Clarkson, Editor
James C. McNutt, Text Editor
Kate Glassner Brainerd, Art Director
Adam Duncan Harris, Assistant Editor
John Thompson, Contributing Writer
Jon Rizzi, Picture Legends Writer
Kristen Wright, Copy Editor

MANUFACTURING AND QUALITY MANAGEMENT
Phillip L. Schlosser, Senior Vice President
Chris Brown, Vice President, NG Book Manufacturing
George Bounelis, Vice President, Production Services
Nicole Elliott, Manager
Rachel Faulise, Manager
Robert L. Barr, Manager

The National Geographic Society is one of the world's largest nonprofit scientific and educational organizations. Founded in 1888 to "increase and diffuse geographic knowledge," the Society's mission is to inspire people to care about the planet. It reaches more than 400 million people worldwide each month through its official journal, *National Geographic,* and other magazines; National Geographic Channel; television documentaries; music; radio; films; books; DVDs; maps; exhibitions; live events; school publishing programs; interactive media; and merchandise. National Geographic has funded more than 9,600 scientific research, conservation and exploration projects and supports an education program promoting geographic literacy. For more information, visit www.nationalgeographic.com.

For more information, please call 1-800-NGS-LINE (647-5463) or write to the following address:
National Geographic Society
1145 17th Street N.W.
Washington, DC 20036-4688 U.S.A.

For information about special discounts for bulk purchases, please contact National Geographic Books Special Sales: ngspecsales@ngs.org

For rights or permissions inquiries, please contact National Geographic Books Subsidiary Rights: ngbookrights@ngs.org

ISBN: 978-1-4262-0956-7
Printed in China
12/CCOS/1

IMAGE CREDITS

All images from the National Geographic Society Image Collection, with the exception of the following: pg. 9, Ansel Adams / Ansel Adams Publishing Trust; pg. 17, Underwood & Underwood / Corbis Corp.; pg. 116/117, Ansel Adams / Yosemite Park and Curry Co.; pg. 132, Charles Herbert / Western Ways; pg. 176/177, Timothy Fitzharris / Minden Pictures

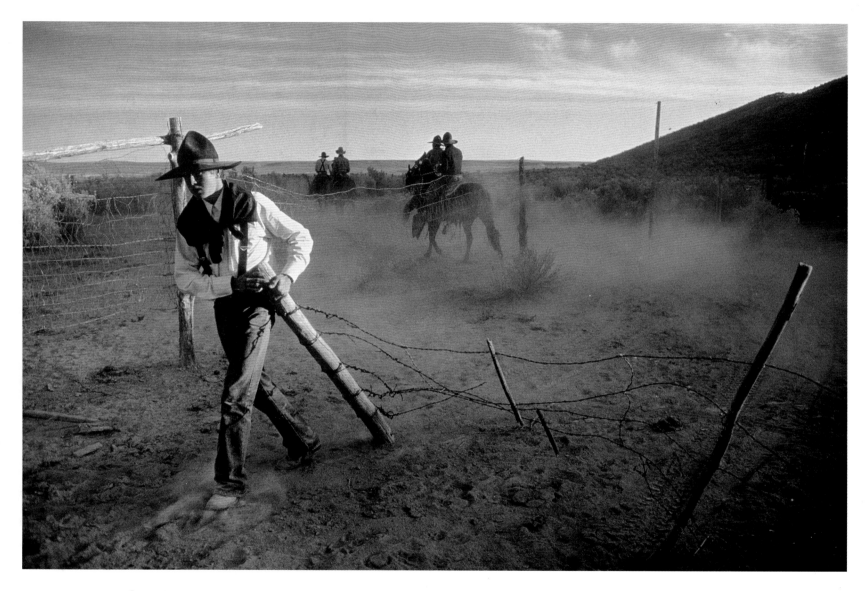

WILLIAM ALBERT ALLARD | Nevada, 1979

A cowhand secures a barbed-wire fence at IL Ranch.